RED ALERT

RED ALERT

Marxist Approaches
to Science Fiction Cinema

Edited by Ewa Mazierska and Alfredo Suppia

WAYNE STATE UNIVERSITY PRESS

DETROIT

20 19 18 17 16 5 4 3 2 1

Library of Cataloging Control Number: 2015954128
ISBN 978-0-8143-4011-0 (paperback) | ISBN 978-0-8143-4012-7 (ebook)

Designed and typeset by Adam B. Bohannon
Composed in Minion

CONTENTS

Introduction

Marxism and Science Fiction Cinema

EWA MAZIERSKA AND ALFREDO SUPPIA

Looking to the Future

This book attempts to bring together three entities: Marxist philosophy, science fiction (SF), and cinema. By putting them together we claim that there is something important that links them and that it is worth exploring and strengthening their connections. Their most important point of correspondence, from our perspective, is their orientation toward the future. More specifically, Istvan Csicsery-Ronay Jr. remarks that imagining a better world is the most immediate link between Marxism and science fiction:

> [SF] and the closely related genre of utopian fiction have deep affinities with Marxist thought in particular, and socialist thought in general. In its simplest terms, sf and utopian fiction have been concerned with imagining progressive alternatives to the status quo, often implying critiques of contemporary conditions or possible future outcomes of current social trends. Science fiction, in particular, imagines change in terms of the whole human species, and these changes are often the results of scientific discoveries and inventions that are applied by human beings to their own social evolution. These are also the concerns of the Marxist utopian and social imagination. (Csicsery-Ronay 2003: 113)

1

Marxism, science fiction, and cinema thus partake in the shaping of things to come—paraphrasing a seminal author for the genre, H. G. Wells. In the case of Marxism, this drive toward the future is unambiguously enunciated in Marx's eleventh "Thesis on Feuerbach," proclaiming that "the philosophers have only interpreted the world differently, the point is, to change it" (Marx and Engels 1947: 199). Marx himself attempted to change the world by setting up political organizations that fought to introduce communism and by engaging in journalistic writing designed to convert a wider population to his political positions. Inevitably, he had to describe this hypothetical world in order to appeal to any potential supporters.

Cinema is also future-oriented. It literally projects, because what we see on the screen was recorded earlier for later consumption. Cinema is a privileged means to imagine and project future worlds, due to its being a *Gesamtkunstwerk*—a total work of art, combining elements of literature, visual arts, and music. As the early Polish film theorist Karol Irzykowski put it, cinema is able to show the "possibility of the impossible" (Irzykowski 1982: 28); it presents objects and phenomena that do not exist in reality (or whose existence was not proven), such as extraterrestrial creatures, time travel, or transfer of consciousness from one person to another, but in a way that makes us believe in their existence. The power of montage especially allows cinema to realistically render time travel and journeys to places that in material reality cannot be achieved (Penley 1991: 66). Not surprisingly, some of the earliest films ever made belong to the SF genre. Georges Méliès, one of the fathers of cinema, is remembered mostly as an author of SF films. Of course, cinema's ability to make possible and future worlds look believable is also conditioned by its current state, most importantly technological and political circumstances. In this sense, science fiction cinema is always a contemporary cinema, bearing witness to a given state of technology and reflecting, either affirmatively or critically, on the dominant ideology of the time it was made. It appears that for contemporary filmmakers, using digital technologies, there are no limits of representation and, by the same token, of imagination.

In *The German Ideology* Marx pronounced that "consciousness can sometimes appear further advanced than the contemporary empirical relationships, so that in the struggles of a later epoch one can refer to earlier theoreticians as authorities" (Marx and Engels 1947: 72). Such advanced consciousness is a condition to be a successful political leader and a science fiction author. Marx himself possessed it to a high degree and became an intellectual authority for many generations of philosophers, practicing politicians, sociologists, economists, and critics of culture, including the contributors to this volume. Paraphrasing Annette Kuhn's characterization of science fiction cinema, we can say that Marx produced blockbusters that are revived again and again (Kuhn 1990: 1) and he has a cult following, not unlike science fiction productions such as *Doctor Who* or *Star Trek*. We especially appreciate his insights into how capitalism would change until it is overthrown by communism and, by the same token, how it would develop if communism does not win. Two aspects of his predictions are of special note. One refers to the political and social consequences of the late stages of capitalism, imperialism, and colonialism, as analyzed in his *Capital* (Marx 1965, 1966, 1967); the second to the development of technology, as discussed in *Grundrisse*, in what is known as the "Fragment on the Machines" (Marx 1973: 690–95). Marx can be seen as both a utopian and dystopian writer, a teller of fairy tales with happy endings and a prophet of the apocalypse.

Another important point of correspondence between Marxism, SF, and cinema is their scientific orientation. Unlike the bulk of philosophical systems that are speculative and idealistic, Marxism, like science, comes across as based on solid foundations. Marx himself wanted his work to be seen this way; the term "historical materialism" expressed his ambition to upgrade philosophy to the position of (objective) science. Similarly, SF, as the very term suggests, strives to be scientific. Darko Suvin, one of the fathers of modern science fiction studies, defines this aspect of SF as the "novum" (Suvin 1979: 63–84). The novum is rational or even scientific, as opposed to the supernatural intrusions of marvelous tales, ghost stories, high fantasy, and other genres of the fantastic (Suvin 1979: 8–9 and 65; Csicsery-Ronay

2003: 118–19). This means that when we read a science fiction novel or watch a science fiction film, we believe that we bear witness to something that will become possible thanks to scientific discovery. This belief is justified by concrete historical experience. As Patrick Parrinder observes, "There are probably very few significant developments in modern physics, astronomy, cybernetics, biology and genetics, which have not been reflected in science-fiction stories" (Parrinder 1979: 67).[1] It is worth mentioning that Suvin borrowed the concept of the novum from Marxist author Ernst Bloch. Suvin described it as a concrete innovation in lived history that awakens human collective consciousness out of a static present to awareness that history can be changed (Suvin 1979: 64). The novum inspires hope for positive historical transformation. Again, film is the locus of the novum to a larger extent than the earlier art forms because no other art is so dependent on the development of technology as film. Moreover, from the very beginning filmmakers revealed an ambition to show the latest achievements in man's journey to conquer nature, and film assisted scientists in their work, for example, by allowing them to capture phenomena invisible to the naked eye.

Its special position as both science and prophecy forces Marxism to continuously endure the test of reality, making it vulnerable to these events and experiences, which apparently contradict Marx's predictions, such as the fall of communism at the end of the 1980s and the longevity and strength of the neoliberal version of capitalism. For this reason, as Stathis Kouvelakis points out, Marxism is regarded as being continuously in a state of crisis, while it is unlikely for Platonists to speak of "a crisis of Platonism" or Kantians of a "crisis of Kantianism" (Kouvelakis 2008: 23). However, we do not regard this continuous crisis as a weakness of Marxism, but rather as an opportunity to build upon Marx and Engels's original works, imagining different scenarios for the future toward which they merely hinted. Indeed, such a task is undertaken by practically all the important post-Marxist thinkers, be it Rosa Luxemburg, V. I. Lenin, Hannah Arendt, or Antonio Negri.

The dynamic character of Marxism reflects the fact that Marx saw the world (essentially the capitalist world) as undertaking a continuous and very violent transformation. Again, this links Marxism with science fiction.

As Mark Bould observes in his introduction to the collection *Red Planets: Marxism and Science Fiction*, both Marxism and science fiction picture a world that is unable to stand still. Bould even refers to Suvin's interpretation of Jules Verne's *Twenty Thousand Leagues under the Sea* (1869), according to which Captain Nemo was almost crushed beneath the Antarctic ice as a punishment for daring to stop at the South Pole, "the stillpoint of the whirling globe" (Bould 2009: 5).

As we have already stated, Marx is seen both as a prophet of communism and of specific developments of capitalism. Paradoxically, the place of his works in the curricula of economy and political studies, as well as in other areas of the humanities, owes more to the latter than to the former. As recently pronounced by the French philosopher Alain Badiou, "Basically, today's world is exactly the one which, in a brilliant anticipation, a kind of true science fiction, Marx heralded as the full unfolding of the irrational and, in truth, monstrous potentialities of capitalism" (Badiou 2012: 12). Seeing Marx as an analyst and critic of capitalism rather than the prophet of communism reflects in part the fact that he said little about communism in positive terms, except that it would be free from alienation and exploitation, thanks to overcoming the division of labor, as declared in *The German Ideology*:

> In communist society, where nobody has one exclusive sphere of activity but each can become accomplished in any branch he wishes, society regulates the general production and thus makes it possible for me to do one thing today and another tomorrow, to hunt in the morning, fish in the afternoon, rear cattle in the evening, criticize after dinner, just as I have a mind, without ever becoming hunter, fisherman, shepherd or critic. (Marx and Engels 1947: 22)

Under this system, men and women would be able to develop their full potential and achieve happiness. Marx omitted questions such as whether the lack of competition would not lead to social pathologies and violence and hence how to ensure that egalitarianism is sustained. The only answer

the philosopher gave to such (in his times hypothetical) doubts about the practicality of communism is that it should be introduced only when the time is right, namely, under conditions of abundance rather than scarcity of consumer goods. On that basis we can argue that "real socialism" failed because it was introduced under the wrong circumstances, which were never sufficiently improved to convince the bulk of the population that communism is better than capitalism.

Yet the Marxist legacy has survived the dismantling of the experimentally socialist countries, which happened in the late 1980s and early 1990s. Post-industrial, late, or neoliberal capitalism has even led to a revival of Marxist thought. This is because, as Badiou and many other authors claim (e.g., Harvey 2005, 2006, 2010; Hardt and Negri 2000, 2006), Marx anticipated the neoliberal version of capitalism that today dominates the world, most famously in *The Communist Manifesto*, predicting that development of such a system would not be hampered by any external obstacles, such as religion or the remnants of the feudal system.

Neoliberalism developed very rapidly thanks to inventions of technology, especially cybernetics and biotechnologies, transforming the world of labor and society at large. According to authors such as Jean-François Lyotard and Slavoj Žižek, this development requires redefining the most important concepts we use to think about the world, including the very notion of "humanity" (Lyotard 1991; Žižek 2001: 4). Lyotard goes as far as to argue that there is a danger of becoming inhuman as a result of adhering to a neoliberal logic (which he described as "development") (Lyotard 1991: 2). Investigating what it means to be human in the neoliberal age is also a task on which the most ambitious authors of science fiction books and films embark. One can think here about such SF films as Darren Lynn Bousman's *Repo! The Genetic Opera* (2008), Miguel Sapochnik's *Repo Men* (2010), and Mark Romanek's *Never Let Me Go* (2010), based on Kazuo Ishiguro's homonymous novel. In all these cinematic extrapolations of our present realities, the human body is overtly featured as a commodity, harvested and cropped in film parables where the self, deprived of any rights, plays the role of a

"ghost in the shell," a disposable, unwanted "residue" which is often ruthlessly effaced by socioeconomic authorities.

As already mentioned, neoliberal capitalism is also global. Rapid communication across the continents is paramount for its survival. Pan-national institutions such as the International Monetary Fund and the World Bank enjoy more power over citizens than national governments. Again, this links the contemporary world to the world as described in science fiction works (Sontag 1994). It is a world marked by extreme colonialism, resulting from the fact that capital is approaching its limits because apart from such corners of the Earth as Cuba and North Korea, it has conquered the whole world (Harvey 2006), even entering a state that Melinda Cooper describes as "capitalist delirium" (Cooper 2008: 12). This situation forces capitalists to search for new reserves, hidden in human bodies and communities, as well as outside the traditionally "usable" surface of the Earth. In this world work is both paramount for human survival and increasingly scarce. A rapidly growing proportion of people are therefore condemned to become "human waste," a situation that forces them to discover often extreme ways of survival, including trading their organs or taking part in dangerous medical experiments.

Because of the speed and volatility with which reality changes under neoliberalism, this system, more than any earlier political regime, challenges people's ability to understand their world. Today we often feel as if we live more in the future than in the present, which, paradoxically, is coupled with a feeling of lagging behind, not being able to catch up with what is going on around us. We believe that science fiction cinema can help us to understand the world and save us from being passive victims of a slow apocalypse unleashed jointly by neoliberal politicians, entrepreneurs, economists, and scientists.

The belief that SF cinema can be seen as a tool in resisting the onslaught of capitalism and its ideology is typically linked to the opinion that science fiction is left-leaning. Such an opinion is, again, attributed to the highly influential Darko Suvin, who, as we already argued, was influenced by Ernst

Bloch, as well as Georg Lukács and his concept of estrangement. It should also be added that the leading critics and theoreticians of SF, such as Fredric Jameson and Carl Freedman, are themselves Marxist. However, while we agree that SF films, like SF literature, offer us many progressive (from a Marxist perspective) ideas, echoing a recent study by Aaron Santesso, concerning fascism and science fiction (Santesso 2014), we argue that SF films can convey different ideologies.

This depends on where and when they are made. In particular, as some of the authors of this anthology would argue, producing SF films in Hollywood requires conforming to certain tenets such as focusing on an individual protagonist, often a superhero, saving the world. This superhero is typically male and white. Moreover, Hollywood productions, even when they criticize the uneven distribution of global resources, leading to the impoverishment of masses of people, simultaneously lure viewers with breathtaking spectacles, which are possible to produce thanks to such uneven distribution and accumulation of capital in the hands of a few. Needless to add, our purpose is not to prove that SF cinema is Marxist, but to use the tools of Marxism to examine different types of SF films.

Science Fiction Cinema across the Globe (and Beyond)

Science fiction cinema is associated primarily with Western or even American cinema. According to John Baxter, "Most countries have attempted sf, some have succeeded to an extent, but the form remains aggressively American, an expression of a national impulse that, like the Western, lies too deep under the American skin ever to be revealed by any but a native son" (Baxter 1970: 208). We tend to disagree with this claim by arguing that many countries developed their own idiom of science fiction.[2] This reflects the fact that this genre was used to transmit local histories and anxieties. Moreover, many of the leading science fiction writers did not come from the West but from the "rest" of the world, examples being Czech Karel Čapek, the Russians Evgeny Zamiatin and the Strugatsky brothers, and Polish Stanisław Lem, widely regarded as the most important science

fiction author of all time (Rottensteiner 1979: 204). This is of great importance, as much in itself as in the light of the fact that a large proportion of science fiction films are based on literature, such as the famous novel by Lem, *Solaris*, that was adapted by both Russian and American filmmakers.

The frame of this introduction does not allow us to provide even a concise history of the world of science fiction films, but we would like to make some observations about the regions and the period this book covers. Let's begin with Western science fiction. In the 1950s and 1960s an important motif of SF films was the invasion of aliens, which is typically read as a reflection of an American anxiety concerning possible attack of alien military forces and ideology: that of communism, as in Jack Arnold's *It Came from Outer Space* (1953) and Don Siegel's *Invasion of the Body Snatchers* (1956). Some Western SF films also envisaged inner contradictions and future collapse in the idea of the American Dream and the emergence of late capitalism, such as Edgar G. Ulmer's *The Man from Planet X* (1951), the sequels to Jack Arnold's *Creature from the Black Lagoon*, Robert Aldrich's *Kiss Me Deadly* (1955), Chris Marker's *La Jetée* (1962), Jean-Luc Godard's *Alphaville* (1965), and Peter Watkins's *The War Game* (1965), *Privilege* (1967), and *Gladiators* (1969).

Throughout the 1970s and 1980s, Western SF film was instrumental in the speculation on the outcomes of rampant neoliberalism, the police state, and "soft" dictatorships. One can think of Stanley Kubrick's *A Clockwork Orange* (1971), Richard Fleischer's *Soylent Green* (1979), Ridley Scott's *Blade Runner* (1982), and Paul Verhoeven's *Robocop* (1987). Based on Anthony Burgess's celebrated novel (1963), Kubrick's film presents a near-future dystopia when a police state takes hold of the individual's basic instincts. "Civilization and its discontents" pervades the whole narrative, standing as the backdrop of a morality tale (much in the way of some eighteenth-century "contes philosophiques"). This and other SF films of this period frequently question the role of the corporations in state administration and the hedonistic underpinnings of neoliberalism. *Soylent Green* draws on Malthusian theories to speculate on a trillion-populated future, to the point that dead bodies cannot be wasted in the face of a growing famine. Reification and

alienation—among other Marxist concepts—come into play in the wake of the Soylent®, the "syntetic" food massively distributed to the impoverished people. In *Blade Runner*, a forerunner of the literary SF movement known as cyberpunk, alienation and reification also appear as lurking subtexts revolving around the replicant characters, androids indistinguishable from human beings, postmodern slaves treated as mere merchandise. The film also questions the boundaries between illusion and reality, questions pertaining to postmodernism. Consequently, an impressive critique of the corporate state, multinational corporations, and their grip on the individual emerge from this by now classic SF film. Verhoeven's *Robocop* goes even further in its critique of the rise of multi/transnational capitalism, the feral infiltration of the corporations into both the state and the social thread, to the point when the welfare state becomes just a matter of assets and liabilities.

Contemporarily, some mainstream Western productions and to an even larger extent more peripheral, independent films, produced on modest budgets and often written and directed by and starring non-Western professionals, have embarked on fierce criticism of social, political, and economic consequences of neoliberalism. Films such as Andrew Niccol's *Gattaca* (1997), Michael Winterbottom's *Code 46* (2003), Alfonso Cuarón's *Children of Men* (2006), Alex Rivera's *Sleep Dealer* (2008), Neill Blomkamp's *District 9* (2009), Miguel Sapochnik's *Repo Men* (2010), and Damir Lukacevic's *Transfer* (2010) address issues such as illegal immigration, telepresence, biotechnology, genetic engineering, high-tech surveillance, the new type of police state, virtual labor, and commodification of the human body. While doing so, they demonstrate the influence of Marxist theory on the ideological foundations of films. Over the years, Western science fiction remains a creative and perfunctory instrument for unveiling and investigating the abuses promoted by different types of capitalism and contradictions inherent in this system.

Unlike Western SF films, which were produced by private studios, concerned principally with making a profit, their Soviet and Eastern European counterparts, in common with any other films made under the

conditions of state socialism, were state-produced and served somewhat different purposes. They were intended to showcase the achievements of the socialist political organization, economy, science, and technology and in this way demonstrate the superiority of state socialism over capitalism. However, largely thanks to the fact that SF was not a realistic genre, hence it did not suffer the same degree of censorship as, for instance, war films or construction films, they often managed to convey the most poignant criticism of the socialist reality ever offered by Soviet and Eastern European directors.

The first impulse, namely proving that socialist reality is superior to its capitalist counterpart, informs the first film belonging to this genre ever made in the socialist world, *Aelita* (1925). Yakov Protazanov's classic compares Russia of 1921 with the capitalistic planet Mars, arguing for a worldwide revolution, so that the whole population can enjoy the advantages of socialism. Many socialist films made after the Second World War, such as Czechoslovak *Icarus XB 1* (*Ikarie XB-1*, 1963), directed by Jindřich Polák, Andrei Tarkovskii's *Solaris* (1971), Marek Piestrak's *The Test of Pilot Pirx* (*Test pilota Pirxa / Navigaator Pirx*, 1979), Andrzej Żuławski's unfinished *On the Silver Globe* (*Na srebrnym globie*, 1988), and several films by Piotr Szulkin were also concerned with travel to faraway planets. This interest in part reflected, as Petra Hanáková observes in her chapter in this volume, significant ambitions and successes of the Soviet Union in exploring space, such as the first artificial satellite orbiting the Earth (Sputnik, 1957), the first flight manned by two astronauts (Nikolajev/Popovich, 1962), and the first woman in space (Tereshkova, 1963). A contrasting interpretation of the endurance of this motif, as well as the subtlety with which some of the aforementioned directors explored the hypothetical encounter with a foreign civilization, is that it conveyed the isolation of Eastern Europeans behind the Iron Curtain. Another frequent motif of aliens invading Earth and time travelers expressed the uneasiness of the citizens of Eastern Europe related to their countries being invaded by foreign ideology (that of communism), armies, and people, and by the same token losing their national sovereignty (Näripea 2010).

As Ewa Mazierska and Eva Näripea have observed, the world as pictured in Soviet and Eastern European science fiction cinema tends to lack human emotion, reflecting a sense that the state communist system proved to be depersonalized and highly bureaucratic (Mazierska 2004; Näripea 2010). Finally, many Russian and Eastern European SF films presented the consequences of the atomic bomb, most importantly depopulation and ultimately the end of humanity, for example in the Czech film *The End of August at the Hotel Ozone* (*Konec srpna v hotelu Ozón* / *Late August at the Hotel Ozone*, 1967), directed by Jan Schmidt, and the Polish *Sex Mission* (*Seksmisja*, 1983), directed by Juliusz Machulski (Mazierska and Näripea 2014). Not infrequently, Eastern European SF films demonstrated that the ambition to produce an egalitarian society, especially in terms of equality of women and men, was either not fulfilled or led to a deep conflict between the sexes (Mazierska and Näripea 2014). Paradoxically, we find more dystopian than utopian films in this part of the world, testifying to the failures of the "real socialist" societies to live up to their Marxist ideals. These films could be seen as indirectly pointing to the superiority of capitalism over socialism, thus confirming our view that SF cinema, while revealing Marxist concerns, does not necessarily embrace Marxist solutions to humanity's problems.

In Latin American cinema, SF tropes have been instrumental to the critique of colonialism, capitalist savagery, and militarism. For instance, in Brazil some modern filmmakers associated with the Brazilian cinematic movement called Cinema Novo resorted to SF imagery in order to engender allegorical critiques of the country's social and political context, sometimes with relevant hints at the environmental issue. One can think of Walter Lima Jr.'s *Brazil Year 2000* (*Brasil Ano 2000*, 1969) and Nelson Pereira dos Santos's *Who is Beta?* (*Quem é Beta*, 1972), and later José de Anchieta's *Stop 88: Alert Limit* (*Parada 88: O Limite de Alerta*, 1978) and Roberto Pires's *Nuclear Shelter* (*Abrigo Nuclear*, 1981). Some of these films employed SF rhetoric to condemn the status quo under military rule from the late 1960s to the early 1980s. Contemporaneously, albeit seemingly free from the threat of censorship, Latin American cinema continues to find in SF a means to "estrange" the continent's complex reality. This can be seen in recent films

such as Alex Rivera's *Sleep Dealer* (2008), in which Mexico's workforce is exploited by a near-future American corporate state, by means of telepresence technology, or Luiz Bolognesi's animated *A Tale of Love and Fury* (*Uma História de Amor e Fúria*, 2013) that performs a revision of Brazilian history and its consecrated national heroes, culminating with a dystopian vision of Rio de Janeiro in 2096, when water is a commodity fiercely controlled by private interests. These films can be regarded as pertaining to the trend in Marxist thought known as eco-Marxism.

The connections between fantasy/magic realism and science fiction cannot be overlooked in this context. Magic realism is the literary and cinematic genre most often associated with Latin America, as exemplified by authors such as Jorge Luis Borges, Adolfo Bioy Casáres, and Júlio Cortázar. There is a strong tradition of fantastic and non-naturalistic representation in Latin America that can be traced back to at least the nineteenth century and the process of state formation that took place across the majority of the region in this period. Science fiction should be situated as part of this tradition, and early examples of the genre exist in Argentinean, Brazilian, Mexican, and Cuban literature. Cinema has been no exception, and films of the genre have been produced in these and other Latin American countries since the 1930s.

Science fiction cinema also bears similarity to Marxist thought because of its latent transnationalism. As a speculative film genre—or, in a broader sense, a mode of representation (Chu 2011: 73)[3]—SF cinema benefits from general claims concerning the history of humankind in the universe, its future, and the ways human beings relate to their environment by means of their cultural products (both material and immaterial). Speculation on the present and the future are frequent in a variety of cultures, as well as the acknowledgment of scientific principles as a means of explaining the world. The sum of such universal speculative drive and the scientific discourse is more evident in SF than any other film genre. In other words, the SF "mode of representation" ultimately claims to be universal and, in so doing, it partakes in the same supranational drive Marxism does. This is conveyed, most commonly, by projecting a future in which national barriers do not

exist or do not matter any longer; the world is one country or is divided into two, one populated by the poor and one inhabited by the rich, as in *Elysium*, discussed by Ewa Mazierska and Alfredo Suppia in their jointly written chapter.

A large proportion of SF films, including many discussed in this volume, are international coproductions, and on the level of film text they try to erase national particularities. *Sleep Dealer* perfectly represents this trend. Its director, Alex Rivera, is an American born in the United States, but he is of Latin American descent. It is a coproduction between Mexico and the United States and represents characters whose work is literally trans-national—they work in their own country, but operating robots placed all over the world and producing surplus value appropriated by an American or transnational company. Another recent film emblematic for this trend is Blomkamp's *District 9*, which is a transnational coproduction between the United States, New Zealand, Canada, and South Africa and reflects tensions between different African countries, as well as between Africa and pan-national institutions, such as the United Nations and the International Monetary Fund; the latter supposedly help underdeveloped and badly managed countries, but at the price of accepting a neoliberal regime. These films travel well across the globe, often becoming objects of a worldwide cult. However, some are only superficially transnational, because they were conceived, designed, and produced by the hegemonic American film industry and reflect Western concerns and preoccupations, although they target worldwide audiences.

Structure and Chapter Outline

We are not the first to bring together science fiction and Marxism in one publication. This was already done by Patrick L. McGuire in *Red Stars: Political Aspects of Soviet Science Fiction* (1985), Mark Bould and China Miéville in their collection *Red Planets: Marxism and Science Fiction* (2009), to some extent in Suvin's *Metamorphoses of Science Fiction* (1979), and many essays published in *Science Fiction Studies* and other journals. However, this

collection is unique in analyzing solely science fiction cinema, as opposed to literature, and its focus on the two political systems with which Marx grappled in his writings, capitalism and socialism.

Our collection attests to the different ways in which science fiction cinema engages with Marxism and Marxism seen as science fiction, namely a science-informed imagining of the future, as Darko Suvin described the genre. It tackles issues such as individualism versus collectivism, the development of science and technology, and especially overcoming technological obstacles to travel in time and space and reaching immortality, accumulation of capital and colonization, struggles of emancipation of oppressed groups, and the problem of ideology as false consciousness. The largest part of the essays deals with the issue of work and especially the extension of the concept of labor due to technological and social transformations. This choice also reflects the fact that labor, understood as alienated work, occupies a central position in Marx's oeuvre. We want to show that these subjects are tackled by science fiction films made in different countries and under different political and economic regimes. By the same token, this collection diverges from the perception that science fiction cinema is a Western or specifically American genre. Instead, a broader approach to SF cinema as a transnational genre orients the following texts. This is also in the spirit of Marx's supranational considerations and the work of some contemporary world cinema theorists and historians (Shohat and Stam 1995; Andrew 2006; Nagib 2006). Thus, most continents are represented here and many films tackled in this book are international coproductions. However, to reflect the fact that Marx is seen today more often as a critic of capitalism than a prophet of socialism, as well as that the majority of science fiction films were produced under conditions of capitalism, the majority of the essays concern Western films dealing with the problems of capitalism.

The collection begins with "First Contact or Primal Scene: Communism Meets Real Socialism Meets Capitalism in Early Czechoslovak Science Fiction Cinema" by Petra Hanáková. Hanáková discusses what is regarded as the ultimate concern of science fiction art: traveling into outer space. She analyzes two Czechoslovak SF films from the 1960s that explore the motif of

first contact with an alien civilization, namely *Man from Outer Space* (*Muž z prvního století*, 1962), directed by Oldřich Lipský, and *Icarus XB* (*1Ikarie XB-1*, 1963), directed by Jindřich Polák. She argues that the metaphor of first contact is used in these post-Sputnik films only as a displaced and displacing stage for another encounter, of both geopolitical and trans-historical character, and for an examination of the presumed political achievements of humanity on its way to a communist future. She claims that in Eastern European SF a specific type of time travel is actually often shown as a necessary component (or phase) of space travel, and even as a prerequisite for successful progress toward the final contact with another civilization. Time travel mediating an encounter with the history of humanity forms a particular version of a geopolitical "primal scene" to reach full maturity (i.e., to meet the aliens). The socialist East has to both encounter the West, but also, and more importantly, to inspect its own history and contemplate less advanced historical and political eras of its own society. Socialist science fiction is thus an important chapter in the history of the genre.

The next chapter, Eva Näripea's "Soviet and Post-Soviet Images of Capitalism: Ideological Fissures in Marek Piestrak's Polish-Estonian Coproductions," also analyzes Eastern European SF and the motif of travel to outer space. She examines the ideological stances in three films made by the Polish director Marek Piestrak in collaboration with the Estonian studio Tallinnfilm: the aforementioned *The Test of Pilot*, a futuristic science fiction story about a mission into outer space, compromised by an android crew member; *Curse of Snakes Valley* (*Klątwa Doliny Węży* / *Madude oru needus*, 1987), a fantasy adventure peppered with SF elements, traveling between the Orient and the Occident; and *Tear of the Prince of Darkness* (*Łza księcia ciemności* / *Saatana pisar*, 1992), a horror/detective story, set in late 1930s Estonia. Rather than claiming that these films represent or dissect socialism, Näripea argues that they reveal interesting ideological discrepancies, in terms of their representations of commodity culture, colonialism, nationalism, and gender. She examines them in the framework of Althusserian critiques of ideology and in the light of an emerging neoliberal world order, as theorized by David Harvey. She claims that while not straightforwardly

"political" or "progressive," nevertheless Piestrak's films, because of their incoherence, unsettle the hegemonic discourses to a certain extent.

By virtue of examining space exploration, Hanáková and Näripea's chapters tackle the problem of colonialism. However, it is not their main concern. By contrast, the problems of colonialism and racism are at the center of the next two essays. Mark Bould's chapter, "Paying Freedom Dues: Marxism, Black Radicalism, and Blaxploitation Science Fiction," traces some of the complex interrelations between Marxism and African American radicalism, locating SF images and ideas often deployed at the intersections of these political and theoretical traditions—in, for example, the fiction by W.E.B. Du Bois, George S. Schulyer, and Richard Wright, autobiographical writings by Paul Robeson, and the revolutionary activism of James Boggs. The essay outlines the emergence of 1970s blaxploitation filmmaking, and how such low-budget action movies were imbricated in the debates around the nature of post–civil rights black politics. It then turns to consider a group of nine SF blaxploitation films: Robert Stevens's *Change of Mind* (1969); Melvin van Peebles's *The Watermelon Man* (1970); Lee Frost's *The Thing with Two Heads* (1972) and *The Black Gestapo* (1975); Ivan Dixon's *The Spook Who Sat by the Door* (1973); William Levey's *Blackenstein* (1973); John Coney's *Space Is the Place* (1974); William Crain's *Dr Black, Mr Hyde* (1976); and Frank Packard's *Abar, the First Black Superman* (1977). Drawing on Frantz Fanon, Huey P. Newton, and others, Bould positions these films in relation to African American responses to postwar anticolonial struggles, particularly the Algerian revolution, and to epidermality—that is, the emphasis on skin and skin color in the interlocked imaginaries of the colonizer and the colonized.

The contemporary film *Transfer* (2010), directed by Damir Lukacevic, examines one of the consequences of neoliberalism, according to Sherryl Vint: human life becoming a commodity. It also demonstrates, as Vint argues, the globalized context of debt imperialism, in which this reinvention of life occurs. The bodies of those in the Global South are literally as well as metaphorically consumed to sustain the affluence of those in the Global North. Her chapter reads the film through a Marxist critique informed by

sociological work on the contemporary market in organs for transplant. The economic and political context of biotech research and organ transplantation encourages us to detach biological tissues from their human origins, a process exacerbated by the commodity form. *Transfer* insists on restoring the human connections that lie behind this commodity form. Further, drawing on Ian Baucom's work in *Spectres of the Atlantic*, she argues that the film critiques a liberal cosmopolitan response to these issues in favor of what Baucom calls "cosmopolitan interestedness." *Transfer* literalizes the metaphorical connection across bodies that informs Baucom's work and demonstrates how the bodies of those in the Global North are simultaneously complicit in and vulnerable to a market in biological life that can be resisted only by affirming human connections across nation-state boundaries.

The following chapter, "Capitalism and Wasted Lives in *District 9* and *Elysium*," authored by the editors of this volume, analyzes two films by Neill Blomkamp, applying two concepts used in Marxist critique: humans-as-waste and human rights. The first concept reflects the fact that capitalist production also leads to the production of useless people, waiting, often in vain, to be given a chance to work and earn their living. Although useless in an economic sense, the "waste" has political value for the ruling class. The concept of "human rights," deriving from "natural rights," might be seen as a means of protecting the right of a capitalist to private property and other privileges associated with it. Conversely, the concept of "human rights" can be seen more progressively, as a vehicle to protect the most vulnerable members of society, especially those condemned to the position of "waste" by various historical circumstances, be it capitalism, racism, nationalism, or combinations of these. Blomkamp points to the fact that under neoliberalism a large number of economically redundant human beings are produced and that their human rights are jeopardized by the way neoliberal states work. The authors also draw attention to the way Blomkamp uses different styles to add satirical edge or drama to his films and in particular his focus on the single protagonist, the hero who acts a savior, against the masses of useless people.

The next chapter is concerned with one of the most popular and ac-claimed SF films of the postmodern era: *The Matrix* (1999) by the Wa-chowski brothers. Tony Burns observes that its postmodernity obscures the fact that it also lends itself to a Marxist critique. Consequently, very little has been written about *The Matrix* from the standpoint of Marxism. His chapter is structured around a discussion of six themes, namely appearance and reality; science and technology; consumer society; nihilism and eth-ics; media society; and education and emancipation. Burns argues that it is Marxism rather than postmodernism that allows us to understand these issues. The chapter notes the existence of different variants of Marxism, including the critical theory of the Frankfurt School. It also points to the significance of the ideas of Guy Debord. In response to Lewis Call, who has claimed Debord for postmodern anarchism, Burns draws attention to the importance that in *Society of the Spectacle* Debord attaches to the ideas of the young Marx, especially his concept of alienation. The chapter concludes with a discussion of the possible contribution that works of science fiction film like *The Matrix* can make to efforts to transform society.

In "Representation of 'Gaming Capitalism' in *Avalon* and *Gamer*," Ewa Mazierska also approaches some of the problems tackled in *The Matrix*. She discusses the economic, political, and social system represented in two films, *Avalon*, a Polish-Japanese production directed by Mamoru Oshii, and *Gamer*, a Hollywood movie directed by Mark Neveldine and Brian Taylor. By drawing on the work of Marx and a number of post-Marxist thinkers, such as David Harvey, Ulrich Beck, Michael Hardt, Antonio Negri, and Melinda Cooper, Mazierska argues that *Avalon* and *Gamer* amplify certain traits of neoliberal capitalism, specifically the proliferation of gaming and the application of digital technologies and biomedical research. She sees these traits as catalysts of class divisions that also distract people from the vicissitudes of their true condition. At the same time she points to the fact that the different circumstances of production of these two films affect their respective tone. The future in *Avalon* comes across as less bleak than in *Gamer*, which might testify to the fact that Poles and Eastern Europeans,

following the failed experiment of state socialism, are more positive about neoliberal capitalism than their Western counterparts.

"Immaterial labor" is the main concern in Alfredo Suppia's chapter, "Remote Exploitations: Alex Rivera's Materialist SF Films in the Age of Cognitive Capitalism." The first film discussed by Suppia, *Why Cybraceros?* (1997), is a mockumentary based on the American Bracero Program put in practice during World War II. This short film remixes the 1940s American policy for foreign workers with the ideals of home-office working and remote technology, devising a tragicomic dystopia in which Mexican laborers are exploited in their own country. *Sleep Dealer* enhances this dystopia in a 2008 science fiction feature film. Regarded as a kind of Latin American *Matrix*, *Sleep Dealer* sets out further debates on alienation, global capital, and particularly American imperialism, and the impact of technology on everyday life and social relations. It does so by depicting a future in which telepresence diligently serves capital, thus making the human body a commodity. *Sleep Dealer*'s Marxist orientation, with certain realist aesthetics, its anti-imperialist discourse, and its focus on identity in a globalized world, likens Rivera's film to a number of contemporary world SF productions that are more author-oriented, with "moderate" budgets in a more cosmopolitan or transnational context, such as Michael Winterbottom's *Code 46* (2003), Neill Blomkamp's *District 9* (2009), and Alfonso Cuarón's *Children of Men* (2006).

In the last chapter, Mariano Paz continues the exploration of Latin American SF, focusing on a rarely studied phenomenon: the Latin American zombie film. Drawing on Marxist theory of social stratification, he argues that, whereas the figure of the zombie in Anglophone cinema has often been read as an allusion to the working classes and the proletariat, in contemporary Latin American films they can be better understood as a representation of the lumpenproletariat. Following recent developments in the concepts of class and labor by Marxist thinkers such as Zygmunt Bauman, Michael Hardt, and Antonio Negri, Paz discusses the dystopian impulse that lies behind Latin American films dealing with devastating

zombie outbreaks. Analyzing zombie films from Argentina and Cuba, such as *Juan de los Muertos* (*Juan of the Dead*, 2011), by Alejandro Brugués, and the *Plaga Zombie* trilogy, codirected by Pablo Parés and Hernán Sáez (1997, 2007, and 2012), Paz argues that these creatures can be interpreted through notions such as "human waste" and "multitude." The chapter concludes that the films, both through their conditions of production and through the narrative and visual strategies they present, subvert conventional representations of the zombie and offer a perceptive criticism of dominant neoliberal discourses.

Ambivalence and inner contradictions are traits highlighted in many chapters of this book. Such characteristics can be indicative of the richness of Marx's legacy on the one hand and the heterogeneity and complexity of the science fiction genre on the other. All authors in this collection draw attention to the relation between the character of the future world painted by the filmmakers and the world in which they operate. They all show that the future in science fiction works is never imagined "freely," but extrapolated from what is experienced here and now. In this sense they follow Marx, who presented both unrestrained capitalism (very much like today's neoliberalism) and communism as, in a sense, being already "there," rooted in his time. As the editors of this volume we hope that in criticizing capitalism in its different versions the chapters help, even in a small measure, to imagine a different, socialist future and encourage the readers and ourselves to work toward achieving it. This is one reason why we give it the title *Red Alert*: we want to warn readers of the dangers of accepting capitalist economic structures and ways of life, and especially in its extreme version of neoliberalism.

Notes

1. However, the relation of science fiction to science is a topic attracting significant controversy. See Parrinder 1979.
2. The literature on non-American science fiction is rapidly growing. See, for example, Rottensteiner 1979; Griffiths 1980; McGuire 1985; Fritzsche 2006.

3. Seo Young Chu considers science fiction as a mode of representation rather than a genre. Chu explains she prefers the word "mode" because it is more expansive and less determinable than the word "genre" (2011: 73). According to this author, "Science fiction, being 'modal,' can assume a variety of 'external forms'—electronica, concept art, prose fiction, film, architecture, etc.—while remaining recognizably science-fictional throughout" (2011: 73–74). The idea of "mode" and the quality of "modal" implies a more flexible, expandable, and adaptive framework for a theoretical approach to science fiction, beyond the more conventional "genre" theory. Furthermore, the idea of "mode" seems to better fit the approach to science fiction as a regime of representation.

References

Andrew, Dudley. 2006. *An Atlas of World Cinema*. In *Remapping World Cinema: Identity, Culture and Politics in Film*, ed. Stephanie Dennison and Song Hwee Lim, 19–29. London: Wallflower.

Badiou, Alain. 2012. *The Rebirth of History: Times of Riots and Uprisings*. London: Verso.

Baxter, John. 1970. *Science Fiction in the Cinema*. New York: A. S. Barnes & Co.

Bould, Mark. 2009. "Introduction: Rough Guide to a Lonely Planet, from Nemo to Neo." In *Red Planets: Marxism and Science Fiction*, ed. Mark Bould and China Miéville, 1–26. London: Pluto.

Chu, Seo Young. 2011. *Do Metaphors Dream of Literal Sleep: A Science Fictional Theory of Representation*. Cambridge, Mass.: Harvard University Press.

Cooper, Melinda. 2008. *Life as Surplus*. Seattle: University of Washington Press.

Csicsery-Ronay, Istvan Jr. 2003. "Marxist Theory and Science Fiction." In *The Cambridge Companion to Science Fiction*, ed. Edward James and Farah Mendlesohn, 113–24. Cambridge: Cambridge University Press.

Freedman, Carl. 2009. "Marxism and Science Fiction." In *Reading Science Fiction*, ed. James Gunn, Marleen S. Barr, and Matthew Candelaria, 120–32. London: Palgrave Macmillan.

Fritzsche, Sonja. 2006. "East Germany's 'Werkstatt Zukunft': Futurology and the Science Fiction Films of 'defa-futurum.'" *German Studies Review* 29 (2): 367–86.

Griffiths, John. 1980. *Three Tomorrows: American, British and Soviet Science Fiction*. London: Macmillan.

Gunning, Tom. 2000. *The Film of Fritz Lang: Allegories of Vision and Modernity*. London: BFI.

Hardt, Michael, and Antonio Negri. 2000. *Empire*. Cambridge, Mass.: Harvard University Press.

Hardt, Michael, and Antonio Negri. 2006. *Multitude: War and Democracy in the Age of Empire*. London: Penguin.

Harvey, David. 2005. *A Brief History of Neoliberalism*. Oxford: Oxford University Press.

Harvey, David. 2006. *The Limits to Capital*. New and fully updated ed. London: Verso.

Harvey, David. 2010. *A Companion to Marx's Capital*. London: Verso.

Harvey, David. 2011. "Feral Capitalism Hits the Streets." *Counterpunch*, August 12–14. www.counterpunch.org/2011/08/12/feral-capitalism-hits-the-streets/. Accessed June 18, 2013.

Irzykowski, Karol. 1982. *Dziesiata Muza oraz Pomniejsze pisma filmowe*. Krakow: Wydawnictwo Literackie.

Kouvelakis, Stathis. 2008. "The Crises of Marxism and the Transformation of Capitalism." In *Critical Companion to Contemporary Marxism*, ed. Jacques Bidet and Stathis Kouvelakis, 23–38. Leiden: Brill.

Kuhn, Annette. 1990. "Introduction: Cultural Theory and Science Fiction Cinema." In *Alien Zone: Cultural Theory and Contemporary Science Fiction Cinema*, ed. Annette Kuhn, 1–12. London: Verso.

LeGuin, Ursula. 1994. *The Dispossessed*. New York: HarperCollins.

Lyotard, Jean-François. 1991 [1988]. *The Inhuman*. Trans. Geoffrey Bennington and Rachel Bowlby. Cambridge: Polity.

Marx, Karl. 1965 [1887]. *Capital: A Critical Analysis of Capitalist Production*, vol. 1. Moscow: Progress Publishers.

Marx, Karl. 1967 [1885]. *Capital: A Critique of Political Economy*, vol. 2, *The Process of Circulation of Capital*. Moscow: Progress Publishers.

Marx, Karl. 1966 [1894]. *Capital: A Critique of Political Economy*, vol. 3, *The Process of Capitalist Production as a Whole*. Moscow: Progress Publishers.

Marx, Karl. 1973 [1953]. *Grundrisse: Foundations of the Critique of Political Economy*. Trans. Martin Nicolaus. London: Penguin.

Marx, Karl, and Frederick Engels. 1947. *The German Ideology, Parts I and III*. New York: International Publishers.

Mazierska, Ewa. 2004. "Polish Cinematic Dystopias." *Kinema: A Journal for Film and Audiovisual Media*. Fall. www.kinema.uwaterloo.ca/article.php?id=77&feature. Accessed May 5, 2013.

Mazierska, Ewa, and Eva Näripea. 2014. "Gender Discourse in Eastern European Science Fiction Cinema." *Science Fiction Studies* 1 (41): 163–80.

McGuire, Patrick L. 1985. *Red Stars: Political Aspects of Soviet Science Fiction*. Ann Arbor: UMI Research Press.

Nagib, Lúcia. 2006. "Towards a Positive Definition of World Cinema." In *Remapping World Cinema: Identity, Culture and Politics in Film*, ed. Stephanie Dennison and Song Hwee Lim, 30–37. London: Wallflower.

Näripea, Eva. 2010. "Aliens and Time-Travellers: Recycling National Space in Estonian Science-Fiction Cinema." *Studies in Eastern European Cinema* 1 (2): 167–82.

Parrinder, Patrick. 1979. "Science Fiction and the Scientific World-view." In *Science Fiction: A Critical Guide*, ed. Patrick Parrinder, 67–88. London: Longman.

Penley, Constance. 1991. "Time Travel, Primal Scene, Critical Dystopia." In *Close Encounters: Film, Feminism and Science Fiction*, ed. Constance Penley, Elisabeth Lyon, Lynn Spigel, and Janet Bergstrom, 63–92. Minneapolis: University of Minnesota Press.

Pohl, Fredrik, and C. M. Kornbluth. 1953. *The Space Merchants*. New York: Ballantine.

Rottensteiner, Franz. 1979. "European Science Fiction." In *Science Fiction: A Critical Guide*, ed. Patrick Parrinder, 203–26. London: Longman.

Santesso, Aaron. 2014. "Fascism and Science Fiction." *Science Fiction Studies* 1 (41): 136–62.

Shohat, Ella, and Robert Stam. 1995. *Unthinking Eurocentrism: Multiculturalism and the Media*. London: Routledge.

Sontag, Susan. 1994. "The Imagination of Disaster." In Sontag, *Against Interpretation*, 209–25. London: Vintage.

Suvin, Darko. 1979. *Metamorphoses of Science Fiction.* New Haven, Conn.: Yale University Press.

Xavier, Ismail. 1997. *Allegories of Underdevelopment: Aesthetics and Politics in Modern Brazilian Cinema.* Minneapolis: University of Minnesota Press.

Žižek, Slavoj. 2001. *Krzysztof Kieślowski between Theory and Post-Theory.* London: British Film Institute.

1

First Contact or Primal Scene

Communism Meets Real Socialism Meets Capitalism in Early Czechoslovak Science Fiction Cinema

PETRA HANÁKOVÁ

The loosening of political control over Czechoslovak cinema in the beginning of the 1960s not only fostered the gradual emergence of the so-called New Wave, known for highly modernist and demanding films, but also significantly enriched the array of popular genres in film production of the time, bringing to the fore genres so far absent from the Czech and Slovak cinematic output. Sci-fi films, especially films picturing the theme of space travel—so topical in the post-Sputnik and even more specifically in the post–Vostok 1 period—are a case in point. Barrandov studios considered the theme of space travel a political and aesthetic priority since the late 1950s[1] and managed to produce two films picturing space and time journeys already in the early 1960s: the first was *Muž z prvního století* (*Man from Outer Space*; literally "Man from the First Century"), directed by Oldřich Lipský in 1962, followed by *Ikarie XB 1* (*Icarus XB 1*), directed by Jindřich Polák, released in Czechoslovakia in 1963, and a few months later distributed also in the United States in a partially reedited version under the title *Voyage to the End of the Universe* (Jack Pollack, 1963).[2] These two remain the only Czech films that depict people traveling into space.[3]

East vs. West

Both films center around the motif of first contact—the primal encounter of the human race with an alien civilization—but both diverge from their original and also generic aim to reflect on another confrontation: the direct encounter of humanity with itself in different stages of political and cultural development. Socialist sci-fi on the semantic level hence clearly references the political subtext or political unconscious that Fredric Jameson refers to as "the outlines of some deeper and vaster narrative movement in which the groups of a given collectivity at a certain conjuncture anxiously inter-rogate their fate, and explore it with hope or dread" (Jameson 1982: 148). *Man from Outer Space*, as a light satirical comedy, uses the framework of space and time travel mainly to satirize the relics of un-socialist behavior in its contemporary, that is, socialist society; *Icarus XB 1*, in existentialist dramatic form, deals with the fundamental questions of humanity, scruti-nizing human behavior in the critical situation of crossing the boundaries of the known universe. Paradoxically, while thematically central, the pri-mal contact is itself invisible and hence visually and narratively displaced in both films—in *Man from Outer Space*, it is only casually mentioned in the opening narration, while in *Icarus XB 1*, the film ends just before the very moment of contact with the alien civilization. The motif of first contact is made even more problematic in the latter film by the changes in the U.S. distribution version—especially by the ending where the alien planet is rep-resented by the instantly recognizable skyline of Manhattan, suggesting it might actually be Earth or its "space double."

In this chapter, I want to argue that the metaphor of first contact is used in these post-Sputnik films only as a displaced and displacing stage for an-other encounter, of both geopolitical and trans-historical character. This displacement is inherently connected to the link between space and time (travel) that is in many ways fundamental for cinema itself—as Constance Penley claims, film is the perfect medium for science fiction, as it has "the properties of a time machine, it lends itself easily to time travel stories, one of the staples of science fiction literature." Paradoxically, she states (the ar-

ticle was written in 1991), there is a surprisingly small number of time-travel stories in Hollywood cinema, which is "more drawn to conquering space and fighting off alien invaders than thinking through the heady paradoxes of voyaging through time" (Penley 1991: 66). I want to argue that in socialist sci-fi, a specific type of time travel is actually often shown as a necessary component (or a phase) of space travel, and even as a prerequisite for successful progress toward the final contact with another civilization. Time travel mediating an encounter with the history of humanity forms a particular version of a geopolitical "primal scene"—as we shall see, to reach full maturity (i.e., to meet the aliens), the socialist East has to both encounter the West, but also, and more importantly, to inspect its own history and contemplate less advanced historical and political eras of its own society.

One of the working hypotheses of a conceivable comparative analysis of the "Western" (or, more specifically, Hollywood) and "Eastern" sci-fi could thus be based in their different relation to space and time as feasible grounds for diverging definitions of the political (as seen in the opposition between the motifs of conquest/defense/space versus progress/emancipation/time). The scope of this text does not allow me to embark on such a broad comparative study, and my focus will remain on two particular Czechoslovak sci-fi films exploring progress and historical emancipation of humanity on the borders between time and space travel. But the complex temporal and political references in both films have broader implications for the intricate history of differences in Western and Eastern imagination of the future.

"Exporting" the conflicts between East and West (or socialism and capitalism) into space was a rather typical narrative strategy in science fiction of the second half of the twentieth century. Czech literary scholar Vladimír Macura has found a similar strategy when he examined in detail the discourse surrounding a real event, the flight of the first Czechoslovak astronaut, Vladimír Remek. Remek participated in the international Soyuz 28 Soviet mission in March 1978 and spent a week onboard the Soviet space station Salyut 6, an achievement that was heavily publicized, mythologized, and semiotized in Czechoslovakia as an apex of brotherly cooperation in the socialist bloc. Macura's findings can also be quite illustrative for our

analysis of the works of fiction. He claims that the space exploration in the East since its beginnings reflected an agonic mode of social functioning[4] and hence was fully defined by a competition with the West (and the United States specifically). Significantly, in the first few years, the East was winning this contest on all fronts:

> The first artificial satellite orbiting the Earth (Sputnik, 1957), the first flight manned by two astronauts (Nikolajev/Popovich, 1962), the first woman in space (Tereshkova, 1963), the first crew of three (1964), the first walk in space (Leonov, 1965), the first interconnection of space ships (1969), etc. Every flight became a new sign of the advantages of socialism, each signaling a victory in new and new contests [with the West]. (Macura 2008: 215)

Macura points out that the sportive competition in fact masked "an irreconcilable conflict of the two worlds, 'capitalism' and 'socialism,' 'West' and 'East,'" yet at the same time the ideological frameworks of the Soviet bloc placed the socialist ventures into space decidedly within the semantic field of "peaceful advancement" (Macura 2008: 216). Gradually, in spite of the declared enmity between East and West, the USSR also managed to incorporate within the umbrella of peaceful collaboration the growing contacts with U.S. space researchers (starting openly with the first joint Apollo–Soyuz Test Project space flight in July 1975).

The narrative of "pacifist advancement" had an internal propagandistic logic to it: Soviet "peaceful cosmic research," turning progressively to international cooperation within (mostly) the Eastern bloc, was from the start presented in opposition to "militarily oriented" and thus archaically colonialist U.S. explorations. One of the contemporaneous newspaper reactions that Macura quotes explicitly states this rationale: "At the times when the socialist countries harvest the fruits of international cooperation in space research for the whole world and favor peace, science and progress, the United States of America continue experimenting with the neutron bomb" (Macura 2008: 216). Peaceful scientific progress in the East versus military

pursuits of the West became a staple binary opposition in the Soviet propagandistic imagination of the "two worlds," and as Sputnik turned into a surprising triumph of the USSR and at the same time into "the most stunning technological embarrassment of the times" for the United States (Penley 1991: 205), the West and capitalism began to be pictured in the socialist bloc as outmoded ("exploitative"), barbaric ("imperialist"), and hence overpowered, defeated by the technological, cultural, and political advancement of the socialist East. This created a powerful semantic code, a potent binary opposition for staging the encounter between the two worlds in socialist sci-fi films.

Space explorations as pictured in the socialist sci-fi films thus both showcase contemporary achievements of Soviet science and metaphorize the idea of historical and political progress. Yet throughout the 1950s, at the beginning of the era when "the world literature and film diligently benefits from increased interest in the future of mankind" (V.Š. 1962: 2), sci-fi film still remains mainly an American and Japanese genre. Soviet sci-fi literature was only slowly shrugging off the "close aim" dogma of the so-called Фантастика ближнего прицела ("fantastic fiction of the nearest frontier"), the cultural guidelines of the time stating that the future was to be preferably imagined "realistically" within the reach of the audience, typically in the short span of the five-year plan.

The genre of communist utopia was established only toward the end of the 1950s with Ivan Efremov's novel *Andromeda* (1957), which catalogued the model communist society. The reviewers of *Man from Outer Space* repeatedly mention the difficulties that socialist filmmakers faced when they jumped on the sci-fi bandwagon—for example recounting the troubles Dimitrij Bogolepov, the author of early documentaries about Soviet astronauts (*Snova k zvezdam/Снова к звездам*, 1961, *Stellar Brothers—From the Kremlin to the Cosmos/Звёздные братья*, 1962), faced when trying to keep the films up to date with the frenetic pace of the current developments in technology and astronautics (Bonko 1962: 18). One of the models for "utopist" or "utopistic" films[5] from the socialist bloc often mentioned at the time in reviews became the Polish–East German coproduction *Der Schweigende*

Stern (*First Spaceship on Venus*, dir. Kurt Maetzig, 1960)—yet most reviewers admit that the genre is tricky and the results of the socialist productions are so far not fully satisfactory.[6]

Muž z prvního století: Back to the Past I

Man from Outer Space, perhaps from today's perspective rather unexpectedly (as it is formally a rather conventional light comedy with only a few "cardboard" special effects), was considered a breakthrough. It was awarded the yearly prize of the Czechoslovak film critics as the best film of 1961[7] and hailed by reviewers as a way out of the generic impasse (one reviewer openly stated: "We go our own way with this genre" [Pitterman 1963: 13]). To understand the reasons for this, let me quote a lengthier but very illustrative passage from an article published by Pavol Branko, reviewer for the daily *Práca*. Branko states that after World War II, sci-fi films abound, both in East and West, but often fail to use the full potential of the genre. While Eastern and Western sci-fi differ ideologically and philosophically, the reviewer finds many similarities between them:

> They are swamped with jealous admiration for future technological advancements, while they imagine the people of the future in surprisingly conservative ways. The films are populated with people of our times, with mental horizons of our era, in which there is 'one world and yet there are two worlds'. . . . Czechoslovak cinema in this sense presents a milestone with *Man from Outer Space*. . . . Its approach to the future is new—instead of an obsequious veneration of "American technology" people from modest conditions usually display, there is a critical, indulgent irony toward the people of the future that haven't extricated themselves from this dwarfish approach to technology. This film . . . concerns itself with depicting the cosmic *psychological* distances man would have to traverse over those 500 years. The main hero, our contemporary, does not share anything with the descendants of the human race, not even language—although they all speak Czech. They do not understand each other, even if

they use the same words and phrases. This paradox is used by the authors to make the spectators fully realize that *to live to see a communist society and to really become a member of a communist society are two very different things.* (Branko 1962: 5; emphasis added)

This review points to some of the foundational contradictions inherent in socialist sci-fi. On the one hand, the official ideology in the whole Soviet bloc presented technological progress and the so-called "scientific-technological revolution" as "a ticket for the train heading right to the communist tomorrow" (Adamovič and Pospiszyl 2010: 32), with firm belief that advances in technology and science will necessarily lead to a fundamental transformation of society. Yet the vision of this transformation and the resulting advent of communism remained surprisingly vague both in the practical guidelines of Marxism-Leninism and in the original Marxism (where it is defined mostly by gradual emancipation that unleashes full freedom of the individual—pictured at its most radical in the freedom to choose one's occupation in different hours of the day—as in Marx's *German Ideology* [1845]). But one of the most important aspects that characterizes the classical prospect of communism (and links it closer to sci-fi) is the temporal complexity of its awaited emergence.

As Marx famously claims in *The German Ideology*: "Communism is for us not a state of affairs which is to be established, an ideal to which reality [will] have to adjust itself. We call communism the *real* movement which abolishes the present state of things. The conditions of this movement result from the premises now in existence" (Marx 1845). In this reading, communism emerges out of the present state of affairs (and is hereby already implied in them), and at the same time abolishes the very conditions of its own emergence. Thus it can exist only as a negation of the present, as becomes further obvious in "Private Property and Communism": "[Communism] is the riddle of history solved and knows itself as the solution" (Marx 1844). This definitiveness and finality links the foresight of communism to older versions of solutions for the "riddle of history," namely the long tradition of social utopias. Yet the very concept of utopia, according to contempo-

rary Marxists, is significantly transformed by the idea of inevitable progress toward communist society, being shifted from its etymological roots (*ou topos*, no place, nowhere) into the sphere of possibility and "functionality":

> Marcuse argues that, in the middle of the twentieth century, utopia remains an impossible dream only to those theorists who use the concept of "utopia" to denounce certain socio-historical possibilities. Every significant advance in wealth, technology and science extends the boundaries not only of the real but of the possible, of the ways this newly won potential can be realized. Today's production of goods and knowledge, together with accompanying skills, have transformed the utopias of an earlier time into practical alternatives to our everyday existence. (Ollman 1977)

As Ollman insists, in the classic Marxist view of communism, the possibility of social change is already embedded in the existing social structures—and Marx only envisioned the new arrangements by extrapolating from the present conditions, believing that the effects of the (inevitably approaching) revolution are fully foreseeable through a critical analysis of the here and now:

> Marx constructed his vision of communism out of the human and technological possibilities already visible in his time, given the priorities that would be adopted by a new socialist society. . . . Projecting the communist future from existing patterns and trends is an integral part of Marx's analysis of capitalism, and an analysis which links social and economic problems with the objective interests that incline each class to deal with them in distinctive ways; what unfolds are the real possibilities inherent in a socialist transformation of the capitalist mode of production. It is in this sense that Marx declares, "we do not anticipate the world dogmatically, but rather wish to find the new world through the criticism of the old." (Ollman 1977)

Envisioning communism here implies a specific type of analytical work, an intense dissecting or "working through" the present. This necessarily turned

into a double-edged sword, as the belief in progress and organic change of society had to clash with the experiences of life under real socialism. Socialism, while thought of as a transitory, hence imperfect phase of the road toward communism, didn't seem to bring the society closer to the "end of history" devoid of all the remains of the past. Yet socialism was the only "real" horizon of experience, and communism remained only a project of the future. All visions of communism as a utopia thus have a certain degree of naïveté in them and in a way simplify the image of the future man, which makes it difficult to present a communist society in fiction other than in an ironic mode. By the 1960s, many artists understood this rather clearly. Significantly, Jan Fišer, one of the authors of the original story for *Man from Outer Space*, admits that he intended to keep the scenario "fully apolitical. There is not one word about communism. It was already obvious at the time that communism is only a fairytale for idiots" (Adamovič and Pospiszyl 2010: 183). In a similar vein, Juráček complained when brainstorming for *Icarus IB 1*: "*Der Schweigende Stern, Небо зовет* [*Battle Beyond the Sun,* M. Karyukov, Alexandr Kozyr, 1959] and *Я был спутником солнца* [*I Was the Sputnik of Sun*, Victor Morgenstern, 1959] are all undoubtedly idiotic precisely because their protagonists embody the ideals of the future, communist man" (Juráček 2003: 49). Yet, as we will see, both films have a clear political message that follows the official Marxist dogmas, and the authorial position in either case did not manage to significantly problematize them.

Man from Outer Space enters into a critical dialogue with both the genre of socialist sci-fi and with the threat of dehumanization of the future man. Technological progress is not the main focus of the movie anymore—it is the mental, psychological growth of mankind toward the communist mindset that redefines citizenship and endows familiar words with new meanings.[8] The film takes place in the year 508 "after Sputnik," suggesting that with the first step into space, humanity entered a wholly new era that profoundly changed the horizon of human experience and in which the worldwide victory of communism became not utopia or distant future, but a logical, inevitable development within the reach of contemporary people. Other socialist films place the advent of the new world order even closer:

While *Man from Outer Space* cautiously situates the abolition of money to the third century after Sputnik, *Der Schweigende Stern* predicts the victory of communism already in 1970.

The idea of organic social progress allows the films to stage historical advancement as a drama of encounter between two worlds and several temporalities. Moreover, this encounter is again played out as a primal scene, in a broader Freudian sense, as the fantasy of a subject's own origin—only in being confronted with the traumatic scenes of its (political) origins can mankind fully recognize and value its real, advanced status. Humanity parades before itself in this confrontation, posing in different phases of its political awareness. In classic Marxist terms, it emerges from a primitive, exploitative (i.e., capitalist) system into a still imperfect socialist period, tainted by remnants of previous eras, and hence figuring only as a transitory stage on the journey toward communism, which is pictured in these films as the credible present condition. While depicting space and time travel, the films do not concern themselves with time and space paradoxes typical for sci-fi literature, presupposing a straightforward conception of social and political progress. Using the vantage point of the "future present"—in both cases supposedly communist, or at least markedly "post-capitalist"—society, the concern of the films is the actual lived "socialist present" as a prerequisite of the future developments. Fredric Jameson, in his classic study of the notion of progress in sci-fi literature, analyzes this turn toward the present, imagining it as a virtual "past" in the following terms:

> SF does not seriously attempt to imagine the "real" future of our social system. Rather, its multiple mock futures serve the quite different function of transforming our own present into the determinable past of something yet to come. It is this present moment—unavailable to us for contemplation in its own right because the sheer quantitative immensity of objects and individual lives it comprises is untotalizable and hence unimaginable . . . —that upon our return from the imaginary constructs of SF [it] is offered to us in the form of some future world's remote past, as

if posthumous and as though collectively remembered. . . . SF thus enacts and enables a structurally unique "method" for apprehending the present as history, and this is so irrespective of the "pessimism" or "optimism" of the imaginary future world which is the pretext for that defamiliarization. (Jameson 1982: 152–53)

Both contemporary reviews and later analyses of *Man from Outer Space* and *Ikarie XB 1* notice this paradoxical twist between imagination of the future and the reflection of the present. In the case of the *Man from Outer Space*, according to a recent study by Ivan Klimeš, "'The other' (the future) serves for de-masking 'the real' (the present)," yet at the same time, the hero is both from the present and "a representative of the other world in the real world" (Klimeš 1999: 110). The reviewer I. Vlha states more straightforwardly that "the movie has something to say mainly about contemporary people," as its main character "represents us—the people from the first century, he hasn't grown up yet for his future" (Vlha 1962: 4); in the case of *Icarus*, the review in the newspaper *Práca* claims there is on the contrary "too much future, too little about the present" (Hořejší 1963: 5). The reviewer identified only by initials "J.Š." takes the time paradoxes even further, claiming that the authors started by asking, "What would people who lived 500 years before us think [when confronted with the present times], how they would be amazed by the present," and transposed this idea 500 years in the opposite direction—to the future (J.Š. 1962: 2). According to yet another reviewer, Josef "returns to the future with all the sins and bad qualities of contemporary men" and becomes, "with his soul of a man from 1962, a monster, a bizarre object of scrutiny, a museum piece" (V.Š. 1962: 2).

Man from Outer Space starts on "Rocket Plant" in Strakonice (a small city in southern Bohemia), where a new prototype of spaceship is being tested and prepared for its first flight. The carpenter Josef, who is evidently more of a slacker and profiteer than a model of socialist discipline, is called to fix the defective upholstery on the spaceship, but being drunk, he by accident pushes the start button and launches the rocket into space. Voiceover nar-

ration informs us that Josef landed on a planet inhabited by creatures "similar to people" who sent him back, providing him with an advanced power source and a guide whom he named Adam. Adam lacks any emotions and "reads" reality only via math formulae, and Josef plans to use this ability for his own advantage, suggesting that Adam can help him to win a lottery or to calculate "a formula for making money" so that he won't need to work anymore. As they return to Earth, five centuries have gone by, and Josef is confronted with a communist society in which money has been abolished and everyone works for free to their full potential because it makes them happy and is in turn freely provided with goods according to their needs (following the classic communist credo "From each according to one's abilities, to each according to one's needs"). Josef is examined by the cosmopsychologist Eva and diagnosed with hypertrophied sense of ownership and "egotistidis," while Adam studies human emotions and love, deciding that love is unique ("because there is no formula for it") and humanity is worth the secrets of advanced technology he is bringing to Earth. Josef is finally confined to a mental hospital, where the doctors believe they can cure his egotistidis, but he prefers to run away and return to the Earth of his century. The film ends with a voiceover warning the contemporary audience: "Be vigilant, as he is returning to you."

The film stages an encounter of Josef with communist society, in which, as one of the operators claims almost with nostalgia, "one prefers to chop the onions oneself, as there is no suffering and so no other reason to cry." We are told that long ago, socialism has triumphed "even in Luxembourg," money and private ownership have been abolished, and the "first [i.e., the twentieth] century" is only documented in the Museum of Ancient Countries. Josef finds in this museum precisely what he has been missing—cigars, liquor, a "bossy" briefcase he sees as a symbol of status, and even a "gentlemen's only" magazine. At the same time, he is also confronted with a darker side of his times, presented first with a comic twist, as a confused robotic teacher explains to a group of school kids that cars were "used for car accidents" and weapons were "toys people played with before the full disarmament." When later complaining about the progress to the scientist

referred to as the Academic ("What happened to humanity? You do not even know what money is, what is assertiveness, what is life, enjoyment, you have no sense for status and social position? Do you even know what does it mean to be human? What do all your possibilities mean, if they belong to everyone?"), Josef has to face a much darker vision of the twentieth century, presented by a documentary footage of wars, explosions, and destruction projected on spherical screens in the Academic's study. As the footage ends with images of dead bodies, the Academic proclaims that fortunately there were enough people already in the first century who saved life for humanity, which brings them back to the beginning of the conversation that started with Gorky's dictum "*Man*—how proud does it *sound*." For Josef, this quote is only one phrase in his arsenal of clichés he overuses ad nauseum; for the Academic, it obviously presents a part of the "functional history" that determined progress toward the present. The conflict between the "proud" and generous future man and the mercenary, materialistic man of the past is played out in terms of misunderstanding in the following conversation: "What do I get for it?" asks Josef when he is told to work, only to get an unexpected reply: "You will enjoy it, it is useful. Do you not want to do anything, don't you want to live? I do not understand you at all."

Josef fails to understand from the first moments they land back on Earth: first he declares in an almost colonial gesture that he feels like Columbus exploring the unknown, although he still believes he is coming back to his century. Then he assumes they have landed "abroad," as he cannot recognize the future Earth and later openly asks if it is East or West, so that he "knows how to act." His personal credo, "If you have money, you can do anything you want," is completely invalidated in the new society, and his attempts to turn the researchers against each other by gossip and manipulation fail. He doesn't understand that his compulsive need of social climbing through obsequiousness has no power in society without the system of subordination (when he asks the Academic, "Who is above you?" he gets the literal answer, the person whose office is above them on the next floor). Josef fails to understand both the new and the "old" times. Adam, on the contrary, in his "alien" innocence, learns to understand ("calculate") human love and

finds it unique ("It makes me happy that I got to know people"). His stance toward Josef completely changes and he refuses to obey his companion anymore: "You are not a human being. I will report home that your formula is no longer valid on Earth." Josef presents the essence of the literary and film type of the "little Czech," juxtaposed with the advanced, "perfected" men of the future. Interestingly, one of the reviewers doesn't want to accept Josef as representing contemporary people and complicates the temporality of *Man from Outer Space* even further: "How primitive is his thinking and inner life, how much has the world changed during a few hundreds of years. . . . But he is not one of us . . . he is not from our century. Today's common man is still a bit self-centered, a bit sly, but he is not anymore only selfish and only sly without any other qualities" (V.Š. 1962: 2). Another reviewer even expresses his belief that the "fist of the working class" would in reality intervene and reckon with Josef in the socialist present: "Workers in any factory would show for sure Josef his place" (Soeldner 1962: 269).

Ikarie XB 1: Back to the Past II

The big budget film *Icarus XB 1* was distributed under the generic label "spaceship drama." Loosely based on Stanisław Lem's novel *The Magellanic Cloud*, it takes place in the year 2163, when the eponymous spaceship is traveling to the Alpha Centauri system in search of life. The spaceship functions like a little city, with several research labs, but also a gym, cafeteria, leisure room, and cinema-like videoconference space at disposal for the astronauts. The journey is long and tedious, and most of the crew are afraid of losing their families, as they will age in space much slower than people on Earth. The modernist, glossy interiors of the spacecraft, designed in the "Brussels style" (popular after the success of Czechoslovak design at Expo 58), are juxtaposed with the specifically nostalgic feel that comes from both the astronauts and the objects they brought along. The 110-year-old scientist Anthony travels always with an obsolete robot, Patrick ("I have had it for 80 years, he always flies with me"), another astronaut brings a large piano, and the women on the crew soon start "missing skirts" and make themselves

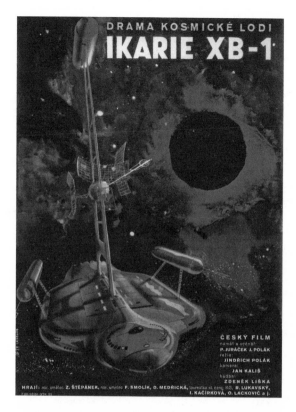

The poster for *Ikarie* presents it as a "Drama of a Cosmic Ship."

dresses for the ball (again very traditional, in a way "retro-futuristic")[9] that they organize for Anthony's birthday.

The crew is clearly international (as the names reveal—there is, for example, Anthony Hopkins, Vladimir Abajev, and Eric Svenson), yet the nationality of the astronauts is never taken up as a theme: all of them speak Czech, and all geopolitical conflicts were supposedly solved by the victory of communism. There has been no contact yet with an alien civilization, as the Earth is supposedly in the "backcountry of the universe." Icarus travels to the White Star in the Alpha Centauri system because the scientists presuppose it has life. They conduct a series of experiments on the way, but also expect to verify that it is possible for humans to give birth in space, as one member of the crew, Štefa, is pregnant. The expedition hence promises not only the possibility of first contact, but also a primal birth and the

implicit future promise of "populating" and conquering space by peaceful colonization.

Before reaching their aim, the crew has to be confronted again with a primal scene, meeting humanity in less advanced stages. In the moment when the spaceship is almost paralyzed with boredom, cabin fever, and the psychical wear of the crew, they encounter another spaceship, first believing it to be an alien vessel. Two explorers are sent to the rocket, and cameras on their helmets transmit to a television screen on the main board of Icarus. They find out the spaceship is from the Earth, determining it to be "a prehistoric vessel" from the twentieth century ("There are cigars, glass, papers, women wear jewelry," reiterates one of the researchers regarding "the emblems" of the time). Everybody on the vessel is dead, killed by a deadly poisoned gas called "Tigger Fun" (misspelled in the original), which the computer identifies as "a clean weapon" of the past. As all objects onboard are intact, the spirit of the twentieth century is conserved here again as in a museum (one of the astronauts actually says that this "job would better suit an archeologist"). The scene becomes gradually intelligible—as the spaceship was running out of oxygen, the commanders first murdered the crew with gas to survive longer but then killed each other in the final struggle. "These are . . . these were . . . people! We found people! We discovered the twentieth century!" exclaims one of the researchers first. But as the deadly events become self-evident, they gradually distance themselves from the visual signs of the "primitive" twentieth century visibly determined as the West—by money, alcohol, clothing that indicates social hierarchies, and, last but not least, lethal weaponry, including nuclear missiles. It is these at the end which explode, killing the two astronauts from Icarus and destroying the memory of the predatory, deadly, exploitative history of humanity. In the following dialogue between the ship captain and one of his deputy commanders, the captain claims that he wouldn't have sent his people on the mission had he known they would find only humans:

Deputy: Humans . . . They were our ancestors.
Captain: Not them. Definitely not them.

Deputy: You can't choose your own ancestors.

Captain: You know who they were? Human trash. That left Auschwitz, Oradour and Hiroshima behind them. The twentieth century . . .

Deputy: Do you know this? [Playing a tune on the piano] Honegger.[10] Also the twentieth century.

Two images of the twentieth century are thus juxtaposed: the barbaric, destructive force of the "Western" powers, and the refined, cultivated, cultural tradition that not only created masterpieces, but also stood firmly against war and produced artworks that actually mourn the grim fate of humanity at the time of armed conflicts. It is not unlike the Gorky quote used in *Man from Outer Space* to represent the "good" tradition of the ancestors, and classical music here validates the past as still instructive for the (future) present.

This message is significantly complicated in the U.S. distribution version, where most of the confrontation with the past is edited out (as well as the "first birth" subplot), so that the main conflict remains the subsequent mental collapse of one of the operators, Michal, who cannot bear the pressure of

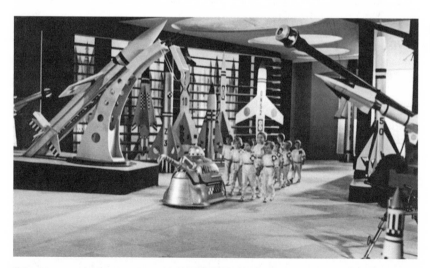

"The Museum of Ancient Countries" harbors weapons from the twentieth century, but also status symbols, alcohol, and glossy magazines.

uncertainty and isolation and also suffers from radiation poisoning emitted by a dark star they cross before reaching their goal. This motif is already present in the original version—just before the first contact, the radiation slows down all biological functions of the crew and puts everyone into a forced hibernation. Before falling asleep, the commander expresses hope that they will wake up again on the other side of the star and he decides to continue their journey. Protected by the shield of the White Planet, they indeed wake up safely and head toward the contact—and as they do, Michal is cured of his delusions ("There is no Earth, Earth has never existed!"), a child is born and hailed as a new member of the crew, and the White Planet appears on the transmission screens. In the Czech version, we see a non-specific infrastructure of an alien city, while the U.S. version replaces it with the clearly recognizable skyline of Manhattan. This is supposed to create, according to the authors, a "Planet of the Apes" type of twist, suggesting that Icarus is actually an alien ship and the White Planet is really the Green Planet: Earth.[11]

While the changes were primarily intended to obscure the political references of the original and to make the film more accessible to American audiences, the slapdash alteration renders the narrative trick of the "mistaken planet"[12] unconvincing and the resulting message comes across as rather bland. While the Icarus crew is not supposed to be the perfect international society of the future anymore, there are not enough indications as to who they really are and what the first contact will actually mean for humanity. We can only speculate about the implied meaning of this version: these might be humans traveling to a parallel universe, or an uncannily similar alien society, and the resemblance to the human race can only be misleading. In any case, we do not have any reliable information about the purpose of their flight anymore—they can be invaders, body snatchers, or other similar figures of the standard American sci-fi imagination. If we take the interpretation in this direction even further, utopia can easily turn into dystopia and the first contact becomes fully negated in its positive, emancipatory potential. Last but not least, removing the underlying structure of socialist sci-fi (i.e., first contact providing the validation of communism purified

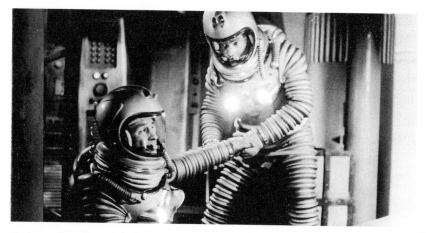

Explorers from Ikarie are about to be killed on board a historic vessel encountered on their journey. The power of the "capitalist" twentieth century remains lethal even in the communist future.

by its encounter with the past) here also reveals that sci-fi in general needs a fundamental ideological structure of some kind to communicate a fully understandable message, if "only" this ideology is a humanistic belief in the uniqueness of the human race and its culture.

Conclusion

As we have seen, the technological optimism of the Eastern bloc brought by the success of the USSR in cosmic research also created the need to reflect on the exploration of space in literary and film sci-fi, originally defined as a "Western" genre. Czechoslovak cinema contributed rather quickly with two films using the framework of first contact with an alien civilization, but significantly digressing from this motif into an examination of the presumed political achievements of humanity on its way to a communist future. The aim of this essay has been to show how these films can be read in relation to the classic Marxist ideas about progress toward communism. The films stage the communist society as an achievable, in fact inevitable realization of the ideal society, and they change the notion of utopia into the belief

in progress and the historical necessity of political change. In their mixed temporality, they stage an encounter of two worlds and two worldviews as the confrontation of the complex present and the one-dimensional, obsolete past, surpassed periods of political development. Socialist sci-fi thus becomes a reflection of the historical change, "the symptom of a mutation in our relationship to historical time itself," picturing "merely the future of one moment of what is now our own past" (Jameson 1982: 149, 151). Socialist sci-fi is thus an important and interesting chapter in the history of the genre, which has always had a remarkable potential for reflecting and exploring the state of society and its political and social structures. A further comparative analysis of the "utopist" and temporal "Eastern" version and "dystopic," spatial, "Western" fantastic fiction could reveal other important facets in imagining the future and experiencing the present.

Notes

1. As Pavel Juráček, the screenwriter of *Icarus XB 1*, writes in his diary on September 26, 1959: "At the [production meeting] . . . we talked about the technical demands for making an astronautic movie and discussed what Barrandov studios offer for such a project. Šebor [the head of the creative unit] claimed that a film about space travel 'has to be' made at any price. Obviously, it had been already discussed at a meeting of the Central Committee of the Communist Party of Czechoslovakia, and when the Soviet rocket reached the Moon, the 'necessity' of this film even increased. The State Film administration had supposedly high interest in this material and would do anything to start the production of such a film as soon as possible" (Juráček 2003: 60).

2. The U.S. version released by American International Pictures was shortened by several minutes and the story was changed by edits and alternative ending. The film was dubbed and all the names in the title sequence were anglicized (for example, Jindřich Polák became Jack Pollack, and Pavel Juráček changed into Paul Jurist). The new edition of the DVD issued by Filmexport Home Video in 2006 features both the alternative ending and the title sequence in the bonus section. The "westernization" of Eastern sci-fi was not an unusual procedure at the time; another famous example was *Battle beyond the Sun* [*Небо зовет*, M. Karyukov, Alexandr Kozyr, 1959], the "westernization" of which was the first job for which Roger Corman hired Francis Ford Coppola.

3. There are other Czech(oslovak) films picturing first contact, but in all of them aliens arrive on Earth, as in Otakar Fuka'a *Akce Bororo* (*Operation Bororo*, 1972) and *Kam zmizel kurýr* (*Where Did the Courier Go?*, 1981), Oldřich Lipský's sci-fi-parody *Srdečný pozdrav ze Zeměkoule* (*Best Regards from the Earth*, 1982), and Věra Chytilová's sci-fi horror *Vlčí bouda* (*Wolf's Lair*, 1986). *Man from Outer Space* also initiates the genre of

sci-fi and fantasy comedy that later (during the 1970s and 1980s) developed into the "hybrid comedies," a genre that blends past and future visions of society, futuristic technology, and archaic—typically monarchic—political arrangement. Two comedies of this subgenre explore time (but not space) travel paradoxes—*Zabil jsem Einsteina, pánové* (*I Killed Einstein, Gentlemen*, 1968), directed by Oldřich Lipský, and *Zítra vstanu a opařím se čajem* (*Tomorrow I Wake up and Scald Myself with Tea*), directed by Jindřich Polák in 1977. For more on the hybrid comedy and their relation to sci-fi, see Hanáková 2008.

4. Macura uses the term in the sense outlined in Michael Chance's theory of two modes of social functioning, agonic and hedonic, with agonic denoting competitive, aggressive contest (Chance and Jolly 1970).

5. The generic label "sci-fi" was not yet commonly used in the 1960s and the reviewers mostly prefer the title "utopist" or "utopistic" films ("Our times of cosmic flights are perfectly suited for making utopist films"—Bonko 1962); another typical denominator is "vědecko-fantastický," a direct translation of the Russian term "научно-фантастический" (literally, "scientific-fantastic"). Contemporary reviews of *Man from Outer Space* also often use the label "post-Sputnik comedy," refraining from calling it either utopist or sci-fi, or even describe it as just a "good socialist comedy" (Bonko 1962; Anonymous 1962). For a detailed analysis of generic labels used for Czechoslovak sci-fi films in the 1960s and 1970s, see Batistová 2011.

6. For example, Ivan Bonko judges the "German-Polish epic" as "somewhat constrained" (1962). Jan Hořejší in a review of *Ikarie XB 1* asks: "How is it possible that the film authors [both in the West and the East] still fail in their attempts to create an artistically and intellectually compelling film about the conquest of the universe which literally 'agitates our times'? . . . In capitalist productions, this type of film turns more and more markedly into 'horrors'—terrifying stories about intergalactic wars or sinister invasions of monsters from faraway galaxies. And Soviet films of this genre, as well as the German-Polish *First Spaceship on Venus,* although made with good intentions, are all drowned in superficial descriptiveness" (Hořejší 1963: 5).

7. Interestingly, 1961 is also the year of Karel Zeman's *Baron Prášil* (*The Fabulous Adventures of Baron Munchausen*), a fantasy film based on a Gottfried Bürger novel and visually inspired in its combined live action and animation technique by the engravings of Gustav Doré. The hero of this fantastic reverie is also an astronaut named Toník, who travels to the Moon only to find it already populated by literary heroes (Verne's space travelers, Cyrano de Bergerac, and Munchausen).

8. The same thematic gesture can be found in *Icarus IB 1*. Jiří Pitterman states this clearly: "*Icarus* wants to introduce the people of the future and align them with the present state of humanity," and further explains that in contemporary sci-fi, the focus is not the technology anymore, but "the man is the question" (Pitterman).

9. The retro-futuristic or even futuro-archaic ambience is a paradoxical part of the sci-fi imagination. It is embedded here already in the film title and in the mythological name of the eponymous spaceship Icarus; similarly, the same futuro-archaic gesture appears in the title of Stanley Kubrick's *2001: A Space Odyssey* (supposedly influenced by *Icarus XB 1* (see the links to DVD reviews in the bibliographic section).

10. Namely, he is playing the introduction to the oratorio *Le Roi David* by Arthur Honegger (1921).

11. See the bonus materials and interviews on the DVD. This is also commented on in more detail by the review of *Closely Watched DVDs*; see above.

12. This narrative trick or device, the arrival or return to the "mistaken planet," appears in a number of films and TV series—including *El Moderno Barba Azul* (Boom in the Moon, 1946), *Planet of the Apes* (1968), and also episodes of *The Twilight Zone* and *Battlestar Gallactica*. I'd like to thank Alfredo Luiz Suppia for reminding me of this. V.Š. 1962. "Muž z prvního století." *Zemědělské noviny* 18 (62) (March 22): 2.

References

Adamovič, Ivan, and Tomáš Pospiszyl. 2010. *Planeta Eden. Svět zítřka v socialistickém Československu 1948–1978* [Planet Eden: The world of tomorrow in socialist Czechoslovakia, 1948–1978]. Prague: Arbor Vitae.

Anonymous. 1962. "Muž z prvního století." *Obrana lidu* 69 (21) (March 22): 5.

Batistová. Anna. 2011. "Fantasicko-dobrodružný nebo utopictický? 'Sci-fi' v domácím filmovém tisku 60. let" [Fantastic-adventurous or utopistic? "Sci-fi" in Czechoslovak film press in the 1960s]. *Iluminace* 23 (3) (83): 53–69.

Bonko, Ivan. 1962. "Veselo o budúcnosti" [Humorously about the future]. *Predvoj* 11 (6) (March 15): 18.

Branko, Pavel. 1962. "Ako by sme sa vynímali o 500 rokov" [How we would look 500 years from now]. *Práca* 13 (4): 5.

Chance, Michael, and Clifford J. Jolly. 1970. *Social Structures of Monkeys, Apes, and Men.* London: Jonathan Cape Ltd.

Erickson, Glenn. 2006. "DVD Savant" (review of *Ikarie XB 1*). www.dvdtalk.com/dvdsavant/s1867ikar.html. Accessed July 6, 2013.

Hanáková, Petra. 2008. "The Films We Are Ashamed Of: Czech Crazy Comedy of the 1970s and 80s." In *Via Transversa: Lost Cinema of the Former Eastern Bloc*, ed. Eva Näripea and Andreas Trossek, 109–21. Koht ja paik / Place and Location: Studies in Environmental Aesthetics and Semiotics 7. Tallinn: Eesti Kunstiakadeemia.

Hořejší, Jan. 1963. "Ikarie XB 1: Příliš mnoho o budoucnosti, příliš málo k dnešku" [Icarus XB 1: Too much about the future, too little about the present]. *Práce* 176 (19) (July 25): 5.

"Icarus XB 1 / Voyage to the End of the Universe." 2006. *Closely Watched DVDs. A Guide to Czech Cinema on DVD.* filmjournal.net/czech/2006/09/17/icarus-xb-1-voyage-to-the-end-of-the-universe. Accessed July 6, 2013.

Jameson, Fredric. 1982. "Progress Versus Utopia; or Can We Imagine the Future?" *Science Fiction Studies* 9: 147–57.

J.Š. 1962. "Svět za 500 let" [The world in 500 years]. *Československý svět* 6 (17) (March 22): 2.

Juráček, Pavel. 2003. *Deník 1959–1974* [The diary, 1959–1974]. Praha: Národní filmový archív.

Klimeš, Ivan. 1999. "Jiné světy" [Other worlds]. In *Hranice (ve) filmu* [Borders in/of film] by Václav Kofroň. Praha: Národní filmový archiv.

Macura, Vladimír. 2008. *Štastný věk (a jiné studie o socialistické kultuře)* [Cheerful times and other studies about socialist culture]. Praha: Academia.

Marx, Karl. 1844. "Private Property and Communism." *Marxist Internet Archive Library.* www.marxists.org/archive/marx/works/1844/manuscripts/comm.htm. Accessed July 6, 2013.

Marx, Karl. 1845. "German Ideology." *Marxist Internet Archive Library.* www.marxists.org/ archive/marx/works/1845/german-ideology/ch01a.htm. Accessed July 6, 2013.

Ollman, Bertell. 1977. "Marx's Vision of Communism." *Dialectical Marxism.* www.nyu.edu/ projects/ollman/docs/vision_of_communism.php#1. Accessed July 6, 2013.

Penley, Constance. 1991. "Time Travel, Primal Scene, Critical Dystopia." In *Close Encounters: Film, Feminism and Science Fiction,* ed. Constance Penley, Elisabeth Lyon, Lynn Spigel, and Janet Bergstrom, 63–81.Minneapolis: University of Minnesota Press.

Pitterman, Jiří. 1963. "Ikarie XB 1." *Kino* 15 (18): 13.

Sobchack, Vivian. 1991. "Child/Alien/Father: Patriarchal Crisis and Generic Exchange." In *Close Encounters: Film, Feminism and Science Fiction,* ed. Constance Penley, Elisabeth Lyon, Lynn Spigel, and Janet Bergstrom. Minneapolis: University of Minnesota Press.

Soeldner, Ivan. 1962. "Muž z prvního století." *Film a doba* 62 (5): 269.

Spigel, Lynn. 1991. "From Domestic Space to Outer Space: The 1960s Fantastic Family Sit-Com." In *Close Encounters: Film, Feminism and Science Fiction,* ed. Constance Penley, Elisabeth Lyon, Lynn Spigel, and Janet Bergstrom, 204–35. Minneapolis: University of Minnesota Press.

Vlha, I. 1962. "Súčasný film z budúcnosti" [Contemporary film from the future]. *Večerník* 87 (6) (April 12): 4.

2

Soviet and Post-Soviet Images of Capitalism

Ideological Fissures in Marek Piestrak's
Polish-Estonian Coproductions

EVA NÄRIPEA

Between the late 1970s and early 1990s, the Polish director Marek Piestrak collaborated with Tallinnfilm, the main Estonian film studio, on three films, all of which share an orientation toward the fantastic—*The Test of Pilot Pirx* (*Test pilota Pirxa / Navigaator Pirx*, 1979), as a science fiction film featuring an interplanetary journey; *Curse of Snakes Valley* (*Klątwa Doliny Węży / Madude oru needus*, 1987), as a fantasy adventure with sci-fi elements; and *Tear of the Prince of Darkness* (*Łza księcia ciemności / Saatana pisar*, 1992), a horror/detective story. While excluded from the "pantheon" of Polish cinema as "the Ed Wood of Eastern Europe," on closer examination Piestrak's Polish-Estonian coproductions reveal intriguing ideological stances that reflect the inherent paradoxes of the late Soviet and early post-Soviet eras just as well as the works by celebrated Polish (and Estonian) auteurs. Although rejected by both Polish and Estonian film establishments—*Curse of Snakes Valley* was voted by the Polish film critics one of the ten worst Polish films of all time in 2002—the audience attraction seems to be unceasing, as testified by remarkable box office results (for instance, upon its release, *Pirx* was seen by millions of people across the Soviet Union and Eastern bloc), regular reruns on Polish and Estonian television, DVD releases, and retro-

spectives at film festivals. Cued by this persistent popularity, this chapter seeks to investigate the ideological positions informing Piestrak's fantastic universes.

As evident from Terry Eagleton's work, ideology is a rather elusive notion. Eagleton lists at least sixteen currently relevant definitions of ideology (Eagleton 2007: 1–2). For the purposes of this chapter, ideology is understood in Althusserian terms, as "material sets of social practices" (Philips 2005: 87). In Slavoj Žižek's interpretation of Althusser, "ideology does not grow out of life itself, it comes into existence only in so far as society is regulated by state" (Žižek 1995: 20). Following Marx, Althusser contended that the economic base or the infrastructure of the capitalist system determines a two-level superstructure. The first is "the State [that] is explicitly conceived as a repressive apparatus . . . a 'machine' of repression, which enables the ruling classes . . . to ensure their domination" (Althusser 2001: 138), and which encompasses police, the courts, the prisons, the army, "the head of State, the government and the administration." The second, in addition to this Repressive State Apparatus (RSA), is what Althusser identifies as Ideological State Apparatuses (ISAs): church, the educational system, family, legislation (also affiliated with the RSA), the political system, trade unions, communications (press, radio, television, etc.) and culture (144). The ISAs, contrary to the RSA, which is single and operates in the public domain, are multiple, belong to the private domain (145), and are apparently nonpolitical (Philips 2005: 88). Moreover, while the RSA functions predominantly by repression and only secondarily by ideology (of the ruling class), the ISAs function chiefly by ideology, but also secondarily by repression "even if ultimately . . . this is very attenuated and concealed, even symbolic" (Althusser 2001: 146). These apparatuses promote forms of ideology that serve the interests of the ruling class and sustain the capitalist hegemony (Philips 2005: 88). Drawing in part on Althusser, Slavoj Žižek proposes that "ideology" can be understood along three axes: first, "as a complex of ideas (theories, convictions, beliefs, argumentative procedures); second, ideology in its externality, that is, the materiality of ideology, Ideological State Apparatuses; and third, the most elusive domain, the 'spontaneous' ideology at

work at the heart of social 'reality' itself" (Žižek 1995: 9). Thus, while striving to appear unified, the terrain of ideology is actually scarred by hidden limits, silences, gaps, and elisions, which in Pierre Macherey's view could be revealed in literary (but also by extension cinematic) texts (Macherey 1978, cited in Eagleton 2007: 46; see also Jorgensen 2009).

The following analysis traces the representations of these material sets of social practices, the manifestations of the IRA and the ISAs in Piestrak's above-mentioned Polish-Estonian coproductions. In particular, I concentrate on ideological stances related to commodity culture, colonialism, nationalism, and gender, identifying Piestrak's apparent attitudes and possible targets of critique. Even though *Pirx* and *Snakes Valley* were made under Soviet rule, I demonstrate that their critical commentaries on capitalism equally addressed the Soviet social practices and communist hegemony. While the Cold War pitted the two global "superpowers" against each other in an irresolvable ideological confrontation, the idea that the capitalist USA (and the West in general) and the communist Soviet bloc in fact shared a number of similarities (e.g., on alienation of labor, see Roberts and Stephenson 1968; on consumerism, see Reid 2002; on suppression of dissenting opinions, see Harvey 2001: 90–107; on passive masses, see Wayne 2005: 27) has been repeated by so many scholars that it has become common knowledge. Moreover, perhaps even more importantly to the discussion at hand, the Soviet system was riven by severe, and ultimately fatal, internal contradictions, conflicts between the rhetorically endorsed Marxist principles and the less than perfect everyday realities of "crude communism" (Marx 1977: 95), not to mention the totalitarian and imperialist *Realpolitik*. Added to this are Soviet ethnic/national policies which on the one hand called for an international unity and persecution of "bourgeois nationalists," and on the other hand promoted ethnic idiosyncrasies in the form of folk songs, material culture, and so forth (e.g., Martin 2001).

In addition to the above mentioned Marxist thinkers, this investigation employs David Harvey's discussions of global capitalism to suggest that Piestrak's films betray signs of the emerging neoliberal world order. Since ideology is firmly situated in social practices, I consider these filmic texts

and their ideological manifestations in the historical context of their production, taking into account both the changing sociopolitical circumstances and industrial conditions.

Shifting Contexts: Society and Film Industry

Pirx is based on the short story "Trial" (*Rozprawa*, 1967) from Stanisław Lem's so-called Pirx cycle, *Tales of Pirx the Pilot* (*Opowieści o pilocie Pirxie*). Set in an Anglophone hemisphere sometime in the twenty-first or twenty-second century, it is a story about a top-secret mission, publicly announced as a space flight around Saturn to test new automatic probes for passing through the Cassini Division. This is only a pretext, which masks the true nature of the operation, namely, testing a new kind of crew—robots, who are described by their makers as "almost ordinary humans." The film was made on the brink of a deepening economic, political, and social crisis. In the early 1970s Poland was opening up to the West under the leadership of Edward Gierek, and the standard of living shot up in the Soviet bloc in general but perhaps especially so in its western peripheries, such as Poland and Estonia, where "consumer communism" flourished for a short while. In Poland, in the aftermath of the world oil shock of 1973, which put an abrupt end to the large-scale borrowing from American and West German banks that Gierek had initiated as part of his new economic program, the short-lived abundance of commodities was replaced with the economics of chronic shortages. Due to a downturn in the economy and an upsurge in political corruption, combined with rapid increases in prices, especially of basic foodstuffs, public discontent in Poland quickly escalated, leading to a nationwide wave of strikes in 1976.[1] Meanwhile in Estonia, closer to the Russian metropole, social stagnation took its toll, culminating in another wave of intensified Russification at the end of the decade, after Karl Vaino, a Russified Estonian "absolutely loyal to . . . the conservative Kremlin line" (Kasekamp 2010: 152), took the leadership of the Estonian Communist Party in 1978. Shortages of consumer goods, accompanied by the poor quality of what little was produced in the Soviet Union, made Western commodity

culture all the more desirable (and in the western border zone, such as the Baltic states, also relatively more accessible) (Kasekamp 2010: 157).

Snakes Valley is an Eastern European Indiana Jones–type story with sci-fi elements, set in Paris and Indochina principally in the mid-1980s, where various groups and individuals chase an Oriental amphora containing a cryptic extraterrestrial force, a key to global domination. By the time of the film's production, the Soviet bloc had entered an era of national liberalization, leading to the fall of communism in Poland in 1989 and the ultimate collapse of the Soviet Union, and the reestablishment of the Estonian nation-state, in 1991. On the background of increasing economic deterioration, severe shortages of consumer goods and various social instabilities, Eastern Europe was experiencing a period of historical "truth-digging" and heightened nationalistic sentiments, which in Estonia took the form of the Singing Revolution.

Prince of Darkness is a mystery-horror film, set in Tallinn on the eve of World War II, about a Polish writer known for her curious accounts on an amber ring, which grants its owner the invincible powers of the Satan. Tallinn becomes a battlefield for agents of German, Russian, and Estonian origin, all of whom are after the ring and its promises of global supremacy. By the time the film premiered in 1993/1994, the culmination of the euphoria over national emancipation and the probing of historical traumas had started to wane, and the harsh realities of transition from communism to capitalism had a somewhat sobering effect.

The Soviet film industry of the Brezhnev era was characterized by a conscious emphasis on the production of genre films, in pursuit of mass appeal equal to or exceeding that of Western European and American productions that reached the Soviet screens, but still not losing track of the strategic role of cinema as a tool of enlightenment and indoctrination. According to studies conducted in the 1960s and 1970s, the Soviet audiences indeed expected "films . . . filled with spectacle, simple and conventional in form, and populated by sympathetic and good-looking characters" (Faraday 2000: 57). In economic terms, major reforms were initiated in the Soviet film industry in the mid-1960s, which redefined spectators as consumers and films as

commodities (First 2008: 324–26). In Poland, while commercial aspirations are sometimes deemed as alien to the Polish "idiom" (e.g., Skwara 1992), a notable trend of commercialization has been detected in Polish film industry in parallel to the Soviet one, spurred in part by the country's economic rapport with the West (Mazierska 2012: 496) and in part by the desire to emulate the box office success of Western entertainment cinema (Haltof 2002: 111). The historical ferment of the second half of the 1980s coincided with further commercialization of the output on the one hand and a marked increase in films about past and present atrocities on the other, accompanied by abolishment of censorship, diversification of funding schemes, and decentralization of production models. The early 1990s witnessed a state of confusion, with the old industrial standards falling apart and the new ones not yet fully established. It also appears that filmmakers were disoriented by newly found creative freedom, as well as shocked by market pressures, and unable to fulfill the heightened expectations of audiences and critics alike (see, e.g., Mazierska 2007).

Pirx, as well as the subsequent *Snakes Valley*, is an example of cultural cooperation within the Soviet bloc that "was strongly endorsed and facilitated" by central cinema authorities (Iordanova 2003: 21). Although collaboration with East Germany and Czechoslovakia as two major Eastern European producers of entertainment cinema (see, e.g., Fritzsche 2010; Pospíšil 2008) was considered, the Soviet Union was most likely chosen as a coproduction partner by the Polish Committee of Cinema due to under-fulfilled coproduction plans, another peculiarity of the Soviet "planning economy" (see Mazierska 2010). The republican studio of Estonian SSR, Tallinnfilm, was the best match for Piestrak's Polish film unit Pryzmat, due to the enthusiasm and professionalism of its staff, as well as the relatively "Western" look of the modern cityscape of the republic's capital city of Tallinn, which offered readymade locations and interiors for creating some of the futuristic settings of *Pirx*'s Anglophone universe.[2] The pleasant coproduction experience led to further cooperation with *Snakes Valley*, which was also partly shot in Tallinn (this time on a soundstage), although the location shooting was done mainly in Vietnam and Poland. Piestrak returned to Estonia even

after the collapse of the Soviet Union; *Prince of Darkness* was not only set in Tallinn but also shot entirely in Estonia. In addition to Tallinnfilm and Zespół Filmowy "Oko," Russian company Eskomfilm was involved as its distribution partner.

One Critique, Two Targets

Pirx, just as Piestrak's Soviet oeuvre in general, is torn between two oppositional forces. On the one hand, there is the "official" ideology as enforced and endorsed by the communist RSA and the ISAs; on the other hand, there is the "spontaneous ideology" or "counter-ideology," which in the Soviet bloc perhaps most clearly manifested in various types of resistance to the RSAs and ISAs, ranging from political dissidence to national or religious divergence, to Aesopian denunciations of the "system" and its practices, and to emulation or, more precisely, unfulfilled appetite of Western lifestyle. In the films, the "top-down" ideology is most obvious in the apparently critical commentaries on certain Western, that is, capitalist social conditions, business practices, and policies. For instance, *Pirx* displays the corporate world in an unmistakably negative light. In the film, the United Atomic Laboratories, a corporation commissioned by Cybertronics to develop a new line of "non-linear" robots for space missions, is a rather brutal organization headed by a dictator-like figure driven by pure greed, with little if any concern for the potentially disastrous ramifications of their invention. At the same time, UAL's boss, in his dark brown military-style suit, is a spitting image of Stalin, as familiar to Soviet and Eastern European audiences from his official portraits. Moreover, he resides in a Mediterranean villa, featuring a stylized historicist interior with empty white walls, dark oversized doors, and paneled ceiling that not only create an authoritarian atmosphere but follow the classicist idiom favored by twentieth-century totalitarian leaders. UAL's ruthless capitalist business practices are underlined by the use of "faceless" mechanical mobsters who, importantly, fail to accomplish their assignment of killing Pirx. The "facelessness" of these figures could be read as a covert reference to the unifying tendencies of Soviet national and

cultural politics, which strove to amalgamate the diversity of its constituent ethnicities into a uniform Russo-Soviet blend—the Great Soviet Family. In this reading, their inability to liquidate Pirx is also symbolic of the impotence of the (Soviet) RSA in conquering its adversaries. In principle, the UAL provides a composite image, and hence critique, of the Althusserian Repressive State Apparatuses in the Soviet bloc *and* demonic capitalism. Hence for contemporary Eastern European audiences, the failures and moral corruption of the UAL most likely resonated with the shortcomings of the Soviet system at large, testifying of a "counter-ideology" at work. For the Soviet watchdogs, however, they evinced the ultimate rottenness of the capitalist West.

At first sight, in *Pirx* the interests of both private enterprises and national governments are contained and presumably balanced by transnational institutions such as the United Nations and UNESCO, which above else stand for the common concerns of "humanity" as a whole, safeguarding its culture, science, and education. At the same time, despite the apparently noble motivations of these supra-national organizations, this arrangement anticipates the neoliberal world order, where national governments have lost part of their authority to the powerful pan-national institutions. The corporations, too, notably in the business of potentially catastrophic biotechnology, appear to have worldwide, if not interplanetary, aspirations, promoting thus the impression of global capitalism. *Snakes Valley* permits a similar reading, although it offers a far more sinister view of the world, one dominated by ambitions of various forces striving to acquire global control, without a single even apparently stabilizing power in sight. The unnamed Parisian institution, a state agency supposedly responsible for national security, is presented in a way that leaves little doubt about its totalitarian disposition and imperialistic aspirations. As such, parallels with Soviet authorities, especially with the secret service, and their intentions are quite obvious. Among other things, such a representation testifies to the political liberalization in both Poland and the Soviet Union at the time the film was made. The loosening of censorship permitted rather sharp criticism of the Soviet RSA, even if still in a roundabout manner, via a set of capital-

ist analogies. The figure of Bernard Traven also suggests a critique of the corrupted RSA, as this antihero is a retired soldier who collaborated with various shady regimes in Africa and is notorious for art smuggling. As argued above, this film, too, reveals traces of the burgeoning neoliberal world order, as the state security agency has contracted a private firm to conduct top-secret military research, in this case examining the contents of an extraterrestrial cube hidden in an oriental vase. According to David Harvey, such privatization of functions that formerly belonged to the public domain is a symptom of "accumulation by dispossession," characteristic to neoliberal capitalism (Harvey 2005: 159–61). Another symptom of neoliberalization is the movement of (ecologically) harmful activities away from the (Western) centers, exemplified in the film by the decision of the French secret service to continue the examination of the extraterrestrial cube on the distant Mataiva atoll in the Pacific Ocean. Moreover, rather than applying brutal force publicly, the secret service operates primarily "behind the scenes," thus resembling "shadowy and secretive" (Harvey 2005: 50) organizations crucial to the neoliberal world order, such as the International Monetary Fund and the World Bank. At the same time, the late Soviet coercive apparatus functioned in a rather similar manner, privileging indirect means of "persuasion" over public confrontations and persecutions.

Consumerism and Women as Commodities

While these issues belong chiefly to the force field of the RSA, also in terms of struggles to resist it, the question of consumerism could be identified as related first and foremost to a certain "counter-ideology" stemming from the social "reality" (although manifesting also on the axis of the ISAs, such as media, as well as in party politics), which in the Soviet bloc was, among other things, one of continuous shortage of consumer goods. Soviet authorities acknowledged the crucial need to contain these unsatisfied consumer desires; hence providing living standards comparable to those in the capitalist West and creating better conditions of consumption became a firm part of official Soviet rhetoric as early as in the 1950s (Reid 2002: 212). Over

the subsequent decades, and in particular during the Brezhnev era, the struggles to define the fine line between "norm and excess in consumption," pitting against each other "vivid depictions of good living and urgent warnings against acquisitiveness," manifested in literature as well as cinema, where "the visual pornography of goods, which often featured in stories of modern life . . . was [especially] alluring and powerful" (Chernyshova 2011: 231). In *Pirx*, the spectacle of Western material culture, which played a central role in the film's mass appeal, appears, at least on the narrative level, to chime with its critique of the technophilic urban culture of this futuristic Anglo-American universe, as suggested by the ultimate conclusion of the film—that the technologically intricate cyborgs might be superior to humans in terms of intellect and physical strength, but the lack of human weakness renders them imperfect and even dangerous. By extension, the capitalist society that gave birth to these monsters is deemed undesirable as well.

The protagonist, Pilot Pirx, a hero with whom the audiences are unmistakably invited to identify, appears to be somewhat detached from this urban consumer culture. His natural habitat belongs to two opposite spheres—the mountains where he hikes for leisure and the outer space where he works, both of which, in their turn, could be contrasted with the earthly sphere of commodities. Although driving a flashy red Ford Mustang and sporting trendy jeans and a denim jacket, he is openly skeptical toward the potential benefits of robotic workforce. Equally, he first encounters the mechanical "hit-men" of UAL in a shopping mall, which by association acquires a somewhat sinister air, further emphasized by a jittery score and anxiously jolting camera. He is also more or less indifferent, perhaps even slightly resentful of the displays of conspicuous consumption on offer there, glancing almost scornfully at the rows of crystal vases (a significant status symbol in the Soviet bloc) and passing the invitingly gleaming neon signs with utter aloofness. The same is perhaps true of the go-go dancers performing in the nightclub, where Harry Brown, one of the crew members of the mission, receives Pirx's phone call. Pirx's avoidance of this site of deca-

Pilot Pirx in his Ford Mustang. (Film Archives of the National Archives of Estonia)

dent display of bodies once again serves to distance him from the imagined capitalist "hegemony" it refers to.

Notably, these two scenes also function to create a mental bridge between consumer objects and women as commodities. Especially in the club sequence, the somewhat mechanical tenor of the soundscape, complemented by almost robotic gestures of the go-go girls, highlights the objectifying impulse of this nexus. On the one hand, the fact that the film assigns women the role of low-skilled workers, basically servants, providing erotic enjoyment and, on a few occasions, professional assistance to mostly highly qualified and/or powerful men corresponds to the officially endorsed Soviet view. This view was based on Engels's famous discussion on the subordination of women in *The Origin of the Family, Private Property, and the State* (1884), that women are oppressed under capitalism and subjected to fundamentally unequal gendered division of labor, in opposition to the (Soviet) communist system that promoted women's full participation in the public sphere of work, encouraging them to take on such "masculine" professions as tractor drivers and astronauts. On the other hand, the scarcity and mar-

ginality of female characters in *Pirx* draws attention to the hollowness and hypocrisy of the official Soviet rhetoric, as the contemporary audiences (and subsequent commentators) were well aware of the inherently patriarchal power structures of the "real socialism" practiced in both the "atheist" Soviet Union and the Catholic Poland. Remarkably, one of the female characters, an assistant at the office of Cybertronics, with the most extensive speaking part of all women in the film, is portrayed by Faime Jürno, an Estonian fashion model who gained prominence across the Soviet Union as one of the "supermodels" of *Siluett*, a fashion magazine produced in Estonia and sold in massive quantities all over the USSR. The film's misogynistic streak is further emphasized by a statement by Tom Nowak, the neurologist on board of the spaceship, who confesses to Pirx that he prefers working with men as they are better in containing their emotions. Importantly, Pirx himself, the unmistakably positive hero of the film, is a man of (nuclear) family—an institution directly associated by Engels with gender oppression.

Jan Tarnas and Christine Jaubert in search of the mysterious amphora in the underground temple at Snakes Valley.

The essential masculinity of *Pirx*'s world to come is also underlined by the predominantly cool and monochrome tonality of the production, and especially by the design of the spaceship, the testosterone-saturated interiors of which, according to Piestrak, were modeled on army vehicles (Mazierska 2010).

At first sight, the gender politics of *Snakes Valley* seem somewhat more balanced. In contrast to *Pirx*, *Snakes Valley* presents a female protagonist—Christine Jaubert, a reporter for *France Soir*. On the one hand, she is portrayed as an independent, strong-willed, educated, and resourceful single woman, pursuing her goal of uncovering the secret of the Snakes Valley with admirable eagerness. On the other hand, ending up as a mere instrument in essentially masculine power games disempowers her completely. Even more, in addition to being consistently portrayed in an "overfeminized" mode (wearing strong makeup and provocative outfits), in a number of scenes she comes across as either physically or mentally weak, falling down from a bridge and into an underground pit, and screaming hysterically. While she is a French reporter in the service of what appears to be a French secret service, that is, part of the capitalist RSA, her situation is not that different from her "sisters" in the Soviet bloc, who were equally manipulated by strong patriarchal currents. In this case, Piestrak's version of the archetypal *femme fatale* also testifies to his own unflattering misogyny, perhaps typical of Catholic society. Her character is rendered even more unsympathetic by casting: Ewa Sałacka, a Polish actress notorious for parts in low-reputation genre films, often performing in nude scenes.

Nudity, the ultimate marker of reification of the female body, is even more prominent in Piestrak's final coproduction with Tallinnfilm, *Prince of Darkness*. The heroine of the story, a Polish writer Joanna Karwicka, finds herself in the middle of historical turmoil in Tallinn of 1939, (ab)used by various men who strive to gain control of the world by means of making a deal with the devil. Joanna, like Christine, has little independence, and is saved from being sacrificed to the devil only to enter an institution of lawful subordination, that of a heterosexual monogamous relationship. Again like Christine, she frequently lapses into episodes of agitation and confusion. In

fact, her whole character is based on an Orientalized understanding of female "intuition" and subconscious "knowledge," as opposed to the hero, an Estonian detective named Gunnar Leppikson, who comes across as an epitome of rationality. The narrative is also regularly decorated with scenes of mass nudity, mainly in relation to (visions of) Satanist rituals, where women turn into zombies under the influence of an amber ring allegedly belonging to the devil himself. A central setting of the film is a brothel, another site of female exploitation. While in *Pirx* the displays of female bareness were associated with decadence of foreign capitalism of the future, here the local national past is evoked rather bluntly and unsympathetically. The nudity also testifies to the dispositions of the early 1990s, when filmmakers were still overenthusiastic about projecting onto screens previously censored tropes and images. That said, even more importantly these portrayals of women of the interwar republic resonate with gender conditions of the newly capitalist Eastern European nation-states, where, according to Marion Pajumets, "anti-egalitarian, patriarchal discursive strategies" have remained prevalent (Pajumets 2012: 58–59) and where commodification of women is a publicly accepted stance (Pilvre 2000: 68). Hence, the film reveals that rather than benefitting from regime change, in post-Soviet, neoliberalizing societies women lose a considerable degree of their sense of security: "In many of the ex-communist countries of the Soviet bloc the loss of women's rights through neoliberalization has been nothing short of catastrophic" (Harvey 2005: 170). Finally, the image of naked Joanna on an altar, seconds away from being sacrificed, evokes an idea of cannibalistic capitalism, internalizing "predatory and fraudulent practices" (Harvey 2003: 148).

Cracks in Form

Even if Pirx himself remains relatively immune to the seductions of consumerism, the way the spaces of consumption are represented in *Pirx* demonstrates an undisguised admiration of this high-tech civilization. The camera keeps caressing the smooth surfaces of modernist high-rise buildings with fluid tilts and flashy angles. On several occasions, the music

accompanying these images is remarkably upbeat, even when narrative developments would call for a more somber tone. For instance, in a scene where Pirx is first summoned to UNESCO headquarters to discuss his potential involvement in the secret mission, the music is fairly sanguine, in contrast to the conceivable dangerousness of the planned enterprise. In previous shots, showing Pirx arriving from the mountains to the city, filmed on location in Charles de Gaulle airport in Paris, the camera lingers on the futuristic escalators running in glass tubes for several moments more than necessary from the narrative point of view. The same peaceful and positive score accompanies these images that seem to function first and foremost as a spectacle of exquisite elegance. On the whole, the awe-inspiring representations of Western built environments, the sleek and chic modernist interiors and exteriors, very likely for the contemporary Soviet and Eastern European audiences threw into relief the helplessness of the Soviet-style interpretations of modernist conceptions, providing thus a covert critique of the immediate architectural realities—the Soviet bloc blocks—and, by extension, of the sociopolitical circumstances.

These formal discrepancies, reappearing in a slightly different frame of reference in *Snakes Valley*, as analyzed below, correspond to an idea suggested by Etienne Balibar and Pierre Macherey that "literary productions must not be studied from the standpoint of their unity which is illusory and false, but from their material disparity. One must not look for unifying effects but for signs of contradictions" (Balibar and Macherey 1996: 283). Moreover, Robert Stam, drawing on Christian Metz, argues that in comparison to the novel, which is "a single-track, uniquely verbal medium" (Stam 2000: 60), the

> film's multitrack nature makes it possible to stage ironic contradictions between music and image. Thus the cinema offers synergistic possibilities of disunity and disjunction not immediately available to the novel. The possible contradictions and tensions between tracks become an aesthetic resource, opening the way to a multitemporal, polyrhythmic art form. (Stam 2005: n.p.)

Perhaps it is precisely this multitrack nature that gives Jean-Luc Comolli and Jean Narboni the occasion to talk about "category e,"

> films which seem at first sight to belong firmly within the ideology and to be completely under its sway, but which turn out to be so only in an ambiguous manner. . . . There is a noticeable gap, a dislocation, between the starting point and the finished product. . . . The films . . . throw up obstacles in the way of the ideology, causing it to swerve and get off course. The cinematic framework lets us see it, but also shows it up and denounces it. . . . An internal criticism is taking place which cracks the film apart at the seams. If one reads the film obliquely, looking for symptoms; if one looks beyond its apparent formal coherence, one can see that it is riddled with cracks: it is splitting under an internal tension . . . while being completely integrated in the system and the ideology [such films] end up by partially dismantling the system from within. (Comolli and Narboni 2004: 817)

Comolli and Narboni suggest that many Hollywood (mainstream) films belong to this category, and given Piestrak's determination to emulate Hollywood genres (science fiction in *Pirx*, adventure thriller with sci-fi elements in *Snakes Valley*, and gangster and horror tropes in *Prince of Darkness*), their classification under "category e" is quite appropriate. It is important to additionally recall Umberto Eco's definition of a cult film as a movie that displays a number of contradictory ideas, living "on in and because of its glorious incoherence" (Eco 1985: 4). Indeed, all of Piestrak's films have developed a sustained cult following testified, first and foremost, by recent releases of his films on DVD by the Russian R.U.S.C.I.C.O and the Polish Telewizja KinoPolska in the Best of Polish Cinema (Przeboje polskiego kina) series, as well as reruns of his films on Polish and Estonian TV and several retrospectives at various Estonian film festivals and events, often with the director himself present. Without suggesting that Piestrak's films are in any way politically "progressive" works, the ruptures of their texture undeniably reveal significant social tensions and conflicting vectors

of ideological forces of the late Soviet and early post-Soviet period. That said, the lack of seamless unity on a narrative and formal level (happy ending accompanied by psychological realism), typical of mainstream cinema, does invest Piestrak's oeuvre with a certain revolutionary potential, whether this potential is fulfilled or not.

Colonialism and National Sentiments

Colonialism is an essential component of capitalism, inevitably related to capital's inherent need of accumulation, search of raw materials, and new investment opportunities. Building on Marx and Engels's analyses on British trade in India (Marx and Engels 2001) and its wretched social ramifications, Lenin defined imperialism as the highest stage in the development of capitalism (Lenin 1947), and anti-imperialism became an essential tenet of Soviet ideology. At the same time, in Istvan Csicsery-Ronay Jr.'s words, the science fiction genre is "an expression of the political-cultural transformation that originated in European imperialism and was inspired by the ideal of a single global technological regime" (Csicsery-Ronay 2003: 231; see also Rieder 2008). Drawing on Michael Hardt and Antonio Negri's conceptualization of "Empire" (Hardt and Negri 2000), Csicsery-Ronay goes on to argue that science fiction "has been driven by a desire for the imaginary transformation of imperialism into Empire, viewed not primarily in terms of political and economic contests among cartels and peoples, but as a technological regime that affects and ensures the global control system of de-nationalized communications" (Csicsery-Ronay 2003: 232). From this quote it is also clear that colonialism is inseparably tied to nationalism; hence they will be tackled together.

In *Pirx*, the general impression of the future Earth is transnational, rather typically to Eastern European science fiction films (see, e.g., Näripea 2013). Technology is indeed of central importance in this world-to-come, as the film's key question revolves around artificial life, an assembly-line, durable android workforce, and its potential impact on human culture and existence. Although the narrative suggests that the globe is still divided into

separate states (the Soviet Union and the United States being mentioned in particular) and alliances (e.g., the socialist bloc), these political borders seem rather blurred and porous and in general the film leaves an impression of a globally unified (capitalist) regime, united in an effort to colonize outer space. Significantly, the purposes of space explorations are never explained, and this omission is telling in terms of the ideological naturalization of the colonialist mindset. As in most other aspects of the film, the potential readings can be twofold. On the one hand, the overt object of criticism is the capitalist regime and its voracious appetite for accumulation. On the other hand, for the cinemagoers in the conquered countries of the Eastern bloc, this colonialist thrust undoubtedly brought to mind their own Russian colonial master. Moreover, the obvious idealization of the Western hemisphere, its material culture, and (seemingly) just policies that take into account the voices of various interest groups (trade unions, free press, third sector activists, the church) testify of the desire to be (again) part of that system. Interestingly, the names of some members of the crew sound Central European, such as Tom Nowak and Kurt Weber, signaling perhaps that this geographical region is under the influence (or protection) of Western allies—a state of affairs yearned by many in the Eastern European countries forcibly subjugated to the Soviet regime. Hence, even though at first instance nationalism as ideology is absent from *Pirx*, nationalist sentiments surface to a certain degree when possible reception contexts of the film are taken into account.

While in *Pirx* issues of nationalism and colonialism are rather latent, although still noticeable, in *Snakes Valley* they find a more direct expression, as the main character of the film, Jan Tarnas, is clearly identified as a Pole, and the conflict involves other nationalities as well as alien intruders. Unlike the more or less borderless futuristic Anglophone universe of *Pirx*, *Snakes Valley* features a world divided into Western and Eastern civilizations, represented as France and the former French colonies (French Indochina—Cambodia, Laos, and Vietnam). An attentive viewer notices additionally that the representatives of the French secret service mention the Soviet Union and the United States as the two current superpowers.

The temporal structure of the film is explicitly contemporary, stretching via a flashback from the mid-twentieth century to the last quarter of the century, that is, the time of the film's making, and the spatial skeleton of the diegetic world includes some clearly identifiable locations—primarily the French capital is introduced by means of the unmistakable Eiffel Tower, while the Orient is still portrayed as an abstraction. Instead of the futuristic, urban(ized), high-tech generic Western world, then, *Snakes Valley* presents, on the one hand, the French-speaking heart of Europe as the old and dignified cultural and intellectual hub of Western civilization, and, on the other hand, the colonized Orient as its mysterious, dangerous, and anachronistic Other. The film focuses on an amphora, which conceals a substance of extraterrestrial origin, and has been preserved as a relic in a temple of the eponymous Snakes Valley for centuries. The above-mentioned critique of predatory capitalism—embodied perhaps most literally in the figure of Bernard Traven, calling the monks "slant-eyed monkeys" and exploiting various Third World regimes for personal gain, as well as in the ways of the French secret service and their contract agents—suggests a commentary on not only capitalist colonialism but also the one practiced by the Soviet Union. This parallel is accentuated by the only Russian character in the film, Andrei Buturlin (played by Sergei Desnitski, Pirx in Piestrak's previous film), who is a typical "Orientalist," fascinated with the East, Tibetian philosophy, and yoga in his youth. Poland, meanwhile, appears to be aligned with the colonized Orient. Jan Tarnas, the Polish scholar of Oriental culture, possesses unique information and skills; the Oriental monks serve as protectors of the Earth from the "good and evil, wisdom and power" brought to the Earth by "visitors from distant stars" and stored in the aforementioned amphora. Both Tarnas and the monks are exploited, victimized, and discarded when their value is exhausted by forces belonging to the colonial metropole, who strive to guarantee their colonial grip and expand its reach across the globe. At the same time, the film suggests a certain superiority of the Polish character, a sense of (national) self that positions itself in the very heart of the Western civilization, by association designating its own Russian subjugators as "savage colonizers." This superiority surfaces with particular

Jan Tarnas, the Polish Orientalist, surrounded by his objects of research in *Curse of Snakes Valley*.

clarity in sequences shot in the East. The Laotian government hosting the Western visitors in search of the amphora resembles its Soviet counterpart in terms of material deficit (the ministry owns only one jungle-proof jeep) and careful, suspicious surveillance of the foreign party. The camera (held by Polish cinematographers), somewhat similarly to *Pirx*, curiously observes the exotic Asian environs, but this time the patterns of camera movement are dominated by lateral tracking trajectories, suggesting a master-like tourist gaze, while in *Pirx* upward tilts were in the majority, testifying to the somewhat awestruck admiration of technological marvelousness.

In *Prince of Darkness*, the issues of nationalism and colonial domination are even more prominent, as the post-Soviet situation called for examinations of historical traumas, for which the genre of horror provides perhaps an especially eloquent platform (see, e.g., Kapur 2005). Interestingly, the national past, in particular the interwar Estonian republic, is treated without much sympathy or sentiment, and Tallinn of 1939 is populated by more or

less secretly operating agents of various nationalities—above all, of course, Soviet Russian and Nazi German, but also Estonian—competing, again, in the name of global power, and demonized to practically equal extent. Overall the film betrays anxiety toward both rampant displays of nationalism and the capitalist/postcolonial future, as discussed above. These inclinations are fairly unexpected, considering the general enthusiasm toward national liberation, running in parallel with rather uncritical admiration of the interwar nation state, and the eager embracing of free-market economy and global capitalism—an inherently contradictory combination typical of the post-Soviet condition.

Conclusion

Marek Piestrak's Polish-Estonian coproductions provide fascinating subject matter for a comparative case study on ideological stances in Soviet and post-Soviet Eastern European science fiction cinema. Notably, all three films are torn by contradictory ideological inclinations, offering material for discrepant readings in relation to consumerism, colonialism, nationalism, and gender politics. In *Pirx*, the capitalist technophilic urban culture and its material manifestations (architecture, design, commodities, etc.) are the object of undisguised admiration, yet the film's critique of capitalism's dehumanizing tendencies is articulated by the eventual rejection of the proposed mass production of "nonlinears"—a new low-maintenance humanoid workforce that would facilitate increasing accumulation of capital. While in *Snakes Valley* the predatory character of capitalism is uttered with more clarity and consistency, the film subscribes quite unproblematically to Orientalist discourse, one of the cornerstones of unrestrained Western hegemony and colonialism. *Prince of Darkness*, a post-Soviet horror thriller, contrasts with Piestrak's earlier pieces due to its historical subject matter, yet quite unexpectedly throws unflattering light on the interwar national past and betrays reservations about the reinstated capitalist formation. Without being outright "political" or "progressive" by intention,

all three belong to the "category e" as defined by Comolli and Narboni, revealing some rather telling ideological fissures.

Notes

1. Similar, consumerism-triggered, "potentially regime-shattering popular revolts" of workers took place as early as 1953 in the German Democratic Republic and in Novocherkassk in Russia in June 1962 (Reid 2002: 214).
2. For example, the Viru Hotel, built in the heart of Tallinn in the mid-1970s exclusively for Western tourists, sporting a look that was, according to Piestrak, not only "contemporary, but futuristic, somewhat ten–twenty years ahead of the West" (Mazierska 2010), was one of the main locations for shooting *Pirx*. Notably, the hotel quickly became a hotspot for the Soviet "shadow economy," providing a place of illegal business for prostitutes and black marketeers. Another prominent location with beyond state-of-the-art interiors was found on the Kirov collective fishery farm near Tallinn, arguably the wealthiest of its kind in the USSR (Kasekamp 2010: 156), testifying to the fact that capital translated to a higher standard of living and elegant material culture on both sides of the Iron Curtain.

References

Althusser, Louis. 2001 [1970]. "Ideology and Ideological State Apparatuses (notes towards an investigation)." In *Lenin and Philosophy and Other Essays*, 127–87. New York: Monthly Review Press.

Balibar, Etienne, and Pierre Macherey. 1996 [1974]. "On Literature as an Ideological Form." In *Marxist Literary Theory*, ed. Terry Eagleton and Drew Milner, 275–95. Oxford: Blackwell.

Chernyshova, Natalya. 2011. "Philistines on the Big Screen: Consumerism in Soviet Cinema of the Brezhnev Era." *Studies in Russian and Soviet Cinema* 5 (2): 227–54.

Comolli, Jean-Luc, and Jean Narboni. 2004 [1969]. "Cinema/Ideology/Criticism." In *Film Theory and Criticism*, 6th ed., ed. Leo Braudy and Marshall Cohen, 812–19. Oxford: Oxford University Press.

Csicsery-Ronay, Istvan Jr. 2003. "Science Fiction and Empire." *Science Fiction Studies* 30 (2): 231–45.

Eagleton, Terry. 2007. *Ideology: An Introduction*, new and updated ed. London: Verso.

Eco, Umberto. 1985. "'Casablanca': Cult Movies and Intertextual Collage." *SubStance* 14 (2): 3–12.

Faraday, George. 2000. *Revolt of the Filmmakers: The Struggle for Artistic Autonomy and the Fall of the Soviet Film Industry*. University Park: Pennsylvania State University Press.

First, Joshua. 2008. "From Spectator to 'Differentiated' Consumer: Film Audience Research in the Era of Developed Socialism (1965–80)." *Kritika: Explorations in Russian and Eurasian History* 9 (2): 317–44.

Fritzsche, Sonja. 2010. "A Natural and Artificial Homeland: East German Science-Fiction Film Responds to Kubrick and Tarkovsky." *Film & History: An Interdisciplinary Journal of Film and Television Studies* 40 (2): 80–101.

Haltof, Marek. 2002. *Polish National Cinema*. New York: Berghahn Books.

Hardt, Michael, and Antonio Negri. 2000. *Empire*. Cambridge, Mass.: Harvard University Press.

Harvey, David. 2001. *Spaces of Capital: Towards a Critical Geography*. New York: Routledge.

Harvey, David. 2003. *The New Imperialism*. Oxford: Oxford University Press.

Harvey, David. 2005. *A Brief History of Neoliberalism*. Oxford: Oxford University Press.

Iordanova, Dina. 2003. *Cinema of the Other Europe: The Industry and Artistry of East Central European Film*. London: Wallflower Press.

Jorgensen, Darren. 2009. "Towards a Revolutionary Science Fiction: Althusser's Critique of Historicity." In *Red Planets: Marxism and Science Fiction*, ed. Mark Bould and China Miéville, 196–212. Middletown, Conn.: Wesleyan University Press.

Kapur, Jyotsna. 2005. "The Return of History as Horror: *Onibaba* and the Atomic Bomb." In *Horror International*, ed. Steven Jay Schneider and Tony Williams, 83–97. Detroit: Wayne State University Press.

Kasekamp, Andres. 2010. *A History of the Baltic States*. Basingstoke: Palgrave Macmillan.

Lenin, Vladimir Ilich. 1947. *Imperialism: The Highest Stage of Capitalism*. Moscow: Foreign Languages Publishing House.

Macherey, Pierre. 1978. *A Theory of Literary Production*. London: Routledge and Kegan Paul.

Martin, Terry. 2001. *The Affirmative Action Empire: Nations and Nationalism in the Soviet Union, 1923–1939*. Ithaca, N.Y.: Cornell University Press.

Marx, Karl. 1977. *Economic and Philosophic Manuscripts of 1844*. Moscow: Progress Publishers.

Marx, Karl, and Friedrich Engels. 2001. *On Colonialism*. Honolulu: University Press of the Pacific.

Mazierska, Ewa. 2007. *Polish Postcommunist Cinema: From Pavement Level* (New Studies in European Cinema 4). Oxford: Peter Lang.

Mazierska, Ewa. 2010. "My Great Estonian Adventure: An Interview with Marek Piestrak." *KinoKultura: New Russian Cinema* (special issue 10: Estonian cinema). www.kinokultura.com/specials/10/pirx-interview.shtml. Accessed May 30, 2013.

Mazierska, Ewa. 2012. "International Co-productions as Productions of Heterotopias." In *A Companion to Eastern European Cinemas*, ed. Anikó Imre, 483–503. Chichester: Wiley-Blackwell.

Näripea, Eva. 2013. "Work in Outer Space: Notes on Eastern European Science Fiction Cinema." In *Work in Cinema: Labor and the Human Condition*, ed. Ewa Mazierska, 209–26. New York: Palgrave Macmillan.

Pajumets, Marion. 2012. "Post-Socialist Masculinities, Identity Work, and Social Change: An Analysis of Discursive (Re)constructions of Gender Identity in Novel Social Situations." PhD diss., Tallinn University. e-ait.tlulib.ee/299. Accessed May 30, 2013.

Philips, Deborah. 2005. "The Althusserian Moment Revisited (Again)." In *Understanding Film: Marxist Perspectives*, ed. Mike Wayne, 87–104. London: Pluto Press.

Pilvre, Barbi. 2000. "Taming the Phantom of Feminism in Estonia: Equal Rights and Women's Issues." In *Private Views: Spaces and Gender in Contemporary Art from Britain*

& *Estonia*, ed. Angela Dimitrakaki, Pam Skelton, and Mare Tralla, 60–71. London: Women's Art Library.

Pospíšil, Tomáš. 2008. "The Bomb, the Cold War and the Czech Film." *Journal of Transatlantic Studies* 6 (2): 142–47.

Reid, Susan E. 2002. "Cold War in the Kitchen: Gender and the De-Stalinization of Consumer Taste in the Soviet Union under Khrushchev." *Slavic Review* 61 (2): 211–52.

Rieder, John. 2008. *Colonialism and the Emergence of Science Fiction*. Middletown, Conn.: Wesleyan University Press.

Roberts, Paul Craig, and Matthew A. Stephenson. 1968. "Alienation and Central Planning in Marx." *Slavic Review* 27 (3): 470–74.

Skwara, Anita. 1992. "'Film Stars Do Not Shine in the Sky over Poland': The Absence of Popular Cinema in Poland." In *Popular European Cinema*, ed. Richard Dyer and Ginette Vincendeau, 220–31. London: Routledge.

Stam, Robert. 2000. "Beyond Fidelity: The Dialogics of Adaptation." In *Film Adaptation*, ed. James Naremore, 54–76. New Brunswick, N.J.: Rutgers University Press.

Stam, Robert. 2005. "Introduction: The Theory and Practice of Adaptation." In *Literature and Film: A Guide to the Theory and Practice of Film Adaptation*, ed. Robert Stam and Alessandra Raengo. Kindle ed. Oxford: Blackwell.

Wayne, Mike. 2005. "Introduction: Marxism, Film and Film Studies." In *Understanding Film: Marxist Perspectives*, ed. Mike Wayne, 1–33. London: Pluto Press.

Žižek, Slavoj. 1995. "Introduction: The Spectre of Ideology." In *Mapping Ideology*, ed. Slavoj Žižek, 1–34. London: Verso.

3

Paying Freedom Dues

Marxism, Black Radicalism, and Blaxploitation Science Fiction

MARK BOULD

Blaxploitation is typically seen as a crime and/or action genre, but it did exist in other forms, such as westerns, horror, and fantasy. This essay is concerned with the ways in which nine blaxploitation films draw upon SF's generic capacities to articulate Marxist and black radical thought.[1] Before turning to the contested emergence of blaxploitation in the postcivil rights era, and to blaxploitation SF, we first sketch in some of the complexly inter-woven history of these political traditions,[2] including the use of SF imagery and ideas by a number of key figures.

Marxism and Black Radicalism in the United States

Karl Marx argued that slavery in the United States

> is as much a pivot upon which our present-day industrialism turns as are machinery, credit, etc. Without slavery, there would be no cotton, without cotton there would be no modern industry. . . . Being an economic cat-egory, slavery has existed in all nations since the beginning of the world.

All that modern nations have achieved is to disguise slavery at home and import it openly into the New World. (1982: 101–2)

Furthermore, because "unqualified slavery pure and simple in the new world" enables "the veiled slavery of the wage workers in Europe" (1996: 747), "labour cannot emancipate itself in the white skin when in the black it is branded" (1996: 305). African American abolitionist Frederick Douglass voiced a similar sentiment in his 1892 autobiography:

The white slave had taken from him by indirection what the black slave had taken from him directly and without ceremony. Both were plundered, and by the same plunderers. The slave was robbed by his master of all his earnings, above what was required for his bare physical necessities, and the white laboring man was by the slave system of the just results of his labor, because he was flung into competition with a class of laborers who worked without wages. (2003: 125)

The question of identity and difference implied by such passages—should African Americans be considered no different from other proletarians, or as a distinct group for which orthodox Marxism could not account?—recurs continually at the intersections of Marxist and black radical thought, and has been complicated by the patronizing attitudes, racism, and segregationism found among leftist parties and organized labor, and by the assimilationist, nationalist, anticommunist, and pro-capitalist currents in African American political praxis. Nonetheless, even the Nation of Islam's extremely conservative Elijah Muhammad "was willing to work with veterans of the old left. . . . especially with the staff of *Muhammad Speaks*, which contained a considerable number of Communists and ex-Communists that he hired and long protected" (Smethurst 2010: 84).

Indeed, throughout the twentieth century numerous African Americans were drawn to socialist and communist ideas and organizations. For example, the African Blood Brotherhood for African Liberation and Redemption

(ABB), a secret society formed in New York in 1919, soon affiliated and then merged with the Workers Party of America, the American Communist Party's (CPUSA) *legal* party organization at that time. This did not, however, prevent the queer Jamaican American author and ABB member Claude McKay, soon to be a central figure of the Harlem Renaissance, from dissenting—in *The Negroes in America*, published in the USSR in Russian in 1924, but not in English in the United States until 1979—from the Comintern's view that the cause of African American oppression was solely economic.

Over the years, a number of African Americans, including Cyril Briggs, Lovett Fort-Whiteman, Claudia Jones, Otto Hall, Louise Thompson Patterson, Otto Huiswood, Harry Haywood, Esther Cooper Jackson, James W. Ford, Richard Wright, and Angela Davis, were prominent in CPUSA. The Comintern drove CPUSA's engagement with African American struggles in the 1920s and 1930s, but Stalin's shifting priorities in the 1930s and 1940s saw much of this work abandoned. However, in a series of discussions in 1939 on "the Negro question," the exiled Leon Trotsky recognized why African Americans might see white workers as oppressors, and argued that white workers should be in the forefront of struggles against Jim Crow and for African American self-determination (see Trotsky 1967). His interlocutor, the Trinidadian C.L.R. James, saw the African American struggle as potentially precipitating a broader, revolutionary movement. James, along with Jewish American Raya Dunayevskaya and Chinese American Grace Lee, formed the Johnson-Forest Tendency (JFT) in the 1940s, which differed from other Trotskyist groups on various theoretical issues but also in its strong support for African American and Third World anticolonial/nationalist struggles. African American James Boggs, a key JFT member in the 1950s, helped to organize the Northern Negro Grassroots Leadership Conference in 1963 and to found the Organization for Black Power in 1965, a full year before Stokely Carmichael, as chairman of the Student Nonviolent Coordinating Committee (SNCC), announced from Mississippi that "the only way we gonna stop them white men from whuppin' us is to take over. We been saying freedom for six year and we ain't got nothin'. What we gonna start saying now is Black Power!" (qtd. in Sitkoff 1993: 199).

Intriguingly, at the interfaces between black radical and Marxist traditions, one sometimes finds science fictional imagery. W.E.B. Du Bois's *Dark Princess* (1928) tells an Afrocentric tale of international intrigue and imminent future war, while "The Comet" (1920) depicts the awkward relationship between an African American bank messenger and a wealthy young white woman after the (apparent) end of the world. In the opening pages of Richard Wright's *The Outsider* (1953), a "tall Negro" maintains that not only are flying saucers real but that they are occupied by two-foot-tall "COLORED MEN . . . FROM MARS!" (1989: 32, 33). White folks "hushed up the story," he explains:

> They didn't want the world to know that the rest of the universe is colored! Most of the folks on this earth is colored, and if the white folks knew that the other worlds was full of colored folks who want to come down here, what the hell chance would the white folks have? . . . For four hundred years these white folks done make everybody on earth feel like they ain't human, like they're *outsiders*. . . . Now our colored brothers are visiting us from Mars and Jupiter and the white folks is sweating in a panic. (1989: 34–35)[3]

Paul Robeson's *Here I Stand* (1958) locates the possibility for massive social change in "Little Rock and little moon"—somewhere between the "Negro children in the Southland who have given us great new epics of courage and dignity . . . as they walk through Jim Crow barriers to attend school" and the sputniks "that somewhere far overhead . . . are rushing by, tracing out the great truth for the whole world to see: *There are no heights which mankind cannot scale*" (1988: 111, 109, 110). James Boggs rapidly concatenates a series of SF images in the final chapter of *Racism and the Class Struggle: Further Pages from a Black Worker's Notebook* (1970), producing a vivid picture of a contemporary world of "labor so monotonous and fragmented that it is more worthy of robots than human beings," of the "earth . . . being turned into asphalt jungle and the atmosphere into smog," and of pollution generated by "today's unlimited mass production" reaching the point "that

ecologists are seriously discussing the possibility of life disappearing on this planet before the end of the twentieth century" (2011: 230). Should society survive, he continues, it "will soon be faced with the even more complex issues arising out of biotechnology, which brings with it the power to create masses of superhuman or subhuman beings" (2011: 231).

Frantz Fanon's *Black Skin, White Masks* (1952) declares that "if . . . Martians undertook to colonize the earth men—not to initiate them into Martian culture but to colonize them—we should be doubtful of the persistence of any earth personality" (1986: 95). This builds upon such anticolonial SF as H. G. Wells's *War of the Worlds* (1898), which explicitly compares the Martian invasion to the British genocide of Tasmanians, and in which the curate's and the artilleryman's deliria and derangement prefigure Fanon's shattering of terrestrial personality; it also resonates with *Les statues meurient aussi* (Marker/Resnais France 1953), a Marxist anticolonialist documentary that states that "we are the Martians of Africa." Fanon writes that "every woman in Martinique" is possessed of a desire to "save the race, but not in the sense one might think: not 'preserve the uniqueness of that part of the world in which they grew up,' but make sure that it will be white" (1986: 47); he later claims, "For several years certain laboratories have been trying to produce a serum for 'denegrification'; with all the earnestness in the world, laboratories have sterilized their test tubes, checked their scales, and embarked on researches that might make it possible for the miserable Negro to whiten himself and thus to throw off the burden of that corporeal malediction" (1986: 111).

This echoes the satirical SF of African American George S. Schuyler's *Black No More* (1931), in which a scientist invents such a treatment, for which there is an immediate and massive demand. The novel ends with the discovery that the denegrified are whiter than those born white, so the latter develop a taste for tanning in order to reinscribe color-based difference and restore racial hierarchy.[4] Although race is purportedly a marker of biological difference, for Schuyler (in this particular novel) and for Fanon (to an extent), its real function is to reinforce class privilege by producing an underclass, a reserve labor force, with which to discipline the proletariat.

Before exploring the role of SF in blaxploitation, it is necessary to outline the larger phenomenon of which it is a part.

Blaxploitation

Blaxploitation refers to low- and medium-budget U.S. films produced in the 1970s with strong black protagonists and some degree of African American creative input (although most of the directors were white).[5] They were targeted specifically at people of color who, after a couple of decades of white flight to the suburbs, constituted 25–40 percent of Hollywood's audience. Following the success of the studio-produced *Cotton Comes to Harlem* (Davis, 1970) and *Shaft* (Parks, 1971), and of the independently produced *Sweet Sweetback's Baadasssss Song* (Van Peebles, 1971), a blaxploitation production cycle of several dozen films helped to restore Hollywood's profitability and then petered out. Blaxploitation was part of a larger "black film boom" that saw, for instance, "ninety-one productions" in 1971–73, "of which forty-seven can be considered models of the Blaxploitation formula" (Guerrero 1993: 95). This formula

> usually consisted of a pimp, gangster, or their baleful female counterparts, violently acting out a revenge or retribution motif against corrupt whites in the romanticized confines of the ghetto or inner city. These elements were fortified with liberal doses of gratuitous sex and drugs and the representation of whites as the very inscription of evil. And all this was rendered in the alluring visuals and aggrandized sartorial fashions of the black underworld and to the accompaniment of black musical scores that were usually of better quality than the films they energized. (1993: 94)

The negative critical response to blaxploitation articulated by such "pioneering Black film historians" as Donald Bogle, Daniel J. Leab, James P. Murray, Gary Null, and Lindsay Patterson, "who wrote at the moment of the movement's peak of success, shaped opinions for the two decades following the trend's demise" (Sieving 2001: 77), and continues to be influential. Their

perspective was shaped by the criticisms of blaxploitation voiced by various post–civil rights spokesmen and journalists.

Henry W. McGee III outlines many of these criticisms. Blaxploitation films are cheaply and poorly made, and they "perpetuate derogatory stereotypes or create counter-productive myths," "promote detrimental political and value orientations," and "plunder the black community artistically and economically" (1972). *Shaft* portrays "black activists who are desperately trying to help the community as brash and fumbling idiots . . . condemned to the ghetto" (1972). *Cotton Comes to Harlem* and its sequel, *Come Back, Charleston Blue* (Warren, 1972), instruct audiences to suspect the motives of "Pan-Africanist leaders . . . and blacks who attempt to serve the community" (1972). Blaxploitation promulgates "reactionary ideas," such as "blacks are incapable of solving their own problems and only the all-embracing parental arm of white law can save blacks from themselves" (1972). Blaxploitation subjects black audiences to "a steady diet of demeaning characterizations. Black actresses are literally and figuratively screwed from one reel to the next" (1972). While McGee does not address masculinity directly, he is clearly troubled by the depiction of the (implicitly male) "self-centered hustler" and other "slick and flashy" characters (1972). Thirty-five years later, Stephane Dunne identifies the "hypermasculine machismo at the center of the genre" as one of its "most striking and disturbing legacies" (2008: 2).[6]

The term "blaxploitation" is itself a product of post–civil rights debates about the direction the movement should take. It emerged, like the films it labels, in the period of disillusionment after the successful struggle for major civil rights legislation failed to deliver broad and significant changes—even Martin Luther King Jr. acknowledged that "the changes that came about" were more superficial than "substantive," and that the "legislative and judicial victories" of 1954–1965 "did very little to improve the lot of millions of Negroes in the teeming ghettoes of the North" (qtd. in Garrow 1986: 537). As a result, this period also saw Black Power and overtly Marxist, Maoist, and anticolonial currents—including the Black Panthers, the Dodge Revolutionary Union Movement (DRUM), and the League of Revolutionary Black Workers (LRBW)—developing more radical agendas.[7]

Junius Griffin, the head of the National Association for the Advancement of Colored People's (NAACP) Beverley Hills–Hollywood branch, is usually credited with coining "blaxploitation" when he was quoted in the *Hollywood Reporter* decrying such "black exploitation films" as *Super Fly* (Parks Jr. 1972). Within days, he resigned from his position (perhaps as a consequence of allowing personal views to be misrepresented as those of the organization) and cofounded the Coalition against Blaxploitation (CAB), with the support of the National Urban League (NUL), the Congress of Racial Equality (CORE), and the Southern Christian Leadership Conference (SCLC).[8] In the *New York Times* later that year he argued, "If black movies do not contribute to building constructive, healthy images of black people and to fairly recording the black experience, we shall have lost our money and our souls [and] have contributed to our own cultural genocide by only offering our children the models of degradation, destruction and dope" (1972: D19). This preference for realism over fantasy and the patronizing assumption that the ghetto masses are powerless before alluring screen images indicate the extent to which the denigration of this vernacular form by certain African Americans was as much an issue of taste and social class. Furthermore, Griffin's call for black audiences to wield their consumer power more effectively so as to influence Hollywood into ceding to African Americans greater creative and financial "participat[ion] in the movie industry at all levels" (1972: D19) reflects the gradualism and reformism typical of these civil rights organizations.[9]

Griffin's opinions were by no means representative of all African Americans. Also writing in the *New York Times*, director Gordon Parks describes the audience's response to a crowded 4 AM screening of his *Shaft*: "Everything was 'right on!' A new hero, black as coal, deadlier than Bogart and handsome as Gable, was doing the thing that everyone in that audience wanted to see done for so long. A black man was winning" (1972: D3). He says of the "so-called black intellectuals" demanding an end to blaxploitation that "it is curious that some black people, egged on by some whites, will use such destructive measures against black endeavors. . . . The most

important thing to me is that young blacks can now . . . enter an industry that has been closed to them for so long" (1972: D3).

In Isaac Julien's documentary *Baadasssss Cinema* (2002), blaxploitation star and occasional director Fred Williamson attacks NAACP and CORE for coining the implicitly derogatory term, asking, "Who was being exploited? All the black actors were getting paid. They had a job. They were going to work. The audience wasn't being exploited. They were getting to see things on their screens they had longed for." Adds blaxploitation star Gloria Hendry, "The organizations failed to understand that the community was really in need of their own heroes and black movies." Perhaps most famously, the *Black Panther* newspaper devoted the entire June 19,1971, issue to Huey P. Newton's review of *Sweet Sweetback's Baadasssss Song*, which concludes, "We need to see it often and learn from it" (2009b: 148).

Moreover, many blaxploitation films were tremendously popular in a period in which African American audiences accounted for a substantial proportion of all U.S. box office. For example, MGM's *Cotton Comes to Harlem* cost $1.2 million and grossed over $8 million domestically, with an estimated 70 percent black audience (Lawrence 2012: 40), while the studio's *Shaft* cost "$1.2 million and earn[ed] over $10.8 million in its first year of distribution" (Guerrero 1993: 92). Among the successful blaxploitation films from low-budget production companies, Cinerama Releasing Corporation's $200,000 *The Mack* (Campus, 1973) grossed over $3 million, and AIP's $500,000 *Coffy* (Hill, 1973) some $6 million (Lawrence 2012: 76, 83). The independent *Sweet Sweetback's Baadasssss Song* cost an estimated $500,000 and took $4.1 million on its initial domestic release (Quinn 2010: 87), eventually grossing $10 million (Lawrence 2012: 44). The sound track albums for some blaxploitation films, such as *Shaft* and *Cleopatra Jones* (Starrett, 1973), sold hundreds of thousands of copies. *Super Fly*, the first entirely black-financed film to be released by a Hollywood studio, and the first to employ an almost entirely black and Puerto Rican crew,[10] had an estimated budget of $100,000 but took in $6.4 million during its initial run, eventually grossing over $12 million (Quinn 2010: 86, 99). Controlled and released "by his own publishing company and independent record label,"

Curtis Mayfield's "hit singles 'Super Fly' and 'Freddie's Dead' both sold more than one million copies, and the crossover sound track album went on to shift a colossal twelve million units," earning him "more than $5 million for this sound track" (Quinn 2010: 89). Replicating the look of *Super Fly* protagonist Youngblood Priest (Ron O'Neal), particularly his hairstyle and the crucifix cocaine spoon he sported, also became fashionable, but as Eithne Quinn (2010: 99–105) shows, the film's cultural resonance was much deeper and sustained than a haircut or trendy accoutrement.

Blaxploitation SF: Insurgency and Epidermality

In 1970, Francee Covington asked, "Are the Revolutionary Techniques Employed in *The Battle of Algiers* Applicable in Harlem?" Her essay begins, "In the past few years the works of Frantz Fanon have become widely read and quoted by those involved in the 'Revolution' that has begun to take place in the communities of Black America. If *The Wretched of the Earth* is the 'handbook for the Black revolution,' then *The Battle of Algiers* is its movie counterpart" (1970: 244). Focusing on the actual strategies deployed by Algeria's Front de Libération Nationale (FLN) in their anticolonial struggle, rather than the representation of them in Gillo Pontecorvo's 1966 film, she concludes that they are not applicable. However, several novels from the period come to a different conclusion, or at least relish the fantasy that there is nothing to lose by trying these and other revolutionary methods.[11] Most of these novels end *in media res*, just as the black uprising starts, the post-revolutionary society remaining a utopian horizon, a locus of hope that is not—indeed cannot—be given form. While its arrival can be anticipated, its shape cannot.

The Spook Who Sat by the Door (Dixon, 1973) does seem to take Pontecorvo's film and Fanon's book as its starting points.[12] It opens with Senator Hennington (Joseph Mascolo) needing to recover the black support he lost after a speech on "law and order" (a euphemism for police violence against African Americans so well established that Richard Nixon felt obliged in his speech accepting the Republican Party's presidential nomination in 1968 to

deny that "law and order is the code word for racism"). Hennington's wife suggests that he win back these voters by denouncing the CIA's discriminatory hiring policies. The Agency responds by seeking black applicants but rigging the training program to ensure they fail. The recruits, supposedly "the best of their race," are no Talented Tenth, however, just dicty, bourgeois individuals who have learned to take advantage of reluctant integrationists' tokenism. The exception is the studiedly unobtrusive Dan Freeman (Lawrence Cook), a college graduate and Korean War veteran, who initially comes across as a particularly self-effacing "model integrationist" and "paragon of black middle-class values" of the sort identified with Sidney Poitier's star persona (Bogle 1973: 175, 176). Although they occasionally "screamed out in rage at the injustices of a racist white society," Poitier's characters appealed to the new black middle class because "he was neither crude nor loud, and, most important, he did not carry any ghetto cultural baggage with him. No dialect. No shuffling. No African cultural past. And he was almost totally devoid of rhythm" (1973: 176).

Such "mild-mannered toms" also appealed to white audiences because they "spoke proper English, dressed conservatively, and had the best of table manners. . . . [They] were tame; never did they act impulsively, nor were they threats to the system. They were amenable and pliant. And . . . they were non-funky, almost sexless and sterile" (1973: 175–76). The first hint that Freeman is not what he seems comes in a confrontation with his fellow recruits. He turns down their invitation to go out on the town because he wants to carry on studying, and they accuse him of being an Uncle Tom, so eager to please the white man that he is making them all fall behind the grade curve. His quietly threatening response reveals a capacity for violence that is kept under tight control—as, indeed, is his black pride. After picking up a prostitute in a bar, he seems less interested in sex than in teaching her about African history and culture (and as if to attest to his potency, each time she reappears over the next half-decade, her dress and appearance are increasingly influenced by black pride, and her loyalties become more radical).

Freeman's façade cracks once more during his training. When it is clear that he alone will graduate, the white martial arts instructor challenges him

to a fight to force him to quit the CIA. Freeman's victory restages the famous incident in which Frederick Douglass, as a sixteen-year-old slave, resisted being whipped by an overseer and fought him to a standstill: "It rekindled in my breast the smouldering embers of liberty," Douglass wrote. "I was a changed being after that fight. . . . It . . . inspired me with a renewed determination to be a free man. . . . I had reached the point at which I was *not afraid to die*. This spirit made me a free man in fact, though I still remained a slave in *form*" (2003: 97; emphasis in the original). Freeman, like the native Fanon describes, "is patiently waiting until the settler is off his guard to fly at him. . . . He is in fact ready at a moment's notice to exchange the role of the quarry for that of the hunter" (1967: 41). After five years of playing the tom, in which he advances from photocopying documents to the general's personal staff, he quits the CIA, ostensibly to work for the Social Services Foundation. Back in Chicago, he seemingly switches from tom to oreo—a little more slick, a little more fly, than a Poitier character, but able to pass with confidence among his black bourgeois friends and colleagues—even as his true purpose is finally revealed to the viewer. Starting with his old street gang, the King Cobras, he begins secretly to recruit gang members and to use what he has learned over the preceding years to establish a revolutionary army, the Black Freedom Fighters of North America.

Huey Newton recalls that one aspect of Black Panther recruitment involved just such an attempt

> to transform many of the so-called criminal activities going on in the street into something political. . . . Black consciousness had generally reached a point where a man felt guilty about exploiting the Black community. However, if his daily activities for survival could be integrated with actions that undermined the established order, he felt good about it. It gave him a feeling of justification and strengthened his own sense of personal worth. Many of the brothers who were burglarizing and participating in similar pursuits began to contribute weapons and material to community defense. . . . That way, ripping off became more than just an individual thing. (2009a: 134–35)[13]

Most blaxploitation films invert this process, converting political or potentially political energies into the depiction of illegal or otherwise questionable endeavors oriented toward violent revenge, personal gain, and/or consumerism, none more starkly than *The Black Gestapo* (Frost, 1975). Just as the *Battle of Algiers'* FLN drive drugs, alcohol, and vice out of the Casbah, and *Spooks'* Freeman rids the Southside ghettoes of drugs, so *The Black Gestapo's* General Ahmed (Rod Perry)—whose rhetoric positions him as a blend of Martin Luther King and Malcolm X, and whose social programs are modeled on the Black Panthers—is concerned about the Mafia's drug trade in the neighborhood. After Marsha (Angela Brent), a Free Clinic nurse and Ahmed's occasional lover, is attacked by Mafia thugs, he finally accedes to Colonel Kojah's (Charles P. Robinson) request to form a small self-defense force. Kojah, however, goes far beyond this, training an army that forces out the Mafia but then takes over its narcotics operation. He relishes the high-roller lifestyle, dresses his soldiers in black, Gestapo-like uniforms, and adopts a raised black fist clutching barbed *fasces* as their banner. The film does all it can to transform the Black Power salute into a *sieg heil*, such as incorporating newsreel footage of Hitler saluting and dubbing the sound track from a Nazi rally over shots of Kojah receiving the acclamation of his troops. In doing so, *The Black Gestapo* prefigures a number

He has a dream. *Abar, the First Black Superman.*

of far more direct and influential attempts, outlined by Bloom and Martin (2013: 6–7), to misrepresent the Panthers as nothing more than criminals and as anti-white racists. In contrast, *Abar, the First Black Superman* (Packard, 1977) gives the newly superpowered Black Front of Unity leader Abar (Tobar Mayo) "positive" connotations by repeatedly associating him not with Malcolm X, Angela Davis, or the Black Panthers but with the civil rights–era (rather than the later, more radical) Martin Luther King, even playing the "I Have a Dream" speech over its closing shots.

Spook focuses on prankster disruptions, paramilitary training, violent action, and armed revolution rather than on social programs, but it nonetheless stays close to the Black Panthers' position that "Black racism is just as bad and dangerous as White racism" (Bobby Seale, qtd. in Bloom and Martin 2013: 300). Indeed, when Freeman's newly appointed Minister of Information, Willy (David Lemieux), talks about hating "white folks," one can hear echoes of Seale—such as his May 10, 1967, address to UC Berkeley's Young Socialist Alliance and his February 17, 1968, speech at the event announcing the Panther's merger with SNCC (see Bloom and Martin 2013: 80, 112)[14]—in Freeman's response: "Hate white folks? This is not about 'hate white folks.' It's about loving freedom enough to die or kill for it if necessary. Now, you're gonna need more than hate to sustain you when this begins. Now if you feel that way, you're no good to us and you're no good to yourself."

Spook does not really develop Seale's argument that the black revolution "is a class struggle" (Bloom and Martin 2013: 300),[15] but Freeman does explicitly connect black revolutionary struggle to anticolonial wars in "Algeria, Kenya, Korea and the Nam." He argues that there has "always been an army of occupation [in black neighborhoods] with police badges and uniforms," and—in line with an old CPUSA position and various strands of black radical thought—that "what we got now is a colony, what we want to create is a new nation." The film does also rework elements of *The Battle of Algiers*,[16] most significantly the sequence in which three light-skinned Algerian women disguise themselves as Europeans to exit the Casbah and plant bombs in the French quarter. Freeman, having already noted the effective

invisibility in the United States of a black man "with a mop or a broom," able to move unnoticed through many white places of business, decides that the best way to fund the revolution is for light-skinned cadre passing as whites to rob a bank. Likewise, when they raid an armory, Freeman is confident that, because such a heist required "brains and guts," nobody will suspect black militants. When the armed uprising starts, the FBI concludes it must be the doing of a Soviet provocateur; as Fanon notes, "Capitalism and imperialism are convinced that the struggles against racialism and the movements towards national freedom are purely and simply directed by remote control, fomented from the outside" (1967: 63).

Freeman's constant performance of context-appropriate identities cannot help but evoke the African American "double consciousness" described by W.E.B. Du Bois: "this sense of always looking at one's self through the eyes of others, of measuring one's soul by the tape of a world that looks on in amused contempt and pity" (2000: 2). However, where Du Bois suggests that "from this must arise a painful self-consciousness, an almost morbid sense of personality and a moral hesitancy which is fatal to self-confidence," and a doubleness that "must . . . tempt the mind to pretence or to revolt, to hypocrisy or radicalism" (2000: 122), Freeman opts to dissimulate *in the service of* revolution.

Fanon offers a much more visceral, anguished picture of divided, colonized consciousness, arguing that the colonial subject of color, shaped by racial hierarchies, simultaneously strives to "become white" *and* takes on a (misrecognized) black identity constructed by and for this racial hierarchy. "Willy-nilly," he writes, "the Negro has to wear the livery that the white man has sewed for him," but this is more than mere motley: "To make [the colonized] talk pidgin is to fasten him to the effigy of him, to snare him, to imprison him, the eternal victim of an essence, of an *appearance* for which he is not responsible" (1986: 34, 35)—indeed, "what is often called the black soul is a white man's artifact" (1986: 16). This sense of overdetermined entrapment in an appearance is perhaps best captured when Fanon refers to "the internalization—or, better, the epidermalization—of this inferiority" (1986: 13). Blaxploitation SF repeatedly raises issues of race in relation to epidermality.

Alterdestiny by transmolecularization. *Space Is the Place.*

Space Is the Place (Coney, 1974) casts tensions in Oakland between black pride/power and black capitalism as part of a cosmic struggle between Sun Ra (Sun Ra) and a demonic Overseer (Ray Johnson).[17] After triumphing, Sun Ra returns to space, taking with him a selection of African Americans—including the "black part" of Jimmy Fey (Christopher Brooks), the Overseer's chief flunky—to establish a colony on an uninhabited garden world. In order to secure this reversal of the Middle Passage from the interference of white people, Sun Ra destroys the Earth behind them. Before this, however, the Overseer returns to the brothel out of which he has been operating, only to be spurned by a white prostitute and by Jimmy Fey's "white part" as a "nigger."

The raucous comedy *The Watermelon Man* (Van Peebles, 1970) and the earnest melodrama *Change of Mind* (Stevens, 1969) similarly divide individuals so as to explore the fissure between the two parts of Du Bois's double consciousness, while inextricably linking race and class. In the former, racist insurance salesman Jeffrey Gerber (Godfrey Cambridge) turns black overnight. His hitherto liberal wife, Althea (Estelle Parsons), cannot cope with his transformation, but while her sexual interest in him fails, his previously frosty secretary, Erica (Kay Kimberly), a statuesque Scandinavian blonde, finds him

irresistible. When the police see him jogging, they assume he is a criminal in flight. His neighbors pool resources to buy his house before property values plummet.[18] Cambridge plays Gerber in whiteface during the opening section of *Watermelon Man*, after Melvin Van Peebles fought with Columbia to cast an African American lead (they reputedly preferred Jack Lemmon or Alan Arkin for the role, even though a white actor would have had to play in black-face for most of the film). *The Watermelon Man*'s original screenplay is said to have ended with Gerber waking up from his "nightmare," but Van Peebles shot a different ending, in which Gerber, who has learned black pride and relocated to a black neighborhood, covertly prepares with other working-class African Americans for self-defense and revolution.

In *Change of Mind*, David Rowe (Raymond St. Jacques), an up-and-coming white district attorney with terminal cancer, undergoes an experimental procedure that transplants his brain into the body of brain-dead African American, Ralph Dickson—"What is he now, doctor?" asks a reporter, "a white man in a black body or a black man with a white brain?" Like Gerber, Rowe must come to terms with being seen by white people as different to them, and with the gulf between how he is perceived and his sense of self. When Rowe's mother first sees her transformed son, she addresses him directly but talks about "David" in the third person. Rowe is snubbed by colleagues and friends and dropped from his party's ticket for the upcoming election. His wife, Margaret (Susan Oliver), cannot bring herself to be intimate with him (although this is as much about his body being completely different as it is about it being black). Gloria (Vivian Reis), a family friend from their mildly swinging suburban circle, makes very clear her sexual interest in the newly embodied Rowe. His assistant, Tommy (David Bailey), assuming that Margaret would never sleep with her now-black husband and will soon divorce him, suggests she have an affair with him. Although we never glimpse the white Rowe, the film emphasizes that his new body is physically larger (at one point, Rowe even fantasizes about having been given a robot body). When he is recognized and denounced in a black neighborhood bar as a "white nigger," Rowe comments that his assailant "picked the right brain but the wrong body" to pick on, especially since his

larger physique retains a barroom-brawler's muscle memories. Despite this incident, he tells the widow of the body donor that the club was the first time he "wasn't self-conscious, . . . wasn't thinking about what [he] looked like or what other people were thinking."

Rowe's situation is complicated when, against the wishes of his own party, he insists on prosecuting Sheriff Webb (Leslie Nielsen), a violent white racist, for the murder of Henrietta Johnson, a black prostitute with whom he had been having an abusive affair. When it looks like Rowe might, against all the odds, actually win the case, the black community rallies to his support, and the white political machine begins to consider him as a potential state's attorney. However, while the jury is deliberating, Rowe discovers that Henrietta was actually killed by her black husband, and he drops the charges against Webb. His professional life in tatters, Rowe rejects Margaret's apparently genuine attempt at reconciliation and leaves the state.

In both films, the mind/body split is mapped onto class hierarchies, with proletarian black masculinity overtly connected to physicality and—if only in the minds of certain white characters—animality. Fanon observes that "it has been said that the Negro is the link between monkey and man— meaning, of course, white man" (1986: 30). This is evident, for example, in *Dr. Jekyll and Mr. Hyde* (Mamoulian, 1931), in which Fredric March's Hyde makeup and movements are consciously simian, and in *King Kong* (Schoedsack and Cooper, 1933), in which the giant ape plays on black buck stereotypes. In *The Thing with Two Heads* (Frost, 1972), bigoted Maxwell Kirshner (Ray Milland) has perfected a technique for transplanting brains—caged in the corner of his laboratory is a gorilla sporting two heads. This creates a particularly uncomfortable association with the body—that of Jack Moss ("Rosey" Grier), an African American on death row for a crime he did not commit—selected to receive the dying Kirshner's head. *Blackenstein* (Levey, 1973), in which quadriplegic Vietnam veteran Eddie Turner (Joe De Sue) undergoes experimental DNA therapy to restore his limbs, is even more explicit. Although obviously indebted to the Frankenstein story, there is more than a hint of Doctor Moreau to the proceedings: the first signs that Eddie's treatment is going awry are a pronouncedly ape-like brow and bulg-

"We not just conscious, we double conscious!" *The Thing with Two Heads.*

ing forehead, and an unnatural hirsuteness on the back of his hands, both of which imply a descent into the bestial.

Blaxploitation SF's most complex exploration of epidermality and animality, race and class, comes in *Dr. Black, Mr. Hyde* (Crain, 1976). African American Dr. Henry Pride (Bernie Casey) regularly leaves his award-winning medical research to work at the Watts Free Clinic; Dr. Billie Worth (Rosalind Cash), his assistant and girlfriend, also makes time to hold children's art classes at the Watts Towers Arts Center. However, Linda (Marie O'Henry), one of Pride's clinic patients, challenges his well-intended condescension when he suggests that she quit working as a prostitute, accusing him of being a "cop-out": "The only time you're ever around black people is when you're down here clearing your conscience. . . . You know, that white coat really suits you. 'Cos you don't know nothing about the ghetto. I mean, you dress white, you think white, you probably even drive a white car."

Soon after Fanon notes of the colonial situation that "one is white above a certain financial level," he adds, "It is in fact customary in Martinique to

dream of a form of salvation that consists of magically turning white" (1986: 44). Pride has developed a serum to strengthen the liver against disease, but when he tests it on a black rat, the experimental subject loses all pigmentation and kills the other rats in the cage. He tests it on a dying black alcoholic, who briefly turns white and attacks her nurse before dying. Stymied, he tests it on himself, only to transform intermittently into a prostitute-murdering brute. Like March's Hyde, his strength increases, his features become heavier, more simian,[19] but at the same time, and far more significantly, he also turns white.

Richard Dyer attributes colonists' "belief or suspicion that black people have in some sense more 'life' than whites" to colonialism's articulation of notions about "the closeness of non-European (and even non-metropolitan) peoples to nature" (1988: 55). At the same time as Europeans were struggling over the status of the peoples of color they encountered during imperialist expansion, "ideas of nature" were becoming "central to Western thought about being human, such that the concepts of human life itself have become inextricable from concepts of nature. Thus the idea that non-whites are more natural than whites also comes to suggest that they have more 'life,' a logically meaningless but commonsensically powerful notion" (1988: 55). *Dr. Black, Mr. Hyde* emphasizes this association, while also illustrating Fanon's point that "alterity for the black man is not the black but the white" (1986: 97). It connects Pride's bestial transformations and murderous attacks not with some descent into dark, simian negritude, as in earlier variants upon Robert Louis Stevenson's *Strange Case of Dr Jekyll and Mr Hyde* (1886), but with an ashen, cadaverous pallor—with whiteness.

Conclusion

Cedric J. Robinson (2000) suggests that Marxism is so flawed from its very inception that it is incapable of addressing race without being rebuilt from the ground up. Other black thinkers suggest substantial but less sweeping ways in which the two intertwined traditions can be reconciled theoretically. For example, Charles W. Mills (2003) argues that white supremacism

needs to be understood as being "located in the base"—as being "in a sense more deeply material than class"—rather than as a "purely superstructural" or ideological phenomenon (2003: 122). From a Marxist perspective, common ground can be found in Michael A. Lebowitz's (2003) call to move beyond "one-sided Marxism"—which, mistaking the purpose of *Capital*'s theoretical modeling of the human subject as an Abstract Proletarian, a "subject-for-capital," has neglected complexly determined, multifaceted "subjects-for-themselves" and the fullness of human being.

Fanon writes that "at the beginning of his life a man is always clotted, he is drowned in contingency" (1986: 231). Blaxploitation cinema was similarly overwhelmed, caught between and emerging from American cinematic institutions and traditions, the conflicting and conflicted political and cultural perspectives of the post–civil rights era, and broader cultural, economic, and social currents. Its most radical films, *Sweet Sweetback's Baadasssss Song* and *The Spook Who Sat by the Door*, could not escape masculinism or misogyny, and thus were not radical enough, perhaps not radical at all (see Dunne 2008: 55–84). Blaxploitation crime films sometimes offered African American inflected critiques of capitalism, of the sort sometimes found in hard-boiled crime fiction and the ethnic gangster movie, but as the furor around *Super Fly* that led to the founding of CAB demonstrates, they often went unnoticed and unheeded. Drawing on the genre's capacity to literalize metaphors, blaxploitation SF stands out from other blaxploitation ventures in its ability to address subjectivity, alterity, and alienation in complex ways. Mired in the period's contradictions of race and class, they might not be able to offer solutions, but as Fanon writes, "Before it can adopt a positive voice, freedom requires an effort at disalienation" (1986: 231). These films provide some of the tools necessary to visualize and comprehend the alienations of race and class, and to imagine a time and space beyond them.

Notes

1. As with any genre, the parameters of both blaxploitation and SF remain debatable. Some of these blaxploitation SF films are less likely to be considered blaxploitation,

and some less likely to be considered SF than others. Several James Bond–style blaxploitation films not discussed in this essay, such as *Black Samurai* (Adamson, 1977), with its long jet-pack sequence and other high-tech gadgetry, could also be considered science fictional. On blaxploitation horror, see Benshoff 2000 and Schneider 2002.

2. On African American radical traditions, see Robinson 1997 and 2000, Kelley 2002, and Springer 2005.

3. I have been unable to determine whether Leigh Brackett was familiar with Wright's novel, but her "All the Colors of the Rainbow" (1957) shares this premise.

4. In *O presidente negro ou o choque das raças* / *The Black President or the Race Clash* (1926), Monteiro Lobato, one of Brazil's most celebrated authors, depicts the election of the first black U.S. president in 2228. In the racist backlash, a white scientist develops a hair-straightening shampoo that sterilizes and thus genocides African Americans.

5. William Crain, Ossie Davis, Ivan Dixon, Gordon Parks, Gordon Parks Jr., Melvin Van Peebles, and Mark Warren, whose films are among those discussed in this essay, were African American directors of blaxploitation.

6. Focusing on female viewers' positive engagement several key films, she argues against the "taken-for-granted note in black film histories and criticism that women" in blaxploitation "are primarily confined to the position of the cool hero's subordinate sex object" (2008: 2–3); her argument, however, has had little impact.

7. On Black Power and the Black Panthers, see Bloom and Martin 2013, Carmichael and Hamilton 1969, Churchill and Vander Wall 1990, Joseph 2006, Lester 1969, Nelson 2011, Ogbar 2004, and Slate 2012. On DRUM and LRBW, see Georgakas and Surkin 2012 and Geschwender 1977. On black feminist organizations of the period, see Springer 2005.

8. Other affiliated organizations included Black Media Representatives, California Communications Coalition, American Advancement Association, and New Frontier Democrats (Toy 1972: 24).

9. Such patronizing and reformist attitudes are also evident in Griffin's attack on *Super Fly* as "one of the most expensive and sophisticated commercials for cocaine ever conceived. Young people are more concerned with style and symbolism than with substance and can't understand that this is the most insidious behavioral manipulation by the most sophisticated propagandistic industry in the world. The movie tells young people that if you can't beat the man in reality, you can beat him in fantasy. This is counter-revolutionary because our leaders have always emphasized the importance of dealing with reality" (Lawrence 2012: 66). Similar class condescension marks McGee's article. Responding to Curtis Mayfield's argument that his sound track contradicts any potential glamorization of drugs in *Super Fly*, McGee writes: "But counterpoints provided in theme songs are often lost on the most sophisticated of audiences, and to the millions of blacks around the country there is only one message—Freddy may be dead in the theme song but Ron O'Neal is still cruising around in his Cadillac with all those fine women. Get yourself a hustle brother, it's a lot easier than struggling for freedom" (1972). He adds, "Like heroin and cocaine, whites and some unscrupulous blacks are once again giving the black community what it wants but not what it needs" (1972).

10. Made almost entirely on location in Harlem, it drew on the pool of "technicians and apprentices coming from Third World Cinema Corporation, the Harlem-based collective that Ossie Davis cofounded in 1971" (Quinn 2010: 90, 92).

11. See, for example, John A. Williams's *The Man Who Cried I Am* (1967), *Sons of Darkness, Sons of Light* (1969), and *Captain Blackman* (1972), Julian Moreau's *The Black Commandos* (1967), Blyden Jackson's *Operation Burning Candle* (1973), Nivi-kofi A. Easley's *The Militants* (1974), and Chester Himes's *Plan B* (written 1969–1972; published 1983). See Bould 2007 and Tal 2002.

12. It is actually based on a 1969 novel of the same name by Sam Greenlee, who cowrote the screenplay and coproduced the film.

13. Also of note in this context are the Puerto Rican Young Lords, the Latino Los Siete de la Raza, some of whom later became members of the Chicano/a Brown Berets, and the Chinese-American Red Guards.

14. The Panthers were repeatedly criticized by SNCC for their willingness to work with white radicals.

15. In July 1969, just "two weeks before [Seale stated this at] the United Front Against Fascism Conference, the Panthers changed point 3 of their Ten Point Program from 'We want an end to the robbery by the white man of our Black Community' to 'We want an end to the robbery by the CAPITALIST of our Black Community'" (Bloom and Martin 2013: 300).

16. Both contain expositions of the cell structure of underground organizations. The Colonel's (Stephen Ferry) press conference resembles those held by Pontecorvo's Colonel Matthieu (Jean Martin), the national guardsmen's arrest of an innocent bystander because of his skin color recalls the fate of the Algerian street sweeper, and the seizure of a radio station to make a revolutionary broadcast develops the moment in which little Omar (Mohamed Ben Kassen) nabs an unguarded microphone to broadcast FLN propaganda.

17. Sun Ra was one of the leading jazz composers and orchestra leaders of the second half of the twentieth century, and a key figure in the development of Afrofuturism. In the late 1950s, he formed the Arkestra, whose lineup—and actual name—was subject to constant change and with whom he performed until his death in 1993. An exponent of free jazz, jazz fusion, avant-garde jazz, and world music, he was also a pioneer of electronic keyboards. From 1952—the year in which he legally changed his name from Herman Poole Blount to Le Sony'r Ra—onward, he began to describe a visionary experience from 1936 or 1937 (or sometimes the late 1940s) in which aliens teleported him to Saturn to instruct him to speak to the world through his music; later, he would claim to come from Saturn. In conjunction with his groundbreaking, prolific musical output, he also developed an Astro Black Mythology, drawing on Ancient Egyptian mysticism, Gnosticism, Kabbalah, black nationalism, numerology, Rosicrucianism, freemasonry, and so on, which he would express elliptically, in fragments, contradictions, *non sequiturs*, cut-ups of biblical verses, koans, and SF imagery and ideas. Parts of *Space Is the Place* were often screened as a backdrop to the Arkestra's immersive, multimedia—and frequently several hours long—stage shows. See Lock 1999, Rieder 2013, Szwed 1997.

18. In *Abar*, African American scientist Dr. Kincade (J. Walter Smith) moves his family to an all-white suburb so as to conduct his research in secret. The Meadow Park

Homeowners Association promptly offers to buy his home at above market value, and the mayor's office intends to condemn the luxurious property if he does not accept the deal.

19. His gait also becomes simian when he pursues Linda up her apartment stairs, but this hunched loping is not consistently a feature of the transformed doctor, not even in this climactic chase. It is as if Casey's performance is briefly infected by earlier versions of Mr. Hyde. Pride ends his final rampage with a Kong-like ascent of the Watts Towers—which the police's Lieutenant Jackson (Ji-Tu Cumbuka), in order to impress its cultural significance upon his white colleagues, compares to the Lincoln Memorial. In *Abar*, Abar retreats to the Watts Towers to meditate while the chemicals he imbibed transform him into a superhuman. It is there, also, that he first exercises his powers, driving away armed police before turning to heal members of the immiserated black community.

References

Benshoff, Harry M. 2000. "Blaxploitation Horror Films: Generic Reappropriation or Rein-scription?" *Cinema Journal* 39 (2): 31–50.

Bloom, Joshua, and Waldo E. Martin Jr. 2013. *Black against Empire: The History and Politics of the Black Panther Party*. Berkeley: University of California Press.

Boggs, James. 2011. "The American Revolution: Putting Politics in Command." In *Pages from a Black Radical's Notebook: A James Boggs Reader*, ed. Stephen M. Ward, 229–50. Detroit: Wayne State University Press.

Bogle, Donald. 1973. *Toms, Coons, Mammies, Mulattos, and Bucks: An Interpretive History of Blacks in American Films*. New York: Viking.

Bould, Mark. 2007. "Come Alive by Saying No: An Introduction to Black Power SF." *Science Fiction Studies* 102: 220–40.

Carmichael, Stokely, and Charles V. Hamilton. 1969. *Black Power: The Politics of Liberation in America*. London: Pelican.

Churchill, Ward, and Jim Vander Wall. 1990. *Agents of Repression: The FBI's Wars against the Black Panther Party and the American Indian Movement*. Corrected ed. Boston: South End Press.

Covington, Francee. 1970. "Are the Revolutionary Techniques Employed in *The Battle of Algiers* Applicable to Harlem?" In *The Black Woman: An Anthology*, ed. Toni Cade, 244–51. New York: New American Library.

Douglass, Frederick. 2003. *The Life and Times of Frederick Douglass*. New York: Dover.

Du Bois, W.E.B. 2000. *The Souls of Black Folk*. New York: Dover.

Dunne, Stephane. 2008. *"Baad Bitches" and Sassy Supermamas: Black Power Action Films*. Urbana: University of Illinois Press.

Dyer, Richard. 1988. "White." *Screen* 29 (4): 44–64.

Fanon, Frantz. 1967. *The Wretched of the Earth*. Trans. Constance Farrington. Harmondsworth: Penguin.

Fanon, Frantz. 1986. *Black Skin, White Masks*. Trans. Charles Lam Markmann. London: Pluto.

Garrow, David J. 1986. *Bearing the Cross: Martin Luther King, Jr., and the Southern Christian Leadership Conference*. New York: William Morrow.

Georgakas, Dan, and Marvin Surkin. 2012. *Detroit: I Do Mind Dying. A Study in Urban Revolution.* 3rd ed. Chicago: Haymarket.

Geschwander, James A. 1977. *Class, Race, and Worker Insurgency: The League of Revolutionary Black Workers.* Cambridge: Cambridge University Press.

Griffin, Junius. 1972. "Black Movie Boom—Good or Bad?" *New York Times,* December 17: D3, D19.

Guerrero, Ed. 1993. *Framing Blackness: The African American Image in Film.* Philadelphia: Temple University Press.

Innis, Roy. 1972. "Black Movie Boom—Good or Bad?" *New York Times,* December 17: D3.

Joseph, Peniel E., ed. 2006. *The Black Power Movement: Rethinking the Civil Rights—Black Power Era.* London: Routledge.

Kelley, Robin D.G. 2002. *Freedom Dreams: The Black Radical Imagination.* Boston: Beacon.

Lawrence, Novotny. 2012. *Blaxploitation Films of the 1970s: Blackness and Genre.* New York: Routledge.

Lebowitz, Michael A. 2003. *Beyond Capital: Marx's Political Economy of the Working Class.* 2nd ed. Basingstoke: Palgrave Macmillan.

Lester, Julius. 1969. *Look Out, Whitey, Black Power's Gon' Get Your Mama.* New York: Grove Press.

Lock, Graham. 1999. *Blutopia: Visions of the Future and Revisions of the Past in the Work of Sun Ra, Duke Ellington, and Anthony Braxton.* Durham, N.C.: Duke University Press.

Marx, Karl. 1982. Marx to Pavel Vasilyevich Annenkov (December 28, 1846). In *Karl Marx and Frederick Engels, Collected Works, Volume 38: Marx and Engels 1844–1851,* 95–106. London: Lawrence and Wishart.

Marx, Karl. 1996. *Capital, Volume 1.* In *Karl Marx and Frederick Engels, Collected Works, Volume 35.* London: Lawrence and Wishart.

McGee, Henry III. 1972. "Black Movies: A New Wave of Exploitation." *Harvard Crimson,* 10 October. www.thecrimson.com/article/1972/10/10/black-movies-a-new-wave-of/. Accessed June 22, 2013.

Mills, Charles W. 2003. *From Race to Class: Essays in White Marxism and Black Radicalism.* Lanham, Md.: Rowman and Littlefield.

Naison, Mark. 2005. *Communists in Harlem during the Depression.* Urbana: University of Illinois Press.

Nelson, Alondra. 2011. *Body and Soul: The Black Panther Party and the Fight against Medical Discrimination.* Minneapolis: University of Minnesota Press.

Newton, Huey P. 2009a. *Revolutionary Suicide.* New York: Penguin.

Newton, Huey P. 2009b. *To Die for the People.* San Francisco: City Lights.

Nixon, Richard. 1968. Acceptance Speech Delivered before the Republican National Convention, June 26. www2.vcdh.virginia.edu/HIUS316/mbase/docs/nixon.html.

Ogbar, Jeffrey O.G. 2004. *Black Power and African American Identity.* Baltimore: Johns Hopkins University Press.

Parks, Gordon. 1972. "Black Movie Boom—Good or Bad?" *New York Times,* December 17: D3.

Quinn, Eithne. 2010. "'Tryin' to Get Over': *Super Fly,* Black Politics, and Post–Civil Rights Film Enterprise." *Cinema Journal* 49 (2): 86–105.

Rieder, John. 2013. "Sun Ra's Otherworldliness." *Paradoxa 25: Africa SF:* 235–52.

Robeson, Paul. 1988. *Here I Stand.* Boston: Beacon Press.

Robinson, Cedric J. 1997. *Black Movements in America*. London: Routledge.

Robinson, Cedric J. 2000. *Black Marxism: The Making of the Black Radical Tradition*. Chapel Hill: University of North Carolina Press.

Schneider, Steven Jay. 2002. "Possessed by Soul: Generic (Dis)continuity in the Blaxploitation Horror Film." In *Necronomicon Presents Shocking Cinema of the Seventies*, ed. Xavier Mendik, 106–20. London: Noir.

Sieving, Christopher. 2001. "Super Sonics: Song Score as Counter-Narration in *Super Fly*." *Journal of Popular Music Studies* 13: 77–91.

Sitkoff, Harvard. 1993. *The Struggle for Black Equality*. Rev. ed. New York: Hill and Wang.

Slate, Nico, ed. 2012. *Black Power beyond Borders: The Global Dimensions of the Black Power Movement*. New York: Palgrave Macmillan.

Smethurst, James. 2010. "Malcolm X and the Black Arts Movement." In *The Cambridge Companion to Malcolm X*, ed. Robert E. Terrill, 78–89. Cambridge: Cambridge University Press.

Springer, Kimberly. 2005. *Living for the Revolution: Black Feminist Organizations, 1968–80*. Durham, N.C.: Duke University Press.

Szwed, John F. 1997. *Space Is the Place: The Lives and Times of Sun Ra*. New York: Pantheon.

Tal, Kalil. 2002. "'That Just Kills Me'; Black Militant Near-Future Fiction." *Social Text* 71 (20) (2): 65–91.

Toy, Steve. 1972. "NAACP & CORE Hit Black Capers: Distortion of Race Life-Style; Black Brokers Serve White Cos." *Variety* (August 23): 5, 24.

Trotsky, Leon. 1967. *Leon Trotsky on Black Nationalism and Self-Determination*. New York: Pathfinder.

Wright, Richard. 1989. *The Outsider*. New York: Perennial.

4

The Biopolitics of Globalization in Damir Lukacevic's *Transfer*

SHERRYL VINT

It has become a truism to say that reality has caught up with science fiction, and nowhere is this more evident than in the biotech and biomedical industries. As Catherine Waldby and Robert Mitchell point out in *Tissue Economies*, questions of life and human identity are no longer self-evident in a context in which parts of the human body can be disaggregated from a particular individual, and transferred among bodies or incorporated into products such as research cell lines that are simultaneously human and commodity. Both life and labor are separated from the human body in the biotech industry based on what Eugene Thacker calls *"biomaterial labor*, or even *living dead labor"* (2006: 40), in which biological processes perform work without a human body/subjectivity attached. Capitalist biotech eliminates "the integrated 'inorganic body' of the living world in favor of a total objectification of labor in commodities" (Thacker 2006: 39). The biotech industry is also one financed by speculative capital, a system whose rhetoric conflates economic and medical value, in which the promise of a therapeutic intervention that saves lives is also the promise of a marketable product that saves bottom lines. Drawing on Freud's notion of the psychotic's reinvention of reality, Melinda Cooper describes this context as the delirium

of biotechnology, a "project of reinventing life beyond the limit" that "is inseparable from the dynamics of contemporary debt imperialism" (2008: 12). In a biocultural age, understanding these speculative discourses of bio-politics is imperative, and SF is in a privileged position to help us work through their anxieties and contradictions.

Damir Lukacevic's *Transfer* (2010) is an exemplary text for thinking about the consequences of life itself becoming a commodity and, crucially, one that also demonstrates the globalized context in which such reinvention of life occurs, a context in which the bodies of those in the Global South are literally as well as metaphorically consumed to sustain the affluence of those in the Global North. The film narrates the experience of a wealthy Western couple who use their economic privilege to acquire new bodies to replace their failing ones. Unlike a number of other SF texts dealing with this theme of immortality through technology, which suggest that we can replace our mortal biological body with a mechanical body or a clone, *Transfer* situates its tale of posthumanism within the realities of globalized capital, a context in which it is already the case that some bodies are able to live longer than others—and at the cost of the shortened lives of the disenfranchised—due to uneven distribution of food, medicine, and other resources. The "donor" bodies in the film are those of impoverished people from the Global South, who "volunteer" and are paid for their service: this volunteering, of course, occurs in the context of the forced choice that capital always offers labor. In the film, it is not merely their body tissues or their labor power that are sold; rather, the entire bodies of the poor are turned into hosts for the identities of the wealthy who purchase them. The film posits a technology by which the body's original consciousness can be sequestered and return only for four hours a day of control, while the transferred consciousness of the pur-chaser takes possession of the body for the rest of the time.

The delirium of biotechnology seeks to modify nature and harness it to the productive demands of capital, and living-dead labor transforms into capital the biological work performed by "mammalian bioreactors, trans-genic lab animals, immortalized cell lines, lab-grown tissues and organs and the bioinformatic labor of cells, enzymes, and DNA" (Thacker 2006: 203).

In *Transfer* we see this taken one step further so that it is not merely fragments of the human body that are turned into commodities and the living-dead labor of biotech: the film demonstrates the continuum between the alienation that results from capitalism's separation of labor-power from the living laborer and the alienation of being displaced from one's own body. Apolain (B. J. Britt) and Sarah (Regine Nehy), from Mali and Ethiopia, respectively, make clear that they have agreed to this procedure because selling their bodies was their only economic option and because they believed, indeed, were told that their siblings would have access to educational and other opportunities due to this sacrifice. At separate points in its narrative, the film shows images of the brochures given to prospective clients of the service and those given to prospective donors. In both, smiling African and Asian faces beam out and promise the benefits of a middle-class lifestyle—either continued life of affluent white customers who can now enjoy their privilege in young and fit bodies, or the promise of opportunity suggested by the graduation gowns prominently featured in the brochure for donors.

Transfer narrates the struggle between the "original" and the "immigrant" inhabitants of these posthuman bodies within this context in which biology itself has become part of the global economy. Nancy Scheper-Hughes uses the term "late modern cannibalism" (2002a: 1) to refer to the global market in kidneys, based on ethnographic interviews with people who have chosen to compromise their health by selling this organ because it was the only commodity they could bring to market to feed their families. The introduction of the drug cyclosporine, which manages rejection, radically changed the context of organ donation, as Lawrence Cohen points out. Powered by this drug, transplant culture shifted from "the heroic age of immune recognition to the assembly-line surgeries of the immunosuppression era" (Cohen 2002: 12): now that almost anyone could be a donor, specific populations, targeted for their economic vulnerability, materialize as sources of life for the aging, privileged consumers of high-tech medicine. And those disadvantaged by global capitalism, already "lacking the hope of an extended life span," can easily be recruited into "spending their bodies in the present" (Waldby and Mitchell 2006: 187). Scheper-Hughes argues

that "global capitalism, advanced medicine and biotechnologies have incited new tastes and desires for the skin, bone, blood, organs, tissue, and reproductive and genetic material of the other" (2002a: 5), and the economic inequities that shape one's relationship to this milieu mean that, in Waldby and Mitchell's words, "the South appears as a source of tissue surplus for the North" (2006: 187). This nexus is fueled by desperation on both sides of the equation, as Scheper-Hughes observes in her work on what she calls "transplant tourism": the transplanted kidney becomes both "an *organ of opportunity* for the buyer and an *organ of last resort* for the seller" (2002b: 50–51).

One of the strengths of *Transfer* is that it portrays with complexity and sympathy both sides of this fetishized exchange. The German couple who seek out the transfer technology offered by Menzana Corporation, Hermann (Hans-Michael Rehberg) and Anna (Ingrid Andree), are blind to their own privilege, but they are not monstrous. When they are first shown their prospective new bodies, Anna in particular resists seeing them sim-

Anna and Hermann contemplate their long life of loving one another. (Image courtesy of Damir Lukacevic)

ply as commodities. Watching Sarah on a monitor, Anna asks where she is from, before correcting herself, "Oh yes, you're not allowed to tell us," and she leaves the demonstration telling Hermann, "I can't do this." Their long and enduring love for one another is emphasized throughout the film: they are physically affectionate in most scenes, speak of more than fifty years together, and early in the film we hear a voiceover reading from Anna's diary in which she talks about their desire to die together so that "neither of us would have to suffer alone on earth." Anna, we soon learn, is dying of cancer and has only months to live: when Hermann returns home one day to find her collapsed on the floor in agony, all reservations about the transfer system are brushed aside in his fear of losing her, and they go through with the procedure. Thus, although they are characterized as privileged and somewhat solipsistic people, it is love rather than greed that fuels their desire to extend their lives beyond given biological limits. In their own way, their grief makes them as desperate as are Apolain and Sarah, but at the same time the film never lets us forget that these two kinds of desperation

Apolain is managed on a strict fitness and diet regime to ensure the quality of the transferred body. (Image courtesy of Damir Lukacevic)

are separated by a vast difference: Hermann and Anna have had a full life they now fear losing, whereas Apolain and Sarah have never had a chance at life at all.

The film's opening shots demonstrate the "new tastes and desires" for the bodies of others that Scheper-Hughes argues are produced by biomedical capitalism. Our first images are of Sarah and Apolain at the Menzana facility: its prisonlike institutional setting is emphasized by the grey and white color palette, the only brightness the vegetables set out for Apolain to consume, the implication being that their bodies are resources monitored and maintained by the corporation. Both are asked to disrobe to their undergarments in a series of shots that implicate the film's viewers with the subject position of white Westerners viewing these bodies as resources to be consumed: some of the shots show the diegetic framing and filming of their bodies, either by showing the camera in-shot or by pulling back to reveal that the shot we are seeing is also one being viewed on a screen within the diegesis, as Hermann and Anna evaluate their prospective new bodies on monitors in Dr. Menzel's (Jeanette Hain) office. Both actors are in superb physical condition and look into the camera with affectless and unflinching gazes, their experience of their bodies already alienated by this surveillance. The shots invite us visually to consume their bodies, but not in an eroticized way: instead, they stand as models of perfect conditioning, almost machine-like in their toned perfection, and close-up shots focus not on sexualized body parts but on features such as Apolain's gleaming teeth as they are maintained by a dental hygienist.[1] Like Hermann and Anna, we are encouraged to see them as commodities, not subjects, the institutional setting and uniform-based clothing stripping them of any specificity so that we too are discouraged from asking who they are and where they are from. We learn Hermann and Anna's names very early in the film, but do not learn Sarah's until after the surgery, when Anna asks Dr. Menzel about "this girl inside of me," and Apolain's even later when, awake for their four hours at night, Sarah asks him his name.

The economic and political context of biotech research and organ transplantation encourages us to detach biological tissues from their human ori-

gins, a process exacerbated by the commodity form which also seeks to hide the fact that relationships among things stand in for relationships among the people who produce and consume them. As Marx argues in *Capital* volume 1, all commodities are products of human labor, but the commodity form hides this truth. As the commodity enters the realm of exchange value instead of use value, "all its sensuous characteristics are extinguished" and, "with the disappearance of the useful character of the products of labour, the useful character of the kinds of labour embodied in them also disappears" (1990: 128). Thus, instead of being confronted by particular humans whose work is congealed in the commodity form, we are confronted with an equivalizing notion of labor in the abstract, when we remember that labor is part of the commodity form at all. As Marx further elaborates, the commodity form, in making all things exchangeable for other things, makes "the labour expended in the production of a useful article [appear] as an 'objective' property of that article" (1990: 153–54). Small wonder, then, that Marx insists that commodities are far more than mere objects, that they come to us "abounding in metaphysical subtleties and theological niceties" (1990: 163). This mystery of the commodity fetish is at the center of why labor is alienating under capitalist social relations, separating humans from both their own sensuous capacities, which are abstracted as undifferentiated labor power, and from the products of this labor. The result is that "the definite social relation between men themselves" becomes for them "the fantastic form of a relation between things" (1990: 165).

Transfer explores a context in which this alienation assumes an even more sinister and fantastical form, in which one is alienated not only from the productive power of one's body abstracted as the commodity labor power, but from the concrete materiality of one's bodies abstracted into biological commodities. In biotechnology, "body parts are *extracted* like a mineral, *harvested* like a crop, or *mined* like a resource. Tissue is *procured*— a term more commonly used for land, goods, and prostitutes" (Rose 2006: 39): the human being is reduced to just another unit of exchange, as is emphasized at the film's conclusion when Hermann and Anna are offered different bodies to replace those of Apolain and Sarah. Like the stories of

kidney sales to support one's family, another real-life parallel to the film's premise can be found in research on the sale of human eggs for reproductive technologies that suggests that "women who participate in any one sector of this reproductive economy are likely to migrate to another, so that the boundaries between actual biomedical, reproductive labor on the one hand and sexual and domestic labor on the other are extremely fluid" (Cooper 2008: 149–50). *Transfer* insists on restoring the human connections that lie behind the commodity form of such exchanges, and it does so through the pregnancy that is the source of a crisis in the narrative.

Biotechnology and globalized transplant medicine partake of regimes of biopolitical governance in which some lives are valued and made to live, often through extreme interventions, while other lives are left to die, such as the lives of the tissue donors who are integrated into this bioeconomy not as subjects but as spare parts. Like the economics of kidney transplantation, there is a contemporary, "real world" analogue to the different ways that Anna and Hermann are integrated into this procedures, as subjects, compared to Apolain and Sarah's experience, as objects. In *Biocapital*, Kaushik Sunder Rajan compares the biotech industries in the United States and in India, using as one of his case studies Wellspring Hospital in Mumbai, a site of frequent clinical trials. As Sunder Rajan points out, this facility is located in a community devastated by recent neoliberal deindustrialization, resulting in "a huge unemployed local population that ends up being easily recruited into clinical trials, which do, after all, compensate their volunteers" (2006: 96). Thus, Western and Indian subjects are both integrated into globalized biotech medicine, but in distinct ways: Westerners are positioned as potential consumers of these therapies, while impoverished Indians are integrated into these circuits as experimental subjects, *consumed by* rather than consuming these therapies.

By making the exchange apply to the entire body, not simply to detached fragments of that body, *Transfer* requires us to keep in view the fact that there are four individuals involved, not simply two agents. The film initially establishes a contrast between the way that Sarah and Anna negotiate this connection and the way Hermann and Apolain resist it. Anna shows curios-

ity about Sarah and begins to address her diary to Sarah, linking her daytime life to the four hours at night during which Sarah is conscious. Hermann, on the other hand, builds special, locked bedrooms in the basement of their house and initially tries to force the bodies to remain thus confined during the hours when he must relinquish control to Apolain. Trying to convince Anna of the wisdom of this plan, he tells her, "What if they hurt themselves outside? We paid good money for them," to which she acerbically replies, "They survived Africa—they will also survive our garden." When Apolain wakes up this first night to find himself without memories of the day and in a locked room, he reacts with fear and aggression and wants to cancel his contract. Told he cannot change his mind or leave the program, he directly identifies the way in which capital always extracts more surplus value than the labor it has paid for: "My contract says four hours a day—of life!" he shouts. "Four hours a day of life, free life."

Apolain's situation, of course, is the common situation of labor under capital: one sells one's labor power for a portion of the day, but it is one's whole life that is ultimately sold to the structures of wage labor. This is true not only in the sense that one's sensuous capacities, congealed in the commodity form, are made alien (and here, it is one's very embodiment that is so alienated), but further in the sense that the exchange between capitalist and worker for labor power is structurally designed to impoverish the worker. As Marx elaborates, once labor power is abstracted from living labor and made equivalizable through the commodity form, labor becomes "*absolute poverty*: poverty not as shortage, but as a total exclusion of objective wealth" (1973: 296) because this wealth cannot be separated from the body of the worker. As he explains in more detail in *Capital*, volume 1, the worker, owning no capital, can only enter into market relations by making his labor power objective in this way, selling it as an abstract thing as if it were a commodity like any other, but all while he is compelled to sell his labor as labor power, having no other commodity to bring to market and no longer being able to reproduce his existence without entering into market relations and exchanging this commodity for others he needs. In thus selling labor power to the capitalist, the worker gives up this commodity to be

consumed like any other. From the point of view of the capitalist, his labor power exists only as a certain quantity of time that is "absorbed" (1990: 297) into the commodity the worker produces.

Yet in order to receive a profit, the capitalist must be able to sell the commodity on the market for a sum that is greater than the total of the raw materials and labor power that went into making it. In analyzing this conundrum, Marx unveils the necessary exploitation of capitalism and its necessary impoverishment of workers in order to enrich capitalists through the mechanisms of surplus value. A gap exists between "the daily cost of maintaining labour-power," or its use value if labor is expended by the worker on his/her own behalf, and "its daily expenditure in work," or its exchange value, the value the capitalist has purchased in the commodity labor power (1990: 300). The wage relation traps the worker because "the seller of labour-power, like the seller of any other commodity, realizes [*realisiert*] its exchange-value, and alienates [*veräussert*] its use-value" (301). The worker needs only part of the day for labor to reproduce his own means of existence, but by abstracting his labor into labor power, he sells the whole day to the capitalist, who thereby profits from the portion of the day expended in labor power that exceeds the time for which he compensates the worker.

This necessary antagonism of class interests is reflected in *Transfer* in the animosity that grows between the couples. The men are more suspicious of one another, and Hermann openly displays his racism even while being willing to inhabit a black body. Hermann's racism is also mirrored in the response that others have to the couple in their new bodies, visibly reacting to their black skin as out of place in social settings populated only by white bodies. During the first night after the procedure, Hermann has dreams of images drawn from Apolain's life and we get a fleeting glimpse of the conditions that drove him to sign the contract with Menzana: soldiers in the street, people being rounded up at gunpoint and kept in camps, a vision of Apolain standing naked before a group of Menzana employees who evaluate his worth. Within the dream we hear Hermann's fearful voice asking, "What if I'm stuck inside a cannibal?" and yet it is Apolain who is being consumed. Anna convinces Hermann to abandon the nightly confinement of the bod-

ies, but Hermann becomes adamant about control again when he awakens one morning naked beside Anna: at first Apolain and Sarah did not know one another and slept separately, but their relationship grows and they too begin to have sex. Anna tells Hermann, "Stop acting like a child. These bodies are just as much theirs as ours," but he continues to rant, "While we're deep in sleep, the two negroes screw each other." Anna never displays Hermann's racism and fears about miscegenation—indeed, she just walks out on him after this comment, and at other times tells him not to use the word "negro"—and yet her own blindness and assumptions are revealed in her sense that the bodies belong equally to the two couples: her right via purchase is unquestioned.

Thus the pregnancy produces a crisis of miscegenation. Both Sarah and Anna are happy and at first approach the child as a shared project. Anna writes to Sarah about all she can give this child who will bring together the four of them, and even omits her medication (used to suppress the original consciousnesses) for a night to allow Sarah to retain control of the body in the day so she can appeal to Hermann. Sarah, likewise, resists Apolain's narrative of inevitable antagonism. Apolain insists, "Those white people will never be our friends. We live for the community. We have faith, ideals. They have nothing. Their god is the euro," but Sarah tries to point out all that the money can do for their child, the opportunities it will have not only for a better life but also to help their people. Apolain counters, "When it grows up, it'll be black outside and white inside. It'll be just like them, and buy itself a new body when it's old and ugly." Hermann is eventually convinced through his love for Anna to proceed with the pregnancy, and he even has a dream that suggests a kind of racial harmony, in which the two couples joke and play together at a picnic, all focused on a young African girl who unites them. Yet the dream ends abruptly as the child begins to cry, suggesting this vision cannot last. In the meantime, Apolain has convinced Sarah to participate in his plan to switch the suppression drugs for placebos and thus regain control of their own bodies for the full twenty-four hours of the day. The realities of postcolonial racism and globalized capital do not allow this vision of the fusion child to persist as anything other than an unrealistic

dream.[2] Sarah is finally compelled to accept Apolain's point of view when she sees a recreation of the genetic modifications planned for the baby, incorporation of DNA from Hermann and Anna that would result in the child literally as well as metaphorically becoming white.

Yet despite the fact that the film refuses to allow us the consolation of the image of shared racial harmony in the child, it nonetheless suggests some degree of rapprochement: the shared body and more importantly shared dreams have encouraged Hermann to take an interest in the ethics and financial details of the transfer, something he had steadfastly refused to see previously even though he was bluntly confronted by his friend, Otto (Ulrich Voß), who asked, "Do you really think people do something like that by choice?" In a later conversation, Hermann insists that the Africans get ten percent of the one million euro price for the procedure, but Otto remains incredulous, chiding, "My boy, you don't really believe that those poor devils actually get a hundred thousand euro, do you?" And indeed, when he finally investigates, Otto discovers that "the 10 percent really does go to Africa: to a subsidiary corporation. The family actually gets only one percent, " to which the visibly shocked Hermann can only reply, "For selling their lives?" Otto also takes it upon himself to investigate the details of Apolain's family, and when Hermann is confronted with the degree of suffering he had denied, he immediately takes steps to set up a trust that will financially support them. Crucially, as has been established earlier in the film, Hermann's wealth comes from his stocks, and owning stock in Menzana Corporation is highly lucrative. Despite Otto's objections to the morality of the procedure, for example, he nonetheless advises Hermann to buy the stock, but not to take the cure. In this way, the film reminds us that we are all implicated in the ways that global capital distributes opportunity and destitution.

Taking the slaves from the *Zong* massacre and the court case that followed as paradigmatic of finance capital's translation of the body into a commodity, Ian Baucom argues in *Spectres of the Atlantic* that this trial is about the creation of imaginary or speculative value as key to the economies and cultures of modernity. The slaves were killed in order to fix their value as com-

modities: living they could depreciate, but dead they remained pure financial instruments through the value of insurance attached to their lives. Further, Baucom reminds us of credit's role in producing the bodies of certain Africans as currency rather than people, thus linking this historical moment of the *Zong* massacre's transformation of slaves into wealth with contemporary debt imperialism and the abstractions that encourage Sarah and Apolain to transform their flesh into financial opportunity for their families. "Credit did not only follow the slave trade. Nor did it simply enable the purchase of slaves," Baucom reminds us: "By frequently producing debtors unable to settle their debts, credit produced slaves: a class of debtors whose bodies or whose relations' bodies functioned as their 'guarantee' of last resort" (2005: 89).

Baucom notes that we have many historical details about the *Zong* slaves as commodities—details of how they were transported, insured, and killed—but no traces of their lives as individuals—how they entered slavery, what lives and family they left behind. This difference mirrors Hermann and Anna's changed relationship to Apolain and Sarah over the course of the film. At first they see the Africans only as commodities, focusing on the toned perfection of their bodies' exteriors, as the opening sequence of the film shows. But unlike those involved in the slave trade and the *Zong* court case, Hermann and Anna are unable to maintain this distanced and supposedly disinterested view. Instead, the intimacy of shared embodiment requires that they begin to know something of Sarah and Apolain as people. Anna and Sarah achieve this intimacy more quickly because of the shared diary and a greater willingness on Anna's part to accept their necessary closeness, but even the reluctant Hermann and Apolain are inevitably drawn into seeing one another as human when their dreams bleed together. The embodied nature of their commodity transaction, thus, is so intimate that it threatens the necessary division upon which capitalist social relations depend. Hermann increasingly cannot see Apolain's body as merely an object purchased for his use, but is reminded of its congealed labor power, of the concrete and specific individual whose vital essence the body represents. This human connection between Apolain and Hermann has implications as well for the financialization of human life that Baucom interrogates.

Drawing on Kant's idea of global cosmopolitanism, Baucom argues for a distinction between what he calls liberal cosmopolitanism—which he associates with the "theoretical realism" of finance capital and liberalism and their abstract concepts of value and subjectivity, respectively—from a mode Baucom calls cosmopolitan interestedness. Unlike liberal cosmopolitanism, cosmopolitan interestedness retains Kant's notion of "the global dissemination of a specific sublime spectacle, the universal consumption of the image of a uniquely sublime event: the French Revolution," which produces "the capacity to express a disinterested sympathy—however terrifying that sympathy might be—for humanity as an end in itself" (2005: 157). This collective, global sublime experience, Kant contended, would secure subjective identification with the collective project of freedom. Cosmopolitan interestedness is characteristic, Baucom argues, of a melancholy[3] romanticism that is set against the "tide of modernity" (2005: 178) and its discourses of abstraction, which produce humanity as "a speculative idea" (2005: 180), and the concentration camp, as Agamben argues, as the paradigmatic site of its biopolitical governance. In contrast to the impartial spectator/witness of liberal tradition, who attests to events witnessed but remains untouched by them, Baucom asserts the ideal of the witness as a survivor, one who observed but was also moved by the events, a witness who embodies the quality Agamben and Derrida call responsibility in their analyses. "To persevere in a truth, to refuse to give up on it, is thus not only to continue but to endure *with and in* precisely what cannot be known, only affirmed," Baucom argues, affirmed "by testimony, by bearing witness, by the public example of perseverance" (2005: 183).

Baucom thus concludes that the *Zong* trial was "a contest between the speculative imagination of finance capital and the sentimental, romantic imagination of melancholy" (2005: 205), between testimony at a trial which emphasized the financial logic by which it was sensible to drown the slaves and thus convert the capital lost through their "depreciation" into insurance money capital, versus a dissenting story about the massacre's meaning in terms of the loss of unique, individual full human lives embodied in each slave. *Transfer* manifests this same contrast but also a journey from one kind

of imagination to the other as Hermann and Anna move away from being the liberal cosmopolitan consumers of a product, having faith that Sarah and Apolain have been duly compensated in the financial transaction and that their own material wealth rightfully entitles them to a stake in the future, including their reproductive future with the baby. By the film's conclusion, Hermann and Anna invest instead in a melancholy, romantic speculation, become witnesses who see through the individual suffering of Sarah and Apolain to the larger systemic structures of capital which continue to produce a world of rights-bearing subjects of the Global North, who can purchase protection from even death due to age, and the bare life of those of the Global South, who cannot even retain rights status in their original bodies. Baucom links his counterdiscourse of modernity to the speculative mode of sentimental fiction, countering it to the speculative mode of finance capital.

Drawing on Adam Smith's discussion of the economic miseries capital hides from its privileged subjects, Baucom points out, "The mind of capital may refuse to see, may refuse to admit into evidence what imagination forces it to know; or, barring that, it may choose to neutralize the ethical burden of such knowledge by collapsing all the system's imagined miseries into a dispassionate, disinterested, actuarial science of aggregates, averages, and such numbers" (2005: 239). This is precisely Hermann's first speculative engagement with the suffering he abstractly knows motivated Apolain's decision to sell his body, and this moves Hermann to offer financial help but to leave the system of exploitation intact. It is only when—through shared embodiment and shared dreams—he imaginatively partakes of Apolain's experiences that his sentimental, sympathetic imagination is engaged and this inspires him to larger interventions.

The film thus suggests some reasons for hope in the globalized biotech future on the level of the individuals involved. Both couples have their own narratives of desperation that drive them toward these choices, and both are able to see the humanity of the other through their shared embodiment. When Apolain and Sarah's substitution of the drugs is revealed and Menzana confines them, it is only the corporation that maintains a relentlessly dehumanizing attitude. Apolain pleads that they punish only him and

let Sarah go, but Dr. Menzel tells him, "Sarah is property of the corpora-
tion. Her body will soon be perfect again." The next scene shows Hermann
and Anna back in control of the African bodies, being offered new models,
which they refuse. Instead, Anna says, "We want to buy [Apolain and Sarah]
free. How much do you want for them?" but Dr. Menzel primly rebuts her,
"We don't sell people. We are not slave traders." Hermann insists that slave
traders are precisely what they are and, further, demands that Apolain and
Sarah be released or he will go public with their practices. This reference
to slavery makes undeniably visible the continuum between the colonial
practice of slavery and the neo- or *bio*-colonial practices of the globalized
body tissue market. Thus the market in organs simply continues the eco-
nomics—and desperate human circumstances—of the Atlantic slave trade.[4]

As Cooper and Mitchell and Waldby both argue, the market in human
body tissues, historically, had to negotiate an emergent exchange of human
bodily substances, originating in national blood bank projects in the post–
World War II period, in relation to a welfare state premised on the logic of
protecting rights-bearing human subjects—at least in some aspects of their
lives—from the vicissitudes of market forces. Thus blood banks were es-
tablished through rhetoric about community and commonality, and in the
UK and commonwealth nations were specifically modeled on a gift rather
than market exchange. As Waldby and Mitchell point out, the rhetoric of
the gift commodity was easily fragmented by the rise of neoliberalism, al-
ready impelled to push market rationality into previously uncommodified
aspects of human life, and in this specific case able to mobilize a discourse
that public blood banks gave parts of the self to "strangers" and hence were
as suspect as were other collective public social services under attack, such
as education, social security, and childcare. In the context of biomedically
processed body tissues, the gift economy's link between donor and recipient
as two people in communal relation is increasingly difficult to sustain, given
that many commodified tissues are broken down into constituent parts and
recombined (such as blood serum produced from a number of donors) and
so the one-to-one exchange that reminds us of the person behind the com-
modity is more difficult to grasp.

Cooper goes further in her analysis, linking biotechnologies to market values in a number of ways. First, she also notes that the welfare state and its ideology of mutual protection and entwined obligation has been swept aside by the individualism of neoliberalism. Further, she argues that the speculative nature of finance capital—aimed at consuming a future through financial instruments such as derivatives and pollution bonds—is structurally homologous to the speculative nature of most biotech medicine, based as it is on promised future therapies themselves based on genomics rather than on actually existing products.[5] Thus, the biotech process of "transfer" imagined in Lukacevic's film, from this point of view, is only marginally more science fictional or speculative than other biotech therapies being researched, often using people disenfranchised by global wealth inequities (such as Sunder Rajan's Wellspring subjects). The market in body tissues, organs, and reproductive capacities, meanwhile, is material rather than speculative, and draws on similarly marginalized subjects often placed in such dire circumstances precisely by the speculative markets of neoliberal capital and its relentless channeling of wealth back to the Global North through things such as IMF austerity politics that decimate social welfare programs in debtor nations.

Cooper contends these two parallel logics come together in biotech genomic agribusiness, in which the reproductive capacities of nature are themselves compelled to serve the logic of capitalist accumulation, wrenched out of biological limits that suggest ecological limits to growth. She elaborates:

> The promise of capital in its present form—which after all is still irresistibly tied to oil—now so far outweighs the earth's geological reserves that we are already living on borrowed time, beyond the limits. U.S. debt imperialism is currently reproducing itself with an utter obliviousness to the imminent depletion of oil reserves. Fueling this apparently precarious situation is the delirium of the debt form, which in effect enables capital to reproduce itself in a realm of pure promise, in excess of the earth's actual limits, at least for a while. (2008: 31)

In *Transfer* this same logic is at work in the desire of wealthy recipients of the therapy to live beyond the natural capacity of the human body. Anna and Hermann at first also partake of a kind of delirium, an "utter obliviousness" to the damage their desire does to those whose bodies are so consumed. Examining practices such as precapitalization—patenting cell lines before any therapeutic property is attributed to them, just in case one is found in the future; the transformation of reproductive cycles of animals such as chickens and cows to produce eggs and milk more quickly; and the use of animals or plants as bioreactors to produce marketable biological substances such as insulin, Cooper demonstrates that this valuing of some kinds of forms of life "beyond the limit" is simultaneously the devaluing of other life, such as the animals distorted by genomic intervention. *Transfer* makes a similar point on the personal level, prompting those of us in the Global North who consume beyond the limits of the planet to confront the fact that we are consuming the future possibilities of other inhabitants, most quickly those of already disenfranchised people in the Global South.

The film concludes on a very sinister note, one that makes it clear that it is the structures of globalized financial capital and the commodity form of human bodies and tissues that ensure such exploitation will continue. After Hermann utters his threat to Dr. Menzel, he and Anna come to terms with their mortality and accept that they will be transferred back into their own bodies. She will die of her cancer, but she implores him to live on without her in order to fight for Apolain and Sarah. The scene of their conversation visually conveys the same logic: it begins with a shot of Britt and Nehy, speaking in their own voices[6] but conveying the thoughts of Anna and Hermann, sitting together on a bench both in medium-close shot, their heads together; as they speak of the need to return to their own bodies, and her inevitable death, Britt stands up and walks to the left, the camera following him; Nehy's voice changes to Andree's voice as she tells him that even without her, he must live, for the sake of Apolain and Sarah; the camera moves back toward the right, showing us Andree now on the bench; it remains on her as Hermann speaks and Rehberg walks into the shot, joining her on the

bench, once again pressing foreheads together. One side of the transplant equation of desperation has been transformed, and Hermann and Anna accept responsibility for their privilege and plan to use their resources to help others rather than to extend their own lives.

The film then cuts immediately to a repetition of the transfer procedure, focusing first in medium shot on Hermann's body from above: he never awakens from the operation. A shattered Anna mourns over his corpse, as Dr. Menzel coolly offers condolences for the loss, explaining that his body was too weak while her sly smile tells the audience that his death was intentional. Even privileged white people cannot stand in the way of the corporate drive toward profit. The film's final moments cut from a long shot of a frail Anna collapsing in tears in the hallway, to a close-up of Dr. Menzel's face as she narrates the new Menzana promotional video: demand for the transfer procedure is growing every day, she tells us, and not only have over 400 individuals claimed renewed youthful lives, but also twenty-one children have been born to transfer couples. Looking straight into the camera, and thus positioning the film's audience as Menzana's clients (as in the film's

Sarah and Apolain look down on the transfer equipment room with Dr. Menzel. (Image courtesy of Damir Lukacevic)

opening), she promises, "Don't delay. You have more than just the past. You have the future." The screen cuts to black as we are left to contemplate this image of corporate profit as the future.

Yet there is also a kernel of hope in how viewers might respond to this melancholy conclusion about the future rapidly being created by neoliberalism. The centrality of the sentimental imagination in Baucom's counterdiscourse is, I think, key to understanding why Hermann and Anna's love is so important to the plot of the film. It is when they give up the selfishness of preserving their own love and instead work to save Sarah and Apolain that they have effectively moved beyond liberal cosmopolitanism and risked the affective engagement of cosmopolitan interestedness. Baucom writes,

> a formal and proper discourse on justice is finally more concerned with us than with them, more a means of cultivating a type of subject whose ultimate goal is not to acknowledge some responsibility for the unpaid debt of global suffering or to assume some property in the global suffering of the world's dimly lit ex-urban others; [in contrast it is] to enter into a liberal, cosmopolitan community of those like-minded progressive souls [able to] recognize in one another's ability to be affected by such visions of global suffering the grounds of their own common humanity and the (pleasurably guilty) title to their own political sovereignty. (2005: 265)

In its final and direct address to the viewer as a potential client of Menzana Corporation, then, *Transfer* invites us to give up the comfort of cultivating ourselves as concerned subjects of liberal cosmopolitanism who regret such global disparities of wealth. The film encourages us instead to view this suffering through the eyes of cosmopolitan interestedness, to see the roots of our own relative privilege as rights-bearing subjects of liberal discourse in the same founding moment that also created spaces of exception and categories of humanity politically present only as vulnerable, bare life. And this witnessing of cosmopolitan interestedness, Baucom argues, reveals to its agents a view of such facts of history, such hidden miseries, as the way

things are and "as obligation to act on that knowledge—to persist in it as it persists in the world" (295). Witnessing the reality of biotech medicine in *Transfer* we are obliged to be moved by it and question the innocence of modern medical life extension.

Notes

1. This attention to Apolain's teeth might be taken to suggest some continuity between this film's concern with contemporary regimes of biopolitical governance and the biomedical consumption of the bodies marginalized subjects and the history of Nazi death camps, which similarly harvested the bodies of Jews, seeking to render them "useful," including taking the metal from teeth fillings. While there are clearly connections between the way that Nazis used the bodies of Jews and the international market in body organs that this film evokes, there are important distinctions to maintain as well. The Nazi regime sought to use Jewish bodies through their destruction, reducing them to component parts, whereas Menzana seeks to use bodies through caring for and cultivating them, augmenting their health but in the interests of their buyers, not those born into them. As well, evocations of Nazi regimes in things such as exploitation cinema tend to stress excess and the horror of body parts; in contrast, part of the point of *Transfer* is the cool and clinical context in which Menzana conducts its horror, a context that fosters the liberal belief that this care for the bodies serves the ends of both those in the North buying the bodies and those in the South selling them.

2. Research on the transplant market also suggests the persistent effects of racism and colonialism. Scheper-Hughes states that in South Africa, "under the old (apartheid) regime, human tissues and organs were harvested from black and mixed race bodies in the ICU (intensive care unit) without the family's knowledge or consent and transplanted into the bodies of more affluent white patients" (1) and also tells of an incident of a women whose critically wounded black son died in police custody: she was unable to see his body for more than 24 hours and when she was given access she discovered that his eyes had been removed. As she notes, there is an established exchange of black vitality given to white bodies in South Africa: "Township residents are quick to note the inequality of the exchanges by which organs and tissues are taken from young, productive, black bodies—the victims of excess mortality caused by the legacy of apartheid's policies of substandard housing, poor street lighting, bad sanitation, hazardous transportation, and the political and criminal violence that arose in opposition to white control—and transplanted to older, debilitated, affluent, white bodies" (2002b: 40).

3. In using the term melancholy here, Baucom is drawing on Freud's distinction between mourning and melancholia. In Freud's conception, the ego cathects to loved objects and thus suffers from their loss. In the process of mourning, one learns to reinvest this libidinal energy elsewhere, returning it to the subject. In melancholy, the lost object is instead introjected and becomes part of the ego, forestalling the

process of working through grief and trapping the subject in a state of perpetual mourning.

4. There are a number of other recent films that investigate, using SF imagery, the realities of a global market in human tissues and organs. Some, such as *Dirty Pretty Things* (Frears, 2002) also interrogate the context of global inequity that structures such exchanges. Others, such as *Repo: The Genetic Opera* (Bousman, 2008) and *Never Let Me Go* (Romanek, 2010), focus on the biopolitical production of marginalized subjects whose organs can thus be harvested since they do not count as full human beings. Given their different cinematic registers (*Repo*, for example, is a satiric comedy) and geopolitical settings, it is beyond the scope of this chapter to explore their relation to *Transfer* in detail. *Dirty Pretty Things* comes closest, in my view, to *Transfer* in their common focus on the structures of neoliberalist globalization as necessary conditions for this organ market.

5. Sunder Rajan notes further that the actual market value of biotech companies is also doubly speculative: based on imagined future products and also projecting its earnings (and reporting them in ways that produce its "real" stock market value) based on these projections rather than any tangible assets.

6. The relationship of voices to bodies is somewhat difficult to convey because Britt and Nehy's parts were both dubbed by German-speaking actors. When asked about casting at the 2011 IconTLV film festival, he explained that he was unable to find German-speaking actors who looked appropriate for the roles. Thus, he cast English-speaking actors and dubbed their voices. Nonetheless, care is taken in the film through sound editing to at times use the voices associated with Apolain and Sarah for the actors, even when they are speaking as Hermann and Anna, and at other times to use the voices of Andree and Rehberg, even if the bodies on screen when we hear these voices are those of the English-speaking actors.

References

Baucom, Ian. 2005. *Specters of the Atlantic: Finance, Capital, Slavery and the Philosophy of History*. Durham, N.C.: Duke University Press.

Cohen, Lawrence. 2002. "The Other Kidney: Biopolitics beyond Recognition." In *Commodifying Bodies*, ed. Nancy Scheper-Hughes and Loic Wacquant, 9–30. New York: Sage.

Cooper, Melinda. 2008. *Life as Surplus: Biotechnology and Capitalism in the Neoliberal Era*. Seattle: University of Washington Press.

Marx, Karl. 1973. *Grundrisse*. Trans. Martin Nicolaus. Toronto: Penguin Books.

Marx, Karl. 1990. *Capital*. Volume 1. Introduction by Ernest Mandel. Trans. Ben Fowkes. Toronto: Penguin Books.

Rose, Nikolas. 2006. *The Politic of Life Itself: Biomedicine, Power and Subjectivity in the Twenty-first Century*. Princeton, N.J.: Princeton University Press.

Scheper-Hughes, Nancy. 2002a. "Bodies for Sale—Whole or in Parts." In *Commodifying Bodies*, ed. Nancy Scheper-Hughes and Loic Wacquant, 1–8. New York: Sage.

Scheper-Hughes, Nancy. 2002b. "Commodity Fetishism in Organs Trafficking." In *Commodifying Bodies*, ed. Nancy Scheper-Hughes and Loic Wacquant, 31–62. New York: Sage.

Sunder Rajan, Kaushik. 2006. *Biocapital: The Constitution of Postgenomic Life*. Durham, N.C.: Duke University Press.

Thacker, Eugene. 2006. *The Global Genome: Biotechnology, Politics and Culture*. Cambridge, Mass.: MIT Press.

Waldby, Catherine, and Robert Mitchell. 2006. *Tissue Economies: Blood, Organs and Cell Lines in Late Capitalism*. Durham, N.C.: Duke University Press.

5

Capitalism and Wasted Lives in *District 9* and *Elysium*

EWA MAZIERSKA AND ALFREDO SUPPIA

This essay analyzes *District 9* (2009) and *Elysium* (2013) by Neill Blomkamp through the lens of two related concepts, humans-as-waste and human rights, both rooted in Marxist writings. Blomkamp's oeuvre is particularly suitable to our investigation, because this South African director has consistently employed science fictional tropes in his cinematic parables about class struggle in an extrapolated post-industrial, capitalist context. What is of specific interest to him is the erosion of human rights following accumulation of capital through dispossession, technological advancement, growth in population, and migration. However, in the two films he employs markedly different styles to create a discourse on contemporary capitalism as a system of strict social demarcation. In our discussion we will attempt to identify what connects and what divides these two films. Before focusing on Blomkamp's dystopian future, it is worth presenting some original Marxian and post-Marxian remarks on the human-as-waste condition and human rights under the rise of bourgeois capitalism.

The Discourse on Humans-as-Waste and Human Rights

Marx's criticism of capitalism is polyvalent, but perhaps his harshest criticism concerns the fact that under this system the value of human beings is

reduced to creating surplus value, either directly (by selling his/her labor power) or through extracting it from others (by making them work). Those who are unable or unwilling to participate in this economy are reduced to waste:

> The labouring population produces, along with the accumulation of capital produced by it, the means by which itself is made relatively superfluous, is turned into a relative surplus-population; and it does this to an always increasing extent.... This surplus population ... forms a disposable industrial reserve army that belongs to capital quite as absolutely as if the latter had bred it at its own cost. Independently of the limits of the actual increase of population, it creates, for the changing needs of the self-expansion of capital, a mass of human material always ready for exploitation. (Marx 1965: 631–32)

The existence of humans-as-waste is both advantageous and dangerous for the capitalist class. It is advantageous because it allows the capitalists to easily replace unproductive or unruly workers with those who belong to the "reserve army." Further, it helps to "regulate" the market in favor of capital, keeping wages at manageable levels. It is dangerous because when this section of the population reaches large proportions and a high level of discontent, it threatens the power of the capitalists. The capitalist class is thus always living with the danger of the hungry and disgruntled masses depriving it of its privileges. Hence, bourgeois elites try to contain redundant humans by naked force and ideological devices, most importantly convincing the productive laborers that their interests are in conflict with the objectives of the waste and using them to police those at the bottom of the human pile. This happens by pointing to the "natural" differences between the laborers and the waste, regarding their race, ethnicity, intellect, and physical appearance, with the waste being malnourished and in rags, in contrast to the more respectable looking workers.

However, during periods of political upheaval, when the proletariat rises against the capitalists, the dominant classes turn to the humans-as-waste

to help them fight the rebels. Such a scenario is presented by Marx in "The Eighteenth Brumaire of Louis Bonaparte." During the titular event which took place in 1851, Louis Bonaparte, the self-declared Napoleon III, enforced his coup d'état with the help of what Marx names the "lumpenproletariat," consisting of ex-peasants, vagabonds, discharged soldiers, released criminals, escaped galley slaves, pickpockets, tricksters, gamblers, pimps, brothel keepers, ragpickers, knife grinders, tinkers, and beggars. These people, not belonging to the proper proletariat, took the opportunity to gain some power (however minimal or illusionary) by aligning themselves with the most reactionary segment of the French bourgeoisie (Marx 1978: 613–16). Encouraging conflict between proletariat and the "waste" is conducive to sustaining the capitalist status quo, because internal conflict weakens the masses. This explains why, despite numerically dominating the class of capitalists, the workers and the humans-as-waste tend to be politically weak. Another reason is their lack of economic and human capital: financial resources and knowledge about how to improve their position.

Consigning somebody to the position of waste inevitably results in denying this person the right to exist in dignity or even to live at all. On the other hand, people believe that humans are entitled to certain rights, most importantly the right to live, and enjoy certain freedoms; this is their human or "natural" (as it was previously called) right. In religious societies, this belief is based on the assumption that humans are creations of God. However, it is under (secular) capitalism that the idea of human rights became widespread but, as Marx noticed, under the capitalist hegemony, human or natural rights work to protect bourgeois privileges. As Costas Douzinas observes, under capitalism

natural rights support selfishness and private profit. Politics and the state, on the other hand, replace religion and the church, becoming a terrestrial quasi-heaven in which social divisions are temporarily forgotten as the citizens participate in limited formal democracy. The liberal subject lives a double life: a daily life of strife in pursuit of personal economic interest and a second life, which, like a metaphorical Sabbath, is devoted

to political activity and the "common good." In reality, a clear hierarchy subordinates the political rights of the ethereal citizen to the concrete interests of the capitalist presented in the form of natural rights. (Douzinas 2010: 82–83)

Hence, Douzinas continues, for Marx "equality and liberty are ideological fictions emanating from the state and sustaining a society of inequality, oppression and exploitation. While old natural and today's human rights are hailed as symbols of universal humanity, they were at the same time powerful weapons in the hands of the particular (bourgeoisie)" (83). Douzinas also refers to another Marxist thinker, Ernst Bloch, who, in common with Marx, attacked the illusions of "bourgeois natural law" but noticed that human rights "hail also from the tradition of critique of power, convention and law" and were "adopted in a quite different way by the exploited and oppressed, the humiliated and degraded" (85) and thus can be used as a weapon in the revolutionary struggle.

Marx and virtually all authors tackling the subject of human rights point to the state as the privileged, perhaps even the only effective guarantor of human rights. Effective rights follow national belonging. "The gap between universal man and national citizen is populated by millions of refugees, migrants, stateless, moving and nomadic people, the inhabitants of camps and internment centres, the *homines sacri* who belong to 'humanity' but have few if any rights because they do not enjoy state protection" (83). This point was conveyed persuasively by Hannah Arendt in her seminal essay "The Decline of the Nation-State and the End of the Rights of Man":

Civil wars which ushered in and spread over the twenty years of uneasy peace were not only bloodier and more cruel than all their predecessors; they were followed by migrations of groups who, unlike their happier predecessors in the religious wars, were welcomed nowhere and could be assimilated nowhere. Once they had left their homeland they became stateless; once they had been deprived of their human rights they were rightless, the scum of the earth. (Arendt 1958: 267)

However, while Marx and Arendt are scornful of the way the concept of human rights is used by capitalist ideology and how it is implemented in different political realities, they agree, as do other authors, that human rights need to be protected. For Marx, only the communist revolution will realize the universal promise of rights (Douzinas 2010: 94). By contrast, apologists of (capitalist) liberal democracy try to convince the public that this system is not an obstacle to respecting human rights but its guarantor, pointing to the abuses of human rights in faraway places, such as, recently, Iraq, Pakistan, or Afghanistan, although they typically reflect capitalist reality, most importantly colonial exploitation of the Third World by the First World.

To reflect on the problem of the complexity of human rights, Ian Balfour and Eduardo Cadava, in their introduction to a special edition of the *South Atlantic Quarterly*, published in 2004 and devoted in full to the problem of human rights, state,

> Human rights have become one of the most pressing and intractable matters of political life, and perhaps even of life as such. We might even say that there could be no life without human rights, without, at the very least, the right to live. This is why, from their very beginnings, human rights have always been—with and beyond all the praxes that seek to secure them—a way to think about what it means to be human, and what it means to have the right both to live and to be human. (Balfour and Cadava 2004: 277–78)

As Hannah Arendt, and after her Balfour and Cadava, observed, it is not enough to pronounce that something is a human right; human rights call for the existence of legal frameworks and organizations able to ensure their protection against the power of those who want to violate them. In reality, such institutions tend to prove weak against the might of those who, for their own interest, deny human rights to specific groups, often by stating that members of these groups are not fully human, or merely by not catering to their needs.

Each historical period has its own definition of human rights. It also has its own dominant type of human-as-waste and they are interconnected. What people sentenced to the position of waste lack most is usually also at the core of the human rights discourse. What is specific about people condemned to be waste in contemporary times? Sociologists researching this subject point to its scale and durability. Mike Davis, in the book *Planet of Slums*, writes:

> This outcast proletariat—perhaps 1.5 billion people today, 2.5 billion by 2030—is the fastest growing and most novel social class on the planet. By and large, the urban informal working class is not a labor reserve army in the nineteenth-century sense: a backlog of strikebreakers during booms; to be expelled during busts; then reabsorbed again in the next expansion. On the contrary, this is a mass of humanity structurally and biologically redundant to global accumulation and the corporate matrix. (Davis 2006: 11)

Davis published his book in 2006, but his diagnosis is still valid, even more so today, because the proportion of people who can be classified as waste is larger than a decade or so ago. What these people need most is a minimum standard of living, as measured, for example, by access to clean water, food, electricity, and healthcare. This is also, however, what the capitalist authorities deny them, claiming that there is simply "no money" to give them these goods; welfare budgets are already stretched too far. If these poor people strive for these goods, they have to buy them. Such an approach goes hand in hand with the governments' refusal to increase taxation of the rich on the grounds that taking from the rich to give to the poor would not really help the poor, only dampen the ability of the capitalists to create jobs and prosperity for all.

Given that the problem of humans-as-waste is global and it belongs not only to the present but also to the future and is about to reach apocalyptic proportions, it is not surprising that it has been tackled in many contemporary science fiction films. Virtually all films discussed in the second part

of this collection are to some extent concerned with this topic. However, in *District 9* and *Elysium* it is the main subject, and the humans-as-waste (or rather aliens-as-waste in the first film) represented in these films fit most closely the definition of "contemporary redundant humans" as provided by Davis.

Aliens as Waste in *District 9*

District 9 is the full-length feature debut of South African director Neill Blomkamp. The film is a development of Blomkamp's short film *Alive in Joburg* (2006), which contains the motif of the arrival in Johannesburg of aliens from a different planet. Produced by Peter Jackson, the New Zealand director best known for the "Tolkien Trilogy," it boasts a budget of $30 million, which is modest for Hollywood science fiction and fantasy films, but high for the first film of a "provincial."

The film begins with the announcement that aliens have been in Johannesburg for twenty years. These "twenty years" were compared in many reviews to the period since apartheid was abolished in South Africa. Indeed, in 1990, hence roughly twenty years before the film was shot and set, the country's president, Frederik de Klerk, giving in to internal and external pressures, began negotiations to finish this racist system, culminating in multiracial democratic elections in 1994, which were won by the African National Congress under Nelson Mandela. The victory meant, from the perspective of the white population in South Africa, that the "aliens could be among us": the black citizens of South Africa had achieved the same political rights as the white population. However, the enthusiasm of black South Africans gave way to disillusionment, when it became clear that political emancipation did not lead to economic and social emancipation. The bulk of the black population remained poor and by the same token marginalized from the more affluent, white citizens, confirming Marx's diagnosis that political equality not accompanied by economic equality is empty, as it does not lead to true egalitarianism, as mentioned earlier. The very transition can be seen as a pragmatic decision on the part of South African

capitalist elites, namely a shift from one type of capitalism, for which black subjugation, guaranteed by law, was highly advantageous to another one that develops better under conditions of a (formal) equality of black and white inhabitants (Glaser 2001: 32–58).

Since the end of apartheid, South Africa, which is also one of the richest countries in Africa, became a magnet to economic migrants and refugees. It is home to an estimated five million illegal immigrants, including three million coming from neighboring Zimbabwe. This great influx is due to the country's general economic collapse following the EU-imposed sanctions and the failed nationalization/assimilation program, which included the forced land re-redistribution policy introduced by Robert Mugabe's Zanu-PF and, consequently, high unemployment. Under such circumstances emigration appears as the only solution, although it means changing one desperate situation to one that is not much better and ridden with risk. The migrants are not greeted with sympathy by the local population, as their arrival means, in a nutshell, that South African citizens have to share with them their already scarce resources in terms of space, food, and health provisions, not to mention access to culture. Especially hostile are those who are in a similar situation to that to the new immigrants—South Africa's black poor and those belonging to the earlier wave of migrants.

Blomkamp's film lends itself both to literal and metaphorical interpretation. It can be regarded as a prediction about how people would greet guests from another planet, if it happens in specific historical circumstances, namely contemporary South Africa. In this sense, it can be compared to science fiction films in the vein of Peter Watkins's *The War Game* (1965), which attempted to predict the reaction of the population of a British city to a nuclear attack. Other antecedents of *District 9* can be found in John Sayles's *The Brother from Another Planet* (1984) and Graham Baker's *Alien Nation* (1988). What is significant in *District 9* is that there is no fear or euphoria, no "metaphysical thrill," normally taking place during the "primal contact," as portrayed in science fiction literature and cinema. Their arrival is treated with a matter-of-fact attitude, pertaining to the way illegal immigrants are received. This approach points to a certain shift in

meaning of space exploration, which took place in the last thirty years or so, roughly coinciding with the introduction of neoliberalism. Since then it is regarded less as a means to learn about the unknown, to encounter something strange and unpredictable; more often it is seen pragmatically as a way to find solutions to the problems of capitalism, such as discovering new sources of income and getting rid of useless by-products of capitalism (Cooper 2008).

According to a metaphorical interpretation, favored by most reviewers, the "aliens" who arrived in Johannesburg are not extraterrestrial, but represent a certain category of the inhabitants of Earth. There is, of course, no precise equivalent between the signifier (the metaphor) and the signified (what the metaphor refers to), which is the advantage of the metaphor, as it is open to multiple interpretations. In terms of their social and economic position the "aliens" have much in common with the poor illegal immigrants from Zimbabwe and elsewhere in Africa. This is because like these migrants, they arrive in large numbers. In the film it is mentioned that the ship contained a million of them, as opposed to the crews counted in tens or hundreds ascending to Earth in the majority of films about space travel and primal contact. The fact that they are unable to "descend" to the city immediately after their arrival on its "shores," but have to rely on their hosts' curiosity and good will to free and help them to reach the Earth, is another point of correspondence with the illegal migrants. By the time they are brought to a "stable land," they are malnourished and in poor health, again, as is often the case with refugees.

The term "District 9" evokes Cape Town's historic District 6, from which 60,000 of its inhabitants, known as Cape Coloureds, were forcibly removed in the 1970s during the apartheid regime. The aliens are given the nickname the "prawns." The term reflects their specific appearance: a large number of soft tentacles coming from their faces and arms. The term "prawns" is also a reference to "parktown prawns," which is a common name given to a species of king cricket endemic to Southern Africa, found, among other places, in the suburb of Parktown in Johannesburg. "Parktown prawns" are regarded as pests and by the same token the aliens are also regarded as a

pest—something unwelcome and dangerous that needs to be eliminated or at least contained.

The "prawns" are not only the "other" due to their origin and appearance, but "othered" by specific policies of Johannesburg's authorities and ordinary citizens of this town. One of them, as already mentioned, is the policy of ghettoization. Once on Earth, they are moved to temporary accommodation in District 9, a slum made up of wooden huts with minimal facilities. Another means of othering is denying them high quality food, which reduces them to scavenging or purchasing food on the black market from Nigerian gangsters. It is mentioned that the aliens' favorite food is cat food, but it is plausible that they only like this food because they have no access to higher quality nutrition. Neither do the local businesses try to use the "prawns" as laborers, nor do they themselves seek employment, which is regarded as the easiest path to be integrated into a society and earn respect, knowing that such an attempt will be in vain. This confirms the opinion that neoliberalism, unlike industrial capitalism of the nineteenth century, is marked by a diminished need of labor. It is mentioned that the "prawns" breed excessively. This might be due to their lack of access to contraception, as is often the case with the poorest section of society. Their proliferation is used by the authorities as an excuse to destroy their fertilized eggs, what is described as abortion. Again, if the "prawns" were human, this would be regarded as breaking their human rights. At this point it is worth evoking Mary Douglas's ideas in *Purity and Danger: An Analysis of the Concepts of Pollution and Taboo*, first published in 1966. According to Douglas, "Our idea of dirt is compounded of two things, care for hygiene and respect for conventions. The rules of hygiene change, of course, with changes in our state of knowledge. As for the conventional side of dirt-avoidance, these rules can be set aside for the sake of friendship" (Douglas 1988: 7). Furthermore, Douglas explains that dirt "implies two conditions: a set of ordered relations and a contravention of that order. Dirt then, is never a unique, isolated event. Where there is dirt there is system" (35).

Unlike the authorities, which try to increase the gap between the "prawns" and the humans, the film's authors go the other way, so to speak,

by making them feel less different from us, as the film's action progresses. Hence, while at the beginning they seem repulsive, later this impression diminishes, when we see them behaving like people, using language, and looking after their offspring. The crucial point when we warm toward the "prawns" is when one of them, which bears a human name, Christopher Johnson, is singled out and shown behaving in a very intelligent and "humane" way. His small son even comes across as cute. Blomkamp's strategy confirms the view that we tend to hate and fear what we do not know—ignorance is the key to various types of prejudices. Thus, *District 9* remixes, by means of a science fictional discourse, issues addressed by Mary Douglas in her analysis of eurocentric strategies concerning human exclusion. Denied integration into South African society, the "prawns" are forced to live illegal lives. This includes trading with Nigerian gangsters and, although the film is not clear about it, developing technologies that allow them to defend themselves against the humans' attack. The fact that the "prawns" break the law is convenient for the South African authorities, as it allows them to justify turning the screw on them, further reducing their rights. All these policies bring to mind the way Jews were treated in Nazi Germany, and the way illegal migrants and refugees are treated in contemporary times. The Nazi's strategy was to strip the Jews (and other "undesirables") of any signs of their humanity, given their putative "impurity." This was a means to make the Nazi's ultimate goal of annihilating them more acceptable to the Aryan population of Germany. By and large, it is easier to accept marginalization and annihilation of those who look and behave as semi-human (those who look "dirty" and "impure," like the "prawns" in *District 9*), due to being malnourished, demoralized, and forced to break the law, than of those who come across as respectable citizens. Hannah Arendt makes this point in her previously quoted essay:

> The official SS newspaper, the *Schwarze Korps*, stated explicitly in 1938 that if the world was not yet convinced that the Jews were the scum of the earth, it soon would be when unidentifiable beggars, without nationality, without money, and without passports crossed their frontiers. And it is

true that this kind of factual propaganda worked better than Goebbels' rhetoric, not only because it established the Jews as scum of the earth, but also because the incredible plight of an ever-growing group of innocent people was like a practical demonstration of the totalitarian movements' cynical claims that no such thing as inalienable human rights existed and that the affirmations of the democracies to the contrary were more preju- dice, hypocrisy, and cowardice in the face of the cruel majesty of a new world. (Arendt 1958: 269)

Blomkamp's *District 9* suggests that of all the inhabitants of Johannesburg, the most hostile to the aliens are the blacks, who constitute the poorest section of the population. One can see some people saying that their coun- try cannot afford to help them when there are more pressing issues. Such an attitude bears similarity to race relations and the relations between the working class and the oppressed minorities during the period of neoliber- alism in other countries and their representations in science fiction films. David Harvey mentions that "an older generation of mainly white male workers in the US, for example, are incensed at what they consider to be the rising power of minorities, immigrants, gays and feminists, aided and abetted by arrogant intellectual ('coastal') elites and greedy and ungodly Wall Street Bankers who are generally perceived (wrongly) to be Jewish" (Harvey 2010: 248). Adilifu Nama observes that "in the Reagan era, white working-class Americans became increasingly hostile to helping the black and brown underclass, poor, and working poor communities either because their own economic opportunities were stymied or because they perceived that America could ill afford to invest in resource-draining domestic enti- tlement programs, such as welfare and affirmative action, given the need for the country to reassert its economic dominance in a hypercompetitive global marketplace" (Nama 2008: 97).

District 9 begins during the turning of the screw on the "prawns" by the authorities, consisting of moving them from District 9 to District 10, which in the course of action is described as a "concentration camp." It is mentioned that their situation will be worsened because, instead of dwell-

Time to move: the corporate state keeps sweeping inequality under the rug.

ing in the huts, they will be moved to tents and, instead of living in close proximity to Johannesburg, they will be completely cut off from the city. For the authorities it means that the aliens will be easier to police, punish, and annihilate because it will be more difficult for them to trade and engage in any form of economic activity, legal or illegal, while making it even more necessary for their survival. To give the appearance that evacuating District 9 is legal, the authorities prepare a special eviction act, which the "prawns" have to sign. Again, such actions bear similarity to the practice of the Nazis, who not only persecuted the Jews but implicated them in their own op-pression and annihilation. When they refuse to sign their eviction order, they are shot. The operation of transferring the "prawns" from District 9 to District 10 takes place under the watchful eyes of various human rights activists, who gather around District 9 during the time of their relocation.

However, they do not interfere in the process and this is not because the transfer is conducted in a humane way, but because such organizations, as Blomkamp shows, are ineffectual. They do not use physical force, unlike the army and the police, and stand at a distance from those whom they are meant to help, rather than joining forces with them. It could even be argued that their actions do the "prawns" a disservice, because their presence legiti-

mizes the actions of their oppressors; similarly, the visits of the Red Cross to Nazi concentration camps sent the world a signal that some minimal human rights were respected in the camps.

The operation of eviction is conducted not by South African police or its army but by a private organization, named Multinational United (NMU), subcontracted for this purpose by the South African government. This is a typical neoliberal practice, reflecting a drive toward privatization of even the most essential public services and the focus of the neoliberal authorities on security, which results in security becoming a major business. Preoccupation with security points to the contradiction of neoliberalism—although it preaches freedom, it has to rely on a huge apparatus of repression (army, police, private security firms) to ensure its existence (Harvey 2005: 64–86; Hardt and Negri 2006: 3–62).

The advantage of using private armies over national ones is that they are not accountable to democratic institutions that are obliged to respect some human rights, even the rights of their enemies. One can expect from private armies more ruthless behavior than from national ones. The leader of the operation of moving the aliens from one district to another, Wikus van de Merwe, is white and, given his name, of Dutch origin, but his team consists largely of black people. No doubt many of them joined the mercenary army because other careers were unavailable to them. In this respect NMU is not dissimilar to the American army, which includes a disproportionally high number of African American soldiers and predominantly in the position of foot soldiers. This situation also confirms the diagnosis offered by Marx in "The Eighteenth Brumaire of Louis Bonaparte" that political leaders tend to use one section of the poor to fight with another section of the poor, although in this case the proletariat is in charge of fighting the very poor, Marx's equivalent of the lumpenproletariat, rather than the other way round. Here we can also evoke the case of Sonderkommando—a special unit in the Nazi concentration camps used to manning gas chambers and crematoria, made up of the camp's inmates.

Although the "prawns" are not allowed to work, the authorities still try to use them economically and politically, again bringing association with

the uses of the lumpenproletariat as described by Marx. Blomkamp makes reference to two such interconnected uses. One is medical experiments. We guess that the research on the "prawns" might help to cure some serious diseases and prolong human life. This research is conducted without the aliens' consent and it ultimately leads to the death of those used in the experiments. It also causes the "prawns" great physical and mental discomfort, as shown in a scene when Wikus shoots an alien, killing him. In the same lab we see the carcasses of the aliens, hanging on hooks in the same way animal carcasses hang in slaughterhouses. Not surprisingly, these experiments are kept secret, in the same way medical experiments on animals and prisoners are conducted according to the rule "out of sight, out of mind," to avoid disturbing the general population. The second use of the "prawns" has military purposes. The humans assume that the aliens possess sophisticated weapons. Such an assumption strikes one as irrational, because if the "prawns" had such mighty weapons, one would assume that they would use them to defend themselves against their human oppressors. Such irrational (or pretended) faith, however, mirrors Western claims about the large number of chemical and biological weapons amassed by Saddam Hussein's regime and evokes the whole discourse on "weapons of mass destruction" in the hands of rogue states and Muslim terrorists. In the film we learn that only the "prawns" can use their weapons. This can be read either literally—the guns and missiles can only act on the touch of the aliens' "hands"—or metaphorically—they can be used by everybody, but it will be politically too dangerous for humans to use them. A much preferable option is to use the "prawns" and make them responsible for the damage caused, even if they were only puppets in the hands of their oppressors. It is suggested that the lab where the experiments on the "prawns" take place is owned privately, most likely by the same NMU, which is in charge of the eviction operation. Again, this is very advantageous from the perspective of the capitalists, because private companies are less accountable to the public than publicly owned enterprises. Behind the heavily guarded walls of the private lab one can practically do with the "prawns" anything one wishes. As one reviewer noticed, the medical experiments on

the aliens would make the most famous Nazi doctor, Dr. Mengele, envious (Foundas 2009).

Making the "prawns" use their weapons in the service of humans becomes possible thanks to an accident, which takes place during their transfer from District 9 to District 10. The man in charge of the operation, Wikus van de Merwe, becomes infected with the DNA of the "prawns" and starts to change into a "prawn" himself. This metamorphosis, reminiscent of that in *The Fly* (1986) by David Cronenberg, on both occasions points to the danger of genetic manipulation. In *District 9*, however, this motif is used mostly to criticize neoliberal disrespect for human rights, resulting from unrestrained pursuit of surplus value. The key scene of the "infection," when Wikus manipulates an alien artifact that unexpectedly liberates a weird liquid which touches his skin and penetrates his eyes, installs the upcoming tragedy: "contamination." Taking advantage of narrative possibilities only speculative fiction can afford, the "natural-born" citizen, "pure" white man turns out to be "impure" in Douglas's terms, not only spiritually but literally, genetically, which is a sign of our times. The overall depiction of the "prawns" and the condition of Wikus van de Merwe (his transformation into a monster, a borderline creature between the two worlds) could be considered as an allegory of an issue addressed by Douglas:

> We can recognise in our own notions of dirt that we are using a kind of omnibus compendium which includes all the rejected elements of ordered systems. It is a relative idea. Shoes are not dirty in themselves, but it is dirty to place them on the dining-table; food is not dirty in itself, but it is dirty to leave cooking utensils in the bedroom, or food bespattered on clothing; similarly, bathroom equipment in the drawing room; clothing lying on chairs; out-door things in-doors; upstairs things downstairs; under-clothing appearing where over-clothing should be, and so on. In short, our pollution behaviour is the reaction which condemns any object or idea likely to confuse or contradict cherished classifications. (Douglas 1988: 37)

Douglas points to the link between primitive ideas of contagion and moral rules: "It is true that pollution rules do not correspond closely to moral rules. Some kinds of behavior may be judged wrong and yet not provoke pollution beliefs, while others not thought very reprehensible are held to be polluting and dangerous" (Douglas 1988: 129).

Although Wikus seems to hold a position of power thanks to being married to the daughter of MNU's boss, this amounts to very little when he loses his previous appearance (as did Jews and other "undesirables" after receiving the special "treatment" by their Nazi oppressors) and his body becomes an immensely profitable fertile field, from which one can "harvest" valuable organs and tissues. In such circumstances his identity and his human rights no longer matter—his own father-in-law, together with his medical advisers, decide to "disembody" Wikus, effectively treating him in the same way as the "prawns" or laboratory animals.

The contrast between, on the one hand, the disregard shown to Wikus as a person and, on the other hand, the great, even if perverse, care of his body can be linked to Marx's idea of the "fetishism of commodities," according to which the more blood and tears go into the production of a commodity, the more precious and beautiful it tends to be. The difference is that on this occasion Wikus is not producing commodities—he becomes himself a commodity. Once he is pronounced as a "semi-prawn," valuable for medical research and the military industry, he is disowned by his family and friends. We can thus conjecture that the value of love and friendship in this world is subjugated to the power of money, which again points to a wider rule that under neoliberalism everything is financialized, even supposedly spiritual goods, even humans themselves—they only value as much as they can produce or as can be produced from them.

However, in Blomkamp's film it is only humans who live according to this neoliberal logic. The "prawns" behave in a more moral way, as shown by their acceptance of Wikus as one of them, offering him protection from their oppressors, although till the very end he looks more human than "prawn"-like. They also come across as peace-loving and gentle, never at-

The clash of civilizations—and not necessarily the most advanced species prevails.

tacking first and barely rebelling against their harsh treatment by the people. Unlike the humans, who are shown as conspicuously lacking a political leader, as everybody seems to live by the logic of maximizing profit, the "prawns" have one, the previously mentioned Christopher Johnson. This Moses-like figure works incessantly on collecting or creating enough fuel to allow the aliens' spaceship to return to its home and then come again to Earth to save his compatriots. He also promises to help Wikus, which can be read metaphorically—helping people to regain their humanity by respecting each other's human rights. The fact that humans need an "alien" to be saved points to the depth of their moral depravity, caused by giving in to the capitalist logic.

District 9 takes the form of a mockumentary, a discursive strategy already seen in Blomkamp's *Alive in Joburg*. It begins when various people tell us what happened to the "prawns" since they arrived in Johannesburg and the sad story of Wikus van de Merwe. We see an academic specializing in South African history, an investigative journalist, some employees of NMU, Wikus's parents and his wife, and Wikus himself. The last one is presented in a kind of corporate video, informing and promoting the work of his or-

ganization. Each person gives his/her version of the story, as if the author of the film wanted to ensure that he offers us an objective account. Some fragments of *District 9* are shot in black and white and, even in the remaining parts, the hues have been washed out, as in television reports. Moreover, we get the exact time of the action, which, again, suggests an effort to present events with as much precision as possible, an ambition pertaining to documentarists.

It is also interesting to notice how *District 9* makes use of found footage and remix techniques in its re-signification of audiovisual media. Several "documentary" scenes are re-signified by dislocation of its original context. For instance, when some people appear interviewed on the streets, telling about civil discontent and the perils of that neighborhood, they are actually referring to baboon attacks and other concerns involving daily life in Johannesburg's poorest areas. By editing, the film takes advantage of interviews concerning something else in order to organize a structural fabulation (Scholes 1975) addressing alien encounters.

As Craig Hight notes, mockumentary is frequently employed in science fiction narratives. The (in)famous 1938 *War of the Worlds* radio broadcast falls into this category, together with *The X Files* (Hight 2008: 286). To this we would also add Peter Watkins's "documentaries of the future," like the previously mentioned *The War Game* (1965), as well as *Privilege* (1967) and *Punishment Park* (1971), with which Blomkamp's film has much in common. One of the latest examples can be found in Graham Baker's *Alien Nation* (1988), to which *District 9* bears interesting similarities and differences. *Alien Nation*'s narrative strategy also relies on newsreel aesthetics in its initial scenes, and Baker's film shares with *District 9* a focus on the material and cultural dramas involving the coexistence of an alien community on Earth, in the case of *Alien Nation* an alien community "virtually" incorporated to the late 1980s American urban society. By using the science fiction genre to portray imagined minorities and to speculate, Blomkamp also sides with other contemporary filmmakers such as the American media artist Alex Rivera. Similar to Blomkamp, Rivera expanded his short science

fiction mockumentary film, *Why Cybraceros?* (1997), into a feature film with a focus on segregation, neoliberalism, and exploitation, *Sleep Dealer* (2008) (see chapter 8 in this book).

Hight notes that the agendas used by the authors of mockumentaries vary. However, we will mention here the two most likely reasons why this style is employed in *District 9*. One is for dramatic purposes. As Hight writes, "A dramatic mockumentary might use the observational form in order to justify a limited set of narrative information being provided to an audience, through replicating the partial access available to a documentary film crew" (207). He adds that this tendency has been used in horror and science fiction narratives to produce suspense. This is also the case in *District 9*; withdrawing information points to the fact that documentary filmmakers have only partial knowledge about the reality they represent and adds to the suspense. Another reason to use mockumentary is to satirize the existing forms of documentaries. "Satire establishes a more political stance towards its target, intending to replace it with something better" (Hight 2008: 207). This is, again, the case with *District 9*, and in this sense Blomkamp's film follows in the footsteps of the previously mentioned Alex Rivera as movies of both directors use mockumentary to account for the complexities of exploitation and commodification that happens under the neoliberal regime.

In the case of Blomkamp's film, the point of using such a style is not only to engage critically with the experience of the aliens in contemporary Johannesburg, but also, to paraphrase Jean-Luc Godard, with the reality of its representation. Thanks to watching *District 9* we realize that we tend to accept uncritically certain representations not because they are truthful, but because they follow a certain set of conventions or fit into a particular institutional format. For example, we tend to believe in material presented in television news programs because it is included in these programs and they employ a specific aesthetic. Blomkamp's film encourages us to reflect on our viewing patterns and be more skeptical about what we see on screen. As we argue in due course, this is not the case with *Elysium*.

Rightless People and Capitalist Privileges in *Elysium*

The commercial and critical success of *District 9* took Blomkamp to Hollywood, where he made his second feature, *Elysium*, on a budget of a $115 million, roughly four times more expensive than *District 9*. This fact, as we argue in due course, had a significant impact on the style and aspects of ideology of the film. *Elysium* deals with the same topic as *District 9*: the life of those sentenced to waste by privileged members of the society and the conflict between the rights of the mighty and the excluded. However, Blomkamp's second science fiction apartheid parable produced in Hollywood has not been as critically acclaimed as his South African feature film debut. In his film review of *Elysium* in *The Guardian*, Peter Bradshaw remarks that "nothing in the movie matches the fascination of its premise and its opening 10 minutes: the undisturbed status quo is mesmeric. Once the narrative grinds into gear, however, the film's distinctive quality is lost" (Bradshaw 2013).

In *Elysium*, in lieu of aliens, human beings play the role of waste in an ultra-neoliberal society that fiercely segregates the proletariat from the wealthy elite. Reproducing the obvious heaven-and-hell structure (a vertical geography reminiscent of Fritz Lang's *Metropolis*), near-future Earth is herein a hellish place where masses of workers fight for survival, sharing the wasteland with the lumpenproletariat, whereas the elite enjoy a quasi-immortal life up in the heavens—the pristine utopian artificial environment called Elysium, a space station the size of the moon that floats harmoniously over the stratosphere, orbiting Earth. The idea of the artificial planet occurred to Blomkamp from a *National Geographic* illustration of the proposed Stanford Torus space station, designed by concept artist Syd Mead. Blomkamp subsequently hired Mead to design Elysium's luxury environments (Cox 2013).

However, the privileged elites in *Elysium* are removed much further from the masses than in *District 9* and *Metropolis,* as they literally live on a different planet. This has a significant impact on the relationship between the two societies. For the poor in *Elysium* it is much more difficult to reach the

spaces of the wealthy than in *District 9* and *Metropolis*. By the same token, the rich are much more insulated from the intrusions of the poor than the characters in the other films. It has an impact on the human rights of the poor. Although in all the films they are disrespected, in *District 9* and *Metropolis* this is done quietly and with a sense of guilt. In *District 9* the neglect of the welfare of the aliens is challenged by humanitarian organizations. The inhabitants of Elysium, by contrast, do not see the plight of those who remained on Earth as their responsibility; their only concern is to remain at a comfortable distance from them.

This brings to mind the growing indifference of the rich countries to the plight of the poor, as well as the plight of their "internal aliens," usually consisting of ethnic minorities. Hence, we can argue that *Elysium* offers reenactment of a Mexican American border crisis, as well as other crises of this kind, for example a North African–European crisis, because in all these situations poor, unhealthy, and oppressed people put all their hopes in illegal immigration.

For the underprivileged the greatest attraction of Elysium is a "med bay." This prop, a home appliance available at any home in this paradise, provides medical care that heals all diseases, accidents, and malformations, a *deus ex machina* not so different from magic potions, magic carpet rides, and the like. However, it can also be seen as a metaphor of "full treatment" that wealthy people receive these days, which includes plastic surgery: a practice that does not ensure immortality, but allows its recipients to look and feel younger than they really are. The inhabitants of Earth also receive medical treatment, but it is very basic and only when their lives are at stake. The disparity between the residents of Elysium and the Earthlings in their access to healthcare confirms the observations made by Marx and Arendt: "human rights" are an empty letter if they are not supported by legal regulations, most importantly protection by the nation state, and economic privileges, which only come by introducing socialism. The poor, as shown by Blomkamp, have neither. There is no government to represent and protect them. Instead, the role of the authorities is to police and harass them, as was also the case with the "prawns" in *District 9*. Moreover, as in the Nazi concentra-

The decaying Earth in *Elysium*: subhuman working conditions in a predominantly Latino environment.

tion camps, this role is delegated by the mighty to what can be described as the underclass, in this case the robots. As Max, the main character in the film, learns, there is no point to argue with the robot, as he is programmed merely to oppress and punish most efficiently. Blomkamp thus shows that the development of technology under the conditions of capitalism does not bring any widespread social benefits. On the contrary, it leads to an increase in economic and social divisions and, by the same token, it deprives people of their rights, dehumanizing them, as also demonstrated in other chapters of this book.

An orbiting Eden in *Elysium*: immortality granted to French and English speakers with a bloodline.

Although the inhabitants of the Earth, like the "prawns" in *District 9*, are treated like vermin, it does not mean that they are useless for those living in Elysium. We can conjecture that it is thanks to their labor that the inhabitants of Elysium enjoy their luxuries. Some of them are employed perversely, again in common with the inmates of concentration camps, in the production of the means of their own oppression and destruction, exemplified by a factory producing robots, which is a property of Armadyne, the world's leading weapon manufacturing corporation. As one might expect, the conditions of working there are very harsh. Health and safety regulations do not exist or are not obeyed, hence accidents are common. The management of the factory does not mind their workers being maimed or killed, because, as in the concentration camps or contemporary sweatshops, labor on Earth is extremely cheap: a dead or injured worker can easily be replaced by another one. Needless to add that the workers in Armadyne have no labor rights; they are not allowed to make any demands or go on strike. On the entrance to the plant they are checked, ironically, for possessing weapons.

Blomkamp also shows, mirroring our present times, that illegal immigration to Elysium is a profitable black market exploited by futuristic coyotes. Hence, the Earthlings end up exploited twice: when they try to make their living on Earth and when they try to escape. However, in line with the Hollywood formula, which attempts to bring hope in the face of hopelessness, Blomkamp disrupts this depressing narrative by presenting his main character, the previously mentioned Max, as a superhero. Max is a blue-collar Earthling on parole. Initially he tries to make his living in accordance with his world's "natural laws," staying out of trouble. He accepts subhuman working shifts in Armadyne, lives in a barely inhabitable shack, and puts up with being harassed by the authorities, namely the robotic police and robotic civil servants. Life goes as badly as possible for Max until he is victimized by a lethal accident in the factory, an outcome of his superiors' negligence and authoritarianism that will put him face to face with his death in five days. Caught in this cul-de-sac, Max decides to sell his criminal skills to his former partners in crime, just one more time, in return for a trip to Elysium, where he could save his life using a med bay.

By orders of the kingpin Spider, Max kidnaps an Elysium mogul, who comes to be the owner of Armadyne, John Carlyle, but the trade ends up being more complicated than expected. Led by Kruger, mercenaries start chasing Max by order of Delacourt, Elysium's minister of defense, a kind of extrapolated metonymy for former British prime minister Margaret Thatcher. The events become even more complex when a plot, put forward by Delacourt with the aid of her watchdogs (Kruger and company), comes to be unveiled. Yet, toward the end all characters, including cold-blooded Delacourt herself, lose control of the situation. At this point Max, like a new Jesus, has the chance to either save his life or "redeem" the world by granting all Earthlings effectively the chance to become citizens of Elysium. Predictably, he sacrifices his own life for the sake of his compatriots. The film ends when a fleet of medical spaceships carrying med bays is dispatched to Earth. Soon after its landing, robot-doctors start caring for the Earthlings, which might suggest the rise of a new social order. As anyone can see, the bulk of *Elysium*'s plot derives from the contemporary global, political, and economic agenda, as stated by Blomkamp himself in an interview with *The Guardian*.

> The film's intransigent robot parole officer was inspired by Blomkamp's experiences with automated bureaucracy ("I'll actually huck the phone across the room trying to deal with a bank"); a nasty radiation incident has parallels with developing-world labour (specifically, he says, the Bangladesh textile industry); while the totalitarian slumland was inspired by his own 2005 arrest by cops on the bribe in Tijuana. (Cox 2013)

To a large extent, *Elysium* conveys a messianic-conciliatory speech akin to the highly criticized moral featured by Fritz Lang's *Metropolis* approximately eighty years ago: "The mediator between head and hands must be the heart." Even though Max is far from being a member of the ruling class in *Elysium*, his trajectory, in the company of Frey, somewhat echoes the couple Freder-Maria from *Metropolis*. That said, there are also important differences between the two films, perhaps reflecting the cynicism or realism of the neoliberal era. Maria in Lang's film was completely selfless; she acted solely

for the benefit of the underprivileged. Max in Blomkamp's movie is primarily concerned with his own welfare; his saving the world can be described as a by-product of saving himself. However, in this way Blomkamp's film is closer to the scenario offered by Marx in *The Communist Manifesto*, which pronounced that if the working class would ever liberate itself from capitalist chains, it will be thanks to the effort of the proletariat itself, not that of an enlightened or altruistic bourgeoisie. That said, Marx regarded such a salvation as an outcome of the group, not individual action.

The happy ending is only one of several motifs that render *Elysium* a typical Hollywood product. Another is the use of a star, Matt Damon, in the role of the new Jesus, bringing salvation to his people, whose main nemesis, Delacourt, is played by an even greater Hollywood star, Jodie Foster. Although Damon plays down his star persona, nevertheless such a casting choice carries significant ideological connotations. In particular, Damon's character is a white/Northern man among a largely Latino population. This might be read as a suggestion that those who constitute the bulk of humans-as-waste, namely the people from Mexico, South America, and Africa, cannot save themselves; they need a Hollywood-style "white man" to do the job. Furthermore, a large part of the film is taken up by a duel between Max and his arch-nemesis, Kruger, who works for the Elysium authorities. As is the case in action movies, the spectacular dimension of these scenes, featuring two exceptionally strong and resilient individuals, diverts our attention from the plight of those who are not in a position to defend themselves in such a spectacular way. Moreover, as much as criticizing the luxurious style of the Elysians, the film fetishizes it. His own high budget can be seen as a monument to the neoliberal order, in which accumulation of capital in the hands of the few (including the most powerful film producers) is a condition of shooting super-productions. Blomkamp's own transition from the marginal South Africa and the mockumentary style of *District 9* to Hollywood and the mainstream *Elysium* somewhat weakens the political message conveyed by *Elysium*'s narrative. Still, *Elysium* is one of the most successful films using a science fiction formula to criticize the logic of neoliberal capitalism.

Conclusion: Who Needs Human Rights

District 9 and *Elysium* can be read as morality tales about the need to protect human rights and, indeed, the need to extend some of these rights to other types of sensing creatures, such as animals and, perhaps in the future, creatures possessing artificial intelligence. In this regard, Blomkamp's first film tackles the issue of "specism," as well as other controversial aspects related to contemporary ethics and philosophy addressed by authors such as Peter Singer, from his *Animal Liberation* (1975) onward. Both films also suggest that respecting human rights is not only in the interest of the poorest and weakest sections of society, but also the rich and the powerful, because the latter might need them, too. This is especially true under the conditions of neoliberalism, where businesses are very volatile and many of yesterday's millionaires are today's bankrupt and respectable citizens who turn out to be criminals.

At the same time, Blomkamp's films confirm a Marxist diagnosis that the capitalist state—especially of the type we observe today, namely the "reduced" state, where most of its old functions, including security, are subcontracted to private companies, whose main objective is profit—is unable to ensure respect for human rights, either of any "stateless people" (or creatures) entering its territory or even of its own citizens. The right to unlimited private property cannot be squared with universal rights to security, prosperity, even life itself. That said, *District 9* and *Elysium* do not offer any viable solution to the problems of humans-as-waste and the mass violation of human rights, in the case of *Elysium* resorting to the fairy-tale happy ending, expected from Hollywood productions, that emphasizes the role of a superhero, able to stand up to the power of the army, the police, and the most powerful corporations.

References

Anders, Charlie Jane. 2008. "Cyberpunk South of the Border: io9 Meets *Sleep Dealer*'s Alex Rivera. *io9*." November 17. io9.com/5089202/cyberpunk-south-of-the-border-io9-meets-sleep-dealers-alex-rivera. Accessed November 4, 2013.

Arendt, Hannah. 1958. "The Decline of the Nation-State and the End of the Rights of Man." In *The Origins of Totalitarianism*, 267–302. London: George Allen and Unwin.

Balfour, Ian, and Eduardo Cadava. 2004. "The Claims of Human Rights: An Introduction." *South Atlantic Quarterly* 103, no. 2–3, 277–96.

Bradshaw, Peter. 2013. Review of *Elysium*. *The Guardian*, August 22. www.theguardian.com/film/2013/aug/22/elysium-review. Accessed September 21, 2014.

Comolli, Jean-Luc, and Jean Narboni. 1992 [1969]. "Cinema/Ideology/Criticism." In *Film Theory and Criticism*, 4th ed., ed. Gerald Mast et al., 682–89. Oxford: Oxford University Press.

Cooper, Melinda. 2008. *Life as Surplus*. Seattle: University of Washington Press.

Cox, David. 2013. "Why Elysium's Moral Message Is Destined to Miss Its Mark." *The Guardian*, September 2. www.theguardian.com/film/filmblog/2013/sep/02/elysium-morality-neill-blomkamp. Accessed September 21, 2014.

Davis, Mike. 2006. *Planet of Slums*. New York: Verso.

Douglas, Mary. 1988 [1966]. *Purity and Danger: An Analysis of the Concepts of Pollution and Taboo*. London: ARK.

Douzinas, Costas. 2010. "*Adikia*: On Communism and Rights." In *The Idea of Communism*, ed. Costas Douzinas and Slavoj Žižek, 81–100. London: Verso.

Engler, Mark. 2009. "Science Fiction from Below: Alex Rivera, Director of the New Film *Sleep Dealer*, Imagines the Future of the Global South." *Foreign Policy in Focus*, May 13. fpif.org/science_fiction_from_below/. Accessed November 4, 2013.

Foundas, Scott. 2009. "Aliens as Apartheid Metaphor in *District 9*." *Village Voice*, August 11. www.villagevoice.com/2009-08-11/film/aliens-as-apartheid-metaphor-in-district-9/. Accessed October 12, 2013.

Glaser, Daryl. 2001. *Politics and Society in South Africa*. London: Sage.

Hardt, Michael, and Antonio Negri. 2006. *Multitude: War and Democracy in the Age of Empire*. London: Penguin.

Harvey, David. 2005. *A Brief History of Neoliberalism*. Oxford: Oxford University Press.

Harvey, David. 2010. *The Enigma of Capital and the Crises of Capitalism*. London: Profile Books.

Hight, Craig. 2008. "Mockumentary: A Call to Play." In *Rethinking Documentary: New Perspectives, New Practices*, ed. Thomas Austin and Wilma de Jong, 204–16. Berkshire: Open University Press.

Marx, Karl. 1965 [1887]. *Capital: A Critical Analysis of Capitalist Production*, vol. 1. Moscow: Progress Publishers.

Marx, Karl. 1978 [1852]. "The Eighteenth Brumaire of Louis Bonaparte." In *The Marx-Engels Reader*, 2nd ed., ed. Robert C. Tucker, 595–617. New York: W. W. Norton and Company.

Nama, Adilifu. 2008. *Black Space: Imagining Race in Science Fiction Film*. Austin: University of Texas Press.

Rivera, Lysa. 2012. "Future Histories and Cyborg Labor: Reading Borderlands Science Fiction after NAFTA." *Science Fiction Studies* 39, no. 118, part 3 (November): 415–36.

Scholes, Robert. 1975. *Structural Fabulation: An Essay on Fiction of the Future*. South Bend, Ind.: University of Notre Dame Press.

Singer, Peter. 2002 [1975]. *Animal Liberation*. New York: Ecco Press.

Yates, Michelle. 2011. "The Human-As-Waste, the Labor Theory of Value and Disposability in Contemporary Capitalism." *Antipode* 43 (5): 1679–95.

6

Marxism vs. Postmodernism
The Case of *The Matrix*

TONY BURNS

The Wachowski brothers' film *The Matrix* has generated an enormous amount of interest since its release in 1999. So far at least eighteen books have been published devoted to one or another aspect of the film (Boyd and Larson 2005; Condon 2003; Constable 2009a; Diocaratz and Herbrecher 2006; Faller 2004; Gillis 2005a; Grau 2005; Haber 2003; Irwin 2002; Irwin 2005b; Kapel and Doty 2004; LaVelle 2002; Lawrence 2004; Lloyd 2003; Marriott 2003; Seay and Garrett 2003; Worthing 2004; Yeffeth 2003).

I make two starting assumptions. The first is that *The Matrix* is of interest because it tells us something about contemporary society and politics. It addresses, cinematically, issues that are of concern to social and political theorists. The second is that an understanding of both contemporary society and of works of science fiction (whether literature or film) necessarily requires the invocation of some theoretical framework or other. In the case of *The Matrix* this is usually thought to be not Marxism, but postmodernism—a way of thinking about the world generally, associated in France with the writings of Jean Baudrillard (Butler 1999; Constable 2009a; Lane 2000; Levin 1996).

Given the influence of postmodernism on leftist intellectuals and on critical theory generally in the last two or three decades, it is not too surprising that it has also had an influence on the genre of science fiction, and on those who have written about it (Broderick 1995; Butler 2003; Call 1999; Cavallaro 2000; Csicsery-Ronay 1991; Jorgensen 2009; Wolmark 1994). More to the point, however, for present purposes, it has influenced a number of those who have written about *The Matrix*. Indeed, there is a widely held view that *The Matrix* is a work of postmodern science fiction. There are a number of reasons for thinking this. However, one of them is the fact that the Wachowski brothers have indicated the importance of the work of Jean Baudrillard, especially his *Simulacra and Simulation,* as a source of theoretical influence upon them (Constable 2005; Constable 2009a; Detmer 2005; Felluga 2003; Gillis 2005b; Gordon 2003; Hanley 2003; Rovira 2003; Wardlow 2003; Watson 2003; Weberman 2002; Wilhelm and Kapell 2004).

In contrast, very little has been written about *The Matrix* from the standpoint of Marxism. The film appeared too late to be included in Carl Freedman's *Critical Theory and Science Fiction* (2000) and, although it is mentioned in their introduction, there is not a separate chapter devoted to it in Bould and Miéville's more recent *Red Planets: Marxism and Science Fiction* (2009: 12–17). Indeed, I have so far been able to identify only two academic papers devoted to this subject (Danahay 2005; Danahay and Reader 2002). This is a surprising lacuna in the critical literature devoted to the interpretation of *The Matrix*. For a number of issues addressed by the Wachowski brothers in the film are also of obvious interest to Marxists. I should emphasize at the outset that I am not claiming that the Wachowski brothers are Marxists. It is not at all my intention to speculate about the theoretical intentions, if any, that they had when making the film. My focus is on the issues that are addressed in the film, and on how these issues might best be understood, irrespective of what the Wachowski brothers themselves happen to think about them.

In what follows, I identify six core issues addressed in *The Matrix* and discuss each of them in turn. In each case I believe that it is Marxism, or at least one version of it, rather than postmodernism that best helps us to

understand the issue in question. These issues are: 1. appearance and reality; 2. science and technology; 3. consumer society; 4. nihilism and ethics; 5. media society; and 6. education and emancipation.

Appearance and Reality

So far as this first issue is concerned, it must be conceded at the outset that there is at least some evidence which supports the view that *The Matrix* is a work of postmodern science fiction. Those commentators who have discussed this issue all draw attention to the scene in which the film's central character, Neo, pulls a hollowed out book from the shelf. The book is Baudrillard's *Simulacra and Simulation*. Moreover, when Neo opens it, we immediately see the opening page of the chapter entitled "On Nihilism," which has been moved from the back of the book to the middle, and from the right-hand side of the book to the left. Similarly, when one of the other central characters of the film, Morpheus, explains to Neo for the first time what the Matrix is, he introduces the computer program by welcoming Neo to "the desert of the real," a phrase taken from another of Baudrillard's works, *Simulations* (1983: 2). It has also been noted that in the first "shooting script" of

The reality behind *The Matrix*.

the film Morpheus refers to Baudrillard explicitly by name (Constable 2005: 151; Detmer 2005: 94; Felluga 2003: 86). Indeed, according to David Detmer, "we have the testimony of Baudrillard himself that the Wachowskis asked him to serve as a consultant for their movies" (2005: 93). Finally, Keanu Reeves, the actor who plays Neo, has recorded that he was asked to read Baudrillard as preparation for shooting the film (Constable 2005: 151; Detmer 2005: 93). It seems clear enough, therefore, that when they made the film the Wachowski brothers were extremely interested in the work of Baudrillard and considered the film to be in some sense a Baudrillardian work.

Nor is it the case that the Wachowski brothers might be said to have completely misunderstood Baudrillard and his ideas. It was, after all, Baudrillard, and not they, who first maintained that in the age of simulacra and simulation, "genetic miniaturisation is the dimension of simulation." In this world, Baudrillard argues, the "real" is "produced from miniaturised units, from matrices, memory banks and command models." As such, it is "nothing more than operational." Indeed, it is, Baudrillard argues, "no longer real at all," strictly speaking, but "hyperreal" (Baudrillard 1983: 3). These ideas do seem to apply very well to the simulated world of the Matrix within the film.

On the other hand, however, a number of commentators have pointed out that the philosophical assumptions upon which *The Matrix* is based are not those of Baudrillard and postmodernism. There are a number of reasons for thinking this. Consider, for example, the Wachowski brothers' attitude toward questions of metaphysics, especially the traditional distinction, made by philosophers from the time of the Presocratics down to Nietzsche, between the concept of appearance and that of reality. With respect to this issue, Nietzsche famously argued, in the manner of contemporary constructivism, that no such distinction can be made, and that "the apparent world is the only one" (Nietzsche 1968 [1888]: 35–36). In making this claim, Nietzsche pronounced the death of metaphysics. However, the same idea can also be found in the writings of postmodernists like Baudrillard who, in his "The Orders of Simulacra," explicitly endorsed Nietzsche's critique of traditional metaphysics: "As Nietzsche says there, 'Down with all hypotheses that have allowed the belief in a real world'" (1983: 115).

This is not an attitude of mind shared by the Wachowski brothers when they made *The Matrix*. On the contrary, they placed the traditional metaphysical distinction between appearance and reality at the very heart of the film. As Zynda Lyle has noted, "The overall position of *The Matrix* on this issue is realist," rather than constructivist, precisely because the movie "draws a sharp distinction between the simulated Matrix-world and the real world." The people inside the Matrix do not "know it is an illusion, but it is" (2003: 51). Similarly, Andrew Gordon has argued that *The Matrix* is premised on "the old distinction," which has lain at the heart of the metaphysical enterprise for at least two millennia "between appearance and reality," that is to say, "a division between two worlds: a false world of appearances that obstructs or disguises the true world" (2003: 120).

In this respect, the philosophical assumptions upon which *The Matrix* is based are significantly different from those of Jean Baudrillard and postmodernism. It is perhaps not too surprising that Dino Felluga has claimed that although *The Matrix* "is clearly influenced by Baudrillard's ideas" regarding a number of issues, nevertheless "it waters them down to the point that it doesn't really reflect his thinking" at all (2003: 119). Indeed, in Felluga's opinion, the Wachowski brothers simply "misunderstand postmodernist theory" (2003: 96). I am not at all surprised, therefore, by the fact that Baudrillard himself has stated that the Wachowski brothers had misunderstood him when they incorporated a reference to the ideas laid out in his *Simulation and Simulacra* into the film. As Baudrillard puts it, "The most embarrassing part of the film is that the new problem posed by simulation is confused with its classical, Platonic treatment." This is, he says, "a serious flaw" (Baudrillard 2004; but see Constable 2009a: 26–27, 157). I shall return to the issue of the influence of the philosophy of Plato on *The Matrix* later.

According to several commentators, then, including Baudrillard himself, there are good reasons for not regarding *The Matrix* as a work of postmodern science fiction. In their view, far from being postmodern, the film is quite old-fashioned in terms of its philosophical assumptions. Indeed, David Detmer has gone so far as to claim that the film is "profoundly *anti-postmodern*," because Neo, Morpheus, Trinity, and their group "clearly be-

lieve in reality—in a real world that is to be defended against the artificial world of the Matrix" (2005: 106).

If, philosophically speaking, *The Matrix* is not a work of postmodern science fiction, then how is it best characterized? Which theoretical framework can be most fruitfully applied when assessing the intellectual premises upon which the film is based, together with their political significance: their relevance for a critical theory of contemporary society? When attempting to answer this question, very few commentators have pointed out the affinities that exist between *The Matrix* and Marxism. It seems to me, though, that the film has much more in common with Marxism than it does with postmodernism.

A core element of Marxist political economy, and of science, as Marx understood it in *Capital,* volume 1, is the belief that we can make a distinction between how things appear and how things really are, and that the aim of all science is to get behind or beneath the misleading surface appearances of things in order to establish what is really going on beneath the surface. In this sense the assumptions of Marxism are, in a number of respects, similar to those of traditional metaphysics from the time of Plato onward.

In the case of Marx himself, of course, the misleading appearances can be associated with the economic theories of vulgar economists, who conceive of the social relations of a capitalist society as being between free and equal individuals, voluntarily entered into for reasons of self-interest, and therefore as being not at all oppressive. As against this, as is well known, Marx suggests that a truly scientific political economy will present a critique of ideological illusions or mystifications of this kind and lay bare the essentially exploitative social relations of production that predominate in contemporary capitalist society. Indeed, there are a number of occasions in his *Economic and Philosophical Manuscripts of 1844* when Marx refers to the condition of the workers in a capitalist society as being analogous to that of the slaves in the pre-capitalist societies of the ancient world. The notion of wage-slavery is central to Marx's thinking at this time (1967 [1844]: 27, 33, 46, 74–77).

The conceptual distinction between appearance and reality is central to the thinking that underpins *The Matrix*. It is also central to Marxism. However, thinking of this kind has no part at all to play in the philosophy and social theory associated with postmodernism. The main source of inspiration for postmodernism is the philosophy of Nietzsche, which, as we have seen, rejects metaphysics as traditionally understood. This is one of my reasons for thinking that *The Matrix* is not a postmodern film at all, despite the allusions to the work of Baudrillard within it.

Science, Technology, and Slavery

As Christopher Falzon has noted, the basic scenario of *The Matrix* "is that most of humanity has been enslaved by a race of intelligent machines who use human bodies as a power source" (2002a: 29). Indeed, human beings are referred to in the film as if they were nothing more than a source of energy supply, as batteries or "copper-tops" (Danahay and Reader 2002). However, the vast majority of them, as Falzon also notes, echoing Herbert Marcuse's thesis in *One Dimensional Man*, are "completely unaware of their real situation." To them "everything seems normal because a supercomputer feeds them a simulated reality (the Matrix)." Falzon points out that "only a few rebels have managed to escape this enslavement and are able to offer resistance to the machines" (2002: 29). *The Matrix* tells the story of the members of this resistance movement, and especially that of its central character, Neo, in their effort to emancipate humanity from this new form of slavery.

There are two things about this characterization of *The Matrix* that interest me. The first is the suggestion that the film is about slavery and humanity's struggle to emancipate itself from its own enslavement. This has been an important theme for philosophers and social theorists in the modern era, from the time of Hegel onward. It is not too surprising, therefore, that William Irwin has made this connection explicitly when discussing *The Matrix*. As he puts it, the film illustrates "what the philosopher Georg Hegel called the 'master-slave dialectic'" (2005a: 13). In so doing, it "appeals to what is

universal" in human history, namely "the struggle to overcome" all forms of slavery and "oppression" (2005a: 13).

The second interesting thing about *The Matrix* is the fact that it addresses questions relating to the place of science and technology in contemporary society. Read Mercer Schuchardt has argued, for example, that the basic message of *The Matrix* is that we are all "pawns in a modern technological society where life happens around us but is scarcely influenced by us. Whether it is by our choice, or unwillingness to make a choice, our technology already controls us" (2003: 30). As Irwin has noted, a similar story is also told by Hegel when discussing the master-slave dialectic in his *Phenomenology of Spirit*. According to Irwin, in Hegel's account "the master becomes so dependent on the slave that eventually the tables are turned" (2005a: 14). A "Hegelian reversal" of this kind, Irwin argues, is central to the plot of "the first Matrix film" (2005a: 14).

In this respect, *The Matrix* can be associated with both the history of science fiction and that of dystopian literature, especially the notion of "the future as nightmare" (Amis 2000 [1960]; Baccolini and Moylan 2003; Hillegas 1967; Walsh 1962), for a concern with the ethical implications of science and technology, and the negative consequences for mankind of developments in this area, is central to that history. It can be found, for example, in works such as H. G. Wells's *The Sleeper Awakes*, Yevgeny Zamyatin's *We*, and Aldous Huxley's *Brave New World* (Moylan 2000). An early expression of this concern can also be found in Mary Shelley's novel *Frankenstein,* the often overlooked subtitle of which is *The Modern Prometheus.* Shelley's monster can easily be seen as a metaphor for science and technology out of control. On this view, science and technology are supposed to provide a solution to all the problems of mankind. In particular they hold out the promise of emancipating humanity from servitude, especially that which is associated with the compulsion to manual labor. This assumption lies at the heart of the idea of the "scientific utopia," from the time of Francis Bacon onward. According to dystopian thinkers, however, there is a darker side to this alleged story of human progress. For innovations in science and technology always bring with them new and unforeseen problems, new forms of enslavement and oppression.

"Welcome to the Desert of the Real."

A similar idea can also be found in the writings of Marx and Engels. For example, in the critique of anarchism presented in his essay "On Authority," Engels points out that "if man, by dint of his knowledge and inventive genius, has subdued the forces of nature," using new machinery made possible by recent developments in the fields of science and technology, nevertheless it is also true that "the latter avenge themselves upon him by subjecting him, in so far as he employs them, to a veritable despotism" that is "independent of all social organisation" (Engels 1958 [1872]: 637). And in *The Manifesto of the Communist Party,* Marx and Engels make the same point by employing the simile of "the sorcerer's apprentice." Modern bourgeois society is, they say, "like the sorcerer, who is no longer able to control the powers of the nether world whom he has called up by his spells" (Marx and Engels 1958 [1848]: 39).

A concern with this issue can also be found in the theory of alienation that the young Marx lays out in his *Economic and Philosophical Manuscripts of 1844.* For example, one of the four dimensions of alienation that Marx identifies in the *Manuscripts* has to do with the nature of the labor process in modern capitalist societies, within which machine production predominates. As Martin Danahay and David Reader have noted, Marx is very clear that within this process those involved, the workers, are as much enslaved to the machines they operate as they are to the individual capitalists who employ them (2002: 217–18). This is at least part of what Marx means when

he talks about alienated labor in the *Manuscripts*. The suggestion made by Marx is that of society itself as being a machine, or machine-like, and that within it human beings have been reduced to the status of robots, automata, or "cogs in the machine." Danahay and Reader also note that, in the *Manifesto of the Communist Party*, Marx and Engels say of the proletariat that "not only are they the slaves of the bourgeois class," they are also "daily and hourly enslaved by the machine" (Marx and Engels 1958 [1848]: 41; Danahay and Reader 2002: 218). They have been dehumanized. Consequently, they are treated as if they were nothing more than inanimate objects, instruments, or tools to be put to use to serve the interests of their employers. Hence the numerous references to slavery in the *Manuscripts*, which I pointed out earlier (see also Burns 2015).

This view can also be found in the writings of later Marxists. For example, Lenin refers at one point to "man's enslavement by the machine" under the Taylor System of "scientific management" (Lenin 1914). And this is also, of course, something that was a target for criticism in Zamyatin's *We* (Bailes 1977; Beauchamp 1983; Rhodes 1976). According to Marxists, however, any adequate theory of the role of machinery in contemporary society, and of science and technology more generally, must acknowledge the fact that the machines in question constitute a form of *capital*, and that the labor process within which alienation occurs is dominated by capitalist social relations of production. For Marx, then, the root cause of the problem of man's enslavement to machines in contemporary society is not so much science and technology per se as an autonomous or independent source of oppression, but rather the fact that technological innovation takes place within the framework of a capitalist society, within which science and technology are put to use in pursuit of profit.

In the second half of the twentieth century, a number of other Marxists have also taken an interest in the potential or actual oppressive nature of science and technology in contemporary society, whether or not the society in question is specifically a capitalist one. This is one of the main themes of the critical theory of the Frankfurt School, especially as it is developed in the writings of Theodor Adorno, Max Horkheimer, Herbert Marcuse,

and the young Jurgen Habermas (Adorno and Horkheimer 1979c [1944]; Marcuse 1978 [1941]; Marcuse 1972 [1964]: 14, 28, 114–15, 120–21, 126–30, 136; Marcuse 1989 [1958–59]; Habermas 1970 [1968]; Alford 1985; Pippin 1995; Vogel 1995). A theoretical interest in this issue also lies at the heart of what has come to be called "science and technology studies," or the critical theory of science and technology (Feenberg 1991; Feenberg 1995a; Feenberg 1999; Feenberg 2002; Feenberg and Hannay 1995). Given this, it is not at all surprising that, in his *Critical Theory and Science Fiction,* Carl Freedman has attempted to show how a Marxist version of critical theory might help us to interpret and understand works of science fiction, although Freedman does not discuss *The Matrix* in this connection.

It is true that an interest in this issue is not uniquely the domain of Marx and Marxism. On the contrary, a concern with the politics of science and technology, especially in relation to the notion of experts and scientific expertise, is present in the history of anarchism, from the time of Bakunin onward. Moreover, it can also be found in the writings associated with postmodern anarchism today, although perhaps not so much in the writings of Jean Baudrillard (Best and Kellner 2001; Feenberg 1995b; Gross and Levitt 1994; Gross, Levitt, and Lewis 1997; Koertge 1998; Sokal and Bricmont 2003 [1997]). However, as we have seen, so far as its philosophical assumptions are concerned, postmodernism is associated with the principles of relativism and constructivism. It cannot, therefore, help us to understand the concerns of the Wachowski brothers in *The Matrix*. In my view, then, as a theoretical approach for those who wish to develop an understanding of the theme of mankind's enslavement to machines that is addressed in the film, Marxism is to be preferred to postmodernism.

Consumer Society

A third theme addressed by *The Matrix* is that of the nature of contemporary society, which is presented to the film's viewers as a consumer society. In the film the Wachowski brothers postulate the existence of two worlds. First, there is the real world, in which human beings have become enslaved

by machines, having their lifeblood sucked out of them. Second, there is the world of the Matrix, or of everyday life, in which things appear to the casual observer to be very different from this. In this apparent world, which is a simulated world, individual human beings live their daily lives: they get up in the morning, go out to work or school, have families and holidays, go out to eat in restaurants, go shopping and to the cinema, and so on. This simulated world of the Matrix is a consumer society. It is a society in which, as William Irwin has observed, the world of everyday life is inscribed with the values of "affluenza" and the ideology of consumerism (Irwin 2002: 20; De Graff, Wann, and Naylor 2002).

So far as the understanding of this third issue is concerned, one figure in particular immediately springs to mind, namely Herbert Marcuse. In his *One Dimensional Man: Studies in the Ideology of Advanced Industrial Society*, published in 1964, Marcuse offers a somewhat unorthodox but nevertheless recognizably Marxist theory of consumer society. In Marcuse's account we are living in a "one dimensional society," in which society legitimates itself by "delivering the goods" (1972 [1964]: 10, 12). At the heart of Marcuse's critique of this society is a distinction he makes between the notions of "true" and "false" needs (1972 [1964]: 19). According to Marcuse, a life that delivers true happiness or human flourishing is not a life devoted to consumption. On the contrary, such a life panders to these false needs and promotes an erroneous understanding of where our true happiness lies, thereby helping to legitimate and sustain the social relations of contemporary consumer society. Much like the authors of a number of works of science fiction or dystopian literature, including Huxley's *Brave New World* and *The Matrix*, Marcuse suggests that the inhabitants of that consumer society are in fact nothing more than happy slaves who, like most of the human beings in *The Matrix*, namely those who have not been released from their pods, are completely unaware of their own situation (1972 [1964]: 33–34, 36, 40, 45–46, 118). Echoing the notion of the "unhappy consciousness" that Hegel advances in his *Phenomenology of Spirit*, Marcuse refers in *One Dimensional Man* to the "happy consciousness" that prevails in the consumer society of today (1972 [1964]: 78–79).

A somewhat similar analysis of contemporary society is also offered by Guy Debord in his *Society of the Spectacle*, published in 1967. Debord argues that contemporary society is a society of "abundance" rather than "scarcity" (1977 [1967]: §§39–40, 43, 62, 67). For this reason the society of the spectacle is, he claims, "the promised land of total consumption" (1977 [1967]: §69). Like Marcuse, Debord thinks it is appropriate to talk about the existence of artificially created "pseudo-needs" in this society (1977 [1967]: §§51, 68).

It is true that it is not only Marxists who have taken an interest in offering theories of contemporary consumer society. Such a theory can also be found in the writings of postmodern anarchists such as Baudrillard (1998 [1970]). However, Baudrillard's theory of consumer society is significantly different, in a number of respects, from that endorsed by Marxists such as Marcuse and Debord. Moreover, it seems to me that it is those aspects of the Marxist theory that Baudrillard rejects, especially its anthropological basis, and the conceptual distinction that both Marcuse and Debord make between true and false needs, which is most helpful for understanding this particular theme addressed by the Wachowski brothers in *The Matrix* (Baudrillard 2005 [1968]: 43–44; Baudrillard 1998 [1970]: 49; Baudrillard 1981 [1972]: 31, 74; Baudrillard 1975 [1973]: 79).

Nihilism and Ethics

One of my reasons for preferring the theory of consumer society advanced by Marcuse and Debord, rather than that of Baudrillard, is that the Marxist theory provides the basis for an ethical critique of consumer society that draws upon the idea of human flourishing or "happiness," properly understood. Baudrillard's version of postmodern anarchism, on the other hand, rejects all thinking of this kind (1998 [1970]: 29, 49). Indeed, it is explicitly nihilist (Baudrillard 1994 [1981]: 159–64; see also Constable 2009b; King 1998; Woodward 2008; Woodward 2010). In the words of David Detmer, Baudrillard endorses a "disabling skepticism" that invalidates "any critique that would expose the deception" which lies at the heart of the scenario depicted in *The Matrix* (Detmer 2005: 107). For this reason, as Douglas

Kellner has argued, it can have very little to offer to a critical theory of society, or to any political movement devoted to a practical effort to emancipate humanity from slavery (1991: 82, 188, 214; but see also Call 2002: 104–13). As Herbert Marcuse suggests, any critical theory of society, including Marxism, necessarily requires an ethically defensible vision of a better society in the future, that is to say a "utopia," in one sense of that much used and abused term (Marcuse 1970; Marcuse 1973a [1955]: 110, 112–18; Marcuse 1973b: 11–13, 28–30; see also Geoghegan 2008 [1987]; Martineau 1986; Pippin, Feenberg, and Webel 1988).

The issue of Baudrillard's relationship to nihilism is of some significance for those wishing to understand the issues addressed in *The Matrix* (Constable 2005: 156–60; Constable 2009b; Erion and Smith 2002; Hibbs 2002; Wrathall 2005). After all, the Wachowski brothers take pains to emphasize to viewers of the film the importance of this issue when they have Neo open his copy of Baudrillard's *Simulacra and Simulation* at the very point where the chapter on nihilism begins.

This is a complex and contentious issue, and I do not have sufficient space to give it the attention it deserves here. I will point out, however, that rightly or wrongly nihilism has in the past often been associated with anarchism, understood, in the words of Richard J. Lane, as the "extreme form of rejection" of all forms of "authority, institutions, systems of belief (especially religious beliefs) and value." As Lane notes, it has also been associated with a proclivity for "mindless violence" and with the idea of "revolutionary destruction for its own sake." And finally, in consequence, it has been connected with a certain way of thinking about "terrorism" (2000: 125). There is considerable doubt as to whether such a characterization of anarchism is defensible. Moreover, Lewis Call has claimed that Baudrillard, in particular, ought not to be associated with nihilism, understood in this way (2002: 104–13). Again, however, these are issues that will have to be set aside for the time being.

More to the point, for present purposes, is the fact that a number of commentators on *The Matrix* have, rightly or wrongly, associated both the film and its directors with nihilism as Lane understands it (Detmer 2005:

93–96; Gordon 2005: 117–18; Lawrence 2004: 84, 87–89; Watson 2003: 158; Wrathall 2005: 50). In my view this nihilist reading of *The Matrix* overlooks completely the ethical dimension of the film, which points in the direction of a normative critique of contemporary forms of enslavement and oppression. It seems to me, then, that although the issue of nihilism is evidently of concern to the Wachowski brothers, this is not a reason for thinking either that they are themselves nihilists or that *The Matrix* is a nihilistic film in Lane's sense of the term.

It has sometimes been argued that Marxism itself is nihilistic and that Marx, together with a number of later Marxists, explicitly repudiated the idea that an ethical critique of contemporary society is something that should or even could be associated with Marxism. It is, therefore, not only postmodern anarchism that has an affinity with the philosophy of Nietzsche (Burns 2001: 31–32, 47–48). My response to this is to point out that although this is certainly true of some variants of Marxism, it is not true of others. In particular, it is not true of the young Marx, or of the type of Marxism commonly associated with the work of Marcuse and the critical theory of the Frankfurt School, both of which might be characterized as a form of ethical Marxism (Burns 2015; Fraser 2001; Wilde 1998; Wilde 2001).

The Mass Media

In his *Society of the Spectacle*, Guy Debord goes further than Herbert Marcuse by focusing his attention on the political significance of the mass media in contemporary society (1977 [1967]: §25). As Debord points out at the very beginning of his book, in the society of the spectacle everything "that was directly lived" in societies in the past has now "moved away into representation" (1977 [1967]: §1). In contemporary society, Debord maintains, human existence "presents itself as an immense accumulation of spectacles." Everything in this society has become "an object of mere contemplation" (1977 [1967]: §2). The spectacle "in all its specific forms," whether "as information or propaganda, as advertisement," or as "entertainment consumption," is, Debord argues, "the present model of socially dominant life" (1977 [1967]: §6).

In a striking remark Debord states at one point that the consciousness of the spectator in his society of the spectacle is "imprisoned in a flattened universe, bound by the screen of the spectacle behind which his life has been deported" (1977 [1967]: §218). This has obvious relevance for a discussion of *The Matrix* from the standpoint of Marxism.

The hallmark of human existence in Debord's society of the spectacle is passivity. Debord maintains that those who inhabit this society are on the whole mere observers of the world rather than active participants within it, or practically involved in any effort to change it. For this reason the society of the spectacle can be seen as "the negation of life" (1977 [1967]: §10). Those who inhabit this society may exist, but they do not really live. The existing social order rests, Debord argues, upon the principle of "passive acceptance" (1977 [1967]: §12). The society of the spectacle is, he claims, "the empire of modern passivity" (1977 [1967]: §13). The situation of Debord's spectators parallels that of the human race as it is characterized in *The Matrix,* which is of course, as Slavoj Žižek has noted, one of "utter passivity" (2002: 263–64).

Employing another powerful metaphor, which again has an obvious relevance for those who are interested in understanding the situation of humanity as it is portrayed in *The Matrix,* Debord states that the society of the spectacle has a hypnotic effect on those who passively observe it (1977 [1967]: §18). In the words of Martin Danahay, they are "anaesthetized" (Danahay 2005: 48). Through their involvement with that which is spectacular, the inhabitants of contemporary society, much like Odysseus and his companions on numerous occasions in Homer's *Odyssey,* express "nothing more" than their "desire to sleep." The society of the spectacle is, he argues, "the guardian of sleep" (1977 [1967]: §21). As Debord sees it, contemporary society is a world in which everybody appears to be awake but in which they are in fact (in one sense anyway) fast asleep and dreaming. Moreover, once the situation is properly understood, it becomes clear that this dream is in fact a nightmare. It is "the nightmare" of our "imprisoned modern society" (1977 [1967]: §21).

Readers of *The Dialectic of Enlightenment* by Theodor Adorno and Max Horkheimer, especially the chapters that offer a reading of the *Odyssey,* will recognize immediately the affinity that the thinking of Debord has in this

respect with the critical theory of the Frankfurt School, which is of course a form of Marxism (1979a [1944]: 32–33; 1979d [1944]: 62–63). Lewis Call has attempted to appropriate Debord for the cause of postmodern anarchism (2002: 100–101). According to Call, Debord was not a Marxist at all but an anarchist. Indeed, he was an early representative of the principles of postmodern anarchism. As such, he was a staunch critic of Marx and Marxism. In my view, however, Call offers a highly selective reading of the thought of Debord that overlooks completely the intellectual debt Debord owed to the ideas of Marx, especially but not only to the young Marx (Best 1994: 47).

Like Herbert Marcuse, Debord owed a great deal to the young Marx's theory of alienation. He maintains that "the spectacle" corresponds to "a concrete manufacture of alienation" and to the "alienation of the spectator" in this society (1977 [1967]: §§32, 30, 37). In words that echo those used by Marx himself in his *Paris Manuscripts*, Debord also states that the more the spectator in contemporary society "contemplates the less he lives" (1977 [1967]: §30; Marx 1967 [1844]: 110). The spectator is, he says, "separated from his product" and "from his world" and "from his life," all of which have "become foreign to him" (1977 [1967]: §33, 31). This "separation," in Debord's view, is fundamental to our understanding of contemporary society (1977 [1967]: §7). The "common language of this separation" is, he says, "the alpha and the omega of the spectacle" (1977 [1967]: §§29, 25, 54). Alienation, Debord concludes, "is the essence and the support" of contemporary consumer society (1977 [1967]: §8).

In my view it is not Marxism that Debord objects to in *The Society of the Spectacle*, but Stalinism, the bureaucratized "official" Marxism of the French Communist Party, which he criticized from the standpoint not of anarchism, let alone of postmodern anarchism, but rather of a more authentic (some would say heretical) Marxism inspired by the writings of the young Marx. Despite Baudrillard's occasional allusions to Debord and the idea of the society of the spectacle, then, it seems to me that there are significant differences between the two thinkers so far as their attitude toward Marxism is concerned (Baudrillard 1975 [1973]: 120; Baudrillard 1998 [1970]: 33–34; Baudrillard 2004; see also Plant 1992: 10, 34, 176).

Education and Human Emancipation

In *The Matrix* the issue of education and its association with the notion of human emancipation is connected to the choice with which Neo is presented early in the film, between the red pill and the blue pill. Take the blue pill and remain forever in the "happy" world of the Matrix and of contemporary consumer society. Take the red pill and another world, another life, is offered to you. This may not be a happy life at all, in the everyday sense of the term. It might indeed be a life of strife, pain, and suffering.

With respect to this issue *The Matrix* can be located within the tradition of twentieth-century dystopian thought and literature, specifically with respect to the "freedom versus happiness debate" as treated in works such as Yevgeny Zamyatin's *We* and Aldous Huxley's *Brave New World* (Zamyatin 1972 [1921]; Huxley 1963 [1932]). The terms of this debate are simple: if we had to choose, and we could not have both, which is the better choice for a human being to make? Should we choose freedom without happiness, or should we choose happiness without freedom? It is clear that Zamyatin and Huxley both associate the choice of happiness without freedom with the scientific utopianism of the modern era and its promise of a future society in which all will be "happy," at least in one sense of that term. The occupants of this utopian society of the future are hedonists whose lives are devoted, more or less successfully, to the pursuit of pleasure, understood as the gratification of instinctual desires. It is also clear that the authors of these two great works of dystopian fiction, though perhaps for different reasons, are extremely critical of those utopian thinkers and writers who recommend that we make this particular choice.

David Weberman has observed that "the Matrix is a paradise of sensual pleasures compared to the real world" (2002: 234). The character Cypher, who chooses to return to the Matrix, and who in effect chooses not the red but the blue pill, may therefore be thought of as representing the basic motivational principle upon which life within the Matrix, like that in our present consumer society, is based. Similarly, Read Mercer Schuchardt has pointed out that the Matrix was "designed, like Huxley's 'brave new world,' to oppress

you not through totalitarian force, but through totalitarian pleasure" (2003: 17). And Weberman has also noted that Cypher "is a hedonist through and through—a pleasure seeker" (2002: 234). What differentiates him from Neo, Morpheus, Trinity, and the others is the fact that for them "there's something more important to them than pleasure, namely, truth and freedom" (2002: 234). In the words of Robin Hanson, "a viewer who sides with the rebels" in the film "must place a high value on humans knowing the truth, on humans not being slaves, even happy slaves" (2003: 33; see also Griswold 2002: 136).

For the Wachowski brothers, just as for Aldous Huxley, if we were presented with a stark choice between freedom without happiness (the red pill) or happiness without freedom (the blue pill), then only one of these alternatives is to be associated with a life which is fit for human beings. It is difficult to watch *The Matrix* without the impression that, so far as this issue is concerned, the viewers are being taught a moral lesson: they are being told that they really *ought* to take the red pill. As again David Weberman has noted, "In putting forth this message, we get an old-fashioned Hollywood morality tale," all of which, in Weberman's view, is not at all nihilistic and "very unpostmodern" (2002: 234).

In the secondary literature on *The Matrix* that has appeared since its release, this aspect of the film has almost invariably been associated with the philosophy of Plato, especially the simile of the cave in Plato's *Republic*. As Christopher Falzon has pointed out, the character Cypher is like those of Plato's prisoners "who are bewildered when their illusions are disturbed and who are happier left in their original state." Cypher "is willing to sacrifice truth for a happiness based on illusion" (2002: 30).

Plato was arguably the first major figure in the history of western philosophy to suggest that the pursuit of philosophy and the achievement of true knowledge of reality requires that we set aside the immediate evidence of our senses and the common sense views associated with the world of everyday life, and that we attempt to get behind or beneath the misleading appearances of things and consider alternative possibilities: that what is really going on might in fact be quite different from the way in which things appear on the surface. This connection between the depiction of the world of the Matrix in

the film and the depiction of the world of the cave in Plato's *Republic* is readily apparent and has been much discussed. None of those who have considered this aspect of the film have attempted to relate a discussion of it to Marx and Marxism. In my view, however, it is extremely fruitful to draw this parallel, just as it is fruitful to connect a discussion of the film to the concerns of the authors of the great works of twentieth-century dystopian fiction.

One reason for thinking this is that, unlike the philosophy of Plato, Marxism offers what purports to be a satisfactory (because true) explanation of that form of enslavement the depiction of which lies at the heart of the film. It is important to be clear about this. Like Plato's *Republic*, *The Matrix* is not a work of science or a contribution to social theory, but a cultural production. The way in which the enslavement of humanity is communicated to the film's audience relies on the use of imagery and metaphor. *The Matrix* is not a documentary and the story it tells is not of course intended to be taken literally. When directing it the Wachowski brothers did not make any attempt to offer a realistic explanation of the causes of the enslavement depicted within it. However, the fact that the film does not provide such a theoretical explanation should not be taken as a weakness or deficiency. For what *The Matrix* does is point its viewers in the direction of such a theory, should they be interested in thinking further about this issue. Moreover, as a theoretical explanation of the specific form of human enslavement that is depicted in the film, it seems to me that Marxism has more to offer than postmodernism, or at least that version of the doctrine associated with an extreme form of constructivism. Whatever its alleged theoretical deficiencies might be when discussing other forms of oppression in contemporary society, for example those relating to questions of race, gender, and identity politics more generally (see Burns 2015), the great strength of Marxism undoubtedly lies within the sphere of political economy.

Conclusion

I shall conclude by making a few remarks about the inevitable question of whether it is possible for a cultural production like *The Matrix*, which is

itself of course an item of consumption, a "commodity" in Marx's sense of the term, to make a significant contribution to a political project devoted to the emancipation of humanity from contemporary forms of oppression and slavery (Gordon 2005; Isaacs and Trost 2005; Wilhelm and Kapell 2004). Is it possible, for example, that watching *The Matrix* might raise the level of political consciousness of its audience? If one is a Marxist, is that the point of watching the film or of encouraging others to watch it? In what sense could a Hollywood film, a big budget "blockbuster" aimed at a mass market and which is hugely entertaining, be thought of as serving such a political purpose? After all, for those who do wish to better understand the world around them, striking metaphors and powerful visual images are no substitute for that abstract or dry theory of the kind that Marx offers the readers of *Capital,* volume 1, or for the arduous intellectual labor associated with the achievement of knowledge of that kind. Marx believed that without scientific knowledge we cannot change the world, but he also believed that "there is no royal road to science" (Marx 1974 [1872]: 30).

With respect to this question, opinion among commentators, even among those who are Marxists, is divided. We might perhaps identify two groups here, whose outlooks might be characterized as pessimistic and optimistic, respectively. Among the pessimists are those who think of *The Matrix* as having nothing at all to offer to a critical theory of society, or to those who are interested in changing the world for the better. On the contrary, because it is itself a product of consumer society, or of what Theodor Adorno refers to as "the culture industry" (Adorno 1996; Adorno and Horkheimer 1979b [1944]), it undermines all such efforts. Indeed, it is testimony to the unparalleled ability of that society to absorb and neutralize all possible dissent. For example, Andrew Gordon has argued that the belief that *The Matrix* "has politically radical potential and may inspire some viewers to organize or to revolt against the capitalist system" is "far too utopian" (i.e., impractical and unrealistic) to be taken at all seriously (2005 116).

This also appears to have been the view of Baudrillard, who in an interview devoted to *The Matrix* in 2004 stated that "what makes our times so oppressive" is the fact that although the "system" does produce a "negativity,"

or an internal critique, nevertheless this critique is "integrated into products of the spectacle just as obsolescence is built into industrial products" (Baudrillard 2004). This is, Baudrillard maintained, "the most efficient way of incorporating all genuine alternatives" within existing society, thereby neutralizing any potential for radical change. On this view, as Douglas Kellner has noted, things that "appear to be oppositional, outside, or threatening to the system are really functional parts" of it. As such, they "only further enhance" existing forms of social control (1991: 82).

It is interesting that, when making the observation cited above, Baudrillard refers to "the spectacle." Slavoj Žižek does something similar when he refers to the audience of *The Matrix* as "spectators" (2005: 198). Baudrillard and Žižek both employ the theoretical vocabulary of Debord in their readings of *The Matrix*, although neither of them mentions Debord explicitly by name. In effect, they both argue that *The Matrix* is itself a part of Debord's society of the spectacle. As Martin Danahay has put it, the *Matrix* is "part of the media system that is in the business of marketing illusions." As such, it provides "an illusory solution to real problems" (Danahay 2005: 48).

We saw earlier that Debord maintains at one point that the inhabitant of this society is "imprisoned in a flattened universe, bound by the screen of the spectacle behind which his life has been deported" (1977 [1967]: §218). This comment does put one in mind of the simile of the cave in Plato's *Republic*. It conjures up the image of a number of people who are bound together, just like the prisoners in Plato's cave, but in this case their prison is the cinema. Facing forward they are somehow constrained to watch images projected on the wall in front of them by a light source behind them. However, what they are watching is a film, *The Matrix*. Michael Sexson has observed that Plato's image of "a group of prisoners chained together watching shadows flicker on the wall of a cave is eerily prophetic." In Sexson's opinion, "Had the technology of the cinema been available in Plato's time, he would most surely have used it as the basis for his famous allegory" (2004: 122). Arguing in a similar vein, Slavoj Žižek has also observed, although again without mentioning Debord's name, that every screening of *The Matrix* can be thought of as repeating exactly Plato's scenario, in which

"the cinema spectators themselves" are "prisoners, tied firmly to their seats and compelled to watch the shadowy performances of (what they falsely consider to be) reality" (2005: 198).

The crucial issue, here, is this: by what means might those who are in such a situation be encouraged to leave the cinema which is their (all too cozy) prison? Could watching the film that is being projected on the screen in front of them make any contribution at all to their emancipation? Or alternatively, and more pessimistically, does watching films like *The Matrix* ensure only that they continue to be constrained by the mental shackles or, in the words of William Blake, "the mind forged manacles" (Blake 1970 [1789]: 150), which currently bind them, and which lead them to contribute toward their own enslavement?

Unlike Baudrillard, at least some commentators have been more upbeat about the potential of *The Matrix* to encourage its viewers to think seriously about the issues it addresses, thereby making a contribution to the struggle for human emancipation. Schuchardt, for example, has claimed that *The Matrix* is "doing something absolutely unique in the history of cinema," because "it is preaching a sermon to you from the only pulpit left. It is calling you to action, to change, to reform and modify your ways" (2003: 24). Similarly, P. Chad Barnett has suggested that *The Matrix* is an "accurate cognitive mapping of the world space of multinational capital" that "allows those who experience it to begin to grasp their position as individual and collective subjects and regain a capacity to act and struggle" (2000: 372).

Another commentator interested in exploring "some possible progressive readings of *The Matrix*" is Peter Fitting. Fitting acknowledges the persuasive force of a more conventional Marxist reading, which sees the film as offering its viewers a "facsimile of capitalism itself," in which "workers are vampirically drained of surplus value through the labour process." However, what interests him more about *The Matrix* is the way in which it "focuses on the representation of collective struggle" (2003: 161). In Fitting's view, rather than promoting the idea of an "individual escape from a stifling, false reality into a personal fantasy world," *The Matrix* encourages the idea of "a collective struggle to free the human race from oppression." In this way, it

constitutes "a welcome correction to the myth of the solitary hacker" that is the hallmark of so much cyberpunk and of postmodern science fiction (2003: 161; see also Moylan 2000: 193–94). To end on an optimistic note, for all of us, it is here perhaps where the political lesson of *The Matrix* lies.

References

Adorno, Theodor. 1996. *The Culture Industry: Selected Essays on Mass Culture*. Trans. J. M. Bernstein. London: Routledge.

Adorno, Theodor, and Max Horkheimer. 1979a [1944]. "The Concept of Enlightenment." In *Dialectic of Enlightenment*, 3–42. Trans. John Cumming. London: Verso Books.

Adorno, Theodor, and Max Horkheimer. 1979b [1944]. "The Culture Industry: Enlightenment as Mass Deception." In *Dialectic of Enlightenment*, 120–67. Trans. John Cumming. London: Verso Books.

Adorno, Theodor, and Max Horkheimer. 1979c [1944]. *Dialectic of Enlightenment*. Trans. John Cumming. London: Verso Books.

Adorno, Theodor, and Max Horkheimer. 1979d [1944]. "Excursus I: Odysseus or Myth and Enlightenment." In *Dialectic of Enlightenment*, 43–80. Trans. John Cumming. London: Verso Books.

Alford, C. Fred. 1985. *Science and the Revenge of Nature: Marcuse and Habermas*. Gainesville: University Press of Florida.

Amis, Kingsley. 2000 [1960]. *New Maps of Hell: A Survey of Science Fiction*. London: Ayer.

Baccolini, Raffaella, and Tom Moylan, eds. 2003. *Dark Horizons: Science Fiction and the Dystopian Imagination*. London: Routledge.

Bailes, Kendall E. 1977. "Alexei Gastev and the Soviet Controversy Over Taylorism." *Soviet Studies* 29 (3): 373–94.

Barnett, P. Chad. 2000. "Reviving Cyberpunk: ReConstructing the Subject and Mapping Cyberspace in the Wachowski Brothers' Film *The Matrix*." *Extrapolation* 41 (4): 359–74.

Baudrillard, Jean. 1975 [1973]. *The Mirror of Production*. Trans. Mark Poster. St. Louis: Telos Press.

Baudrillard, Jean. 1981 [1972]. *For a Critique of the Political Economy of the Sign*. Trans. Charles Levin. St. Louis: Telos Press.

Baudrillard, Jean. 1983. "The Orders of Simulacra." In Baudrillard, *Simulations*. Trans. Paul Foss, Paul Patton, and Phillip Beitchman, 81–159. New York: Semiotext[e].

Baudrillard, Jean. 1994 [1981]. "On Nihilism." In Baudrillard, *Simulacra and Simulation*, 159–64. Trans. Sheila Glaser. Ann Arbor: University of Michigan Press.

Baudrillard, Jean. 1998 [1970]. *The Consumer Society: Myths and Structures*. Trans. Chris Turner. London: Sage.

Baudrillard, Jean. 2004. "*The Matrix* Decoded: *Le Nouvel Observateur* Interview with Jean Baudrillard." *International Journal of Baudrillard Studies* 1 (2). www.ubishops.ca/baudrillardstudies/vol1_2/genosko.htm.

Baudrillard, Jean. 2005 [1968]. *The System of Objects*. Trans. James Benedict. London: Verso.

Beauchamp, Gorman. 1983. "Man as Robot: The Taylor System in Zamyatin's *We*." In *Clockwork Worlds: Mechanized Environments in SF*, ed. Richard D. Erlich and Thomas P. Dunn, 85–93. Westport, Conn.: Greenwood Press.

Best, Steven. 1994. "The Commodification of Reality and the Reality of Commodification: Baudrillard, Debord and Postmodern Theory." In *Baudrillard: A Critical Reader*, ed. Douglas Kellner, 41–67. Oxford: Blackwell.

Best, Steven, and Douglas Kellner. 2001. *The Postmodern Adventure: Science, Technology and Cultural Studies at the Third Millennium*. New York: Guilford Press.

Blake, William. 1970 [1789]. *Songs of Innocence and of Experience: Shewing the Two Contrary States of the Human Soul*. Oxford: Oxford University Press.

Bould, Mark, and China Miéville, eds. 2009. *Red Planets: Marxism and Science Fiction*. London: Pluto Press.

Bould, Mark, Andrew M. Butler, Adam Roberts, and Sherryl Vint, eds. 2009. *The Routledge Companion to Science Fiction*. London: Routledge.

Boyd, Gregory A., and Al Larson, eds. 2005. *Escaping the Matrix: Setting Your Mind Free to Experience Real Life in Christ*. Grand Rapids, Mich.: Baker Books.

Broderick, Damien. 1995. *Reading by Starlight: Postmodern Science Fiction*. London: Routledge.

Burns, Tony. 2001. "Karl Kautsky: Ethics and Marxism." In *Marxism's Ethical Thinkers*, ed. Lawrence Wilde, 15–50. London: Palgrave.

Burns, Tony. 2015. "The Idea of 'The Struggle for Recognition' in the Ethical Thought of the Young Marx and Its Relevance Today." In *Constructing Marxist Ethics: Critique, Normativity, Praxis*, ed. Michael Thompson, 33–58. Leiden: Brill.

Butler, Andrew. 2003. "Postmodernism and Science Fiction." In *The Cambridge Companion to Science Fiction*, ed. Edward James and Farah Mendelsohn, 137–48. Cambridge: Cambridge University Press.

Butler, Rex. 1999. *Jean Baudrillard: The Defence of the Real*. London: Sage.

Call, Lewis. 1999. "Anarchy in the Matrix: Postmodern Anarchism in the Novels of William Gibson and Bruce Sterling." *Anarchist Studies* 7 (2): 99–117.

Call, Lewis. 2002. *Postmodern Anarchism*. Lanham, Md.: Lexington Books.

Cavallaro, Dani. 2000. *Cyberpunk and Cyberculture: Science Fiction and the Work of William Gibson*. London: Athlone Press.

Condon, Peter. 2003. *The Matrix Unlocked*. London: Contender Books.

Constable, Catherine. 2005. "Baudrillardian Revolutions: Repetition and Radical Intervention in *The Matrix* Trilogy." In *The Matrix Trilogy: Cyberpunk Reloaded*, ed. Stacey Gillis, 151–61. London: Wallflower Press.

Constable, Catherine. 2009a. *Adapting Philosophy: Jean Baudrillard and The Matrix Trilogy*. Manchester: Manchester University Press.

Constable, Catherine. 2009b. "Beyond Nihilism." In *Adapting Philosophy: Jean Baudrillard and The Matrix Trilogy*, 126–48. Manchester: Manchester University Press.

Csicsery-Ronay, Istvan Jr. 1991. "Science Fiction and Postmodernism." *Science Fiction Studies* 18 (3): 305–8.

Danahay, Martin. 2005. "*The Matrix* Is the Prozac of the People." In *More Matrix and Philosophy: Revolutions and Reloaded Decoded*," ed. William Irwin, 38–49. Chicago and La Salle, Ill.: Open Court.

Danahay, Martin, and David Reader. 2002. "*The Matrix*, Marx and the Coppertop's Life." In *The Matrix and Philosophy: Welcome to the Desert of the Real*, ed. William Irwin, 216–24. Chicago and La Salle, Ill.: Open Court.

Debord, Guy. 1977 [1967]. *Society of the Spectacle*. Exeter: Rebel Press.

De Graff, John, David Wann, and Thomas Naylor. 2002. *Affluenza: The All Consuming Epidemic*. San Francisco: Berrett-Koehler.

Detmer, David. 2005. "Challenging *Simulation and Simulacra*: Baudrillard in *The Matrix*." In *More Matrix and Philosophy: Revolutions and Reloaded Decoded*, ed. William Irwin, 93–108. Chicago and La Salle, Ill.: Open Court.

Diocaratz, Myriam, and Stefan Herbrecher, eds. 2006. *The Matrix in Theory*. Amsterdam: Rodopi.

Engels, Frederick. 1958 [1872]. "On Authority." In Karl Marx and Frederick Engels, *Selected Writings*, Volume 2, 636–39. Moscow: Foreign Languages Publishing House.

Erion, Gerald J., and Barry Smith. 2002. "Skepticism, Morality and *The Matrix*." In *The Matrix and Philosophy: Welcome to the Desert of the Real*, ed. William Irwin, 16–27. Chicago and La Salle, Ill.: Open Court.

Faller, Stephen. 2004. *Beyond the Matrix: Revolutions and Revelations*. London: Chalice Press.

Falzon, Christopher. 2002. "Plato's Picture Show: The Theory of Knowledge." In Falzon, *Philosophy Goes to the Movies: An Introduction to Philosophy*, 19–48. London: Routledge.

Feenberg, Andrew. 1991. *Critical Theory of Technology*. Oxford: Oxford University Press.

Feenberg, Andrew. 1995a. *Alternative Modernity: The Technical Turn in Philosophy and Social Theory*. Berkeley: University of California Press.

Feenberg, Andrew. 1995b. "The Technocracy Thesis Revisited: Adorno, Foucault, Habermas." In Andrew Feenberg, *Alternative Modernity: The Technical Turn in Philosophy and Social Theory*, 75–95. Berkeley: University of California Press.

Feenberg, Andrew. 1999. *Questioning Technology*. London: Routledge.

Feenberg, Andrew. 2002. *Transforming Technology: A Critical Theory Revisited*. Oxford: Oxford University Press.

Feenberg, Andrew, and Alastair Hannay, eds. 1995. *Technology and the Politics of Knowledge*. Bloomington: Indiana University Press.

Felluga, Dino. 2003. "*The Matrix*: Paradigm of Postmodernism or Intellectual Poseur? Part I." In *Taking the Red Pill: Science, Philosophy and Religion in The Matrix*, ed. Glenn Yeffeth, 85–101. Chichester: Summersdale.

Fitting, Peter. 2003. "Unmasking the Real? Critique and Utopia in Recent SF Films." In *Dark Horizons: Science Fiction and the Dystopian Imagination*, ed. Raffaella Baccolini and Tom Moylan, 155–66. London: Routledge.

Fraser, Ian. 2001. "Herbert Marcuse: Essence and Existence." In *Marxism's Ethical Thinkers*, ed. Lawrence Wilde, 95–115. London: Palgrave.

Freedman, Carl. 2000. *Critical Theory and Science Fiction*. Hanover, N.H.: Wesleyan University Press.

Geoghegan, Vincent. 2008 [1987]. *Utopianism and Marxism*. Oxford: Peter Lang.

Gillis, Stacy, ed. 2005a. *The Matrix Trilogy: Cyberpunk Reloaded*. London: Wallflower Press.

Gillis, Stacy. 2005b. "The Politics of Modernity and Postmodernity." In *The Matrix Trilogy: Cyberpunk Reloaded*, ed. Stacy Gillis, 89–172. London: Wallflower Press.

Gordon, Andrew. 2003. "*The Matrix*: Paradigm of Postmodernism or Intellectual Poseur? Part I." In *Taking the Red Pill: Science, Philosophy and Religion in The Matrix*, ed. Glenn Yeffeth, 102–23. Chichester: Summersdale.

Grau, Christopher, ed. 2005. *Philosophers Explore the Matrix*. Oxford: Oxford University Press.

Griswold, Charles. 2002. "Happiness and Cypher's Choice: Is Ignorance Bliss?" In *The Matrix and Philosophy: Welcome to the Desert of the Real*, ed. William Irwin, 126–37. Chicago and La Salle, Ill.: Open Court.

Gross, Paul R., and Norman Levitt. 1994. *Higher Superstition: The Academic Left and Its Quarrels with Science*. Baltimore: Johns Hopkins University Press.

Gross, Paul R., Norman Levitt, and Martin W. Lewis. 1997. *The Flight from Science and Reason*. New York: New York Academy of Sciences.

Haber, Karen, ed. 2003. *Exploring the Matrix: New Writings on The Matrix and the Cyber Present*. New York: iBooks.

Habermas, Jürgen. 1968. *Knowledge and Human Interests*. London: Heinemann.

Habermas, Jürgen. 1970 [1968]. "Technology and Science as 'Ideology.'" In *Toward a Rational Society: Student Protest, Science and Politics*, ed. Jurgen Habermas, 81–122. Boston: Beacon Press.

Hanley, R. 2003. "Simulacra and Simulation: Baudrillard and *The Matrix*." www.whatisthematrix.warnerbros.html.

Hanson, Robin. 2003. "Was Cypher Right? Part I: Why We Stay in Our Matrix." In *Taking the Red Pill: Science, Philosophy and Religion in The Matrix*, ed. Glenn Yeffeth, 31–42. Chichester: Summersdale.

Hibbs, Thomas S. 2002. "Notes from Underground: Nihilism and *The Matrix*. " In *The Matrix and Philosophy: Welcome to the Desert of the Real*, ed. William Irwin, 155–65. Chicago and La Salle, Ill.: Open Court.

Hillegas. Mark. 1967. *The Future as Nightmare: H. G. Wells and the Anti-Utopians*. Oxford: Oxford University Press.

Huxley, Aldous. 1963 [1932]. *Brave New World*. Harmondsworth: Penguin Books.

Irwin, William, ed. 2002. *The Matrix and Philosophy: Welcome to the Desert of the Real*. Chicago: Open Court.

Irwin, William. 2005a. "The Matrix of Control: Why *The Matrix* Still Has Us." In *More Matrix and Philosophy: Revolutions and Reloaded Decoded*, ed. William Irwin, 12–25. Chicago and La Salle, Ill.: Open Court.

Irwin, William, ed. 2005b. *More Matrix and Philosophy: Revolutions and Reloaded Decoded*. Chicago and La Salle, Ill.: Open Court.

Isaacs, Bruce, and Theodore Louis Trost. 2005. "Story, Product Franchise: Images of Postmodern Cinema." In *Jacking in to the Matrix Trilogy: Cultural Reception and Interpretation*, ed. Matthew Kapell and William G. Doty, 65–79. London: Continuum.

Jorgensen, Darren. 2009. "Postmodernism." In *The Routledge Companion to Science Fiction*, ed. Mark Bould et al., 279–87. London: Routledge.

Kapell, Matthew, and William G. Doty, eds. 2004. *Jacking in to the Matrix Trilogy: Cultural Reception and Interpretation*. London: Continuum, 2004.

Kellner, Douglas. 1991. *Jean Baudrillard: From Marxism to Postmodernism and Beyond*. Cambridge: Polity Press.

King, Anthony. 1998. "Baudrillard's Nihilism and the End of Theory." *Telos* 112: 89–106.

Koertge, Noretta, ed. 1998. *A House Built on Sand: Exposing Postmodernist Myths about Science.* New York: Oxford University Press.

Lane, Richard J. 2000. *Jean Baudrillard.* London: Routledge.

LaVelle, Kristenea M. 2002. *The Reality within The Matrix.* Wisconsin Dells, Wisc: Saxco.

Lawrence, Matt. 2004. *Like a Splinter in Your Mind: The Philosophy behind the Matrix Trilogy.* Oxford: Blackwell.

Lenin, V. I. 1914. "The Taylor System: Man's Enslavement by the Machine." In *Collected Works*, 20:152–54. Moscow: Progress Publishers.

Levin, Charles. 1996. *Jean Baudrillard: A Study in Cultural Metaphysics.* London: Prentice Hall.

Lloyd, Peter B. 2003. *Exegesis of the Matrix.* London: Whole-Being Books.

Lyle, Zynda. 2003. "Was Cypher Right? Part II: The Nature of Reality and Why it Matters." In *Taking the Red Pill: Science, Philosophy and Religion in the Matrix*, ed. Glenn Yeffeth, 43–55. Chichester: Summersdale.

Marcuse, Herbert. 1970. "The End of Utopia." In *Five Lectures: Psychoanalysis, Politics and Utopia*, 62–82. Boston: Beacon Press.

Marcuse, Herbert. 1972 [1964]. *One Dimensional Man: Studies in the Ideology of Advanced Industrial Society.* London: Routledge.

Marcuse, Herbert. 1973a [1955]. *Eros and Civilization: A Philosophical Inquiry into Freud.* London: Abacus Books.

Marcuse, Herbert. 1973b. *An Essay on Liberation.* Harmondsworth: Penguin Books.

Marcuse, Herbert. 1978 [1941]. "Some Social Implications of Modern Technology." In *The Essential Frankfurt School Reader*, ed. Andrew Arato and Eike Gebhardt, 138–62. Oxford: Basil Blackwell.

Marcuse, Herbert. 1989 [1958–59]. "From Ontology to Technology: Fundamental Tendencies of Industrial Society." In *Critical Theory and Society: A Reader*, ed. Stephen Eric Bronner and Douglas McKay Kellner, 119–27. London: Routledge.

Marriott, M. 2003. *The Matrix Cultural Revolutions: How Deep Does the Rabbit Hole Go?* New York: Thunder's Mouth Press.

Martineau, Alain. 1986. *Herbert Marcuse's Utopia.* Montreal: Harvest House.

Marx, Karl. 1967 [1844]. "Estranged Labour." In *Economic and Philosophical Manuscripts of 1844*, 64–78. Trans. M. Milligan. London: Lawrence and Wishart.

Marx, Karl. 1974 [1872]. Preface to the French Edition. In *Capital*, vol. 1, *A Critical Analysis of Capitalist Production*, 30. Ed. Frederick Engels. Trans. Samuel Moore and Edward Aveling. London: Lawrence and Wishart.

Marx, Karl, and Frederick Engels. 1958 [1848]. *Manifesto of the Communist Party.* In *Selected Works*, 1:21–65. Moscow: Foreign Languages Publishing House.

May, Todd. 1994. *The Political Philosophy of Poststructuralist Anarchism.* University Park: Pennsylvania State University Press.

Moylan, Tom. 2000. *Scraps of the Untainted Sky: Science Fiction, Utopia, Dystopia.* Boulder, Colo.: Westview Press.

Newman, Saul. 2001. *From Bakunin to Lacan: Anti-Authoritarianism and the Dislocation of Power.* Lanham, Md.: Lexington Books.

Nietzsche, Friedrich. 1968 [1888]. *The Twilight of the Idols: Or, How to Philosophize with a Hammer.* Trans R. J. Hollingdale. Harmondsworth: Penguin Books.

Pippin, Robert B. 1995. "On the Notion of Technology as Ideology." In *Technology and the Politics of Knowledge*, ed. Andrew Feenberg and Alastair Hannay, 43–64. Bloomington: Indiana University Press.

Pippin, Robert B., Andrew Feenberg, and Charles P. Webel, eds. 1988. *Critical Theory and the Promise of Utopia*. London: Macmillan.

Plant, Sadie. 1992. *Most Radical Gesture: The Situationist International in a Postmodern Age*. London: Routledge.

Rhodes, Carolyn H. 1976. "Taylor's System of Scientific Management in Zamyatin's *We*." *Journal of General Education* 28: 31–42.

Rovira, J. 2003. "Subverting the Mechanism of Control: Baudrillard and The *Matrix* Trilogy." www.ubishops.ca/baudrillardstudies/vol2_2/rovira.htm.

Rowlands, Mark. 2003. "*The Matrix*: Can We Be Certain of Anything?" In *The Philosopher at the End of the Universe: Philosophy Explained through Science Fiction Films*, 27–56. London: Ebury Press.

Schuchardt, Read Mercer. 2003. "What Is the Matrix?" In *Taking the Red Pill: Science, Philosophy and Religion in The Matrix*, ed. Glenn Yeffeth, 10–30. Chichester: Summersdale.

Seay, C., and G. Garrett. 2003. *The Gospel Reloaded: Exploring Spirituality and Faith in the Matrix*. Colorado Springs: Pinon.

Sexson, Michael. 2004. "The *Déjà Vu* Glitch in the *Matrix* Trilogy." In *Jacking in to the Matrix Trilogy: Cultural Reception and Interpretation,* ed. Matthew Kapell and William G. Doty, 115–24. London: Continuum.

Sokal, Alan, and Jean Bricmont. 2003 [1997]. *Intellectual Impostures: Postmodern Philosophers Abuse of Science*. London: Profile Books.

Vogel, Steven. 1995. "New Science, New Nature: The Habermas-Marcuse Debate Revisited." In *Technology and the Politics of Knowledge*, ed. Andrew Feenberg and Alastair Hannay, 23–42. Bloomington: Indiana University Press.

Walsh, Chad. 1962. *From Utopia to Nightmare*. Westport, Conn.: Greenwood Press.

Wardlow, Russell. 2003. "The Matrix: Postmodern or Anti-Postmodern?" www.meanmrmustard.net/archives/000887.html.

Watson, Ian. 2003. "The Matrix as Simulacrum." In *Exploring the Matrix: New Writings on The Matrix and the Cyber Present*, ed. Karen Haber, 148–67. New York: iBooks.

Weberman, David. 2002. "*The Matrix* Simulation and the Postmodern Age." In *The Matrix and Philosophy: Welcome to the Desert of the Real*, ed. William Irwin, 225–39. Chicago and La Salle, Ill.: Open Court.

Wilde, Lawrence. 1998. *Ethical Marxism and Its Radical Critics*. London: Macmillan.

Wilde, Lawrence, ed. 2001. *Marxism's Ethical Thinkers*. London: Palgrave.

Wilhelm, Stephanie J., and Matthew Kapell. 2004. "Visions of Hope, Freedom of Choice, and the Alleviation of Social Misery: A Pragmatic Reading of the *Matrix* Franchise." In *Jacking in to the Matrix Trilogy: Cultural Reception and Interpretation:* ed. Matthew Kapell and William G. Doty, 25–40. London: Continuum.

Wolmark, Jenny. 1994. *Aliens and Others: Science Fiction, Feminism and Postmodernism*. Iowa City: University of Iowa Press.

Woodward, Ashley. 2008. "Was Baudrillard A Nihilist?" *International Journal of Baudrillard Studies* 5 (1).

Woodward, Ashley. 2010. *Nihilism in Postmodernity: Lyotard, Baudrillard, Vattimo*. Aurora, Colo.: Davies.

Worthing, Mark William. 2004. *The Matrix Revealed: The Theology of The Matrix*. Millswood: Pantaenus Press.

Wrathall, Mark A. 2005. "'The Purpose of Life is to End': Schopenhauerian Pessimism, Nihilism and Nietzschean Will to Power." In *More Matrix and Philosophy: Revolutions and Reloaded Decoded*, ed. William Irwin, 50–66. Chicago and La Salle, Ill.: Open Court.

Yeffeth, Glenn, ed. 2003. *Taking the Red Pill: Science, Philosophy and Religion in The Matrix*. Chichester: Summersdale.

Zamyatin, Yevgeny. 1972 [1921]. *We*. Trans. Bernard Gilbert Guerney. Intro. Michael Glenny. Harmondsworth: Penguin Books.

Žižek, Slavoj. 2002. "The Matrix: Or, The Two Sides of Perversion." In *The Matrix and Philosophy: Welcome to the Desert of the Real*, ed. William Irwin, 240–65. Chicago and La Salle, Ill.: Open Court.

Žižek, Slavoj. 2005. "Reloaded Revolutions." In *More Matrix and Philosophy: Revolutions and Reloaded Decoded*, ed. William Irwin, 198–208. Chicago and La Salle, Ill.: Open Court.

7

Representation of "Gaming Capitalism" in *Avalon* and *Gamer*

EWA MAZIERSKA

This chapter is devoted to two films, *Avalon* (2001), directed by Mamoru Oshii, and *Gamer* (2009), directed by Mark Neveldine and Brian Taylor. Although set in the future, these films exaggerate some features of the economic system that has dominated the West since the early 1980s and the rest of the globe after the fall of communism, known as neoliberalism. Its main features are strong social polarization, weak governments, and high level of risk, in part resulting from the spread of gaming (on a discussion of neoliberalism see Harvey 2005, Beck 1992, and the introduction to this collection). *Avalon* and *Gamer* also point to the interface between neoliberal politics, war, and cyber and biotechnologies. In this sense, they belong to a larger cluster of movies, represented also by *eXistenZ* (1999) by David Cronenberg and *The Hunger Games* (2012) by Gary Ross.[1] In addition, *Avalon* is a descendant of VR (Virtual Reality) films, a subgenre pioneered by *Tron* (1982), directed by Steven Lisberger. *Gamer*, on the other hand, follows in the footsteps of the films about post-economic apocalypse and corporate-controlled games, of which an early example was *Rollerball* (1975), directed by Norman Jewison.

In all these films we encounter a situation where the characters detach themselves, either by choice or due to coercion from material reality by

moving into another world: the world of games played either in some re-stricted physical area or in virtual reality. Although different from the real world, this reality is affected by and affecting it, typically intensifying its features, most importantly competition and individualism at the expense of collaboration and collective values. The game does not allow its players to properly escape from the real world, but live this reality in its more extreme and deadly form.

The production of films whose titles I listed above, the majority of which are American, can be linked to three principal factors. One is a precipitous erosion of industrial and manufacturing sectors in the American economy taking place during the Reagan era and later, which led to high levels of un-employment, especially among blue-collar workers and the diminishing soli-darity between different sectors of the American working class (Nama 2008: 96–7). Another factor is the development of virtual reality from the 1980s and the businesses it generated from the 1990s. The last factor is the growth of biotechnology in the 1990s and the faith put in it as a means of transforming human life, a faith that greatly diminished in subsequent decades.

In order to tease out this connection and their representation in the aforementioned films, I draw on the work of Karl Marx and a number of post-Marxist thinkers, such as David Harvey, Ulrich Beck, Michael Hardt and Antonio Negri, and Melinda Cooper, who attempted to account for the specificity of neoliberalism. I also utilize the work of authors who were in-terested in plays and games, especially in the context of capitalism, includ-ing Walter Benjamin, Johan Huizinga, and Roger Caillois.

Play and Capitalism

The nature of play and the relationship between play and work was dis-cussed by authors such as Walter Benjamin, Johan Huizinga, and Roger Caillois, all elaborating their concepts in the first half of the twentieth cen-tury, the period marked by the two world wars and advanced industrialism.

Miriam Bratu Hansen, in an essay devoted to the concept of play in Wal-ter Benjamin's work, points to the two ways of looking at play by the afore-

mentioned authors. On the one hand, they perceived play as an alternative to work and a means to survive its harsh conditions (Hansen 2004). Caillois observed that industrial civilization has given birth to a special form of *ludus*, the hobby. The role of a hobby is to compensate for the brutally alienating character of industrial work. For example, the worker engaged in his hobby tends to construct "*complete* scale models of the machines in the fabrication of which he is fated to cooperate by always repeating the same movement, an operation demanding no skill or intelligence on his part" (Caillois 2001: 32). In this "the worker-turned-artisan . . . avenges himself upon reality, but in a positive and creative way" (32). The hobby thus responds to one of the highest functions of the play instinct. On the other hand, however, these authors saw play as being similar to work and as its continuation, due to being integrated in the capitalist system and imbricated with technology (Hansen 2004). Benjamin claimed that gambling is marked by "the futility, the emptiness, the inability to complete something which is inherent in the activity of a wage slave in a factory. Gambling even contains the workman's gesture that is produced by the automatic operation, for there can be no game without the quick movement of the hand by which the stake is put down or a card is picked up" (Benjamin 2007: 177). Play and work were also brought together by the large-scale industrialization of leisure and amusement (in the West) since the mid-nineteenth century. As play became an object of mass production and consumption, as sports and other recreational forms grew into technologically mediated spectacles, the ideal of play as free and nonproductive activity frequently came to serve as an ideological cover for its "material correlative, commodified amusement" (Benjamin 2007: 177). Roger Caillois argued that "as for the professionals—the boxers, cyclists, jockeys, or actors who earn their living in the ring, track, or hippodrome or on the stage, and who must think in terms of prize, salary, or title—it is clear that they are not players but workers. When they play, it is at some other game" (Caillois 2001: 6). It is thus worth making a distinction between "playing" and "being played" or "playing" and "working for somebody's game," which is crucial in my analysis of the aforementioned films.

These two tendencies can also be observed in contemporary times, when alienated workers invest a lot of energy and commitment in their hobbies, treating them with a solemnity previously reserved for religious activities. Simultaneously, we notice an increased integration of playing into the regime of profit generation. This happens through, among other things, the states engaging in promoting gambling, by organizing state lotteries and setting up casinos. As Martin Young argues, "The extent to which the state has become involved in gambling is nothing short of remarkable." Unlike in the nineteenth century, when gambling was presented as morally reprehensible, nowadays gambling is presented as a justified, even valuable consumer choice (Young 2010: 266). Gerda Reith describes this change as the celebration and promotion of a new kind of "consumption ethic," replacing an ethos of production and accumulation with a "state sponsored fantasy of the big win" (Reith 2007: 36). Gambling also became integrated into other parts of economic and social life, such as charity, education, and culture. In many countries, such as the United Kingdom, the future of the arts depends to a large extent on gambling revenue.

On the one hand, play borders work; on the other, it is linked to war. Johan Huizinga writes that "ever since words existed for fighting and playing, men have been wont to call war a game. . . . The two ideas often seem to blend absolutely in the archaic mind. . . . Fighting, as a cultural fashion, always presupposes limiting rules, and it requires, to a certain extent anyway, the recognition of its play-quality. We can only speak of war as a cultural function so long as it is waged within a sphere whose members regard each other as equals or antagonists with equal rights; in other words its cultural function depends on its play-quality" (Huizinga 1970: 110–11). In the films I discuss we can identify two seemingly contradictory tendencies. Warfare is presented as utterly barbaric, criminal violence. At the same time, it is rendered as very entertaining. As I argue in due course, such polarization is possible because of the division of players into "real" players and the "ones played."

Many authors conflate "game" with "play." The difference between these two concepts is subtle and in some languages does not even exist, such as

in German, where *Spiel* refers to both. In English, however, "game" suggests a more structured and competitive play, while "play" is associated with a theater play. It is also worth mentioning Roger Caillois's division of games into *agôn*, competitive games, those based on chance or *alea* (from the Latin name for the game of dice), *mimicry*, based on creating an illusionary universe, and *ilinx*, based on the pursuit of vertigo (Caillois 2001: 11–26). In *Avalon* and *Gamer agôn* games occupy a privileged position, but games of other types are also represented.

Avalon: Early Neoliberalism as Seen from the Margins

Avalon is a Japanese-Polish coproduction and the first and only fruit of Polish-Japanese cinematic collaboration since the fall of the Berlin Wall. It was directed by Japanese director Mamoru Oshii, best known for *Ghost in the Shell* (1995), regarded as one of the hallmarks of *anime*, a genre that originated in Japan but became popular across the world. It has an entirely Polish cast, including the actress playing the main role, Małgorzata Foremniak, using their original language. It was shot in Poland and filmed by Polish cinematographer Grzegorz Kędzierski, but was subsequently digitally retouched in Japanese studios.

Both Japan and Poland of 2001 embraced neoliberalism, with its emphasis on competition, as opposed to solidarity, rejection of the welfare state, replacing Fordist with post-Fordist, flexible employment, and acceptance of a high level of unemployment as a condition of low inflation. However, they are at the periphery of this project, unlike Britain, the United States, or even China. Poland adopted neoliberal principles only after the fall of communism and somewhat more slowly than other postcommunist countries. Japan was attached to the principles of Fordism-Keynesianism longer than many other capitalist countries and still holds to the vestiges of the old order. I am interested in finding out whether and to what extent the national colors of neoliberalism are reflected in *Avalon*.

The narrative is set in the not-too-distant future in a country whose identity is not revealed, in line with science fiction tradition, which pres-

ents the future as a time when national borders have been abolished and national particularities overcome (Sontag 1994: 220), and a newer custom of rendering cyberspace as that in which national, ethnic, and racial differences do not matter (Nakamura 1998). It also reflects the neoliberal order, in which national sovereignty is eroded, giving way to pan-national institutions such as the World Bank and the International Monetary Fund, as well as pan-national corporations. Michael Hardt and Antonio Negri label this order "Empire" (Hardt and Negri 2000). However, the use of language, the food labels, and elements of interior design suggest that this reality is a hybrid of Poland and Japan.

In this world the life of most humans is reduced to basics: eating, sleeping, and traveling on tramways. We do not see people engaged in work or any remunerative activity, apart from playing a virtual game called "Avalon," a sign of the diminishing need for ordinary labor under neoliberalism. As announced at the beginning, some people play it for thrills, others play it for money, but it is difficult to establish what is the main motivation in a specific case, which renders "Avalon" more democratic than the games shown in *Gamer*, as discussed later. At the center of the story is Ash, a young female professional player of high standard who seems to get both thrills and money from playing. "Avalon" combines elements of the first-person shooter (FPS) genre with role-playing games (RPG) (Brown 2010: 133). Its participants enter a virtual reality by donning a special headgear in the game center. This act connects their brain directly to the virtual reality, pointing to the interface between medical and digital research.

Avalon is a war game; the task of the players is to destroy enemy forces. They can either play solo or in teams named "parties." If the players succeed, they are allowed to move to a higher level. But few go up—the game is highly competitive and dangerous. Many of those who played went too far and did not return to material reality as conscious people, but only as brain-dead "unreturned." Due to this feature "Avalon" pertains to what Caillois describes as *ilinx*; its goal is to achieve vertigo. This points to the role of biotechnology in making the world a more dangerous place, rather than creating a perfect world for everybody (Cooper 2008). The victors collect

rewards from the subscriptions paid by the losers and we can guess that a large chunk of the profit goes to the owners of the game centers, which rent the headgear to the players. Hence, the progression of the game inevitably leads to the impoverishment of the players and the lack of investment in developing or maintaining the material side of their lives. Such a diagnosis is confirmed by the poor state of the environment in which the players move, with dilapidated buildings and almost empty apartments, where the only ornaments come from the past. An even more poignant marker of their poverty is food, as shown in a sequence set in a canteen, where Ash dines with her old game companion, Stunner. It brings to mind *Miś* (*Teddy Bear*, 1980), a cult film by Stanisław Bareja, whose most famous episode offered a parody of Polish "milk bars": the cheapest places for eating in communist Poland, infamous for bad food and even worse service. As in *Teddy Bear*, Ash and Stunner have to stay in a long queue and eventually receive an unappetizing stew, based on overcooked rice or grain, served in large metal bowls (which in *Teddy Bear* were chained to the tables so that the customers could not steal them). The food is so revolting that Ash cannot force herself to finish her meal, but her companion is happy to eat the leftovers, again not unlike poorer consumers in the bar featured in Bareja's film. Shooting

The future like the communist past.

the film in sepia tones adds to the impression that the material world of the future itself feeds on the past, similar to *Blade Runner* (1982). At the same time, such representation evokes the way the socialist world was represented in its cinema, especially Poland during the period of martial law (Mazierska 2009).

It is difficult to establish the attitude of the political authorities toward "Avalon." We are informed at the beginning that it is illegal to play it, so ostensibly the authorities are against games of this kind. The most obvious explanation is the danger it poses to the human brain, which can be taken as an index of contemporary governments' uneasy relation toward biotechnology and a metaphor of the harm caused by any addiction, be it to alcohol, drugs, or gambling. The modern states traditionally discouraged such addictions by banning dangerous substances and licensing casinos. Yet we do not see any attempts by the police to actually prevent anybody from entering the "Avalon" universe. People do so almost openly. Again, this can be regarded as a sign of the way the neoliberal authorities act: even if they forbid something to its citizens on account of its risk, they do so in a "soft" way, without enforcing the rule, ultimately leaving it to the individual citizen to decide whether the risk is worth taking. Freedom to decide is rendered as a more important value than safety, even if this freedom, as suggested on this occasion, is circumvented by economic factors, such as the lack of opportunities to earn one's living by means other than gaming.

Irrespective of its official status, "Avalon" plays a similar role in the society of the future to the gladiatorial games in the Roman Empire—it is a vehicle of appeasement and distraction of the masses from an unattractive reality. This applies as much to the players as to its audiences, as these two categories overlap. When they are in the "Avalon" world, they act with full energy and focus. In the material world, however, they come across as zombified, not unlike the workers represented in Fritz Lang's *Metropolis* (1927). The lack of energy is emphasized by a slow tempo of the parts of Oshii's film, set in the material world. The most extreme case of this condition is represented by the "unreturned." Their representation brings to mind the figure of a *Spieler* (gambler), as discussed by Walter Benjamin in his essay

"On Some Motifs in Baudelaire," from 1939/40. Benjamin's "gambler" exemplifies a mode of attention ever ready to parry mechanical shocks, similar to the reflex reaction required of the worker on the assembly line and, like the latter, no longer relying on experience in the sense of accumulated wisdom, memory, and tradition (Benjamin 2007: 174–80). The gambler of the future, as presented in *Avalon*, reveals the same symptoms as his ancestor, as discussed by Benjamin, only intensified. The only person of authority with whom Ash enters into contact is the "game master," who addresses her from a large computer screen, situated in the game center. The status of this person is unclear. We do not know whether he only represents the "game hierarchy," official political power, or something else. When Ash asks him whether he is real or not, he replies that this does not matter, which can be read as a reference to the elusiveness of neoliberal political leaders. It shall be added that invisibility works for the rulers' advantage, as it is easier to fight with "material" enemies than with those who are difficult to find or even define.

The virtual world of the "Avalon" game is a state of permanent war, and we can identify here traces of several wars. One is the Second World War, as remembered from Polish war films and popular television series, especially in the early scenes showing tank battles in open space. The second type of war pertains to various Eastern European invasions, including Polish martial law of 1981, in the episodes set in the city, when old-style tanks traverse the streets, passing an iconic Polish car, a Syrena. It is worth mentioning that Polish martial law, like the virtual war of "Avalon" and in contrast to earlier wars fought on Polish soil, was de-centered and almost devoid of geography; it did not include any memorable battles or foci of resistance, and people learned about it mostly from television screens rather than from personal experience (Mazierska 2009: 290). Finally, the images of huge planes and other flying machines bring to mind television reports from recent wars such as those in Afghanistan and Iraq. They appear to have no human crew; they are like heavy birds or dragons invading the Earth from a distant planet. By situating old and new wars in one space Oshii also evokes the discourse of Polish martial law as a kind of diminutive version of the Second

World War and simultaneously suggests that this war led Poland to embrace neoliberal capitalism and participation in "American" wars.

By intertwining elements of different wars and naming the virtual war game, in which they are replayed, the film suggests that every war is a repetition of an earlier war and a premonition of the war to come. Such an idea is also conveyed by using the term "Avalon" as the name of the game and the title of the film. In Celtic legend Avalon is the place where King Arthur is taken after fighting Mordred at the Battle of Camlann to recover from his wounds. According to the tradition, Arthur never really died, but would return from Avalon to lead his people against their enemies. Such legend can be read metaphorically as a reference to the fact that military conflicts never stop, because any defeat leads to a desire for revenge. At best the conflicts can be "put to sleep." The concept of war as never ending but only temporarily removed connects Oshii to Paul Virilio, who perceives world history as the history of development of the war machinery (Virilio 1989, 1994; Virilio and Lotringer 1983). Such military development consists of inventing ever more sophisticated machines and diminishing human involvement in front-line combat. This can be seen as a confirmation of Marx's idea that development of capitalism leads to a reduction of the necessary labor. Marx predicted that under advanced capitalism the work of people would be replaced by that of "general intellect" (Marx 1973: 692–93; Hardt and Negri 2000: 364–69). The final stage of the development of the war machinery is "pure war." As Virilio claims, pure war no longer needs men, and that's why it is pure (Virilio and Lotringer 1983). The war Oshii shows is not entirely pure in Virilio's sense, as we still see people fighting in it, but there appears to be a rather small number of soldiers in comparison with the amount of weapons displayed and the destruction they cause. Moreover, this war never stops and its progress does not depend on who fights in it. War in Oshii's virtual reality, as in Virilio's model of history, is a constant factor; people are the changing factor. Although in this world of the future war is displaced to a virtual world, it has a significant and often deadly effect on the warrior-players, as already indicated, by bringing the risk of losing one's mind. The war in Oshii's film also evokes Virilio's concept of war because the Japanese

Ash against the virtual world.

director links war to spectacle and cinema. Virilio writes that "war's very purpose is to produce spectacle" and "there is no war without representation" (Virilio 1989: 5, 6). In *Avalon*, weapons are not just tools of destruction but also of perception, as already demonstrated in the first scene of the film when we see a map through the "eye" of a sophisticated gun. Oshii is also preoccupied with the bird's-eye view; the virtual war, although fought on the ground and in the air, is seen largely from an aerial perspective. In a sense Oshii goes even further than Virilio in seeing the connection between war and film. This is because for Virilio war and film, although connected by their spectacular qualities and desire to conquer the world, remained distinct. Oshii successfully merges the two regimes, as conveyed by the many uses of the word "Avalon" in his film; it is both the name of the game/spectacle and of the war, where people can perish. "Avalon" is thus equally the successor of cinema and war.

Thanks to playing well in the virtual war, Ash manages to reach "Class Real": the third reality included in Oshii's film, which looks like post-martial law, postcommunist Poland. The name the director gives to this place conveys the view that high-class virtual reality might appear more real than the material world. Ash enters this level after successfully completing all

lower stages of the "Avalon" game and "killing the ghost": shooting at a computer-generated image of a girl, whose function is to guide the player to the highest level of the game. When this happens, we see Ash in present-day Warsaw, among well-clad, cultured inhabitants of a modern, prosperous city. It appears that as the ultimate reward for winning the war, Ash is transported to a better place. However, it is not obvious that she would stay there as in the end we see her trying to kill the "ghost" again, maybe in order to return to her old, mundane, but real life or in hope of being taken to an even better world. In this "postcommunist world" Ash meets Murphy, her old pal, with whom she used to play as a part of the team. Murphy became "unreturned" as demonstrated by the fact that Ash previously met him in the hospital, where he was lying unconscious among other victims of the virtual pleasures. He is unwilling to come back to reality, preferring to stay in this happy land. Unsurprisingly, Murphy turns out to be not real but virtual, as proved by the fact that when Ash kills him, he decomposes into pixels, like other figures and machinery she destroyed in the lower levels of the game. We are left wondering whether by this stage Ash is also like Murphy: half-dead.

Although somewhat lacking in energy, even zombified, the players in the "Avalon" game are still rendered as players in their own right, as opposed to being pawns/workers in somebody else's game. They might be ultimately controlled by the game master or the "general intellect" deciding about the rules of the game, but they play with a sense of autonomy and are even able to extract some pleasure from the game. As I argue below, it differentiates their situation to that presented in *Gamer*.

Gamer

Gamer is an American film produced by Lionsgate, which Wikipedia calls the most commercially successful independent film and television distribution company in North America and the sixth most profitable movie studio in Hollywood. Horror and science fiction films constitute a large part of its portfolio, as exemplified by *Dogma* (1999), directed by Kevin Smith, and

Saw (2004), directed by James Wan. It also produced the acclaimed Michael Moore documentary *Fahrenheit 9/11* (2004). The specialty of the studio can be crudely described as films that criticize contemporary America and, by extension, the capitalist world, using sensationalist rhetoric and style that imitates rather than opposes the dominant Hollywood idiom. This assessment also fits *Gamer*, as revealed by, among other things, its medium-high budget of $50 million. Prior to *Gamer*, the film's directors, Mark Neveldine and Brian Taylor, had to their credit an action movie, *Crank: High Voltage* (2009), also produced by Lionsgate, made on less than half the budget of *Gamer* but in a similar style.

Gamer, like *Avalon*, is set in an unspecified future but in the United States, rendered here as the center of the world, transmitting its values across the world, most importantly by satellite television. In common with *Avalon*, a large proportion of the population in this period does not engage in productive labor but earn their living or spend their capital/surplus income by playing games. It is a period of great economic and social polarization, more pronounced than in *Avalon*. The extreme inequality allows the powerful to take advantage of the situation of those at the bottom of the human pile, as reflected in the games depicted in the film: "Society" and "Slayers." The first name, like the term "Class Real," describing the highest level in "Avalon," points to the obliteration of the division between reality and virtuality, as expressed by the words of the inventor of the game: "We live in society, we visit 'Society,' which one is more real really?" The name "Slayers," on the other hand, connotes utter brutality. This name points to a specific trajectory of war and play. Wars were first conducted according to the fair-play code, then they degenerated into brutal wars, devoid of any rules, as epitomized by the Second World War, and then the war game became like a brutal, total war without any rules.

As in the case of "Avalon," some people enter these games for thrills, others for money, but on this occasion these categories are strictly separate. The idea is that one person, whom I will describe as a "player," controls the body of another, the "pawn" or "worker," having access to his/her brain via a neuronal device called "'nanex," operated through an internet connection.

The film thus demonstrates how the development of computer and genetic technologies at the forefront of the advances of neoliberal capitalism privilege those already privileged, the affluent, and disadvantage those already disadvantaged, the poor. The "pawn" is effectively a slave of the "player" for the duration of the game. S/he has to do what his/her master tells him/her to do. This asymmetry is expressed by the slogans describing the privileges of the players: "They walk them, they talk them, they juice them, they rock them" and "I think it and you do it." The "pawns," however, retain their consciousness for the duration of the game, which adds to their suffering and their masters' pleasure.

"Society" has elements of *mimicry* and *ilinx*. The "pawns" perform certain roles devised for them by their controllers. They wear a specific costume, visit a specific place, meet a certain person. Angie, a "pawn," on whom this narrative strand focuses, describes her role in "Society" as that of an actress. The majority of her activities have an erotic character with a high degree of sadomasochism. In a club at the center of the area where "Society" is played we see men and women hanging on hooks, piercing their bodies. Angie joined the game practically on duress, as a means to earn enough money to get back her daughter, placed for adoption following the murder conviction of her husband, Tillman. Tillman plays in "Slayers" under the name Kable. We can extrapolate that Angie is one of many desperate people who made themselves available to the "players," risking the integrity of their minds and bodies as a means to free themselves from their desperate predicament. Angie is controlled by a man who perspires heavily when telling her what to do, indicating that the game has an intoxicating effect on him; he behaves as if in vertigo. This man is so obese that he has lost the power to move. He thus stands for the cardinal sins of the West: overconsumption and lechery. For him Angie is a prostrate body and a sex toy; the combination of bio and computer technologies allows for some people to be exploited in such a double way.

In "Slayers" performance also matters, but the key to the game is competition. Like "Avalon," it can be described as a war game, played for the enjoyment of the global audience, which has no end, as in Virilio's scheme,

described earlier. The game is for convicts awaiting capital punishment. By agreeing to play in it, they get a chance to avoid this tragic end. The rule is that the "pawn" who survives thirty games is offered parole and is freed. Yet surviving equals killing his competitors. The "pawns" in "Slayers," like the "pawns" in "Society," are also attached to their masters, who control them via "nanex." Their survival is a result of the combination of the high skills of both the player and the "pawn"; the player has to direct the pawn to the right target and the "pawn" has to process the commands precisely and very rapidly; delay of a split-second might have dire consequences. Kable, who is the focus of this strand and an entire film, is a convict who is about to reach the ultimate goal of surviving thirty games. He is controlled by a rich and spoiled teenager, another epitome of the decadence of the Western world.

We learn that Kable received the death penalty because he was framed—he was the first man to kill somebody due to having a "nanex" implant. The success of this experiment encouraged the inventor of the game, Ken Castle, to develop the game commercially. As in the case of "Society," "Slayers" are broadcast globally and the revenue coming from the broadcast allows Castle to develop his gaming empire and approach his goal of gaining absolute power over the world population. Castle belongs to a narrow elite of entrepreneurs, closely linked to the media and politics. Their collaboration is based on mutual advantage—Castle uses the media, most importantly television, to broadcast the game and in this way extracts profit from it and recruits new players. Equally, the media are happy to broadcast his game because it increases their ratings and revenue. The American government is happy to work with Castle, because he is bailing out the entire prison system; without his money it would be bankrupt. Castle, on the other hand, is happy to support the prison system, because he can use the prisoners free of charge for his profitable spectacle. Castle's closeness to the world of the media and politics renders him a typical neoliberal businessman, similar to Bill Gates and Rupert Murdoch, who benefit from their cozy relationship with the political authorities. Castle is indeed compared to Bill Gates in the course of the narrative, but it is suggested that he is a cleverer and more ruthless version of Gates. Castle is also furnished with a "nanex" device,

but as he himself explains to Kable, his device is used to control others by the very power of his thought while others have "nanex" to be controlled. "Nanex," in common with other recent advancements in technology, is very undemocratic as it privileges the few at the expense of many.

Both "Society" and "Slayers" show the remarkable ability of the capitalist class to extract surplus value from material and human waste. The Slayers' contests take place mostly in unused factories, which otherwise would bring no profit, only loss. The fact that deadly games and the destruction of humans flourish where once material production took place points to the character of neoliberalism as marked by wars and immaterial production, as argued by Hardt and Negri (2000). The film also shows that producing human waste is in the interest of the capitalist class, as described by David Harvey:

> In volume 1 of *Capital*, Marx shows that the closer a society conforms to a deregulated, free-market economy, the more asymmetry of power between those who own and those excluded from ownership of the means of production will produce an "accumulation of wealth of one pole" and "accumulation of misery, agony of toil, slavery, ignorance, brutality, mental degradation, at the opposite pole." Three decades of neoliberalization have produced precisely such an unequal outcome. A plausible argument can be constructed, as I sought to show in *A Brief History of Neoliberalism*, that this was what the neoliberalizing agenda of leading factions of the capitalist class was about from the very outset. Elite elements of the capitalist class emerged from the turmoil of the 1970s having restored, consolidated and in some instances reconstituted the power worldwide. (Harvey 2006: xi)

The film also points to the physical distance and the one-way communication between the rulers and the ruled. The players survey and pass commands to the "pawns," but the "pawns" cannot reciprocate. It is even possible that the "pawns" do not know who plays them. The fact that the players control the "pawns" from a distance and are not personally involved

with their actions brings them many advantages—they can kill and torment with impunity, while implicating the "pawns." Equally, it diminishes the danger that the "pawns" will rebel against their masters as they need to know who are their masters and be able to approach them to organize rebellion.

The performance of the "pawns" is observed not only by their masters, but also by viewers all over the world, including in some of the poorest corners of the globe. They follow the action projected on huge public TV screens, skyscrapers, and facades of factories and presumably also in the privacy of their homes, not unlike viewers of reality game shows such as *Big Brother*. The more they enjoy the spectacle, the more revenue it produces and the more likely it is that more viewers will be recruited to the game. Hence, the film demonstrates that the poor are complicit in their own situation, a point also made in *Avalon*.

There is no doubt that the players and Castle's objective is absolute domination over fellow human beings—forcing them to do everything in a way, which is most effective and "cleanest" from their perspective: by the power of their thought. This desire and the ruthlessness with which this goal is executed in the confined area where the "pawns" are under the control of their masters renders this area similar to a concentration camp, which Giorgio Agamben, after Hannah Arendt, defined as a place where "everything is possible" (Agamben 1998: 170). Everything there is permitted for those in positions of power, and those in their power have no rights. Indeed, such extreme actions take place during the narrative—some "pawns" are killed, while others engage in killing others. Again, this reminds one of typical practices in the camp, where the dirtiest work of building and servicing gas chambers and crematoria was allocated not to the Nazis but to the prisoners themselves, such as members of the Sonderkommando. Similarly, those who decided to play in "Society" and "Slayers" have some choice, again like camp prisoners, but the choice is negative, such as killing oneself or killing a fellow prisoner, even a member of one's own family. Another similarity between the area of the game and the concentration camp pertains to the character of labor performed in these places. In the camp one observed a huge gap between the available technology of work and that used at the

camp. Camp work was like traveling back in time, with the inmates using the most primitive tools or even their own hands as their main implements (Długoborski and Piper 2000). This was in contrast to the "work" of surveillance, punishment, and annihilation, which utilized the most advanced materials, tools, and techniques, such as Zyklon B in the gas chambers. Similarly, in the "game camps," as presented by Neveldine and Taylor, people perform tasks normally attributed to machines: they behave like robots or simulations created by computers. The film thus shows desimulation, in the same vein as in the concentration camps de-industrialization took place. The special thrill the "players" derive from these games is that people under their command behave like dolls or robots while retaining their subjectivity and therefore being able to suffer pain. Drawing on the style of the 1970s Nazisploitation films in the sequences that take place in the club at the center of "Society" confirms the connection between the spaces of the games and those of the concentration camps. At the same time, the film confirms Jean Baudrillard's idea of the blurring of the real and virtual (simulated) reality under postmodernism, but in this film this happens not so much because reality takes the character of the game but because the game is like reality: it directly affects one's body and brain.

The narrative is put in crisis when the young man, who "plays" Kable, allows him to run away, although due to mischief rather than out of any specific political conviction or sympathy for the underprivileged. Simultaneously, a group of young people of different races, but all looking distinctly countercultural, punk-like, try to break the genetic code of "nanex" and in this way set free Angie and Kable. Their efforts are observed by Gina Parker Smith, a popular television talk show host. Her role within the narrative is intentionally ambiguous, pointing to the double role played by the mass media under the capitalist and especially neoliberal regime: as promoters of the neoliberal order, with its obsession with gambling and "playing people" in various reality shows and as critics of neoliberal excesses. It is uncertain whether she wants to help the "pawns" for their own sake or only to add market value to her program. Calling her a "media whore" by one of the rebels suggests that the media are seen as servants of the capitalist class. Yet

Fighting till the end.

in the end she plays a positive role, exposing Castle's crimes to the global audience.

The plan of the young punks works. They free Angie and Kable from their "biotechnological handcuffs," which allows Kable to confront and kill Castle and recover his daughter. The victorious Kable also requires switching off the system operating "nanex." Whether this has any lasting effect on those employed in "Society" and "Slayers" is difficult to predict, as the fate of the other players, in Hollywood fashion, which champions (white)

American individualism, is rendered unimportant. In the last scene we see Kable and Angie literally escaping the world of the games, traveling by car in a typical American landscape of a highway in the high mountains to an unknown destination. Such an ending, evoking the ending of westerns and road cinema, with an individual protagonist heading toward an unknown future, proclaims the possibility of individual liberation from the shackles of an unjust system. One can argue that such an ending, while conveying condemnation of "feral capitalism," personified by the evil Castle, ultimately validates capitalism as a system when a resourceful individual, even if put in the most adverse circumstances, can achieve success. A similar conclusion can be found in the previously mentioned *Rollerball*. In his discussion of this film Adilifu Nama maintains that "ultimately, the ending succumbs to the representational demands of American popular cinema, which requires its rebel-protagonists to affirm American individualism . . . rather than organized class revolt" (Nama 2008: 102).

An ambiguous ideological effect is added by the visual style used in the film, which draws heavily on the iconography and montage techniques of computer games and Nazisploitation films, as already mentioned. The use of such style alludes, on the one hand, to the dehumanization of people trapped in the cruel world of "Slayers" and "Society." On the other hand, however, it panders to the "pornographic taste" of the users of such products.

Conclusion

Both films, *Avalon* and *Gamer*, document and amplify certain features of neoliberal capitalism, in particular the proliferation of gaming and the spread of digital technologies and biomedical research. Both these features are presented by neoliberal ideologues, including governments' spokesmen, as beneficial for individuals and humanity at large. Games are meant both to provide entertainment for everybody who wants to play and also to pay for valuable causes that defunded government programs cannot afford. Digital technologies are meant to spread democracy thanks to their omnipresence.

Biomedicine is meant to cure diseases and improve the quality of life of millions of people.

Instead, the films discussed in this chapter point to the anti-democratic character of neoliberal gaming, as well as digitalization and biomedicine. This is because for those who have no other ways to earn their living, gaming is not really a voluntary activity but a result of (however subtle) acts of coercion. Moreover, in neoliberal games the chances of the poor to win are low and their victory is not at the expense of the rich, but of their fellow underprivileged members of the society. Furthermore, the consequences of losing in neoliberal games are very serious: deeper marginalization and pauperization, and a necessity to enter into even riskier and more dangerous games. In contrast, the risk of the privileged to lose is very low or none, according to the rule that the owners of the casinos or lottery monopolies always win. Gaming is thus a means to speed up accumulation of capital and strengthen class divisions. One can draw a parallel between "proper" gaming and the operation of the economy under capitalism, which is frequently seen as a form of game, especially its symbol, the stock exchange. As the crisis of 2008 (as well as other, earlier, and later crises) shows, the "big sharks" always win, even at the time of crisis or especially then, while the losers (the taxpayers, the small businesses, the state) always lose.

Avalon and *Gamer* also suggest that, although digitalization and computerization allow everybody to be connected with everybody else, these connections are not based on the principle of reciprocity. Rather, they are the instruments of surveillance and control of the powerless by the powerful and the means of the powerful to avoid democratic control by making them invisible. Similarly, biomedicine technology privileges the rich and by the same token discriminates against the poor, whose bodies are used to improve the rich people's quality of life (a motif discussed in other chapters in this collection).

Broadly speaking, the conclusions one can derive from these two films match Marx's argument that the development of technology serves the capitalist class. This, however, does not mean that rejecting technological development, moving backward in time (if it will be at all possible), will empower

the proletariat (or whatever name we use to designate those without power of money). Rather, it points to the need to see technology for what it is—a tool that can be used for different purposes: to strengthen democracy or enslave people.

Note

1. Because these films are rather heterogonous—almost nothing connects them except for the motif of game—I use the word "cluster" rather than "cycle," following Leger Grindon's definition: "Sometimes genre films fail to generate a coherent model or a common motifs among productions from the same period. Such groups can be distinguished as clusters rather than cycles" (Grindon 2012: 45).

References

Agamben, Giorgio. 1998 [1995]. *Homo Sacer: Sovereign Power and Bare Life*. Trans. Daniel Heller-Roazen. Stanford, Calif.: Stanford University Press.
Badiou, Alain. 2010 [2008]. *The Communist Hypothesis*. Trans. David Macey and Steve Corcoran. London: Verso.
Beck, Ulrich. 1992 [1986]. *Risk Society: Towards a New Modernity*. Trans. Mark Ritter. London: Sage.
Benjamin, Walter. 2007. *Illuminations*. Trans. Harry Zohn. New York: Schocken Books.
Brown, Steven T. 2010. *Tokyo Cyberpunk: Posthumanism in Japanese Visual Culture*. Houndsmills: Palgrave Macmillan.
Caillois, Roger. 2001 [1958]. *Man, Play and Games*. Trans. Meyer Barash. Urbana: University of Illinois Press.
Cooper, Melinda. 2008. *Life as Surplus*. Seattle: University of Washington Press.
Długoborski, Wacław, and Franciszek Piper, eds. 2000. *Auschwitz, 1940–1945: Central Issues in the History of the Camp*, vol. 2. Oświęcim: Auschwitz-Birkenau State Museum.
Grindon, Leger. 2012. "Cycles and Clusters: The Shape of Film Genre History." In *Film Genre Reader IV*, ed. Barry Keith Grant, pp. 42–59. Austin: University of Texas Press.
Hansen, Miriam Bratu. 2004. "Room-for-Play: Benjamin's Gamble with Cinema." *October* 109 (Summer): 3–45.
Hardt, Michael, and Antonio Negri. 2000. *Empire*. Cambridge, Mass.: Harvard University Press.
Harvey, David. 2005. *A Brief History of Neoliberalism*. Oxford: Oxford University Press.
Harvey, David. 2006. *The Limits to Capital*. New and fully updated ed. London: Verso.
Harvey, David. 2011. "Feral Capitalism Hits the Streets." *Reading Marx's Capital with David Harvey*. davidharvey.org/2011/08/feral-capitalism-hits-the-streets. Accessed August 22, 2011.
Huizinga, Johan. 1970 [1944]. *Homo Ludens*. London: Routledge and Kegan Paul.

Jameson, Fredric. 1984. "Science Fiction and the German Democratic Republic." *Science Fiction Studies* 11 (2): 194–99.

Marx, Karl. 1973 [1953]. *Grundrisse: Foundations of the Critique of Political Economy*. Trans. Martin Nicolaus. London: Penguin.

Marx, Karl, and Friedrich Engels. 2008 [1848]. *The Communist Manifesto*. Introduction by David Harvey. London: Pluto.

Mazierska, Ewa. 2009. "Polish Martial Law of 1981 in Polish Post-Communist films: Between Romanticism and Postmodernism." *Communist and Post-Communist Studies* 2: 289–304.

Morrey, Douglas. 2005. *Jean-Luc Godard*. Manchester: Manchester University Press.

Nakamura, Lisa. 1998. "Where Do You Want to Go Today? Cybernetic Tourism, the Internet, and Transnationality." In *The Visual Culture Reader*, 2nd ed., ed. Nicholas Mirzoeff, 255–63. London: Routledge.

Nama, Adilifu, 2008. *Imagining Race in Science Fiction Film*. Austin: University of Texas Press.

Reith, Gerda. 2007. "Gambling and the Contradictions of Consumption: A Genealogy of the 'Pathological' Subject." *American Behavioral Scientist* 1: 33–55.

Smith, Tony. 2008. "The 'General Intellect' in the *Grundrisse* and Beyond." Paper presented at ISMT conference, Bergamo, July 2008, www.public.iastate.edu/~tonys/10%20The%20 General%20Intellect.pdf. Accessed September 10, 2012.

Sontag, Susan. 1994. *Against Interpretation*. London: Vintage.

Virilio, Paul. 1989. *War and Cinema: The Logistics of Perception*. London: Verso.

Virilio, Paul. 1994. *The Vision Machine*. Bloomington: Indiana University Press.

Virilio, Paul, and Sylvère Lotringer. 1983. *Pure War*. New York: Semiotext(e).

Young, Martin. 2010. "Gambling, Capitalism and the State: Towards a New Dialectic of the Risk Society?" *Journal of Consumer Culture* 10 (2): 254–73.

8

Remote Exploitations

Alex Rivera's Materialist SF Cinema in the Age of Cognitive Capitalism

ALFREDO SUPPIA

"Poor Mexico, so far from God and so near the United States." *Sleep Dealer* (2008) reminds us of the famous phrase uttered more than one hundred years ago by Mexican president Lazaro Cárdenas (1934–1940) (see Calvin 2009). The Mexican president was referring to American imperialism in the nineteenth century, when Mexico lost half its territory to the United States. A Mexican–U.S. coproduction, mostly in Spanish, Alex Rivera's *Sleep Dealer* describes a future in which America drains the water reserves of Mexico and the workforce of its people. The technological utopia described in *Sleep Dealer* covers a social dystopia, as in countless other examples of politically engaged science fiction (SF) narratives.

Rivera's film is the testimony of an SF cinema renewed by contemporary issues in a peripheral perspective, even though it invokes a mosaic of Western cultural references, from August Strindberg to Phillip K. Dick, *Blade Runner* to Bruce Sterling's and William Gibson's cyberpunk. In an interview with *Crossed Genres*, Rivera remarked that "in terms of the spirit, it's pretty clear that films like Terry Gilliam's *Brazil*, the aesthetics of films like *Blade Runner*, and the social issue and the parable around class relationships in Fritz Lang's *Metropolis* all influenced *Sleep Dealer*" (2012a). In another in-

terview the same year, for Gallery@Calit2, Rivera (2012b) also mentioned the inspiration of *Brazil* (1985) when conceiving *Sleep Dealer* and the value he gives to humor in the depiction or critique of the real world—since our reality, according to Rivera himself, is rather surreal.

Sleep Dealer won the Best Screenplay Award at the 2008 Sundance Film Festival and the Alfred P. Sloan for best picture about science and technology. The film's documentary inspiration is formed by means of references—some more, some less direct—to issues such as illegal immigration, post-industrial capitalism, economic exploitation, political oppression, citizenship, cultural identity, the war on terror, privatization of the police state, militarization, and so on. *Sleep Dealer* is basically an expansion of *Why Cybraceros?*, Rivera's short mockumentary from 1997.[1] In both films, the theme of class struggle leads the narrative.

Why Cybraceros?

According to Rivera, the idea of *Sleep Dealer* goes back to 1997, when he read an article in *Wired* about telecommuting and the internet's impact on labor dynamics. The article discussed the possibility of a future in which employees do their job without leaving home. Rivera crossed this hypothesis with the reality of immigrants and imagined a future in which foreign workers no longer had to leave their countries.

The origins of *Sleep Dealer* also resided in Rivera's interest in the upcoming technology of drones and the paradox put forth by the digital era, as commented by the director himself (Harris 2012).[2]

The director says he did not know how to visually express this idea until he discovered the documentary *Why Braceros?* (1959), found in the Prelinger Archives.[3] The Braceros program was spurred by the U.S. government during the Second World War and consisted of providing temporary jobs for Mexicans to work on American farms. The idea was for Mexican workers to come to the United States, work on farms, and return home after a period of time, in order to replace the American workforce that had been redirected to the war effort.[4]

Like *Sleep Dealer, Why Cybraceros?* also addresses the issues of social exclusion and immigration, but by means of satirical speculation. In Rivera's mockumentary, the U.S. government launches a "revolutionary" program in which Mexican workers can operate machines remotely on American soil. Thus, a major social problem is solved: the need for Mexican labor, without the inconvenience of the physical presence of the "Chicanos." Archival imagery, out of the original context, combines with picturesque digital animation in a style that clearly evokes American government documentaries from the 1940s and 1950s, educational films about public health and the atomic era, for instance. Currently, this narrative strategy seems to be intensified in SF cinema. Thus, the documentary rhetoric as a narrative resource in insightful mockumentaries has efficiently served to reconcile SF with the long tradition of literary satire.[5]

In 1998, Rivera was awarded a $35,000 grant from the Rockefeller Foundation and decided to remake *Why Cybraceros?* as a feature film. The money was used to build the robot-peasant but was insufficient for the completion of the project. In 2001, the script for his feature film was accepted by the Sundance Institute, after which the project finally took off. An interesting aspect in the design of Rivera's cybracero is the appearance of the human-machine prop, which directly resembles a marionette, with wires dangling from the hand of a "mechanical puppeteer"—in this case, the "invisible hand" of the neoliberal market. As in both Fritz Lang's *Metropolis* (1927) and Charles Chaplin's *Modern Times* (1936)—as well as in Marx's *Capital*—man is ultimately operated by the machine, and the productive time rules the circadian rhythms. The cybracero is a metaphor for the reified worker, reduced to a mere puppet, a disposable piece—an indication of the persistence of the Fordist industrial paradigm in informational capitalism, blurring lines between industrial labor and the services industry (Hardt and Negri 2000: 285–86).

Rivera's parable eventually extrapolates the silver screen. Resorting to a transmedia strategy, *Sleep Dealer* takes advantage of the Cybracero System's "official" website: www.cybracero.com. On this "mocksite," carefully designed to mislead unaware visitors, one can better know the enterprise and

its mission ("The ultimate in remote control. Workers doing whatever you need, from our state of the art facility in Tijuana, México"), read interviews with "employees," and, lastly, apply for a job.

Sleep Dealer

In *Sleep Dealer*, Memo (Luis Fernando Peña) lives with his family in a *milpa* in Santa Ana, Oaxaca, Mexico. Poverty is aggravated by a water shortage caused by a U.S. company that trades water and builds dams in Latin American countries. Commercial use of water creates regional tensions that result in actions of so-called "aqua-terrorists," who are brutally repressed by the U.S. military for the sake of private corporate interests.

Assuming a Marxist perspective, Memo's awakening to the reality of his condition involves access to technology and to communication with the world beyond his *milpa*—technology and urbanization are initially depicted as utopian factors for social inclusion. Curious about the world outside and with a talent for electronics, Memo enables a radio antenna and begins to eavesdrop on conversations by satellite. On one of those nights of eavesdropping, Memo's equipment is tracked by the U.S. military. Shortly after, a drone remotely piloted by Rudy Ramirez (Jacob Vargas) is sent to Mexico to destroy an alleged terrorist base—which happens to be Memo's house. In an interview with Malcolm Harris (2012), talking about the drone as a metaphor for contemporary reality, Rivera noted, "The drone is the most visceral and intense expression of the transnational/telepresent world we inhabit. In almost every facet of our lives . . . we live in a trans-geographic reality. The nonplace, the transnational vortex, is everywhere, ever present." The drone mission in *Sleep Dealer* is broadcast on a fascist-like reality show (*Drones!*), in the style of *America's Most Wanted* and *Cops*. Memo's home is destroyed and his father is murdered. The conflict that throws Memo into his journey recalls the assault on the farm and murder of Luke Skywalker's relatives in George Lucas's *Star Wars* (1977) (see Calvin 2009: 20). Not surprisingly, Rivera declared the following in his interview with *Crossed Genres* (2012a):

That . . . was very exciting to me; the idea of fusing the sort of epic strug-
gle of a migrant worker to survive with the language of the science fiction
hero. This in movies like *Star Wars* is very familiar to audiences, but tell-
ing that story in a way that makes an actual migrant worker the hero is
something sort of unfamiliar, and I hope, innovative.

After the tragedy, Memo heads to the U.S. border in an attempt to get a job
as a "node worker" (aka "cybracero") for "sleep dealers" in the Cybracero
program—"factories" in which Mexican workers remotely operate machines
residing on American soil. To become a cybracero one needs "nodes"—
connectors installed in the body by which the machines can be remotely
operated. The nodes are surgically implanted by specialists, but they cost
too much for the unemployed. The alternative is to hire the services of a
"coyotek" at the border area. In the future imagined in *Sleep Dealer*, physi-
cally crossing the American border ceases to be a viable option when people
are encouraged to cross it virtually—and thus global connectivity masks
fiercer segregation than in the pre-internet era.

On the way to Tijuana, Memo meets Luz Martinez (Leonor Varela).
She has the nodes so desired by Memo and makes her living as a "virtual
writer." Her writings are actually her own memories, experiences acquired
by contact with other people that are then converted into merchandise.
These "virtual texts" are sold on demand in cyberspace, a sort of YouTube of
memories, the "TruNode." Luz's job reminds us of Adolfo Sánchez Vásquez's
remarks on free work versus art (2011: 169). As a writer, Luz can convert
her memories into art and, consequently, into merchandise. However, the
nodes' mediation technology seems both to stress the character of the mer-
chandise and blur the authorship aspect of her own virtual writings. Louis
Althusser's concept of "practice," as well as the ideas on "the author as pro-
ducer," by Walter Benjamin and Bertolt Brecht, are also pertinent to this
discussion (see Eagleton 2002: 55–70). Memo seems like a good source of
stories for Luz, and she starts "writing" about him. A closer relationship be-
tween the two springs forth, and Luz herself installs nodes in Memo so that
he can work at the Cybracero unit in Tijuana. While Luz is implanting the

The worker as a puppet in the post-industrial capitalism of Alex Rivera's *Sleep Dealer*.

nodes in Memo, he concludes: "Finally, I could connect my nervous system to the other system: the global economy."[6]

About to start his job in a Cybracero unit, Memo hears from his immediate supervisor: "This is the American Dream. We give the United States what they've always wanted: all the work—without the workers." This is supreme reification of the worker, in tandem with the "immaterialization" of industrial work—as Hardt and Negri point out, the new managerial imperative here is to "treat manufacturing as a service" (2000: 285–86). Not only the body's contact with the product of his work is "deleted," but also the corporeal presence of the worker, with his identity and body effaced by the interface of technology. Memo starts working as a cybracero, remotely operating a construction-robot in California, and soon feels the effects of the long working hours. Such scenes illustrate Manuel Castells's observation, quoted by Mark Bould (2009: 9), that while "capital is global, and core production networks are increasingly globalized, the bulk of labor is local. Only an elite specialty labor force, of great strategic importance, is truly

globalized." Moving from the *Gemeinschaft* to the *Gesellschaft* by force of a traumatic event, Memo's journey also illustrates his ascension to the secondary sort of communal identification in which, by means that include getting a job at a big enterprise, the individual accesses a "national" identity—which in turn transubstantiates her primary identification, that with her family and local community (Žižek 1997: 6).

Memo and Rudy are characters that more visibly suggest the concept of alienation. The former helps build up premises miles away, whereas the latter kills people miles away. Both have no contact with the product of their work, both ignore the true nature or identity of the ones affected by their work. These two workers might accurately represent the American paradigm of a service economy model (Hardt and Negri 2000: 286), characters somewhat equivalent to the telemarketing operator in New Delhi who provides technical support to a Brazilian customer of an American company, so to speak. Luz, on the contrary, plays the role of a different kind of worker, one more involved with the outcomes of her toil, the subject of her work, that is, human memories, and one who makes use of the telepresence technology not exactly as a means of alienation.[7] According to Rivera's interview (2012b), the director designed his characters based on a triangular relationship, in which two alienated workers happen to be connected by a third worker of a slightly different kind.[8]

The characters in *Sleep Dealer* also evoke the concept of "immaterial labor," as in Lazzarato and Negri (2001), Hardt and Negri (2000), and Negri (2011). To some extent derived from the Marxist concept of "general intellect," the term "immaterial labor" was coined by Lazzarato and Negri as the "distinctive quality and mark" of labor in a time when information and communication play an essential role in each stage of the production process (Lazzarato and Negri 2001: 86). The immaterial labor is most visibly identified with the rise of the service industry in the post-Fordist global capitalism. Hardt and Negri observe that the transition to an information economy necessarily involves a change in terms of the quality and nature of labor; hence "today, information and communication have come to play a fundamental role in the production processes" (2000: 289). Hardt and

Negri basically explain immaterial labor as follows: "Since the production of services results in no material and durable good, we define the labor involved in this production as *immaterial labor*—that is, labor that produces an immaterial good, such as a service, a cultural product, knowledge or communication" (2000: 290).[9]

Hardt and Negri also remark that immaterial labor is twofold: one side is shaped by the computer as a universal tool—with the informatization of production, all work tends to appear as abstract work (2000: 291–92); the other side of the immaterial labor is the "affective" work, involving human contact and interaction, such as health care and, to a larger extent, the entertainment industry (2000: 292–93). Thus, Hardt and Negri define three types of immaterial labor that propel the service industry to the top of the information economy: (1) high-tech info-industrial production, which incorporated communication technologies to an extent that deeply affects the very production processes; (2) the immaterial labor of analytical and symbolic tasks; and (3) the immaterial labor that involves the production and manipulation of affection and requires human contact (virtual or real), as well as handwork (Hardt and Negri 2000: 293).

In *Sleep Dealer*, Luz is more reminiscent of the "immaterial labor" concept than Memo, given the "subjective" quality of her work in comparison to the more "Fordistlike" shape of his job. Furthermore, Luz's occupation also fits in with the third kind of immaterial labor proposed by Hardt and Negri, the one that involves "affection" and human contact. According to Hardt and Negri (2000), the aesthetic model is hegemonic in the context of immaterial labor—in addition to the economic value, this hardly visible and tangible kind of "work" accounts for the production of new subjectivities and a rhizome of social relationships. Devoid of any recognizable affection involved (in a positive way), Rudy Ramirez's job as a military drone pilot also fits in with the concept of immaterial labor. Only Memo's work remains heavily attached to the Fordist legacy, even though he acts on the stage of the well-known service industry. Moreover, in accordance with Hardt and Negri's (2000: 307) model, one might suppose that the fiction of *Sleep Dealer* suggests the United States as a service economy that masters

the repressive force and controls a subordinated info-industrial economy: Mexico. Based on the premise that every postmodern economy is attached to a global economic structure, the Mexican economy seems to incorporate information technology in favor of the United States. This diagnosis comes from the fact that the film is rather schematical and focuses on just a few characters, leaving much of the background and further connections to our own imagination—it shows the workers, the police/military, the media as part of the underworld and hints at a resistance movement, but it does not embrace other sectors and dimensions of the social life.

The dialogues and interior monologues are particularly meaningful for fitting the overall fable of *Sleep Dealer* into a Marxist framework. In one of his meetings with Luz, Memo complains about his alienated condition: "I don't know what I'm doing. I work in a place I'll never see. I can see my family, but I can't touch them. And, well, the only place I feel . . . connected . . . is here . . . with you." At this point, Memo still ignores the fact that Luz sells memories of their relationship, that this "commodification of time" invades their own leisure time and intimacy. Memo is not only the proletarian worker, but also the object of someone else's work—ultimately, merchandise as well. When he finally discovers the truth, their relationship is compromised.

By coincidence, the main reader of Luz's writings (Memo's memories) is Rudy Ramirez, the military pilot who attacked Memo's house in Santa Ana. Driven by sorrow, Rudy crosses the border into Mexico "at his own risk." In Tijuana, Rudy meets Memo and reveals his identity. Memo tries to pull away from the presence of the murderer of his father, but Rudy insists on offering him some reparation for the crime he committed. The two young men come to an agreement and, with the help of Luz, Rudy takes control of his drone aircraft from the Cybracero unit where Memo works. The drone takes off and flies toward the Santa Ana dam. Other planes depart in pursuit, but Rudy eventually bombs the dam, releasing water to the community, and at last the narrative dénouement goes beyond the private sphere of the triangle of main characters. Now half destroyed, water flows from the dam and the community celebrates. It is unknown whether the company will re-

build the barrier. Rudy cannot return to the United States and heads south. Memo remains at the border. The triangle opens into an indefinite future. According to Lysa Rivera (2012: 432), "This subversive potential of these borderlands narratives [*Sleep Dealer* included] is visible in their open ending, which resist closure and invite a prolonged consideration of the shape of things to come."

Reading *Sleep Dealer*

Rivera (2012a) has clarified that the first two acts of *Sleep Dealer* focus on the increasing consciousness and revelation of the alienated status of the main characters: Memo, Luz, and Rudy. Each one goes deeper into their own condition and gradually discovers their alienation and true role in that dystopian society. In the third act, Rivera points out, they find a way to "twist the Rubik's cube" and get some power to strike back for a moment. In the words of Rivera himself, the film is "65% alienation and 35% connection and rebellion." The director also summarizes the whole film as "a myth of sorts, simplifying and visualizing these oddly symmetrical global flows" (Harris 2012).

Naturally, the concept of immaterial labor has been the object of further debate and counter-arguments, such as the criticism by "George Caffentzis (1998), who accused Negri of celebrating 'cyborgs' and 'immaterial labor' while ignoring the 'renaissance of slavery' effected by factories, agribusiness, and brothels" (Dyer-Whiteford 2001: 72). *Sleep Dealer* challenges "cognitive capitalist" theories as much as Marxist concepts, since its main characters illustrate the polemics around the putative "immateriality" of "immaterial labor." Dyer-Whiteford alerts that "'Immateriality' could easily be read as occluding some very corporeal components of high-tech work" (2001: 71). The same author suggests that "the priority Negri and his collaborators gave 'immaterial labor' seemed to diminish the continued importance in the post-Fordist economy of a vast mass of all too physical and material work" (2001: 71). As stated before, in *Sleep Dealer* Memo is far from being a quintessential "immaterial laborer," a networker of the Web—despite his

"wired" job. It is Luz and Rudy who best fit this category. In his critique of Hardt and Negri's *Empire*, Dyer-Whiteford points out some flaws and contradictions in the expanded concept of immaterial labor: "Repeating what is both a weakness endemic to Marxism and perhaps a particular vulnerability in Negri's work, *Empire* emphasizes the smoothness—the homogenizing effects of global capital—at the expense of the striating divisions" (2001: 75). Furthermore, Dyer-Whiteford suggests two categories that should complement the idea of immaterial labor, two other groups that deserve equal attention: "material labourers" and the "immiserated":

> If immaterial labor is characterized according to its communicational and affective activity, then material labor is that type of work still primarily focused on shaping the physicality of products (from sport utility vehicles to running shoes to semiconductor chips) which obstinately refuse to dematerialize themselves, and immiserated labor is that part of the labor force which, through various gradations of precarious and contingent employment up to the short—and long-term reserve army of the unemployed, is treated by capital as simply surplus to requirements.... If the paradigmatic figures of today's immaterial labor are among the net-workers of the World Wide Web, then those of material labor are surely in the manufacturing plants of the maquiladoras, export-processing zones, and new industrial areas, and those of immiserated labor are in the vast tides of the homeless and itinerant who settle in the doorways and alleys of every rural slum and world city. (Dyer-Whiteford 2001: 76)

It is interesting to see how *Sleep Dealer* provides fictional characters who seem to fit in and illustrate Dyer-Whiteford's three categories: immaterial labor (Luz and Rudy Ramirez), material labor (Memo, essentially), and the immiserated (people in Memo's *milpa*, people on the streets of Tijuana).

Matthew Beaumont's proposal of anamorph and anamorphosis in science fiction narratives is also useful for a better understanding of Rivera's discursive strategies in *Sleep Dealer*. Beaumont departs from Hans Holbein the Younger's double portrait of Jean de Dinteville and Georges de Selve,

The Ambassadors (1533), to suggest a plastic, figurative metaphor or analog to Darko Suvin's concept of "cognitive estrangement" (1979).[10]

In Beaumont's terms, one could easily identify an anamorphosis in *Sleep Dealer*. However, the near future engendered by Rivera's film is too much rooted in the implied spectator's norm of reality to be regarded as such. Let us think about the source point for the hero's journey, Memo's *milpa*, and the whole social and political backdrop, not unfamiliar to any spectator whatsoever. Rather, telepresence technology, in a slightly extrapolated form, plays the role of the anamorph in Rivera's film. The "anamorphic effect" in *Sleep Dealer* is materialized by the Cybracero unit; it is the disruptive element that promotes the estrangement and the further counter-reading of our present-day, extrafilm norm of reality. This anamorph, the telepresence technology impersonated by the Cybracero unit, has a double-edging anamorphic role, both diegetic—it allows Memo's own estrangement, his journey toward class-consciousness and liberational action—and extradiegetic—this is "Holbein's skull" for us, the spectators.

On the reception of *Sleep Dealer*, Rivera (interview with *Crossed Genres*, 2012a) recalls that the film was seen slightly differently in Latin America than in the United States: "In Lima, Peru they connected the film to the tradition of neorealism, which is an important part of Latin American cinema. There, they called *Sleep Dealer* a neorealist science fiction, and I love that phrase." Often regarded as a kind of "Latin American *Matrix*," Rivera's film establishes some opposition, or antinomies in Marxist terms, which evolves from micro- to macrocosm, from the individual to the political sphere: city versus country, corporate State versus worker, First World versus Third World, and so on. In addition, *Sleep Dealer* shows the three basic features that connect science fiction to Marxist thought according to Carl Freedman (2009b: 129): "Materialism" (the movie describes and discusses the material conditions for the survival of its main characters; its technological dystopia is founded in materialistic terms—the need for water, the need to work, rural life, etc.), "the historical perspective" (Memo, Luz, and Rudy are characters in history, in search of a future—but also a past—and the technological dystopia depicted in the movie is inscribed into historical

extrapolation),[11] and finally "the impulse not only to interpret but also to transform the world" (on the most basic diegetic level, the triangle of main characters eventually acts to change their world).

Inflation/Deflation

Also, *Sleep Dealer* is mostly deflationary in accordance with Freedman's Marxist analysis of the dialectics of science fiction and film noir (2009a: 66–82). Freedman analyzes the narrative, characters, and cinematic aesthetics of two noir films (Billy Wilder's *Double Indemnity* [1944] and Stanley Kubrick's *The Killing* [1956]) and two SF films (Robert Wise's *The Day the Earth Stood Still* [1951] and Stanley Kubrick's *2001* [1968]) to propose that (good) science fiction cinema (of literary descent) is inflationary, that is, it propagates the ideal that "life offers much *more* than expected" (2009a: 68; emphasis in the original), and "reality is richer and more various than most people assume" (2009a: 69), whereas film noir is ultimately deflationary, that is, life and reality tend to be exhausted from any will of transcendence or utopianism: "Settling for the mundane is, by contrast, precisely what film noir is all about" (Freedman 2009a: 71). This confrontation between film noir and science fiction could be analogous, in Freedman's terms, to the equivalent dialectics of inflation versus deflation in Marx's and Engels's body of works. In this sense, Marxism is both deflationary (in its political and moral drive) and inflationary (in its scientific drive): "It should be stressed that inflationary and deflationary perspectives not only combine in Marxism but form a genuine dialectic: each animates and concretizes the other" (Freedman 2009a: 75). According to Freedman, more recent technoir films, such as Ridley Scott's *Blade Runner* (1982–91) and Alex Proyas's *Dark City* (1998)—particularly the latter—thus provide aesthetical/figurative analogs for the deflation/inflation dialectics operational within Marxist thought.

Sleep Dealer could be fit into Freedman's framework as well. Apart from being an SF narrative, it also presents some punctual resemblance to the film noir paradigm, a notorious trend in contemporary SF cinema. The noirish elements in *Sleep Dealer* range from the ambivalent roles of both Luz

and Rudy Ramirez through the visual style adopted in the portrayal of Tijuana and the shadowy deals conducted around the border, and to the schematic rendering of both an underworld (of illegal trades) and supraworld of mastery corporations—puppets and puppet-masters are quite familiar characters in the noir tradition. Thus, in Freedman's terms, *Sleep Dealer* could be predominantly deflational. The "anamorphic estrangement" (Beaumont 2009) rendered by the fictional technology of telepresence is nearly completely negative, deflational, a technical tool used in favor of human alienation. It is only glimpsed as a liberational instrument through the work of Luz and her role as the "convergence point" between Memo and Rudy, and, eventually, toward a future-geared liberation. The deflational aspect of *Sleep Dealer* also lies in its account of an everyman's journey into class-consciousness. Memo's journey and his eventual alliance with Luz and Rudy also illustrate the (Marxist) passage from a "class in itself" to a "class for itself"—that is, "the progress from a class that only exists numerically, given the concreteness of its members, to a class that perceives its role as a political agent of transformation of capitalist society" (Jorge 2010: 131–48). Moreover, it ultimately envisages the three characters' passage from the state of "subjects-for-capital" to "subjects-for-themselves"—in spite of the film's open-ended conclusion.

However, much as in Freedman's analysis of Alex Proyas's *Dark City*, *Sleep Dealer* also presents a narrative twist, a role reversal. As Freedman comments on *Dark City*, "What *does* offer escape—or rather inflationary transcendence—is transformative labour and action" (2009a: 81; emphasis in the original). The author goes further, affirming that *Dark City*'s ending suggests that "human freedom is possible after all, and the determining power of the ruling class, which had seemed unassailable, is broken" (2009a: 81). The same diagnosis could be applied to *Sleep Dealer*, given its denouement (the bombing of the damp by Memo, Luz, and Rudy). *Mutatis mutandis*, this balance of deflationary/inflationary drives in *Sleep Dealer* could also be regarded as another point of contact with Marxist thought.

For all that, *Sleep Dealer* could basically be seen as a Marxist or materialist SF film—even though not only this. Fredric Jameson observes that sci-

Selling memories of a relationship in the borderlands.

ence fiction is about our present time, not about expectations or forecasts of the future, as usually perceived (1982: 4). According to Jameson, genuine science fiction does not seek to represent the probable or possible future but promote an impulse (collective and uncontained) toward the distancing and defamiliarization of our present time necessary for a more precise contemplation of our reality:[12] "SF thus enacts and enables a structurally unique 'method' for apprehending the present as history" (Jameson 1982: 5). In this maneuver, the genre produces a "future of the past"—the future of a posthumous time, collectively remembered—that ultimately focuses on our own inability to "breathe in" the present and imagine the future—our current utopian inability—and hence becomes a contemplation of our own limits.[13] We believe that *Sleep Dealer*'s fiction fits in this profile.

Multi/Transculturalism

In literature, multicultural SF has a relevant history.[14] In SF cinema, however, multi- and transculturalism seem to be a more recent phenomenon,

at least in the scope of the film industry. The motifs of cultural identity and immigration seem to be intensified in contemporary SF cinema, and interesting contributions on the subject have come from productions (or coproductions) directed by Europeans, Latin Americans, and Asians. For about ten years, the intersection between science, technology, and peripheral cultures has lured invigorated interest, with the "teletransport" of SF narratives to sets like a ghetto in London (Alfonso Cuarón's *Children of Men* [2006]), a shanty town in Johannesburg (Neill Blomkamp's *District 9* [2009]), Tijuana and the border zone between Mexico and the United States (*Sleep Dealer*), and even a remake of the Oedipus tragedy set in a near-future (Michael Winterbottom's *Code 46* [2003]). Such geopolitical dislocation meets a previously unattended demand for the genre, a feeling Rivera explained in his interview with Dennis Lim in the *New York Times*: "Science fiction in the past has always looked at Los Angeles, New York, London, Tokyo. . . . We've never seen São Paulo, or Jakarta, or México City. We've never seen the future of the rest of the world, which happens to be where the majority of humanity lives" (Lim 2009). Rivera's interviews have outlined his interest in cyberpunk movies that include more of a global perspective, something the director refers to as the "cyberpunk of the South" or "cyberpunk of the developing world" (Anders 2008).[15] On why he makes "trans-border fantasies" in particular, Rivera explains to *Crossed Genres* (2012a):

> When we talk about fantasies, we're talking about reality. . . . I've been interested in the idea of trans-border narratives and fantasy because I know we live in a fundamentally trans-border reality. . . . So to me, telling stories or using the genre of science fiction to look at the fact that we're all connected across borders is crucial work. . . . To me, the trans-national perspective is the only way to understand the world we live in.

In summary, *Sleep Dealer* is in many ways an essentially hybrid film, typical of "borderlands SF" (Lysa Rivera 2012: 430), beginning with its context of coproduction, but especially due to the peripheral gaze it sets on the social, political, and economic agenda.

According to Lysa Rivera, "borderlands SF" narratives such as *Sleep Dealer* are particularly prone to revisit and remix the cyberpunk subgenre. The author points out that "[in] retoiling cyberpunk to write both within and against multinational capitalism and its ideological underpinnings, borderlands science fiction is a type of postcolonial literature that transforms dominant culture through appropriation" (2012: 430).[16]

Also, a series of intertwined discourses, reminiscent of the thoughts of such authors as Néstor García Canclini (2005), Manuel Castells (2009), and Zygmunt Bauman (2004), seems to emerge from the narrative in *Sleep Dealer*. With this in mind, Bauman's idea of multiple identities, "poli-identity," or "liquid identity" could be related to the character Rudy Ramirez, son of Mexican immigrants. Rudy, the American military, is the shattered man par excellence, divided by ethnicity and culture, "here" and "the other side," past and present, duty and guilt. He fluently speaks both English and Spanish, and ends up exiled, surrendered to the romantic quest for a repressed legacy. Moreover, Rudy provides an interesting illustration of the contemporary crisis of "Americaness" as a nation-state narrative of congregation, as posed by authors like Slavoj Žižek (1997: 7).

In its materialist or Marxist inspiration, *Sleep Dealer* also adheres to postcolonialism—or, better still perhaps, "intensified colonialism," in the words of Masao Miyoshi (1993: 734). The film integrates the body of work that Lysa Rivera designates as "post-NAFTA borderlands dystopias," "a type of 'future history' that forces readers/spectators to read the future through the historical presence of the colonial past" (2012: 427). More specifically, *Sleep Dealer* attempts to formulate a critique of American imperialism using the instruments of a genre that has often been associated with imperialist ideology (negatively or positively). Such Marxist orientation, with a certain realist aesthetic and its anti-imperialist discourse, lines Rivera's film with a number of contemporary world SF films—productions that are more author-oriented, with "moderate" budgets in a more cosmopolitan or transnational context.[17] Like the aforementioned *Children of Men* and *District 9*, *Sleep Dealer* is representative of a group of invigorated films within contemporary SF cinema, with a strong realist, Marxist, and transcultural

orientation. In this sense, this breed of film contributes to the rescue of the originally universalist vocation of SF literature, a genre that naturally questions boundaries, classes, and definitions.

Sleep Dealer might also be regarded as a viable option in terms of overperforming multiculturalism as "the cultural logic of multinational capitalism," "a disavowed, inverted, self-referential form of racism, a 'racism with a distance'" (Žižek 2005: 6)—as pointed out by Mark Bould in the Wachowski brothers' *Matrix* trilogy (2009: 14). If Žižek's diagnosis of multiculturalism as the reinforcement of Eurocentric superiority makes sense, perhaps films like *Sleep Dealer* might contribute to such debate obliquely and involuntarily, not through a discourse of reaffirmation of the local and regional culture—of the Latino in contrast to the yankees' post-industrial capitalism—but by means of the film's very open-ended conclusion, a conclusion that territorializes the main characters. The apparent complicity with the multiculturalist speech does not appear to be finally confirmed by such an open-ended conclusion; something like a "negation of the negation" seems to be operational here. The main characters' journey culminates with the disintegration and radical transubstantiation of their national identities and social/economic roles. Such transformation may reveal, albeit unconsciously and involuntarily, the function of Žižek's allegedly "domesticated" multiculturalism in the global capitalist order.

Conclusion

Sleep Dealer is a piece of fiction that extrapolates the world's contemporary agenda in the broader context of cinematic dystopias—an heir to the dystopian tradition in literature[18] and representative of contemporary "critical dystopia," in Tom Moylan's terms (2000: 43). According to Lysa Rivera, borderlands SF—namely Guillermo Lavíns's short story "Reaching the Shore" (1994), Alex Rivera's films, and Rosaura Sanchez and Beatrice Pita's Chicanafuturistic novel *Lunar Braceros* (2009)—are post-NAFTA borderlands dystopias that "function similarly to what Tom Moyan calls the 'critical dystopia,' a cousin of dystopia that rejects the latter's tendencies

towards hopeless resignation by offering 'a horizon of hope' just beyond the page" (Moylan 2000: 181).

Anti-utopia or dystopia may be the locus where the relations between science fiction and reality become more evident—especially when a given text resorts to the satirical style.[19] Schematically, *Sleep Dealer* drives us to some general remarks on contemporary science fiction cinema, such as (1) the interest in issues of the world's social, political, and economic agenda, in speculative extrapolations, generally with a documentary narrative strategy; (2) the recurrence of three issues in particular: the police state (terrorism implied), immigration, and vicariousness; (3) the strength of the peripheral gaze or the appropriation of a supposedly American genre in essence (as John Baxter argues in *Science Fiction in the Cinema* [1970]—mistakenly, in my opinion) by non-American artists; (4) the decline of the blockbuster in comparison to less economically ambitious initiatives, which are sometimes more creative and inspired, renewed by a more cosmopolitan approach; and (5) the importance of digital technology as a tool for accessing more independent SF films—and possibly more cosmopolitan productions.

The protagonist triangle (Luz, Memo, and Rudy Ramirez) in *Sleep Dealer* posits, simultaneously, reaffirmations and challenges to the Marxist thought, suggesting the necessity to better comprehend the antagonisms of such a "cognitive capitalism," irreducible to the traditional dialectics "capital versus labor" and the traditional class divisions (see Szaniecki, Corsini, and Siqueira 2010: 3).[20] Simultaneously challenging "old school" Marxist concepts and contemporary categories such as "immaterial labor" in the context of "cognitive capitalism," *Sleep Dealer* reinserts the demand for a revised, actualized Marxist thought in the critique of information economy. On a basic level, it does so by recontextualizing the *Lumpenproletariat* in a high-tech, global capitalism milieu—only slightly extrapolated from today's point of view. Thus, in its critique of information economy, *Sleep Dealer* seems to evoke a vividly original Marxist approach—since communication technology, in the film, is put at the service of fierce capitalist accumulation and exploitation. In other words, "immateriality" in *Sleep Dealer* is rather corporeal and serves to reveal the deeply rooted material and physi-

cal aspect of high-tech post-Fordist capitalism—there is no stygmata more material and corporeal than the "nodes." The film thus illustrates Žižek's critique of the late capitalist mystification of cyberspace as a locus for "friction-free" capitalism (in the words of Bill Gates), a transparent, ethereal "place" where exchanges run free of material constraints (Žižek 2005: 3–4). As auspiciously recalled by Žižek, Marx observed, in his *Grundrisse*, that the very material organization of a nineteenth-century industrial plant directly materializes the capitalist domination: the workers as a mere appendix subordinated to the capitalist machinery—let us think of the Cybracero unit and the telepresence technology in *Sleep Dealer*. In this sense, the most interesting aspect of the production design in Rivera's film is precisely its lack of a more creative extrapolation in terms of future technology. *Sleep Dealer* actually enacts a retro-future tale, one that outlines the resilience of nineteenth-century exploitative models adapted to the global post-industrial informational economy (Hardt and Negri 2000; Žižek 2005).

Another hypothesis suggested herein is that a certain amount of science fiction cinema has benefited from the subtle realist and documentary "vocation" of the genre, offering new and curious forms for recording contemporary social contradictions. According to the Marxist theorist Adolfo Sánchez Vázquez:

> We call realist art any art that, based on the existence of an objective reality, builds a new reality which gives us truths about the reality of the actual man who lives in a certain society and in the perspective of certain human relations—historically and socially conditioned—works, fights, suffers, enjoys or dreams. (2011: 32)

Sleep Dealer can be considered a good example of a contemporary realist science fiction film, somewhat analogous—*mutatis mutandis*—to the "socialist novel."[21] Thus, the affinity between science fiction—literary or audiovisual—and Marxism, which is evident in the utopian motivation common to both (cf. Csicsery-Ronay 2003: 113), also encompasses the role and relevance of documentary accuracy for both a genre and a philosophy

on a formal level. We can certainly not speak of a "Bazinian realism" in films shaped according to Hollywood cinema's narrative rules and principles. However, we could go as far as considering a certain "Lukacsian realism" in movies like *Sleep Dealer*, which is a work endowed with a complex and comprehensive set of relationships between man, nature, and history, typical in the context of a specific historical period—in this case, the post-industrial capitalism of the war on terror, post-September 11 (see Eagleton 2002: 26).[22]

Nevertheless, *Sleep Dealer*'s Marxist and multicultural thrust seems restricted to its content level; it does not significantly influence its form. Despite its contestatory speech, the film seems to be kept in the mold of the typical American science fiction cinema, a "tentacle" of the same forces of domination Rivera tries to uncover. We could therefore see a supposed "contradiction" between form and content in *Sleep Dealer* (Hollywood narrative rules and principles versus counter-hegemonic political discourse), as well as between the political speech assumed by Rivera's film (counter-hegemonic, inclusive, multicultural) and the design of some characters.[23] In this sense, *Sleep Dealer* loses an impetus that is more formally identified with the proletariat—something stronger in *Why Cybraceros?*—in favor of a greater communication with broader audiences. Thus, Rivera's feature film aligns itself with the controversial strategy of the hegemonic audiovisual industry, which tends to co-opt the independent film scene. These hypotheses, however, deserve further investigation.[24]

Notes

1. *Why Cybraceros?* (1997), directed by Alex Rivera, 1997. blog.altoarizona.com/blog/2010/04/why-cybraceros-a-mock-promotional-film-by-alex-rivera.html. Accessed November 9, 2012.
2. "My fascination with drones emerged from a political satire project that I began in the 1990s. I wanted to explore the dissonance I saw occurring between the discourse around immigration—one of xenophobia and increased territoriality—and the discourse around digitality—one of border-lessness and increased free flows. In the '90s the Internet was in its infancy, but the rhetoric around it was expanding rapidly. Among a whole slew of new metaphors, I was attracted to the concept of telecommuting, because, in its evocation of the idea of working from home, it oddly resonated

with the immigrant experience—the experience of leaving home to work, in a particularly acute sense. At the same time that the borderless space of the Internet was being developed and celebrated, the government of the United States was building a wall for the first time to separate the U.S. and Mexico. And so there was this dream of connectivity, this dream of a global village, and simultaneously a material reality that borders on the ground were being militarized and fortified. Peering into that contradiction, I came up with a nightmare/fantasy of an immigrant worker who stays put in Latin America and, via the Net, transmits their labor to a worker robot in the U.S. The pure labor crosses the border, but the worker stays out. At first, the idea was meant as a critique of Internet utopianism and the politics of immigration. But over the years it has become a reality as call centers emerged in India, for example, and we began to see the first incidents of service-sector labor being transmitted around the globe. Transmitted transnational living labor was born, or what I like to call the first generation of telemigrants" (qtd. in Harris 2012).

3. *Why Braceros?* (ca. 1959). California Grower's Council, www.archive.org/details/WhyBrace1959. Accessed November 9, 2012.

4. According to Rivera in an interview with Charlie Jane Anders in *io9*, "The rhetoric of that industrial film was very trippy, in terms of the abstract nature of labor," so he wanted to play with the idea of disconnecting labor from people (Anders 2008). Anders also recalls that in 1997, when *Why Cybraceros?* was released, there was an obsession with the idea of the "global village" and borders coming down, whereas the United States was building a wall along its border with Mexico and a new anti-immigrant movement emerged in the country.

5. The relations between satire and SF began with the awakening of the science fiction genre, and the satirical strategy has been revived by the most creative SF cinema. Booker and Thomas observe that "satire is an ancient and distinguished literary mode that typically employs humour to expose and critique the follies of various social or political practices or certain habitual modes of human behaviour. In short, satire depends on the phenomenon of cognitive estrangement in order to achieve its effects. In that, it has much in common with science fiction, so it is not surprising that some of the most important science fiction novels ever written have been openly satirical in their orientation" (Booker and Thomas 2009: 98).

6. Memo's thoughts recall the Marxist concept of apparatus developed by the Czech philosopher Vilém Flusser (1998). Further on the topic of labor rendered by telepresence, Rivera remarks that "the next stage in this process, and I've been told by roboticists at M.I.T. that this prediction (which started as satire) is true and in progress, is for capital to configure itself to enable every single job to be put on the global market through the network and its increasingly sophisticated physical outputs" (Harris 2012).

7. This explanation does not free Luz's job from any controversy whatsoever, since her activity generates alienation and reification on a second level: in respect to the people who provide their memories to her.

8. On the Marxist concept of alienation, Rivera explains: "In discussing the menace of these types of imagined alienated labor, I don't want to romanticize the present state of affairs. Most of my taxi rides today are experienced with both the driver and myself on the phone, talking to telepresent individuals. Customers at a restaurant today often

don't see the workers—and they're physically there, maybe 10 feet away—but nonetheless they can become phantoms or invisible presences. The threat that telepresent labor presents—that there'll be no contact between the person eating and preparing food, that a certain social proximity or contact will be lost—has already happened! The erasing has already occurred" (Harris 2012).

9. According to Nick Dyer-Whiteford, "As commodities come to be 'less material' and 'more defined by cultural, informational, or knowledge components or by qualities of service and care', so, *Futur Antérieur* claimed, the labor that produces them undergoes a 'corresponding' change: 'immaterial labor might thus be conceived as the labor that produces the informational, cultural, or affective element of the commodity'. Negri, Hardt, and Lazaratto insisted that 'immaterial labor' was not just a select cadre of technical workers but a generalized form of labor-power, a 'massified quality of the laboring intelligentsia, of cyborgs and hackers' (Dyer-Whiteford 2001: 71).

10. According to Darko Suvin, "*SF is, then, a literary genre whose necessary and sufficient conditions are the presence and interaction of estrangement and cognition, and whose main formal device is an imaginative framework alternative to the author's empirical environment*" (1979: 7–8; emphasis in the original). The author proceeds to explain that "estrangement differentiates SF from the 'realistic' literary mainstream extending from the eighteenth century into the twentieth. Cognition differentiates it not only from myth, but also from the folk (fairy) tale and the fantasy" (1979: 8). In Suvin's terms, the cognitive estrangement is triggered by a narrative device he calls the *novum*: "*SF is distinguished by the narrative dominance or hegemony of a fictional 'novum' (novelty, innovation) validated by cognitive logic*" (1979: 63; emphasis in the original). Suvin explains that "quantitatively, the postulated innovation can be of quite different degrees of magnitude, running from a minimum of one discrete new 'invention' (gadget, technique, phenomenon, relationship) to the maximum of a setting (spatio-temporal locus), agent (main character or characters), and/or relations basically new and unknown in the author's environment" (1979: 64).

11. History, in *Sleep Dealer*, is crucial. Lysa Rivera regards this film as a post-NAFTA broderland dystopia. The author sees "the insistence on a 'future with a past' in Rivera's *Sleep Dealer*" (2012: 413). Still, according to this author, "[in] an instant, then, Rivera is able to signify a futuristic image and a historical referent" (2012: 427). Lysa Rivera further observes that "borderlands sf writers [Alex Rivera included] refuse to foreclose on the possibility of change: the desire for new oppositional tactics that are simultaneously grounded in a revolutionary past—the desire, that is, for a 'future with a past'—motivated these texts, which value cultural recovery but also underscore the vitality of speculation" (Rivera 2012: 431).

12. Actually Jameson is reproducing Darko Suvin's concept of "cognitive estrangement" (1979).

13. In the words of Jameson himself: "We must therefore now return to the relationship of SF and future history and reverse the stereotypical description of this genre: what is indeed authentic about it, as a mode of narrative and a form of knowledge, is not at all its capacity to keep the future alive, even in imagination. On the contrary, its deepest vocation is over and over again to demonstrate and to dramatize our incapacity to imagine the future, to body forth, through apparently full representations which prove on closer inspection to be structurally and constitutively impoverished, the atrophy in

our time of what Marcuse has called the utopian imagination, the imagination of otherness and radical difference" (1982: 6). Nevertheless, the author states that such writers as Ursula K. LeGuin, Marge Piercy, and Samuel Delany have contributed to the rediscovery of the utopian vocation in contemporary science fiction (Jameson 1982: 6).

14. For instance, African culture has been debated through works like Mike Resnick's *Paradise* (1989) and *Kirinyaga* (1998), books that recreate Kenya and Kenyan culture, or Ian McDonald's *The Evolution's Shore* (1995, originally published in the UK as *Chaga*) and *Kirinya* (1998). In his SF novels, McDonald has written about India in 2047 (in *River of Gods* [2005]), and the past, present, and future Brazil (in *Brasyl*, 2007) (2009: 125). African American authors such as Octavia Butler, or the writer and critic Samuel R. Delany, also address Africa, slavery, African diaspora, miscegenation, homosexuality, and so on in some SF masterpieces like Delany's *Babel-17* (1966), *The Einstein Intersection* (1967), and *Dhalgren* (1975), or Butler's Xenogenesis trilogy: the novels *Dawn* (1987), *Adulthood Rites* (1987), and *Imago* (1989).

15. Also in an interview via Skype with this author in January 2013.

16. Lysa Rivera also sustains that "with its trenchant critique of multinational capitalism and its attendant forms of labor and indigenous exploitations, borderlands science fiction produced after NAFTA represents, as I have suggested above, a critical incursion into classic cyberpunk, itself politically charged sf subgenre that emerged in the 1980s, most notably with the publication of William Gibson's novel *Neuromancer* (1984), in direct response to multinational corporate capitalism and the computer technologies that facilitated it" (Rivera 2012: 429).

17. Like *Code 46*, *District 9*, and *Children of Men*, *Sleep Dealer* demonstrates contemporary SF cinema's increasing concern about identity in a globalized world.

18. According to Booker and Thomas, "Also known as anti-utopias, dystopias are often designed to critique the potential negative implications of certain forms of utopian thought. However, dystopian fiction tends to have a strong satirical dimension that is designed to warn against the possible consequences of certain tendencies in the real world of the present. After a flurry of utopian fictions at the end of the nineteenth century, dystopian fiction became particularly prominent in the twentieth century, when suspicions of utopian solutions to political and social problems became increasingly strong as those problems grew more and more complicated and as events such as the rise of fascism in Europe seemed to cast doubt on the whole Western Enlightenment project" (2009: 65).

19. According to Booker and Thomas, "If utopian societies are typically designed to enable the maximum fulfillment of individual human potential, dystopian societies impose oppressive conditions that interfere with that fulfillment. These oppressive conditions are usually extensions or exaggerations of conditions that already exist in the real world, allowing the dystopian text to critique real-world situations by placing them within the defamiliarizing context of an extreme fictional society" (2009: 65). This is the case of *Sleep Dealer* and other recent SF films that continue the cinematic dystopia which began in the 1920s, in films like Fritz Lang's *Metropolis* (1927) and William Cameron Menzies's *Things to Come* (1936), and gained a new momentum in the 1970s in America, incorporating such topics as environmentalism, harsh capitalism, totalitarian technocratic states, and the segregation of minorities—in films like Stanley Kubrick's *A Clockwork Orange* (1972), Richard Fleischer's *Soylent Green* (1973), Norman

Jewison's *Rollerball* (1976), or Michael Anderson's *Logan's Run* (1976). Anderson also directed *1984* (1984), an adaptation of Orwell's famous novel. In the last few years, independent cinema and the phenomenon of coproduction have injected new blood in SF dystopian cinema, through the collaboration of professionals from all over the world—like Rivera, an American of Latino descent, or Alfonso Cuarón, a Chilean based in Spain. And Carl Freedman reminds us that even anti-utopias or dystopias—like George Orwell's *1984* (1949) or Margaret Atwood's *The Handmaid's Tale* (1985)—maintain a link to Marxism: "Such works are of course warnings against evil social systems like those of the invented worlds that the authors depict: but warnings that are generally launched not out of any satisfied embrace of the status quo but, on the contrary, out of a sense that the tendencies represented as having reached a logically and terrifyingly extreme culmination in fiction are already present in actuality to an alarming degree" (Freedman 2009b: 123).

20. In "Trabalho imaterial, cultura e dominação" (immaterial labor, culture and comination), Sílvio Camargo (2010) confronts theories on the cognitive capitalism developed by Antonio Negri, André Gorz, Yann Moulier-Boutang, Carlo Vercellone and Giuseppe Cocco, and the Critical Theory of the Frankfurt School present in the work of contemporary authors such as Fredric Jameson. According to Camargo, the concept of "cognitive capitalism" comes closer to post-structuralism and phenomenology, rather than the solid Marxist theoretical foundations of Adorno and Horkheimer's approach to the culture industry.

21. In a letter to Margaret Harkness, the author of *A City Girl* (1887), Friedrich Engels makes some remarks on literary realism and the socialist novel. According to Engels, realism means, besides the truth of details, the reproduction of typical characters in equally typical circumstances (Marx and Engels 2010: 67). The German thinker celebrates Balzac as an example of a "master of realism," greater than Zola, due to the fact he developed in his *Human Comedy* "the most extraordinary realist history of French society, narrating year by year and like a chronicle, the official habits between 1816 and 1848" (Marx and Engels 2010: 68). Engels's remarks suggest his preference for a certain socially conscious "documentarism."

22. In spite of any revisions or "relativizations" of Georg Lukács's critical theory, notably his notion of "realism," the internal and dialogical contradictions in films like *Why Cybraceros?* and *Sleep Dealer* deserve greater investigation in any subsequent studies, with special attention paid to the supposed Lukácsian realism in contemporary SF film.

23. Character design is particularly interesting when considering contradictions in *Sleep Dealer*. *Why Cybraceros?* is a satire that assumes pamphletary (parodic) rhetoric and, accordingly, has no main character—a propaganda film with no protagonist. However, in order to expand and adjust a political discourse equivalent to that in *Why Cybraceros?*, *Sleep Dealer* needs to have clearly designed main characters—the narrative "engine" of a cinema ideologically lined to bourgeois axioms deeply rooted in capitalism (industrial or post-industrial). In any case, Marx and Engels's ideas in their critiques of Balzac could be similarly transposed to some contemporary cases, like Alex Rivera's. With this in mind, it is worth mentioning that Lenin had already commented that pre-revolutionary formal structures could be used in the communication of revolutionary content (cf. Eagleton 2002).

24. Insofar as it does not seem to compromise *Sleep Dealer*'s "anamorphic effect," as much as the best satyrical/utopian narratives have not focused on radical aesthetical experimentation.

References

Anders, Charlie Jane. 2008. "Cyberpunk South of the Border: *io9* Meets *Sleep Dealer*'s Alex Rivera." *io9*. November 17. io9.com/5089202/cyberpunk-south-of-the-border-io9-meets-sleep-dealers-alex-rivera. Accessed February 12, 2013.

Bauman, Zygmunt. 2004. *Identity (Conversations with Benedetto Vecchi)*. Cambridge: Polity Press.

Beaumont, Matthew. 2009. "The Anamorphic Estrangements of Science Fiction." In *Red Planets*, ed. Mark Bould and China Miéville, 29–46. Middletown, Conn.: Wesleyan University Press.

Booker, M. Keith, and Anne-Marie Thomas. 2009. *The Science Fiction Handbook*. Oxford: Wiley-Blackwell.

Bould, Mark. 2009. "Introduction: Rough Guide to a Lonely Planet, From Nemo to Neo." In *Red Planets*, ed. Mark Bould and China Miéville, 1–26. Middletown, Conn.: Wesleyan University Press.

Calvin, Ritch. 2009. "*Sleep Dealer*." *SFRA Review* 289 (Summer): 19–20.

Camargo, Silvio. 2010. "Trabalho Imaterial, Cultura e Dominação." *Liinc em Revista* 6 (1) (March): 6–21. revista.ibict.br/liinc/index.php/liinc/article/viewFile/324/224. Accessed July 21, 2013.

Canclini, Néstor García. 2005. *Hybrid Cultures: Strategies for Entering and Leaving Modernity*. Minneapolis: University of Minnesota Press.

Castells, Manuel. 2003. *The Rise of the Network Society: The Information Age: Economy, Society, and Culture, Volume I*. 2nd ed. Hoboken, N.J.: Wiley-Blackwell.

Csicsery-Ronay, Istvan Jr. 2003. "Marxist Theory and Science Fiction." In *The Cambridge Companion to Science Fiction*, ed. Edward James and Farah Mendlesohn, 113–24. Cambridge: Cambridge University Press.

Dyer-Whiteford, Nick. 2001. "Empire, Immaterial Labor, the New Combinations, and the Global Worker." *Rethinking Marxism* 13 (3/4) (Fall/Winter). hem.passagen.se/kozelek/rm/8.pdf. Accessed November 9, 2012.

Eagleton, Terry. 2002. *Marxism and Literary Criticism*. London: Routledge.

Flusser, Vilém. 1998. *Ensaio sobre a Fotografia: Para uma filosofia da técnica*. Lisboa: Relógio D'Água.

Freedman, Carl. 2009a. "Marxism, Cinema and Some Dialectics of Science Fiction and Film Noir." In *Red Planets*, ed. Mark Bould and China Miéville, 66–82. Middletown, Conn.: Wesleyan University Press.

Freedman, Carl. 2009b. "Marxism and Science Fiction." In *Reading Science Fiction*, ed. James Gunn, Marleen S. Barr, and Mathew Candelaria, 120–32. London: Palgrave.

Hardt, Michael, and Antonio Negri. 2000. *Empire*. Cambridge, Mass.: Harvard University Press.

Harris, Malcolm. 2012. "Border Control: Interview with Alex Rivera." *New Inquiry*. July 2. thenewinquiry.com/features/border-control/. Accessed November 9, 2012.

Jameson, Fredric. 1982. "Progress versus Utopia; or, Can We Imagine the Future?" *Science Fiction Studies* 9, no. 27, part 2 (July). www.depauw.edu/sfs/backissues/27/jameson.html. Accessed November 9, 2012.

Jorge, Marina Soler. 2010. "Imagens do movimento operário no cinema documental brasileiro." *Art Cultura, Uberlândia* 12 (21) (July-December): 131–48. www.artcultura.inhis. ufu.br/PDF21/m_jorge.pdf. Accessed November 6, 2012.

Lazzarato, Maurizio, and Antonio Negri. 2001. *Trabalho Imaterial*. Rio de Janeiro: DP&A Editora.

Lim, Dennis. 2009. "At the Border between Politics and Thrills." *New York Times*, March 15. www.nytimes.com/2009/03/15/movies/15denn.html. Accessed November 9, 2012.

Marx, Karl, and Friedrich Engels. 2010. *Cultura, Arte e Literatura: Textos Escolhidos*. São Paulo: Editora Expressão Popular.

Miyoshi, Masao. 1993. "A Borderless World? From Colonialism to Transnationalism and the Decline of the Nation-State." *Critical Inquiry* 19 (4): 726–51.

Moylan, Tom. 2000. *Scraps of the Untainted Sky: Science Fiction, Utopia, Dystopia*. Boulder, Colo.: Westview.

Negri, Antonio. 2011. *Art and Multitude*. Cambridge: Polity Press.

Rivera, Alex. 2012a. Interview with *Crossed Genres*. crossedgenres.com/archives/024-charactersofcolor/interview-alex-rivera/. Accessed November 9, 2012.

Rivera, Alex. 2012b. Interview with the project DRONES AT HOME—Phase 2, Gallery@ Calit2, May 11–12. www.youtube.com/watch?v=ncgOsKYkjoM. Published May 30, 2012. Accessed November 9, 2012.

Rivera, Lysa. 2012. "Future Histories and Cyborg Labor: Reading Borderlands Science Fiction after NAFTA." *Science Fiction Studies* 39, no. 118, part 3 (November): 415–36.

Suvin, Darko. 1979. *Metamorphoses of Science Fiction: On the Poetics and History of a Literary Genre*. New Haven, Conn.: Yale University Press.

Szaniecki, Barbara, Leonora Corsini, and Maurício Siqueira. 2010. Apresentação: "Cultura e Trabalho Imaterial / Culture and Immaterial Labour." *Liinc* 6 (1): 1–5. revista.ibict.br/ liinc/index.php/liinc/issue/view/35. Accessed November 9, 2012.

Vásquez, Adolfo Sánchez. 2011. *As Idéias Estéticas de Marx*. São Paulo: Expressão Popular.

Žižek, Slavoj. 1997. "Multiculturalism or the Cultural Logic of Multinational Capitalism?" *New Left Review* 1, no. 225 (September-October). www.egs.edu/faculty/slavoj-Žižek/ articles/multiculturalism-or-the-cultural-logic-of-multinational-capitalism/. Accessed October 1, 2014.

9

Rags and Revolution

Visions of the Lumpenproletariat in Latin American Zombie Films

MARIANO PAZ

The zombie has become so pervasive in American popular culture, particularly during the last few decades, that it is easy to forget that zombies originated in Latin American folklore and myth. Although the religious and cultural foundations of zombies can be traced to African culture, it is in Haiti where modern accounts of these figures were first recorded in literary and journalistic sources. It did not lake long before the zombie was taken up by Hollywood in early films such as *White Zombie* (Victor Halperin, 1932) and *I Walked with a Zombie* (Jacques Tourneur, 1943), although its cult status was not probably achieved until 1968, with the release of George Romero's classic *Night of the Living Dead*. However, zombies have experienced unprecedented success in the twenty-first century, with the final two films in Romero's saga (*Land of the Dead* [2005] and *Diary of the Dead* [2008]), the remake of *Dawn of the Dead* (Zack Snyder, 2004), the new zombie series *Resident Evil*, blockbusters such as *I Am Legend* (Francis Lawrence, 2007), and even the TV series *The Walking Dead* (AMC, 2010–). However, and despite its cultural origins, this particular subgenre has been almost completely absent from Latin American cinema. In 1961, *Santo contra los Zombies* (*Santo vs. the Zombies*, Benito Alazraki) featured

the famous Mexican wrestler Santo fighting against these creatures. This film was inscribed in a series of works in which Santo faced multiple monsters, including vampires, witches, Martians, and the Mummy, among many others—all of them an excuse for Santo to display his wrestling abilities. However, only recently were additional zombie films produced. In what is perhaps the only article on the topic of the Latin American zombie, Alfredo Suppia and Lucio Reis Filho (2010) have identified a select number of Latin American films that draw on the iconography of the zombie, although in many of these cases the zombies are nothing but a marginal presence, and these films would probably fall outside the conventional classification of the subgenre. Suppia and Reis Filho also identify a number of interesting examples of animation and independent short films. However, arguably the most relevant feature-length SF zombie films in the Latin American corpus are to be found in *Plaga Zombie* (*Zombie Plague*, dir. Pablo Parés and Hernán Sáez), a series of three films made in Argentina, and in *Juan de los Muertos* (*Juan of the Dead*, dir. Alejandro Brugués, 2012), the first zombie film made in Cuba. The *Plaga Zombie* trilogy comprises *Plaga Zombie* (1997), *Plaga Zombie: Zona Mutante* (*Zombie Plague: Mutant Zone* [2007]), and *Plaga Zombie Zona Mutante: Revolución Tóxica* (*Zombie Plague Mutant Zone: Toxic Revolution* [2012]).[1]

This chapter proposes a sociopolitical reading of the representation of the zombie in this group of films. I claim that zombies in this case can be read as an allusion to the lumpenproletariat—the social class that Marx (1995) described as the "refuse of society" and which includes the urban masses of vagabonds, criminals, outcasts, and the unemployed. These masses are located outside capitalist relations and are, in ideological and political terms, the opposite of the proletariat. From this starting point, I argue that, given the crucial differences in the economic and sociopolitical organization of Argentina and Cuba, the visions of the lumpenproletariat that the films offer inevitably respond to diverse understandings of class and social stratification. Drawing on contemporary social theorists who have revised the idea of the lumpenproletariat as described by Marx and Engels, I propose that zombies in the Argentinean films can be interpreted

according to what Zygmunt Bauman describes as "human waste"—the outcasts produced by post-industrial, globalized capital. In the Cuban film, the scenario presented is more ambiguous and might be better read through Michael Hardt and Antonio Negri's concept of the multitude. In either of these approaches, Latin American zombie films hint at the possibility of an emancipatory potential that could be conveyed through the portrayal of these monsters.

Latin American Zombies and the Lumpenproletariat

Juan de los Muertos and the *Plaga Zombie* trilogy stand out not only in terms of nationality, but because they are small-scale, low-budget productions—even compared with less expensive European or American independent films. The *Plaga* trilogy has been entirely financed by the independent production company Farsa Producciones; *Juan* is a Spanish-Cuban coproduction, funded by the Cuban film institute (ICAIC) in collaboration with Andalusian Television and TVE. Such low-budget status does not undermine, however, a portrayal of the zombie that is faithful to the conventions of the subgenre, albeit with a less elaborate production design (particularly in terms of makeup, costumes, and CGI images). Thus, the central issue here is whether the political implications behind the zombie are specific to Latin American cinema. This is difficult to address since, as a large number of authors have noted, it is particularly problematic to interpret the zombie. Multiple, and sometimes contradictory, meanings have been ascribed to these creatures. For example, zombies have been interpreted as crystallizing social anxieties about the racial or postcolonial Other, modern viral pandemics such as aids or swine flu, terrorism and consumerism—among many other variables.[2] As Stephanie Boluk and Wylie Lenz argue, such polysemic quality lies in the fact that "an essential characteristic of the zombie is its capacity for mutation and adaptation" (2011: 9). They add that "just as the zombie resists legal containment, it resists generic and taxonomic containment; it is remarkably capable of adapting to a changing cultural and medial imaginary" (2011: 9). This is certainly the case, although one should

add that it is not so much that writers and filmmakers see the zombie in different ways, but that the zombie functions as a floating signifier, whose meaning can express a variety of latent social concerns and fears, and which can also serve as a vehicle for social critique. In fact, Boluk and Lenz go on to add that "the zombie's utility as a metaphor is virtually without limit" (2011: 9). Thus, the possible meaning of the zombie will change according to the social context in which a given film is produced and distributed. For these reasons, the purpose of this chapter is not to offer a general theory of the zombie film, but a specific analysis of the way zombies can be understood in the selected films, and in relation to the sociopolitical contexts in which these works have been created.

In line with the variety of interpretations mentioned above, several authors have claimed that zombies in American cinema are a reference to the proletariat. The zombies, being exploited by masters, lacking a voice or organization, and acting as alienated subjects, would constitute a metaphor for the working class.[3] This may well be the case in other zombie films, but it is my contention that the zombies in the *Plaga* trilogy and *Juan* can be read as an allusion to the lumpenproletariat, rather than the proletariat— and in particular, to the new forms in which the lumpenproletariat finds expression under post-industrial, globalized capitalist relations.

Zombies and Social Class

The conventions and traditions of the zombie subgenre allow for minor variations in the way these creatures are represented. Whereas sometimes zombies can run, usually they can only drag themselves slowly; in some instances they are even able to speak; and while in many films they are literally living dead (reanimated corpses), in others they are ordinary humans affected by viruses or other harmful agents. However, if there is one thing zombies tend to have in common, regardless of these small differences, it is that they are dressed in rags. Whereas other creatures in non-naturalistic genres from science fiction to horror, such as vampires and extraterrestrials, usually wear elegant and elaborate costumes, zombies are portrayed in dirty,

torn, untidy, and ragged clothes. This is important here because, it should be remembered, the term "lumpen" is the German for "rags" (Stallybrass, 1990: 7). Thus, at its most literal, rags are what define the lumpenproletariat, as well as being one of the essential visual traits of the zombie.

In Marxist terms, the lumpenproletariat is defined by its location outside the relations of production. Among the numerous outcasts that Marx identifies as its members are vagabonds, pickpockets, gamblers, escaped galley slaves, ragpickers, tinkers, and beggars. That is to say, this class comprises "the whole indefinite, disintegrated mass, thrown hither and thither, which the French term la bohème" (1995: 38). It is clear, then, that the lumpenproletariat is an unproductive force, and its members make a living by what they can obtain (by begging, stealing, or somehow procuring) from the rest of society. In that sense, there is a clear parallel with zombies, who literally feed off other people (although not in the same way as the aristocratic vampires, who live in small numbers in luxurious castles, and who are often read as a metaphor for the idle classes who exploit peasants, slaves, or workers). Furthermore, unlike the proletariat—a modern class that has emerged out of the industrial revolution—the lumpenproletariat has existed in all modes of production, since there have always been outcasts excluded from relations of production, whether they were ancient, feudal, or capitalist. This underlines the idea of the lumpenproletariat as a remnant that will not go away and that refuses to die, like the specter and the zombie.

Moreover, the lumpenproletariat has famously been described by Marx as the "scum, offal, refuse of all classes" (1995: 38). The term "offal" is particularly illustrative. It is defined both as "the entrails and internal organs of an animal used as food" and as "refuse or waste material" (*New Oxford American Dictionary*). Images of entrails and internal organs are ordinary in zombie films and they constitute a recurring visual motif in *Juan* and, in particular, the *Plaga* trilogy, in which we see zombies eating the entrails of humans, and even humans using the entrails of zombies as weapons. The second meaning of the term, as refuse or waste, can also be connected with the zombie, as to be explored later, but it is interesting to further discuss Marx's views on the lumpenproletariat—views that were, by and large,

negative. By being situated outside the sphere of labor and production, lumpenproletarians have neither class-consciousness nor any interest in a revolutionary process. In *The Communist Manifesto*, Marx and Engels refer to the lumpenproletariat as a "dangerous class" and as a "passively rotten mass" (2010: 20)—descriptions that could be applied to zombies as well. However, it is important to note that, despite all these negative connotations, Marx did concede that there might be a positive side to the lumpenproletariat. For example, it does have the potential for joining the proletariat in its plight for emancipation and revolution. As Stallybrass notes, Marx was "torn between contradictory ways of seeing that multiplicity: Was it an overflowing heterogeneity or a coagulating mass? . . . Was it a carnival of the living or a charnel house of the dying?" (1990: 72). This defining tension between a being that may be alive or dead can also, of course, be applied to the ontology of the zombie, but it can also point to a parallel between the revolutionary potential of the lumpenproletariat and that of zombies. According to Lauro and Embry, it is essential to understand the zombie as a boundary figure, "as simultaneously powerless and powerful, slave and slave rebellion" (2008: 90). It should also be noted that contemporary sociologists and thinkers working from a perspective that is also critical of capitalist relations have identified new ways in which the lumpenproletariat is expressed under the current conditions of globalized, post-industrial capitalism, but these notions are introduced below.

The *Zombie Plague* Trilogy

Farsa Producciones is an independent production company based in Argentina, responsible for making a large number of music videos and some commercial films commissioned by other companies. The small team of directors, writers, and technicians use the proceeds made in this manner to shoot their highly personal cinematic projects, which they approach in the manner of guerrilla filmmaking. Farsa films are thus collaborative efforts in which its members are responsible for all aspects of production, including writing, directing, photography, set and costume design, makeup,

and even acting. Farsa works are also genre films, particularly drawing on the traditions of horror and science fiction. In addition, as the name of the company indicates, these films are essentially farcical, paying homage but also mocking, imitating, and parodying Hollywood genre films.

The first film in the *Plaga Zombie* trilogy was also Farsa's first film; the third film in the group was released fifteen years later. Despite the passage of time in the trilogy's production, the films narrate the same uninterrupted event: a zombie outbreak in a small Argentinean town. The second and third films pick up the narrative at the point where the preceding film ended. In the manner of *Shaun of the Dead* (Edgar Wright, 2004) and *Zombieland* (Ruben Fleisher, 2009), the *Plaga* trilogy is both a story about zombies and a parody of the zombie film. Probably the most original point regarding *Plaga*, however, is one that may be lost to foreign audiences: the films are also a parody of American popular genre films as seen on Argentinean television. In Argentina, American films and series broadcast on terrestrial TV are for the most part dubbed in Spanish (unlike cinema releases, which are mostly screened with subtitles). However, most Spanish-language dubbing for Latin American releases is done in Mexico, the largest Spanish-speaking market in the region (a process far cheaper than dubbing each film in multiple Spanish-speaking countries, although this would better reflect local accents and linguistic inflections). The characters in the *Plaga* films speak precisely in this kind of Spanish with an attenuated Mexican accent that is heard all the time on TV. The fact that the protagonists have Anglophone names (Max Giggs, Bill Johnson, and John West), which sound like they belong to American B-movies and TV series, reinforces the idea that in *Plaga* we are simply viewing one of these films on Argentinean television. At the same time, the three films were shot on location in the suburbs of Buenos Aires, and therefore the architecture and urbanistic layout is unmistakably local, leaving little doubt that the stories are taking place in Argentina. In this way the films produce an uncanny feeling of estrangement in terms of dialogue and images.

The story begins with a zombie outbreak in a town that remains unnamed. The three protagonists fight for survival by alternatively hiding and fighting the zombies (and in some cases also the FBI, which has quaran-

tined the town).[4] An explanation of what is happening is gradually revealed over the first two films: the outbreak is caused by aliens. The zombies are ultimately human pods used for the reproduction of extraterrestrial beings. After a period of incubation, the aliens literally burst out of the human bodies as an anthropomorphic creature. But this is not quite an unexpected invasion: the aliens had made a pact with the U.S. government, which supposedly allowed them to test a virus in a small sector of the town. The U.S. government was hoping to gain access to advanced alien warfare technology, but the situation gets out of hand: the aliens are in fact seeking to spread the infection across the entire world.

Although such plot details seem particularly intricate and exaggerated, they are merely a pretext for cinematic parody and a playful excuse to depict the gory scenes associated with the subgenre. However, it should be considered that the production of the trilogy coincides (at least the main narrative arc and the release of the first two films) with the period that saw the implementation of drastic reforms in the economy of Argentina. These reforms, products of the Carlos Menem administration (1989–1999) and firmly endorsed by the International Monetary Fund and the U.S. government, revolved around the systematic introduction, over the course of the 1990s, of neoliberal policies that produced crucial changes in Argentine society. Although some sectors greatly benefited from this economic model, it had terrible consequences for the poorer strata of society. Widespread privatizations of public companies caused a sharp increase in unemployment. The dismantling of the state through budget cuts and privatizations also meant that millions of people were left with little access to basic public services such as health and education. The liberalization of trade and the lowering of import tariffs severely affected the national industry, forcing large numbers of companies and factories to close—which in turn led to further increases in unemployment numbers. The population living in slums grew significantly. By the end of the 1990s such dire social consequences were clearly visible throughout the country, and the presence of beggars, picketers, protesters, and different types of criminals (pickpockets, robbers, conmen) became part of everyday life in urban centers. Eventu-

ally, the Argentinean economy collapsed in 2001, after massive and violent protests erupted throughout the country.

If we consider the analogy between zombies and the lumpenproletariat proposed in the previous section, it should not be surprising, therefore, that the first Argentinean zombie film was produced in such a period. Whether begging on street corners, along the aisles of trains and buses, or in fast-food restaurants and shopping centers, the abrupt appearance of vast numbers of people ambling about in ragged clothes would have prompted different feelings and reactions across Argentine society. For the bourgeoisie, the lumpenproletariat could represent a threat to their privileged status, while for the dwindling middle classes and the proletariat it would denote a source of anxiety—a reminder that their position was precarious and that the risk of downward social mobility was a clear possibility.

It should be recognized here that Marx's distinction between proletariat and lumpenproletariat is no longer as clear-cut as it may have been when he formulated such theories. In late capitalist society the boundaries between these two classes have become blurred, and the coordinates that define them have changed. Notions such as permanent employment and industrial work (which defined the proletariat) and the reserve army of labor (a function fulfilled by the lumpenproletariat, who could be called in to replace workers) have disappeared. As Zygmunt Bauman writes, "Where the prefix 'un' in 'unemployment' used to suggest a departure from the norm—as in 'unhealthy' or 'unwell'—there is no such suggestion in the notion of 'redundancy.' No inkling of abnormality, anomaly, spell of ill-health or a momentary slip. 'Redundancy' whispers permanence and hints at the ordinariness of the condition. It names a condition without offering a ready-to-use antonym. It suggests a new shape of current normality and the shape of things that are imminent and bound to stay as they are" (2006: 11–12). Bauman is here referring to the new ways in which the lumpenproletariat is expressed in our globalized and post-industrial society—what Bauman (2007) calls "liquid modernity," in which the "society of producers" has given way to the "society of consumers," and where those who are inadequate consumers no longer have a social role to fulfill. These lead to the appearance of what Bauman calls "wasted lives."

That is to say, capitalism does not only produce vast quantities of industrial and commercial waste but also waste in the form of humans: the outcasts, the pariahs, and the excluded that have been pushed outside the fields of production and consumerism. A view of the lumpenproletariat as waste may not be a particularly novel idea, since it is already inherent in Marx, who used the term "refuse" to categorize this class.[5] But Marx was expressing in this way his negative views on a class he often saw as opposed to communist revolution. Bauman is describing what he sees as the negative consequences of the changes in industrial production and in the organization of labor that has taken place over the past decades. Waste, it is important to point out, is not defined by the intrinsic qualities of an object, but is a matter of appreciation. Thus, the new global order produces entire categories of peoples who are defined as "superfluous" for the system.

In the *Plaga* trilogy the zombies are explicitly associated with excess population. They are sometimes seen loitering in a way that alludes to the practices of the unemployed, marginalized youth—which even includes listening to music, not the typical zombie behavior. Thus, zombies in this case are not mindless consumers; on the contrary, they are those who are no longer able to consume, and thus have been rendered superfluous for society. Following this logic, the production of human waste in its multiple meanings is a constant presence throughout the films. Body parts, organs, blood, and tissue are seen in the background or foreground in countless shots, illustrating human waste at its most literal. A scene in the final episode, in which one of the characters fights the zombies inside the coach of an abandoned train, constitutes a clear reference to the Menem administration, during which the wide-ranging rail network of Argentina was privatized. This meant that an important number of services that were not profitable were closed down, although they played a crucial role in linking scattered towns from the interior of the country with the major cities. These towns were thus cut off from urban centers and left isolated, in some cases condemned to become ghost towns. In addition, train formations were left to rot in abandoned depots. A rusty, ruined train coach thus condenses

Post-industrial decay and rusting cars at the end of *Plaga Zombie*.

multiple connotations regarding neoliberal reforms, industrial decay, and the production of outcasts and wasted lives.

Most importantly, it is at the end of the trilogy where the clearest reference to the logic of waste can be found. The final battle against the zombies takes place in a vast car junkyard, among piles of crushed, dismantled, and burnt vehicles. The final shots of the film show us the three survivors, once the fight is over, standing among the wreckage of metal parts and scattered human limbs, bones, and organs. The cars in such a place remind us of the practices of globalized capital and the "society of consumers," in which new models of products continuously replace the old ones, even if there is no need for it. The zombies might also evoke the passage to the "society of consumers": like the cars, they have been rendered useless and redundant. This is the result of a decade of unrestricted neoliberalism, a project that was avowedly (and tragically) compared by President Menem to "carrying out major surgery without anaesthetizing the patient" (Curia 1999).[6] Such an absurd metaphor would not be an inappropriate way to describe how

the heroes combat the zombies, literally tearing out their organs, punching holes in their bodies with fists and feet, and ripping off their limbs.

In addition, it should be highlighted that the *Plaga* films are not only offering a critique of politics at the local level. The aesthetics of parody and pastiche described above (such as the dubbed voices, Anglophone names, and intertextual citations of American cinema) inscribe the films within a context of globalization and postcolonial power relations that make for a more realistic illustration of contemporary social issues. A key example in this sense is the speech given by John West toward the end of the second episode. When his two friends are losing their spirit in the battle against the zombies, West motivates them, in a talk set to an upbeat, martial score, by emphasizing the need to fight evil as a way to achieve "infinite justice" and hence obtain "enduring freedom." Needless to say, these are references to the George W. Bush rhetoric of the "war on terror" and the U.S. military operations in Afghanistan. However, the artificiality of West's words is made explicit not only by the musical score and intonation but by the fact that, although this is supposed to be a spontaneous speech in the middle of the fight, West is seen reading his lines from a scrap of paper. The scene then acts as an instance of interpellation, becoming an extradiegetic commentary on contemporary politics as well as being part of the film's narrative.

This leads to an important point: in light of the above argument, how can the ending of the trilogy be interpreted? Eventually, although all the FBI agents sent to contain the epidemic are killed, the heroes manage to destroy the mothership with all the aliens. This would seem to represent the triumph of heroic bourgeois individualism, threatened both by the government and the out-of-control lumpenproletariat—a positive outcome that resolves the problem of wasted lives and outcasts. In my opinion, however, this is far from the case. The deliberate absurdity of the ending undermines such an ideological premise. When the heroes realize the zombies are merely pods for reproducing the aliens, who will then be lifted into the spaceship using a tractor beam, they come up with a simple plan. The project, which they call "Trojan zombie," involves merely capturing a zombie, feeding it large quantities of gun powder, and taking it to the rendezvous with the ship. Once the alien

is onboard it explodes, blowing the spaceship to pieces. Such a premise is ridiculous even for the standards of the *Plaga* trilogy, therefore highlighting the implausibility of a positive resolution. The last shot of the film, in which the protagonists stand on the top of a mountain of crushed cars against the sun in the background, mocks happy endings as much as it underlines the endurance of industrial waste under the current conditions of global capital.

On the other hand, a more optimistic interpretation is possible if one focuses on the extratextual elements surrounding the trilogy and its conditions of production. The small band of survivors who fight the zombies with hardly any resources can be read as an allusion to Farsa Producciones itself. Although most films in Argentina are funded by the government, through the Argentine film institute (INCAA), or by foreign investment through coproductions, Farsa still manages to produce and release feature-length films without any support from national or international funding. In order to achieve this, not only creativity and technical skills are required, but also a strong commitment to cooperation, both among the Farsa crew and from other people willing to help them with the large number of logistic and material elements that are necessary for the production of a film. Thus, Farsa's films subvert not only Hollywood narratives and characters but also, and most importantly, institutionalized filmmaking practices, through its independent and exceptionally inexpensive approach. These countercultural strategies are enhanced further by the fact that all Farsa films, after initial releases in film festivals, are distributed free online, not illegally but through the company's official YouTube channel. Perhaps, then, collaborative work and the solidarity it engenders, associated with an approach at odds with hegemonic production and distribution policies, are what show that an alternative to multimillion-dollar Hollywood blockbusters is possible. This may be the true lesson behind the Farsa zombies.

Juan of the Dead

The first Cuban zombie film is also a comedy, although it could be said that it is less farcical and bizarre than the *Plaga* trilogy—it even looks closer, in

terms of its visual effects and design, to American zombie films than to its Argentinean counterparts.[7] The story takes place in contemporary Cuba and follows the plight of the hero, Juan, together with his daughter and a group of friends, who must face a zombie outbreak in the Caribbean island. The title echoes another zombie comedy, *Shaun of the Dead*—in fact the name Shaun is a version of the Spanish Juan, although it should be said that this film was released in Spanish-speaking markets under different titles that have little to do with the original, such as *Zombies Party* (Spain), *Muertos de Risa* (Argentina), and *El Despertar de los Muertos* (Mexico). In *Juan*, like in *Shaun*, no explanation for the outbreak is given. In fact, the word "zombie" is not mentioned here until the final third of the film. Before this moment, everybody is uncertain as to the identity of these creatures. The government keeps referring to them as political dissidents and "imperialists" and accuses the United States of being behind the crisis, in yet another plot to overthrow the Cuban regime. In an early encounter with the creatures, Juan and his friends attempt to eliminate them as if they were vampires, by driving a stake through their hearts. They reject the possibility they could be werewolves, though in any case they lack firearms and, most importantly, the necessary silver out of which bullets could be made. But they do attempt to perform an exorcism on one of the zombies, thinking demonic possession might be involved. Only eventually do they discover that they have to destroy the zombies' brains in order to kill them.

These misadventures may imply a critique of Cuba's isolation in contemporary world order (after all, who would not recognize a zombie nowadays?), but it would not be inappropriate to consider them as a self-conscious reflection on the difficulty of identifying and defining the zombie in metaphorical terms. In fact, the film, which was an unexpected success in Cuba, generated widespread debates as to what the possible meanings of this political parable may be.[8] Since *Juan* echoes the common negative stereotypes about Cubans (most men are lazy and only interested in womanizing and drinking rum, all the young people dream of escaping to Miami, and so on) and the Cuban government (it is completely unable to deal with the crisis and attempts to conceal what is happening through fictitious

media broadcasts), it could be considered that the film is merely a platform against the current Cuban order, a call for Cuban society to finally forget about socialism and embrace global capitalism. However, a more careful reading would reveal that this is far from the case. The zombies are not a reference to uniform, homogenous masses living under a socialist regime. It is true that the rotting bodies of the zombies could be read as an allegory of urban decay seen in La Habana, with its crumbling buildings and 1950s cars, and there is no question that film is critical about several aspects of Cuban society. But in *Juan* there are important issues lying under the surface.

It is necessary to consider the opening sequence, which starts with an overhead shot of Juan, asleep on a makeshift raft floating on the ocean. For anyone familiar with Cuba the connotations are obvious: Juan could be mistaken for a *balsero*, trying to reach the United States on an improvised raft. However, we promptly learn that Juan is only fishing with his friend Lázaro. In the ensuing conversation, Lázaro asks Juan if he is not tempted to sail on to Miami, a proposition Juan rejects categorically. In Miami, he says, he would be forced to work to make a living. In Cuba, instead, his existence is more or less granted, and the State provides for everything he needs without him having to make any efforts. Such reasoning could of course be read as veiled pro-capitalist discourse, mocking the laziness and apathy the Cuban government provokes among its citizens. This, however, does not reflect Juan's personality (in fact he will turn out to be a staunch capitalist, as will be developed later). However, the conversation is at this point interrupted by the appearance of the first zombie in the film, who simply walks out of the water. Lázaro shoots him in the head with a harpoon; both men, upset and confused, row back to land as the zombie sinks into the sea. As the camera pans upward and we see the buildings of La Habana, we realize they were only a few yards off the coast. Thus, the zombie emerging out of the water and the final revelation that the characters were so close to the coast imply that things are not always as they appear on the surface. But the crucial detail here is that the zombie is wearing an orange uniform that, as Sara Armegot perceptively points out, resembles those worn by inmates of the Guantanamo Bay prison (2013: 2). Thus, although the zombies are not

First zombie attack in *Juan de los Muertos*.

political dissidents or imperialist agents, as the government will later claim, it may well be true that they have originated in the United States. Going to Miami might not be such a good idea after all.

Regardless of its origins, however, it is clear that in *Juan* the zombies cannot be interpreted in the same way as in the *Plaga* films. They are still associated with some of the most deprived sectors of society—gamblers, prostitutes, the unemployed, and petty criminals are portrayed as those who have become zombies.[9] However, it is clear that the Cuban lumpenproletariat cannot be equal to the outcasts produced by the market deregulations and privatizations implemented in Argentina. The poor and unemployed in Cuba can never be fully excluded; at the very least, they would have access to free healthcare, education, and food rations. At the same time the film underlines that, officially, the zombies are perceived as "a dangerous class" in political terms. Whereas in *Plaga* the zombies were disgusting monsters, in *Juan* they are treated as political dissidents and anarchists. Whether this is seen as a negative or a positive quality is debatable. As Yoss asks in his review of the film, why should the expression of dissent be a problem in itself? (2011: 51).

If the zombies in *Juan* cannot be considered a reference to Bauman's wasted lives (perfectly applicable for neoliberal Argentina but not quite ap-

propriate in this case), then I would suggest one useful perspective here can be that of multitude, as defined by Michael Hardt and Antonio Negri (2006, 2009). According to Hardt and Negri, a new form of global sovereignty came into place with the demise of the nation-state and the collapse of the Soviet Union at the end of the twentieth century. The name they give to the new social, economic, and juridical order that governs the world is "Empire." It consists of a "decentered and deterritorializing apparatus of rule that progressively incorporates the entire global realm within its open, expanding frontiers" (Hardt and Negri 2006: xii–xiii). Although the rule of Empire is entirely negative, it does contain a new potential for emancipation, to be found in the force of the multitude. By introducing the concept of multitude, Hardt and Negri want to replace older forms of social subjects that do not quite adjust to the new global order, such as the people, the masses, and in particular the idea of proletariat. Like Bauman, Hardt and Negri are aware that relations of production and labor have changed in post-industrial capitalism, and that the concept of the working class leaves out entire sectors of society that should not be dismissed. Although they do not provide an exact definition, multitude refers to the new subjectivities and new forms of collective struggle that emerge under Empire.

It is not difficult to see, then, that *Juan* is dealing with the anxieties that surround present Cuban society in relation to a short- or medium-term future in which sociopolitical change is unavoidable. What is not clear at present is in which direction such transformations will go. As Hardt and Negri write, "Cuba constantly has to ward off the two threatening alternatives that seem to prefigure its future: the catastrophic end of the Soviet experience or the neoliberal evolution of the Chinese" (2009: 92). The film illustrates these tensions and uncertainties in several ways. At the beginning, as mentioned, it seems that *Juan* embodies a political critique of socialist subjectivity. He is portrayed as a slacker, content to lead a relaxed life without doing much, and his main activities involve drinking rum, visiting his lover, and hanging out with his best friend on a rooftop, spying on their neighbors. However, once the zombie epidemic breaks out Juan becomes the ultimate capitalist, taking advantage of the crisis to set up his own private business.

His venture is called "Juan de los muertos," a disposal and removal service that can be hired by the relatives and friends of infected people to kill the zombies and get rid of the bodies. This justifies the company's motto: "We kill your loved ones." Several scenes underline Juan's desire for profit. He will not waive his fees even for the poorest or weakest customers, and when the landlady who called him to remove her zombified tenants is accidentally killed in the process, Juan orders his employees to search the house for the dead woman's money, since he will not leave without getting paid.

An equally contradictory status underlies the zombies, and it is in this sense that they may be interpreted as an allegory of the multitude. Some of the ways in which Hardt and Negri describe this concept might certainly fit the zombies. They write that "the multitude is living flesh that rules itself," that it consists of "the rule of everyone by everyone," and that it functions as an "internally different, multiple social subject whose constitution and action is based not on identity or unity (or, much less, indifference) but on what it has in common" (2006: 100). The zombies, like the multitude, include subjects of all races, genders, sexual orientations, ages, and classes. They are clearly a purely democratic force that rules itself. Its carnal status could not be contested: the zombies are still made of living flesh (admittedly, "living dead flesh"). This might sound far-fetched, but it should be considered that while the zombies may not be political dissidents in the normal way, they are clearly disrupting the social order and represent social change.

On the other hand, it must be recognized that it would be difficult to sustain such a claim based on the evidence provided in the film, which unlike the *Plaga* trilogy is deliberately ambiguous and offers more than one possible explanation for what is happening. For example, the fact that zombies may have originated in Guantanamo might also justify their description as "American agents." This point would rule out that zombies have achieved the status of the multitude, being instead a mob or a crowd. These are also collective forms of social action, as Hardt and Negri point out, but they are different from the multitude in that, although they can have horribly destructive social effects, they lack an emancipatory potential (2006: 100).

Zombies in Havana, from *Juan de los Muertos.*

In this case, since it is clear that the forces of Empire attempt to subjugate the multitude, it may simply be that the zombies represent the outcome of global capital as it invades and spreads throughout the island. This is what awaits Cuba if the Castro regime collapses. The relatively attenuated class differences in Cuban society will be shattered, and a sharp increase of the lumpenproletariat will follow.

But ultimately Juan undergoes another change that might reveal his true personality. After helping his friends build a sort of amphibian vehicle and getting it to the sea, Juan rejects the possibility of escaping to Miami. He would rather stay in Cuba, since for him anything else would be even worse. Perhaps he could even contribute to making things better, now that he has found his commitment to solidarity. Perhaps it is here where we can find the key for the relevance of the idea of the multitude. After all, unlike outcasts, pariahs, and wasted lives, Hardt and Negri's notion is not an empirical reality but a political project of emancipation that has not yet been completed. The multitude refers to the utopian potential that can be constructed out of a collaborative effort across different social groups. And this is precisely Juan's project in the end of the film. Earlier he had been portrayed as selfish and disinterested, while, in contrast with his principles, the main slogans of the revolution appeared in the background, in the form

of billboards or graffiti—phrases such as "Patria o muerte" (Fatherland or death) or the classic Guevarian axiom "Hasta la victoria siempre" (Until victory, always). In the end, Juan becomes a true patriot. By staying in Cuba, he says, he may inspire the people to unite and fight back, in a clear emancipatory project. After all, he has survived many crises already, and he is certain he will prevail once more. It could be said that this makes little sense, that his mission is completely against the odds—but for an authentic Cuban, this would hardly represent a deterrent.

In conclusion, it is pertinent to note that both the *Plaga Zombie* trilogy and *Juan de los Muertos* go beyond the expression of respective conjectural anxieties and concerns that are only relevant to the societies in which the films were produced. According to Todd Platts, zombies might not have entered popular American culture had it not been for the U.S. military occupation of Haiti (1915–1934), which produced xenophobic journalistic descriptions of the country (2013: 549). In this sense the tradition of the zombie is not merely a cultural borrowing from Haitian folklore but the result of a political, imperialist intervention in the country. It is interesting to note that, in this sense, through the different production and aesthetic strategies outlined above (from the textual references to the mise-en-scène and from independent low-budget productions to an openly artificial style), the films discussed here can be considered to articulate a critique that addresses the unequal relations of power between the United States and the rest of the Americas, as well as the long-standing attempts at political, military, and economic control that the United States has traditionally tried to impose across Latin America. Undoubtedly, the economies of Cuba and Argentina are weak and disorderly in comparison to the American one, and if zombies can be said to represent the bottom of the social stratification pyramid, an analogy could be traced at a geopolitical level when comparing Cuba, Argentina, and the United States. Thus, the reappropriation of the zombie by Latin American cultural producers should be celebrated. Hopefully an increasing number of Latin American zombie films will further subvert mainstream versions of the genre and deepen the criticism of un-

equal power relations in Latin America, not only at a national level but at a hemispheric one as well.

Notes

1. Both *Juan de los Muertos* and the last *Plaga Zombie* episode are not included in Suppia and Reis Filho's survey, simply because their article predates the release of these films.
2. For a wide variety of interpretations and readings, see three collections on the topic: Moreman and Rushton 2011a; Moreman and Rushton 2011b; and Boluk and Lenz 2011.
3. See, for example, Bishop 2008, Comaroff and Comaroff 2002, and Suppia and Reis Filho 2010.
4. The fact that it is the American FBI attempting to control the aliens in an obviously Argentinean town can be read along several lines, as it is developed later. It can be considered a critique of American-armed interventions abroad, a parady of Hollywood films, or even a reference to Argentinean foreign policy during the 1990s, which sought to be aligned with U.S. interests as much as possible.
5. Marx also spoke of "surplus population," although mostly in the sense of a reserve army of labor already mentioned.
6. In Spanish: "Aquí había que aplicar cirugía mayor sin anestesia."
7. This should not be surprising, since the film was partly funded by Spanish capitals and the postproduction work and visual effects were carried out in Spain.
8. See Yoss 2011 and Armengot 2013.
9. In this sense, one should admit that, as Terry Eagleton (2011: 12–29) argues, dictatorial regimes such as those in the Soviet Union or Cuba do not reflect the Marxist ideal of a classless, socialist mode of production.

References

Armengot, Sara. 2013. "Creatures of Habit: Emergency Thinking in Alejandro Brugués' Juan de los Muertos and Junot Díaz's Monstro." *TRANS*-14. trans.revues.org/566. March 27.

Bauman, Zygmunt. 2006. *Wasted Lives: Modernity and Its Outcasts.* Cambridge: Polity Press.

Bauman, Zygmunt. 2007. "Collateral Casualties of Consumerism." *Journal of Consumer Culture* 7 (1): 25–56.

Bishop, Kyle. 2008. "The Sub-subaltern Monster: Imperialist Hegemony and the Cinematic Voodoo Zombie." *Journal of American Culture* 31 (2): 141–52.

Boluk, Stephanie, and Wylie Lenz, eds. 2011. *Generation Zombie: Essays on the Living Dead in Modern Culture.* Jefferson, N.C.: McFarland.

Comaroff, Jean, and John L. Comaroff. 2002. "Alien-nation: Zombies, Immigrants, and Millennial Capitalism." *South Atlantic Quarterly* 101 (4): 779–805.

Curia, Walter. 1999. "Menem lo dijo (en diez años)." *Clarín*, August 22, 1999. edant.clarin.com/diario/1999/08/22/t-00601d.htm. Accessed April 10, 2013.

Eagleton, Terry. 2011. *Why Marx Was Right.* New Haven, Conn.: Yale University Press.

Hardt, Michael, and Antonio Negri. 2000. *Empire*. Cambridge, Mass.: Harvard University Press.

Hardt, Michael, and Antonio Negri. 2006. *Multitude*. London: Penguin.

Hardt, Michael, and Antonio Negri. 2009. *Commonwealth*. Cambridge, Mass.: Belknap Press of Harvard University Press.

Lauro, Sarah Juliet, and Embri, Karen. "A Zombie Manifesto: The Nonhuman Condition in the Era of Advanced Capitalism." *boundary 2* 35:1 (Spring 2008): 85–108.

Marx, Karl. 1995. *The Eighteenth Brumaire of Louis Bonaparte*. www.marxists.org/archive/marx/works/1852/18th-brumaire/. Accessed February 5, 2013.

Marx, Karl. 2010. *The Communist Manifesto*. www.marxists.org/archive/marx/works/1848/communist-manifesto. Accessed February 5, 2013.

Moreman, Christopher, and Cory James Rushton, eds. 2011a. *Race, Oppression and the Zombie: Essays on Cross-Cultural Appropriations of the Caribbean Tradition*. Jefferson, N.C.: McFarland.

Moreman, Christopher, and Cory James Rushton, eds. 2011b. *Zombies Are Us: Essays on the Humanity of the Walking Dead*. Jefferson, N.C.: McFarland.

Platts, Todd K. 2013. "Locating Zombies in the Sociology of Popular Culture." *Sociology Compass* 7 (7): 547–60.

Stallybrass, Peter. 1990. "Marx and Heterogeneity: Thinking the Lumpenproletariat." *Representations* 31 (Summer 1990): 69–95.

Suppia, Alfredo, and Lucio Reis Filho. 2010. "La invasión zombi en el cine de terror independiente latinoamericano." In *Horrofílmico: aproximaciones al cine de terror en Latinoamérica y el Caribe*, ed. R. Díaz Sambrana and P. Tomé, 142–59. San Juan: Editorial Isla Negra.

Yoss [José Miguel Sánchez]. 2011. "La épica farsa de los sobrevivientes: o varias consideraciones casi sociológicas sobre la actualidad y el más reciente cine cubano, disfrazadas de ¿simple? reseña del filme Juan de los muertos." *Korad: Revista Digital de Literatura Fantástica y de Ciencia Ficción* 7 (October–December 2011): 48–55. scholarcommons.usf.edu/cgi/viewcontent.cgi?article=1231&context=scifistud_pub. Accessed April 27, 2013.

CONTRIBUTORS

MARK BOULD is Reader in Film and Literature at the University of the West of England, and coeditor of *Science Fiction Film and Television.* He is an advisory editor of *Deletion: The Online Journal in Science Fiction Studies, Extrapolation, Historical Materialism: Research in Critical Marxist Theory, Intensities: The Journal of Cult Media, Paradoxa: Studies in World Literary Genres,* and *Science Fiction Studies.* He is the author of *Film Noir: From Berlin to Sin City* (2005), *The Cinema of John Sayles: Lone Star* (2009), *Science Fiction: The Routledge Film Guidebook* (2012), and *Solaris* (2014); coauthor of *The Routledge Concise History of Science Fiction* (2011), and coeditor of *Parietal Games: Critical Writings by and on M. John Harrison* (2005), *The Routledge Companion to Science Fiction* (2009), *Fifty Key Figures in Science Fiction* (2009), *Red Planets: Marxism and Science Fiction* (2009), and *Neo-Noir* (2009).

TONY BURNS is an Associate Professor in the School of Politics and International Relations at the University of Nottingham. His publications include *Political Theory, Science Fiction and Utopian Literature: Ursula K. Le Guin and The Dispossessed* (2008); "Science, Politics and Utopia in

George Orwell's *Nineteen Eighty-Four*" (2012); "Science and Politics in *The Dispossessed*: Le Guin and the 'Science Wars'" (2005); "Marxism and Science Fiction: A Celebration of the Work of Ursula K. Le Guin" (2004); *and* "Zamyatin's *We* and Postmodernism" (2000). He is currently working on a book to be titled *Science, Politics and Dystopia*.

PETRA HANÁKOVÁ is Assistant Professor in the Department of Film Studies and researcher in the Center for Gender Studies at the Charles University in Prague. She is currently working on the representation of national identity in Czech cinema and broader visual culture. She has authored a survey book on feminist film theory, *Pandořina skřínka aneb Co feministky provedly filmu?* (Pandora's Box, or What Did Feminists Do to Cinema? [2007]), edited a volume on theories of spectatorship, *Výzva perspektivy. Obraz a jeho divák od malby quattrocenta k filmu a zpět* (The Challenge of Perspective: The Image and Its Spectator from Quattrocento Painting to Film and Back [2008]), and coedited a collection on Visegrad cinemas (2010).

EWA MAZIERSKA is Professor of Contemporary Cinema in the School of Journalism, Media and Communication at the University of Central Lancashire. Her publications include *From Self-Fulfillment to Survival of the Fittest: Work in European Cinema from the 1960s to the Present* (2015), *European Cinema and Intertextuality: History, Memory, Politics* (2011), *Masculinities in Polish, Czech and Slovak Cinema* (2008), *Roman Polanski: The Cinema of a Cultural Traveller* (2007). She is principal editor of the journal *Studies in Eastern European Cinema*.

EVA NÄRIPEA is Director of Film Archives at the National Archives of Estonia and a senior researcher with the Estonian Academy of Arts. She received her PhD in 2011 for a study on *Estonian Cinescapes: Spaces, Places and Sites in Soviet Estonian Cinema (and Beyond)*. In addition to a number of articles on spatial representations in Estonian and Eastern European cinema, she has published several studies on Marek Piestrak's science fiction

films and other Eastern European science fiction cinema. She has coedited *Via Transversa: Lost Cinema of the Former Eastern Bloc* (2008, with Andreas Trossek), a special issue on Estonian cinema for *Kinokultura* (2010, with Ewa Mazierska and Mari Laaniste), and *Postcolonial Approaches to Eastern European Cinema: Portraying Neighbours on Screen* (2014, with Ewa Mazierska and Lars Kristensen).

MARIANO PAZ is Lecturer in Spanish at the University of Limerick, Ireland. He has a degree in sociology from the University of Buenos Aires and a PhD in screen studies from the University of Manchester. He has taught at the Universities of Liverpool and Glasgow and has published several articles on politics and ideology in Latin American science fiction cinema, including "Vox Politica: Acousmatic Voices in Argentine Science Fiction Cinema" (2011), "Maradona on the Moon: Cultural Hybridity and Postcolonial Politics in Argentina's *Adiós Querida Luna*" (2014), and "Buenos Aires Dreaming: Chronopolitics, Memory and Dystopia in *La Sonámbula*" (2013).

ALFREDO SUPPIA is Professor of Film Studies at the State University of Campinas (UNICAMP), Brazil, and a member of the Brazilian Society for Film and Audiovisual Studies (SOCINE) and the Science Fiction Research Association. He is the author of several articles and chapters on world science fiction film, as well as the books *The Replicant Metropolis: Constructing a Dialogue between Metropolis and Blade Runner* (2011) and *Independent Cinemas: Cartographies for a Global Audiovisual Phenomenon* (2013).

SHERRYL VINT is Professor of Science Fiction Media Studies at the University of California, Riverside (UCR). She is the author of *Bodies of Tomorrow* (2007), *Animal Alterity* (2010), *The Wire* (2013), *Science Fiction: A Guide to the Perplexed* (2014), and *The Routledge Concise History of Science Fiction* (2011, with Mark Bould). She coedits the journal *Science Fiction Film and Television* and *Science Fiction Studies* and codirects the Science Fiction and Technoculture Studies program at UCR.

INDEX